American Graphic Design Awards

No. 1

American Graphic Design Awards

No. 1

Visual Reference Publications/New York

Copyright © 2001 by Kaye Publishing Corp.

Visual Reference Publications, Inc.
302 Fifth Avenue
New York, NY 10001

Distributors to the trade in the United States and Canada
Watson-Guptill
770 Broadway
New York, NY 10003

Distributors outside the United States and Canada
HarperCollins International
10 East 53rd Street
New York, NY 10022

Design: Rob Richards, Pin Design

Library of Congress Cataloging in Publication Data:
American Graphic Design Awards No. 1
Printed in Hong Kong
ISBN 1-58471-060-8

Contents

American Graphic Design Awards No. 1

Introduction ... 7

Advertising ... 9

Announcements / Invitations / Cards 14

Annual Reports...25

Books .. 38

Brochures / Collateral................................. 42

Calendars ..68

Catalogs ... 71

Corporate Identity 75

Direct Mail / Direct Response 81

Internet / Interactive 87

Letterhead / Stationery94

Logos / Trademarks / Symbols100

Newsletters ..111

Packaging ...114

Point-of-Purchase / Displays / Signs130

Posters134

Pro Bono / Public Service139

Publications...142

Sales Promotion150

Self Promotion155

Judges ..163

Firms Represented ...166

Welcome

As completion of the issue neared and we saw all the winning pieces in one place... and we knew that no hype nor window dressing would be necessary. The work itself — representing an elite handful of the nearly 11,000 pieces entered — displays nothing less than the best of graphic design, the power of communication, and the remarkably broad range of projects, clients and venues that creative professionals touch. It is the work that distinguishes this edition of the Annual as no trumped up tagline or forced theme ever could.

Which leaves just one more piece of business in this Welcome Letter, which is to note that the award winning designs were done on a backdrop of unprecedented promise for graphic design as an art, discipline, community and industry.

In the past decade leading up to this moment, professional graphic design has undergone a brilliant transition from back room prettifiers into a central role of responsibility, control and influence in the communication process. The field has well over 100,000 working professionals at independent design firms, advertising agencies, corporations, publishers and various other institutions and organizations. Creative jobs are expanding faster than the workforce as a whole, purchasing influence is growing exponentially, 'graphic design' has eclipsed advertising, printing, and media-related courses at the college level, the AIGA national trade association shows membership at an all-time high, and recent studies by TrendWatch demonstrate that confidence among designers is high and revenues are expected to surge over the next five to ten years. The reasons for the growth are complex, but there are three worth contemplating.

One is the recognition of design as a valuable business and institutional asset. It is simply harder for them to convey their message or even to keep the attention of an impatient, transient, globalized audience. Design is increasingly understood as a valuable business asset with identity and branding entrenched in the communications processes.

Welcome

Second, digital technology has moved responsibility upstream toward the content creator, giving designers more control over the graphic communications process and launching a cross-media era where print design, p-o-p and packaging, internet and broadcast complement, converge and coexist. This has made creative professionals the "gatekeepers" in the design, production, buying and specifying process; and it puts the designer in the center.

Third, top-flight graphics professionals are responding well to these increased challenges and demands by transforming themselves into strategic thinkers and planners, by helping clients solve problems from the beginning of the process, by understanding and synthesizing the culture and communicating it on behalf of clients and causes, and by becoming smarter about their own business.

The vote is in and it reveals a profession that is great and growing, surging with energy and intelligence, interpreting and even shaping commerce and culture. On this point, no recount is required.

Gordon Kaye, *Publisher*

Laura Roth, *Director, American Graphic Design Awards*

Jan Schorr, *Associate Director, American Graphic Design Awards*

Rob Richards, *Creative Director*

Ilana Greenberg, *Design & Production Manager*

Susan Benson, *Editor*

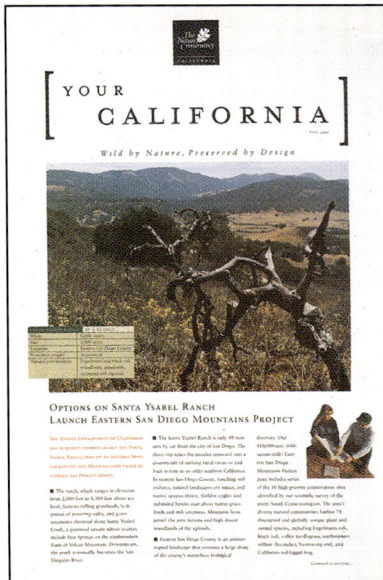

1

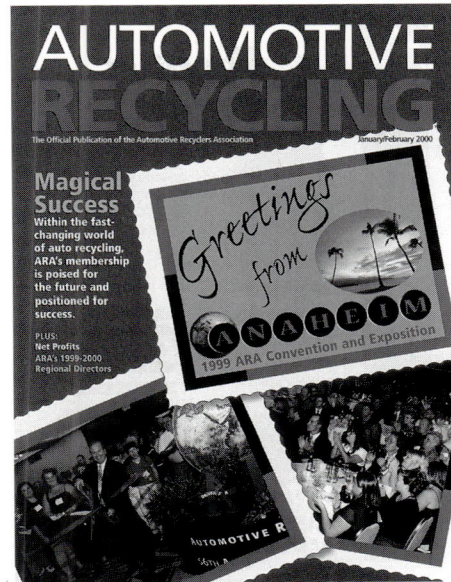

2

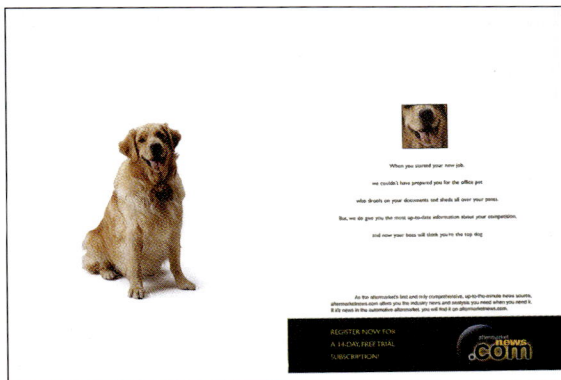

3

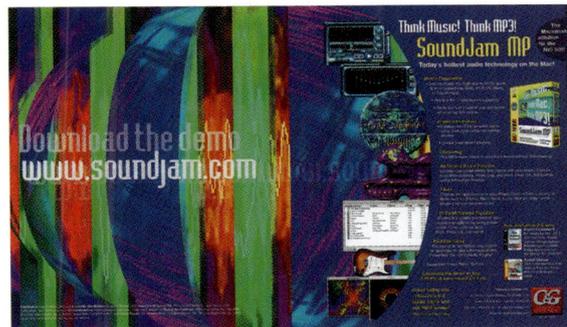

4

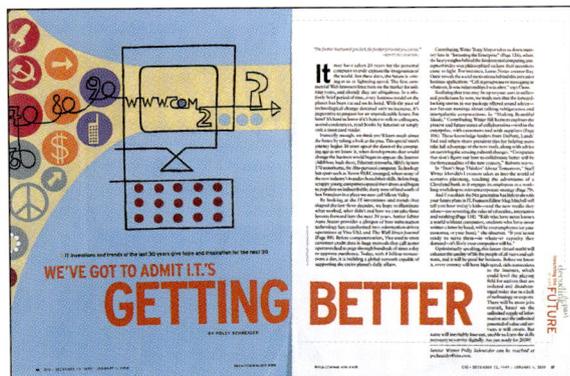

5

Advertising

1 **Design Firm:** Akagi Remington, San Francisco, CA **Client:** Nature Conservancy of California **Project:** Your California **Art Director:** Dorothy Remington **Designer:** Alison McKee, Kimberly Powell

2 **Design Firm:** Automotive Recyclers Association, Fairfax, VA **Project:** Automotive Recycling Magazine, January/February 2000 Issue **Art Director:** Tammy Haire **Designer:** Caryn Suko

3 **Design Firm:** Babcox Publications, Akron, OH **Client:** Aftermarketnews.com **Project:** Ad Series **Designer:** Doug Scheetz

4 **Design Firm:** Casady & Greene, Salinas, CA **Project:** SoundJam MP Ad **Art Director:** Karen Thompson **Designer:** Lisa Dutra

5 **Design Firm:** CIO Magazine, Framingham, MA **Project:** Inventing the Future **Art Director:** Mary Lester **Designer:** Jessica Sepe **Illustrator:** Laura Ljungkvist

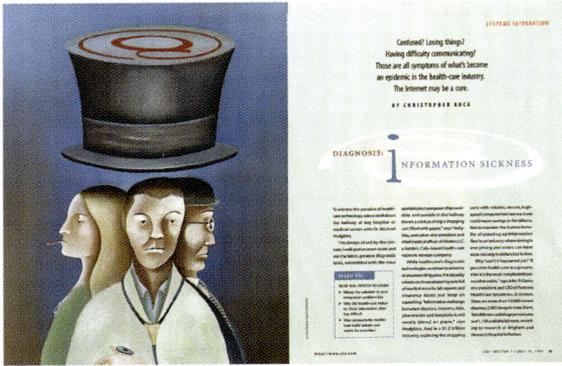

1

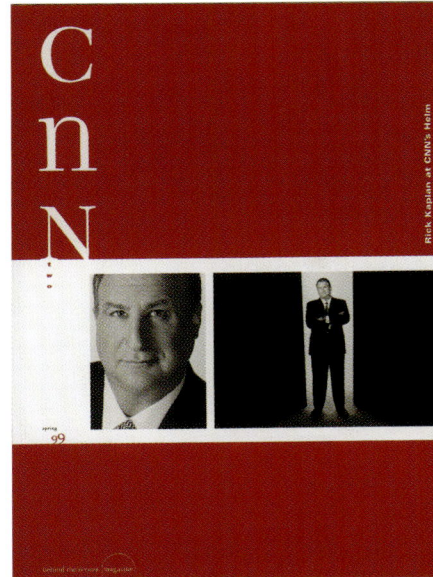

2

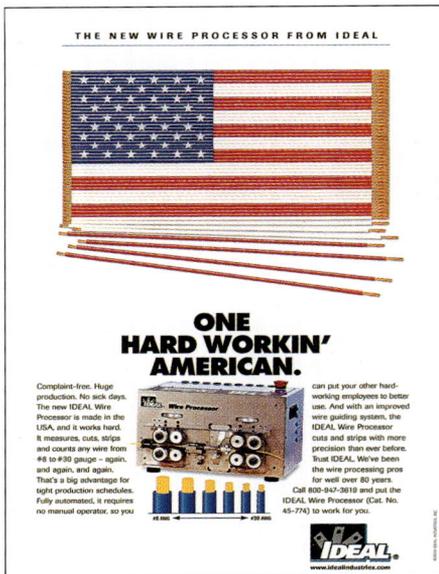

3

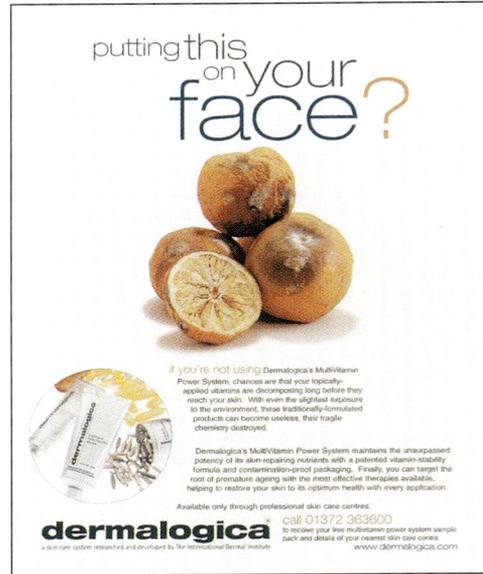

4

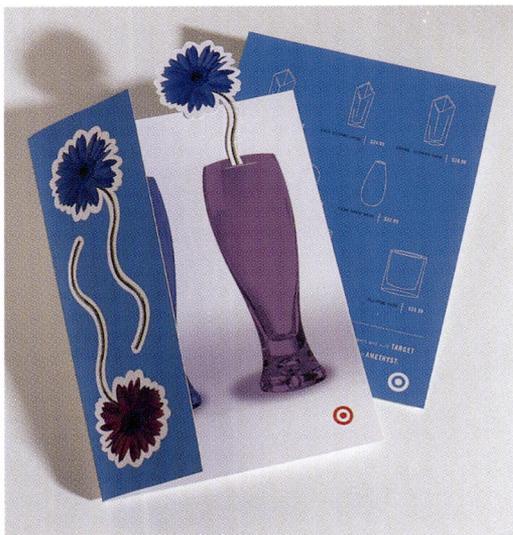

5

1 **Design Firm:** CIO Magazine, Framingham, MA **Project:** Information Sickness **Art Director:** Mary Lester **Designer:** Kaajal Asher **Illustrator:** Jacques Cournoyer

2 **Design Firm:** Clarion Marketing & Communications, Atlanta, GA **Client:** CNN **Project:** CNN Two Magazine **Art Director:** Judi Weber **Designer:** Judi Weber, Dwight Smith **Photographer:** Mark Hill

3 **Design Firm:** Davis Harrison Dion, Chicago, IL **Client:** Ideal Industries, Inc. **Project:** One Hard Workin' American **Art Director:** Brent Vincent, Rob Grogan **Designer:** Bob Dion **Illustrator:** Dave Paoletti

4 **Design Firm:** Dermal Group, Torrance, CA **Client:** Dermalogica UK Division **Project:** Putting This on Your Face Ad **Art Director:** Claudine Villemure **Designer:** Claudine Villemure **Photographer:** Linda Ikeda

5 **Design Firm:** Design Guys, Minneapolis, MN **Client:** Target Stores **Project:** Home Decor Interactive Ads **Art Director:** Steven Sikora **Designer:** Anne Patterson

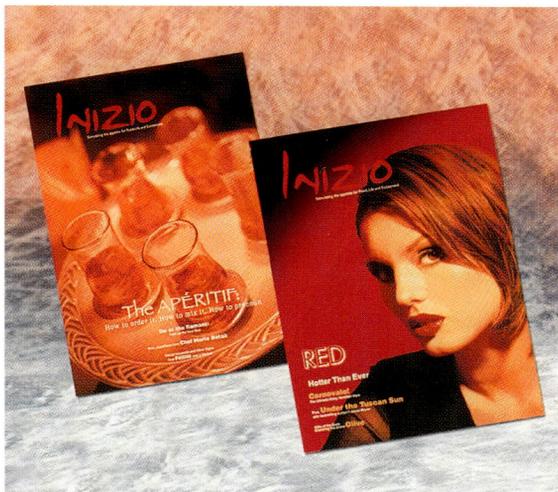

1

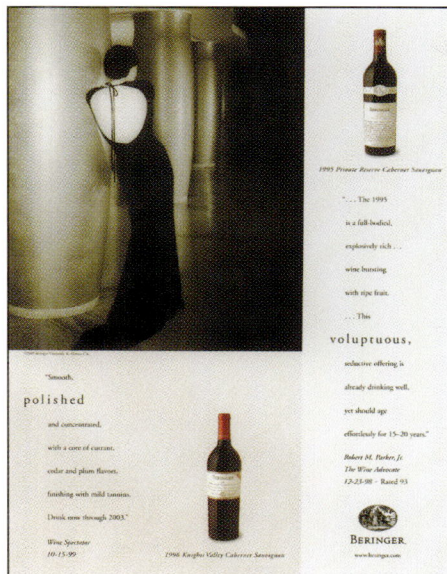

2

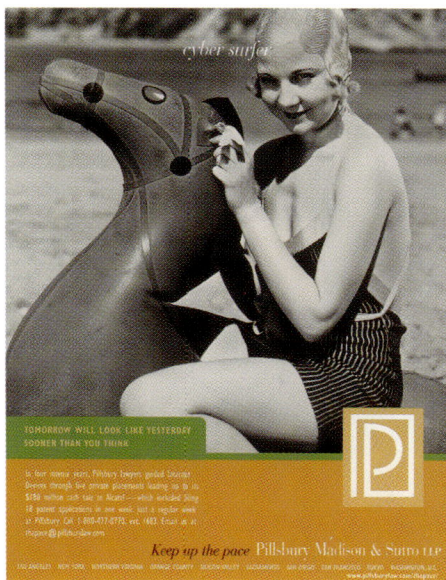

3

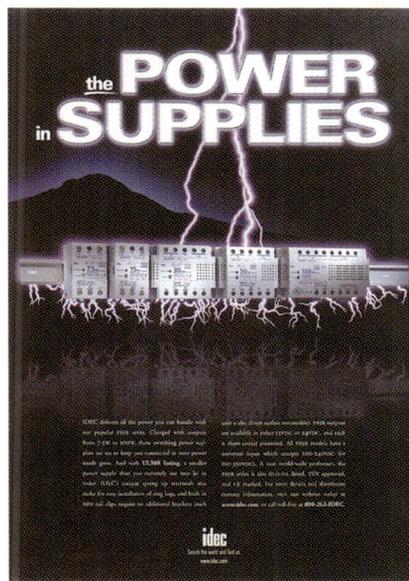

4

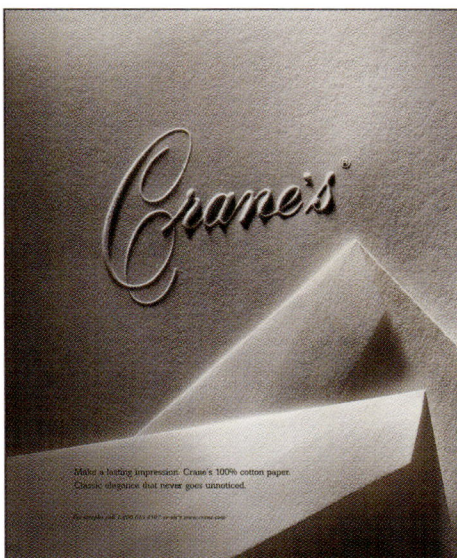

5

1 **Design Firm:** Gammon Ragonesi Associates, New York, NY **Client:** Campari USA **Project:** Inizio Magazine **Art Director:** Mary Ragonesi **Designer:** Mary Ragonesi **Photographer:** Greg Lord

2 **Design Firm:** GMO/Hill Holliday, San Francisco, CA **Client:** Beringer **Project:** Trade Ad **Art Director:** Rick Atwood **Designer:** Marc Woollard **Photographer:** Deborah Samuel **Copywriter:** Amy Caplan

3 **Design Firm:** Greenfield/Belser, Washington, DC **Client:** Pillsbury Madison & Sutro **Project:** Vintage Ad Series **Art Director:** Burkey Belser **Designer:** Kristen Mullican-Ferris, Burkey Belser

4 **Design Firm:** IDEC Corporation, Sunnyvale, CA **Project:** Power Supply Ad **Art Director:** Jared Tipton **Designer:** Jared Tipton **Photographer:** Kent Clemenco **Illustrator:** Jared Tipton

5 **Design Firm:** Keiler & Company, Farmington, CT **Client:** Crane & Company **Project:** Make a Lasting Impression **Art Director:** Liz Dzilenski **Designer:** Liz Dzilenski **Photographer:** Frank Marchese

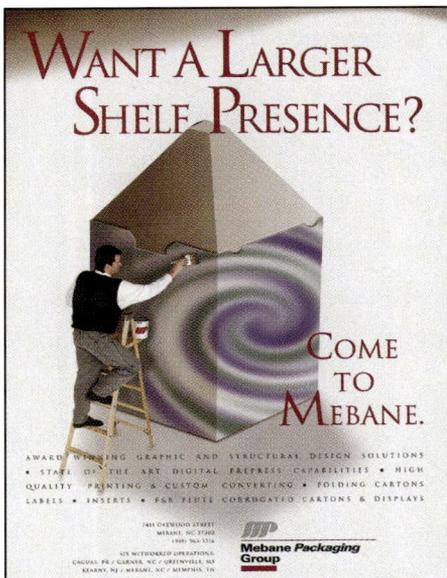

1

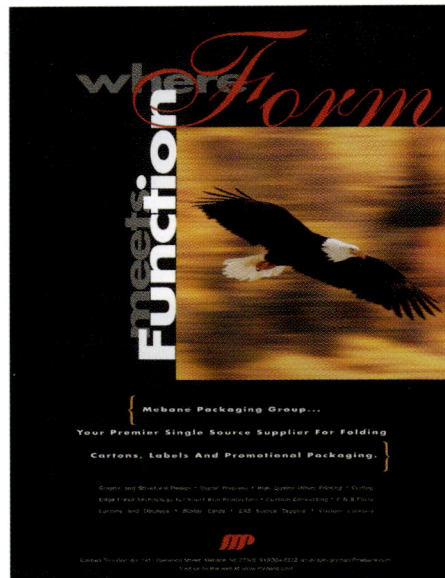

2

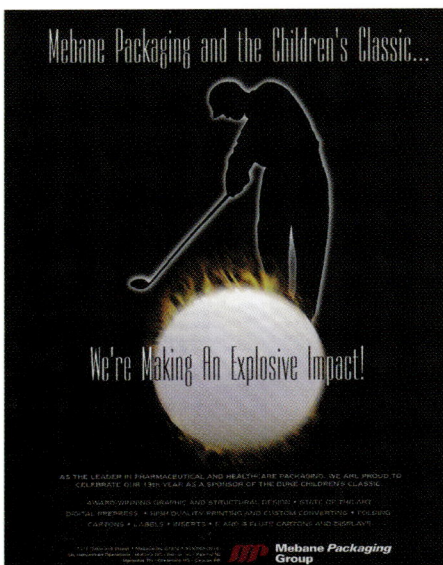

3

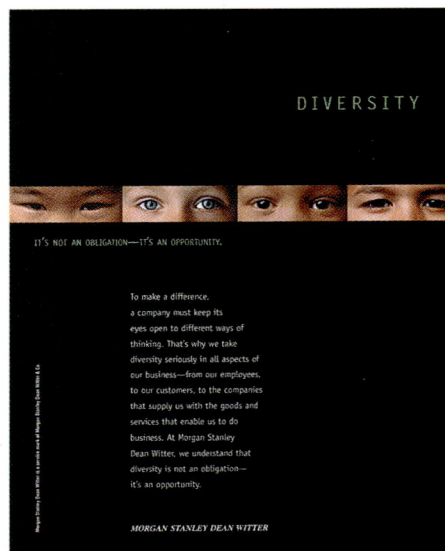

4

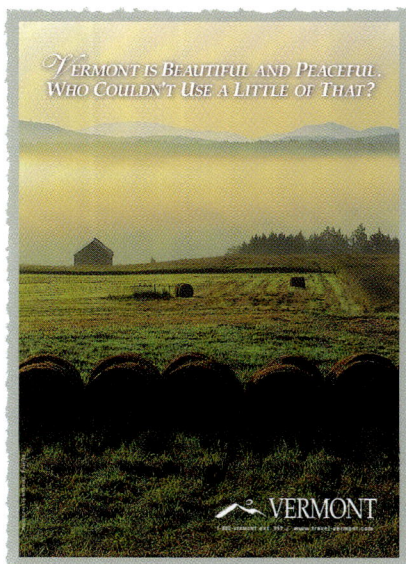

5

1 **Design Firm:** Mebane Packaging of Westvaco, Mebane, NC
Project: Larger Shelf Presence Ad **Art Director:** Lon Gilbert
Designer: Lon Gilbert **Illustrator:** Lon Gilbert

2 **Design Firm:** Mebane Packaging of Westvaco, Mebane, NC
Project: Form and Function Ad **Art Director:** Lon Gilbert **Designer:**
Lon Gilbert

3 **Design Firm:** Mebane Packaging of Westvaco, Mebane, NC
Project: Children's Classic Golf Ad **Art Director:** Lon Gilbert
Designer: Lon Gilbert

4 **Design Firm:** Morgan Stanley Dean Witter: IBD Creative Services,
New York, NY **Project:** Supplier Diversity Ad Campaign **Art
Director:** Freddie Paloma, James Brown, Chris Lee **Designer:**
Freddie Paloma

5 **Design Firm:** Paul Kaza Associates, Inc., South Burlington, VT
Client: Vermont Department of Tourism and Marketing **Project:**
Summer Campaign **Designer:** David Walker **Copywriter:** Paul
Kaza, Stewart Wood **Photographer:** Alan L. Graham, Alan
Jakubek, Paul Boisvert

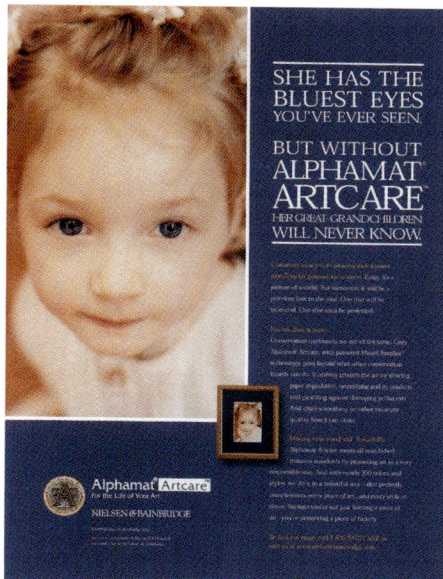

1

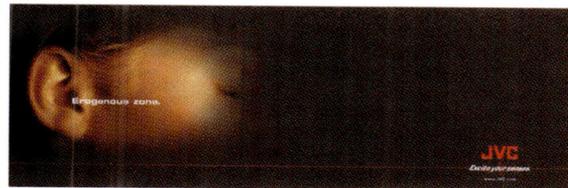

2

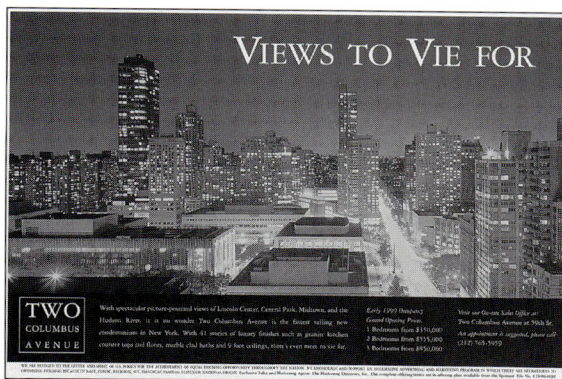

3

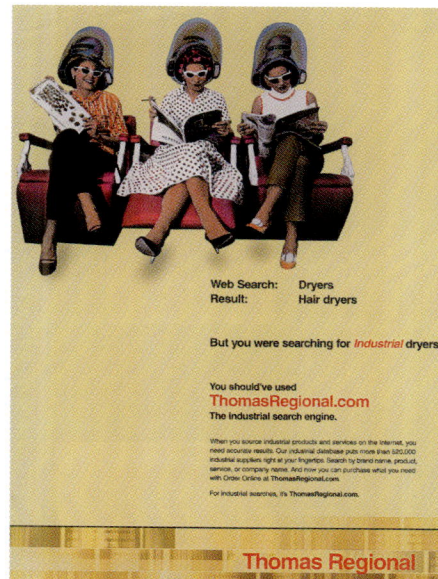

4

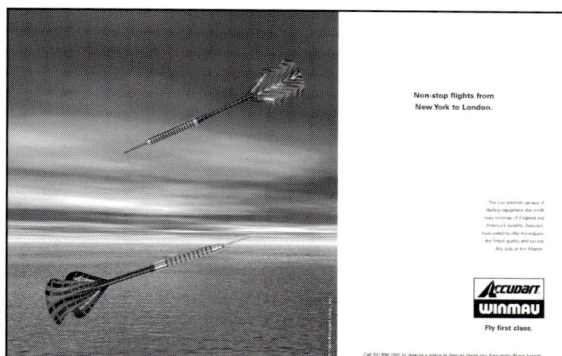

5

1 **Design Firm:** R&J Integrated Marketing Communications, Parsippany, NJ **Client:** Nielsen & Bainbridge **Project:** Blue Eyes **Art Director:** Andrew Cammarata **Designer:** Andrew Cammarata

2 **Design Firm:** R&J Integrated Marketing Communications, Parsippany, NJ **Client:** JVC **Project:** Excite Your Senses **Art Director:** Paul Federico **Designer:** Paul Federico

3 **Design Firm:** Sherman Advertising Associates, New York, NY **Client:** Two Columbus Avenue **Project:** Views to Vie For Ad **Art Director:** Sharon Elaine Lloyd **Designer:** Sharon Elaine Lloyd **Photographer:** Bill Taylor

4 **Design Firm:** St. Jacques Communications Design, Morristown, NJ **Client:** Thomas Regional **Project:** Web Search Ad Campaign **Art Director:** Philip St. Jacques **Designer:** Philip St. Jacques

5 **Design Firm:** Sunspots Creative, Inc., Hoboken, NJ **Client:** Accudart **Project:** Non-stop Flight Ads **Art Director:** Rick Bonelli **Designer:** Deena Hartley **Photographer:** Manny Akis

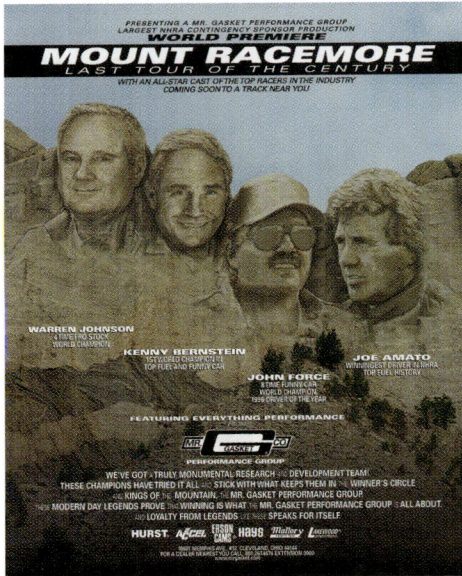

1

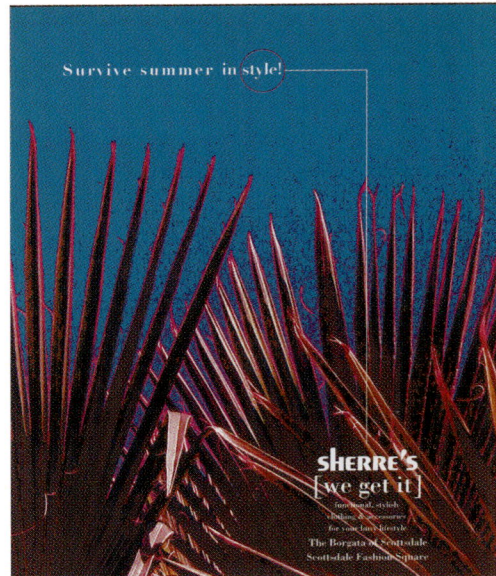

2

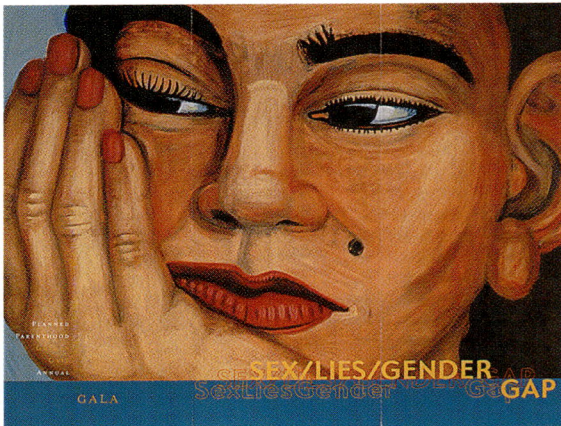

3

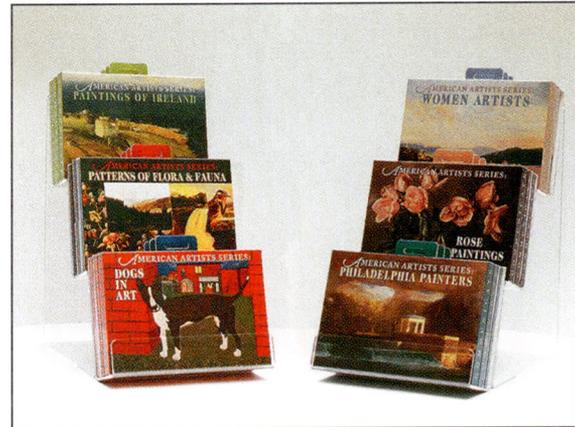

4

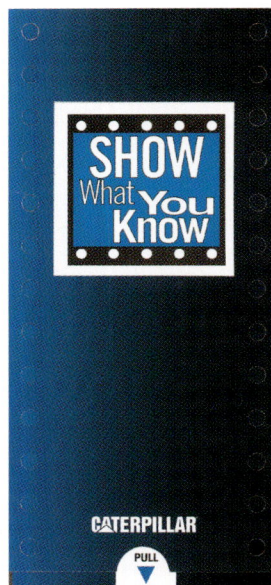

5

1 **Design Firm:** The Mr. Gasket Performance Group, Cleveland, OH **Project:** Mount Racemore Ad **Art Director:** Kirk Tenney **Designer:** Kirk Tenney **Illustrator:** Harvey Phillips

2 **Design Firm:** Tieken Design & Creative Services, Phoenix, AZ **Client:** Sherre's Clothing & Accessories **Project:** Survive Summer Ad **Art Director:** Fred E. Tieken **Designer:** Stan Hattaway **Photographer:** Stan Hattaway

Announcements/Invitations/Cards

3 **Design Firm:** Addis Group, Inc., Berkeley, CA **Client:** Planned Parenthood Golden Gate **Project:** Invitation and Program for 2000 Gala **Art Director:** Steven Addis **Designer:** Asha McLaughlin **Production Artist:** Elizabeth Rowell

4 **Design Firm:** Art dot sos, Philadelphia, PA **Client:** Published for Stationery Market **Project:** American Artist Series **Art Director:** Barbara Sosson **Designer:** Barbara Sosson **Illustrator:** Various artists

5 **Design Firm:** BI Performance Services, Minneapolis, MN **Client:** Caterpillar **Project:** Show What You Know Invite **Art Director:** Mark Geis **Designer:** Mark Geis

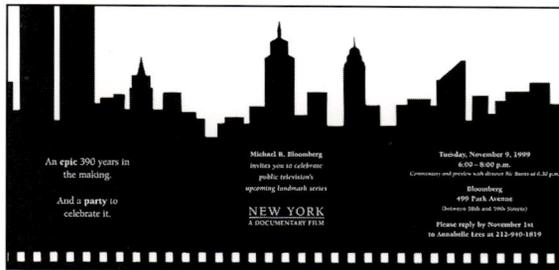

An **epic** 390 years in the making.

And a **party** to celebrate it.

NEW YORK
A DOCUMENTARY FILM

Michael R. Bloomberg invites you to celebrate public television's upcoming landmark series

Tuesday, November 9, 1999
6:00–8:00 p.m.
Ceremony and preview with diverse bit. livens at 6:30 p.m.

Bloomberg
499 Park Avenue
(between 58th and 59th Streets)

Please reply by November 1st
to Annabelle Lees at 212-940-1819

1

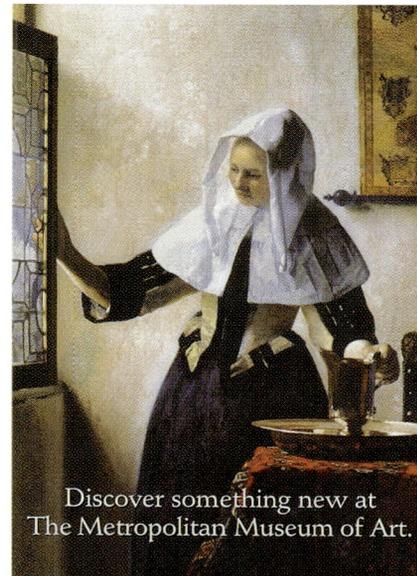

Discover something new at
The Metropolitan Museum of Art.

2

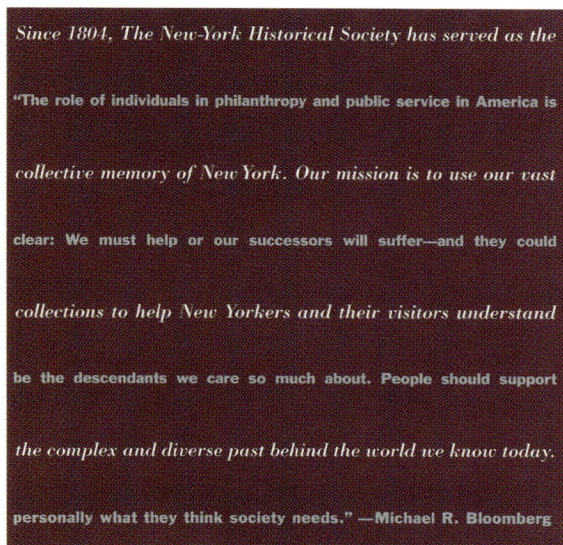

Since 1804, The New-York Historical Society has served as the

"The role of individuals in philanthropy and public service in America is

collective memory of New York. Our mission is to use our vast

clear: We must help or our successors will suffer—and they could

collections to help New Yorkers and their visitors understand

be the descendants we care so much about. People should support

the complex and diverse past behind the world we know today.

personally what they think society needs." —Michael R. Bloomberg

3

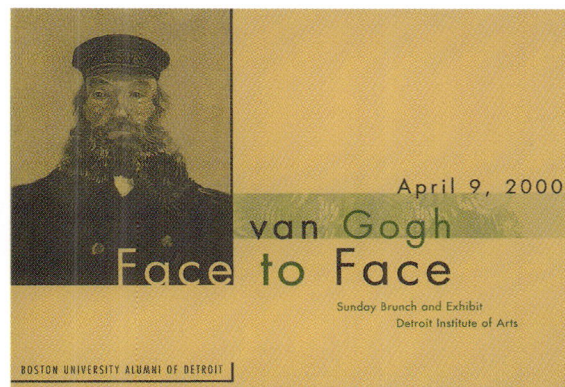

April 9, 2000

van Gogh
Face to Face

Sunday Brunch and Exhibit
Detroit Institute of Arts

BOSTON UNIVERSITY ALUMNI OF DETROIT

4

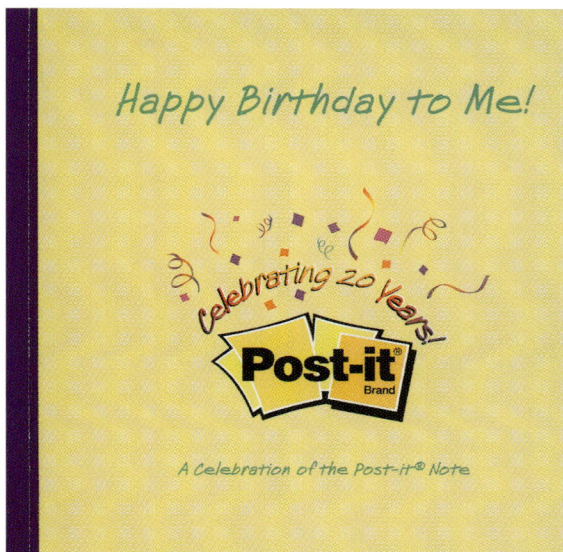

Happy Birthday to Me!

Celebrating 20 Years!
Post-it
Brand

A Celebration of the Post-it® Note

5

1 **Design Firm:** Bloomberg, Princeton, NJ **Project:** New York/ A Documentary Film Invite **Art Director:** Sandy O'Connor, Anthony Warn **Designer:** Anthony Warn

2 **Design Firm:** Bloomberg, Princeton, NJ **Project:** Key to the MET Invite **Art Director:** Sandy O'Connor, Anthony Warn **Designer:** Anthony Warn

3 **Design Firm:** Bloomberg, Princeton, NJ **Project:** New York Historical Society Invite **Art Director:** Sandy O'Connor **Designer:** Holly Tienken

4 **Design Firm:** Boston University, Boston, MA **Project:** Van Gogh Invite **Designer:** Wendy Garbarino **Photographer:** MFA Boston, The Detroit Institute of Arts

5 **Design Firm:** Brodeur Worldwide, Boston, MA **Client:** Post-it **Project:** Post-it Note 20th Anniversary Book **Art Director:** Kristen M. Lepage, Eric D. Stich **Designer:** Kristen M. Lepage, Eric D. Stich, Andrew Seletz **Photographer:** Brian Wilder **Illustrator:** Kristen M. Lepage, Eric D. Stich, Kent High

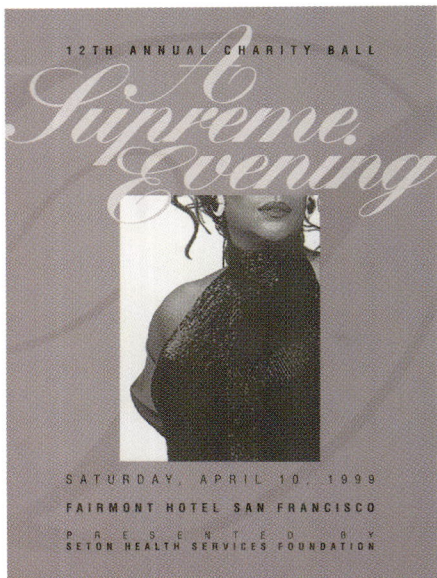

1

2

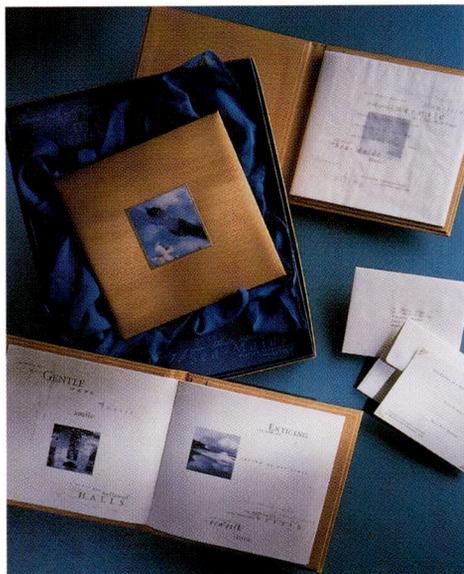

3

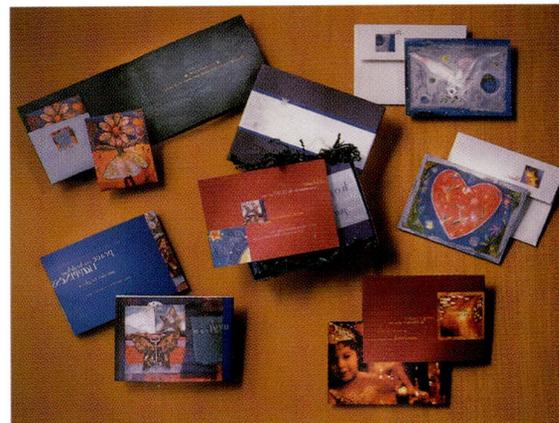

4

5

1 **Design Firm:** Chris Carline Design, San Francisco, CA **Client:** Seton Health Services Foundation **Project:** 12th Annual Charity Ball Invite **Art Director:** Chris J. Carline **Designer:** Chris J. Carline

2 **Design Firm:** Crawford/Mikus Design, Inc., Atlanta, GA **Client:** RSG **Project:** Marketechnics **Art Director:** Elizabeth Crawford **Designer:** Elizabeth Crawford **Illustrator:** Jose Ortega

3 **Design Firm:** David Carter Graphic Design Associates, Dallas, TX **Client:** Le Saint Geran Resort **Project:** Grand Re-Opening Invitation **Art Director:** Lori B. Wilson **Designer:** Tabitha Bogard **Photographer:** Leah Demchick

4 **Design Firm:** David Carter Graphic Design Associates, Dallas, TX **Project:** Holiday Card - Box of Wishes **Art Director:** Lori B. Wilson **Designer:** Stephanie Pickering **Photographer:** Rich Klein **Illustrator:** Sarah Eisler, Susan Leopold, Kelly Stribling Sutherland

5 **Design Firm:** Design Matters, Inc!, New York, NY **Client:** Nuveen Investments **Project:** e-Commerce **Art Director:** Stephen M. McAllister **Designer:** Stephen M. McAllister

www.peacelovejoygoodhealth.com

1

DESIGNING FOR THE FUTURE

BUILDING ON THE PAST

2

PRO TOOLS
2000
WISHING YOU ALL THE BEST THIS HOLIDAY SEASON AND INTO THE NEW MILLENNIUM

3

KiDS

4

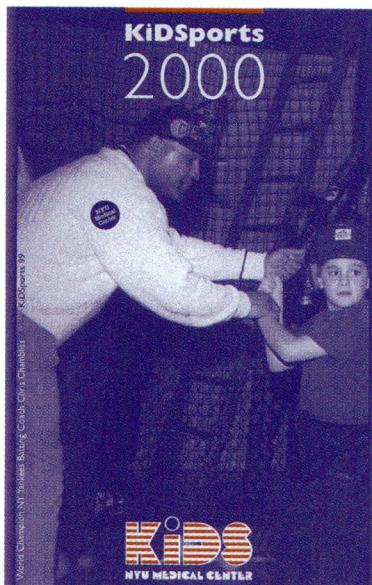

KiDSports
2000

KiDS
NYU MEDICAL CENTER

5

1 **Design Firm:** Design Source East, Cranford, NJ **Project:** Words to Click By...Card **Art Director:** Mark Lo Bello **Designer:** H. Dean Pillion, Mark Lo Bello

2 **Design Firm:** Development Design Group Inc., Baltimore, MD **Client:** Corporate Holiday Greeting Card **Project:** Building on the Past Designing for the Future **Art Director:** Valerie Knauff **Designer:** Candice J. Weinstein

3 **Design Firm:** Digidesign, Palo Alto, CA **Project:** Millennium Greeting Card **Art Director:** Van Chuchom **Designer:** Van Chuchom **Photographer:** Bill Schwob

4 **Design Firm:** Diversity: Architecture & Design, New York, NY **Client:** KiDS of NYU Medical Center **Project:** Stars & Magic 2000 Benefit Invitation **Art Director:** Ian J. Cohn **Designer:** Ian J. Cohn **Photographer:** Jade Albert **Illustrator:** Ian J. Cohn

5 **Design Firm:** Diversity: Architecture & Design, New York, NY **Client:** KiDS of NYU Medical Center **Project:** KiDSports 2000 Benefit Invitation & Program **Art Director:** Ian J. Cohn **Designer:** Ian J. Cohn **Photographer:** Lou Manna **Illustrator:** Ian J. Cohn

1

2000

2

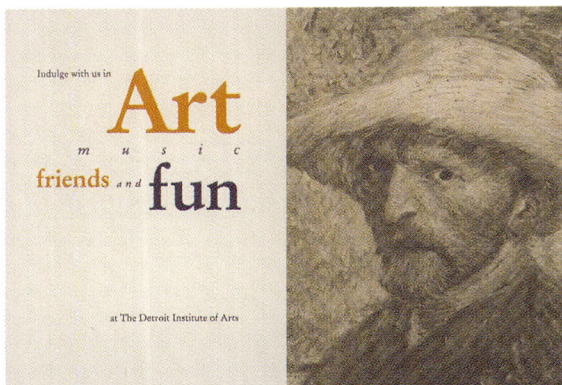

Indulge with us in

Art
music
friends and fun

at The Detroit Institute of Arts

3

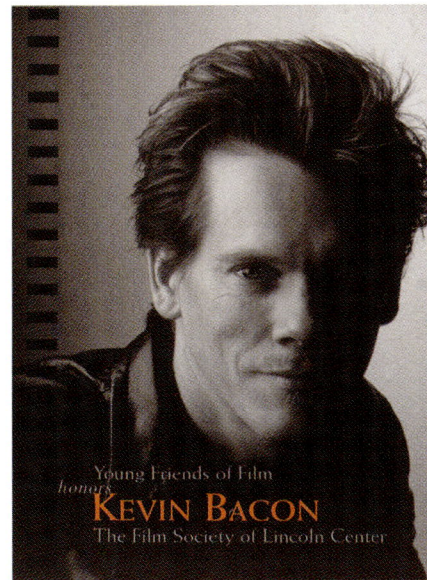

Young Friends of Film
honors
KEVIN BACON
The Film Society of Lincoln Center

4

THOSE OF YOU WHO HAVE JOINED US YEARS PRIOR
KNOW SOMETHING SPECIAL IS COMING THIS WAY.
FOR OUR MOST JOYOUS YEAR END HOLIDAY,
WE'LL RE-CREATE THE 15TH CENTURY
COURT INHABITED WITH RENAISSANCE WOMEN AND MEN.
WE HOPE THERE'S NO REASON YOU CAN'T ATTEND.
PROVING TO BE A NIGHT TO REMEMBER,
ON WE WILL GATHER AT A SPLENDID ESTATE.
A GRAND EVENT—YOU'LL NOT WANT TO COME LATE.

5

1 **Design Firm:** Diversity: Architecture & Design, New York, NY **Client:** Riverdale Country School **Project:** Parcs 2000 Benefit Save the Date **Art Director:** Ian J. Cohn **Designer:** Ian J. Cohn **Illustrator:** Ian J. Cohn

2 **Design Firm:** Ezzona Design Group, Inc., Burbank, CA **Client:** Snaidero USA **Project:** Holiday Card **Art Director:** Jim Pezzullo **Designer:** Gina Vivona

3 **Design Firm:** Ford & Earl Associates, Inc., Troy, MI **Client:** Detroit Institute of Arts **Project:** Van Gogh Invitation **Art Director:** Bonnie Zielinski **Designer:** Robin Olson

4 **Design Firm:** Gatta Design & Co., Inc., New York, NY **Client:** The Film Society of Lincoln Center **Project:** Invitation: Young Friends Of Film Honors Kevin Bacon **Art Director:** Kevin Gatta **Designer:** Punyapol Kittayarak

5 **Design Firm:** GMO/Hill Holliday, San Francisco, CA **Project:** Holiday Feast Invitation **Art Director:** Rick Atwood **Designer:** Marc Woollard **Copywriter:** Amy Caplan

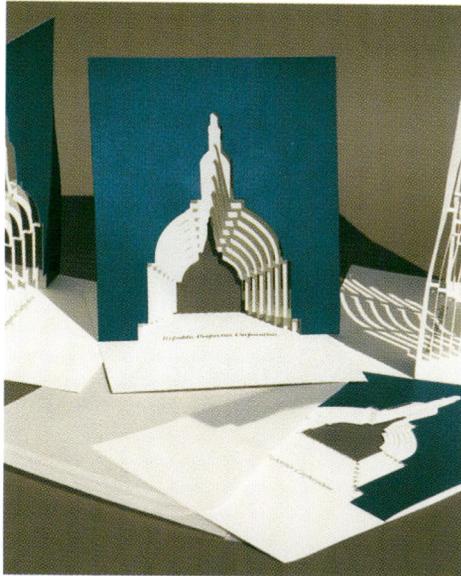

1

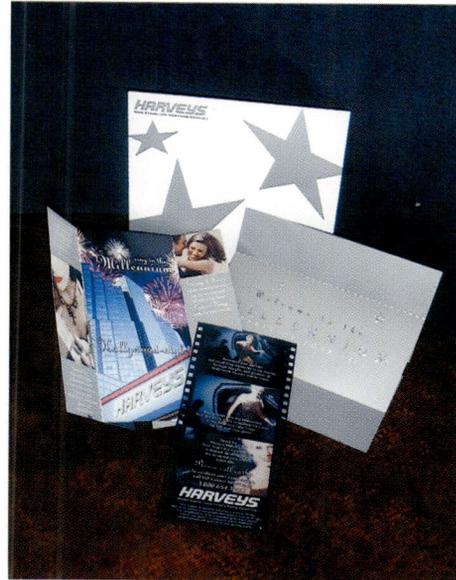

2

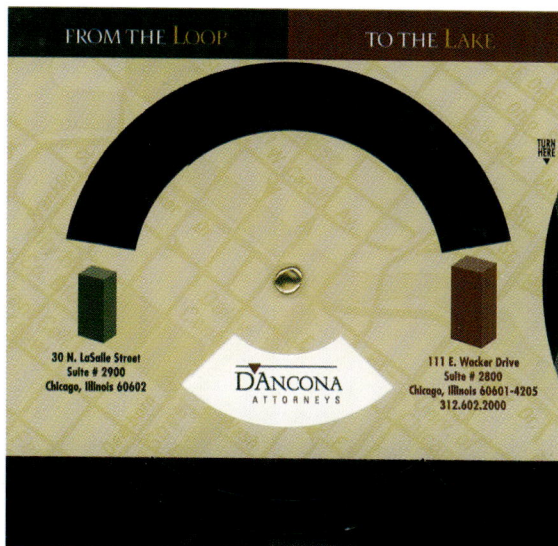

3

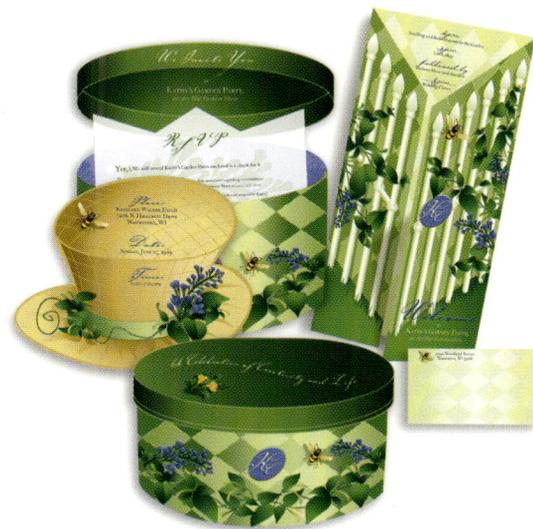

4

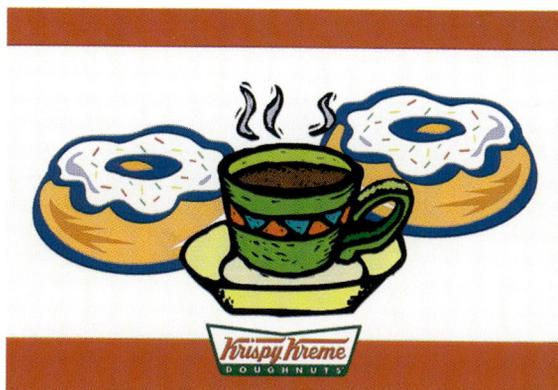

5

1 **Design Firm:** Graphic Design Concepts, Cleveland, OH **Client:** Details International **Project:** Republic Properties Pop-Up Card **Art Director:** Richard Montgomery **Designer:** Richard Montgomery

2 **Design Firm:** Graphic Edge Studio Inc., Reno, NV **Client:** Harveys Hotel Resort **Project:** Harveys Millennium Party **Art Director:** Peter Sanchez **Designer:** Tammy Peterson **Photographer:** Digital Outback **Illustrator:** Milan Sperka

3 **Design Firm:** Greenfield/Belser, Washington, DC **Client:** D'Ancona & Pflaum **Project:** Moving Announcement **Art Director:** Burkey Belser **Designer:** Tom Cameron

4 **Design Firm:** Hare Strigenz Design, Milwaukee, WI **Client:** The Earthgirls **Project:** Kathy's Garden Party **Art Director:** Jeurgen Strigenz **Illustrator:** Kris Marconnet

5 **Design Firm:** Hill and Knowlton, Los Angeles, CA **Client:** Great Circle Family Foods **Project:** Krispy Kreme Doughnuts Postcard **Art Director:** Andrea Leon Grossmann **Designer:** Dennis Claussen

1

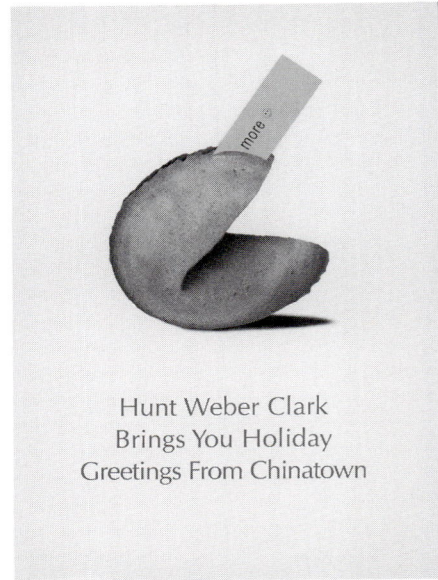

Hunt Weber Clark
Brings You Holiday
Greetings From Chinatown

2

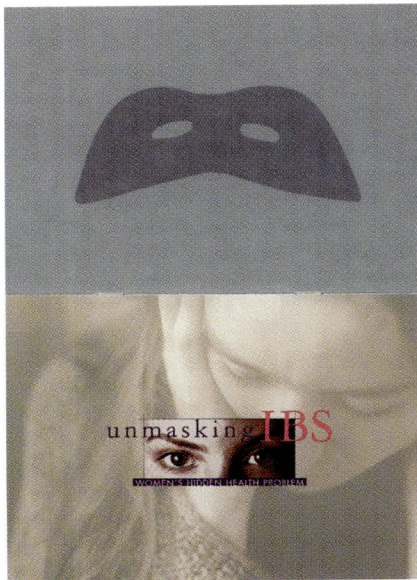

unmasking IBS

3

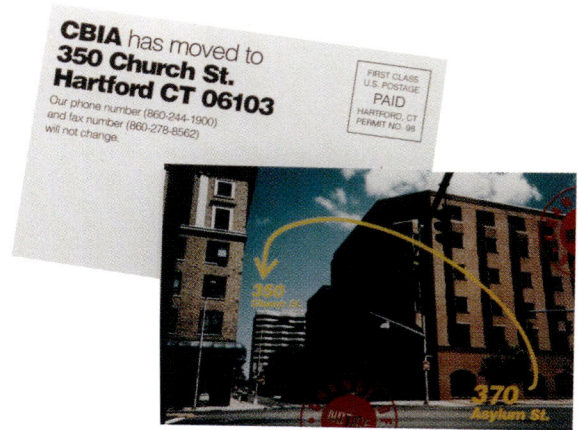

4

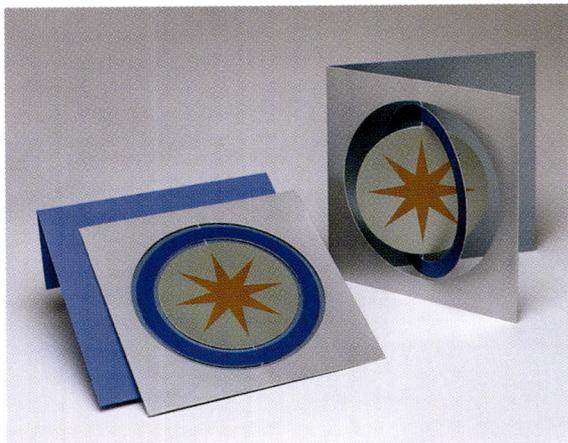

5

1 **Design Firm:** Hill and Knowlton, Los Angeles, CA **Client:** Mazda
Project: Media Teaser **Art Director:** Joyce Eicholtz **Designer:**
Andrea Leon Grossmann

2 **Design Firm:** Hunt Weber Clark Associates, Inc., San Francisco,
CA **Project:** Holiday Card **Art Director:** Nancy Hunt-Weber
Designer: Jim Deeken

3 **Design Firm:** JDC Design, Inc., New York, NY **Client:** Chandler
Chicco Agency **Project:** IBS Invitation **Art Director:** Eileen
McKenna **Designer:** Eileen McKenna **Creative Director:** Jeff
Conway

4 **Design Firm:** John Kallio Graphic Design, New Haven, CT **Client:**
Connecticut Business and Industry Association **Project:** Move
Notice **Art Director:** John Kallio **Designer:** John Kallio
Photographer: John Kallio

5 **Design Firm:** John Kneapler Design, New York, NY **Client:**
Museum Of Modern Art **Project:** Celestial Spin X-mas card **Art
Director:** Holly Buckley, John Kneapler **Designer:** John Kneapler,
Holly Buckley

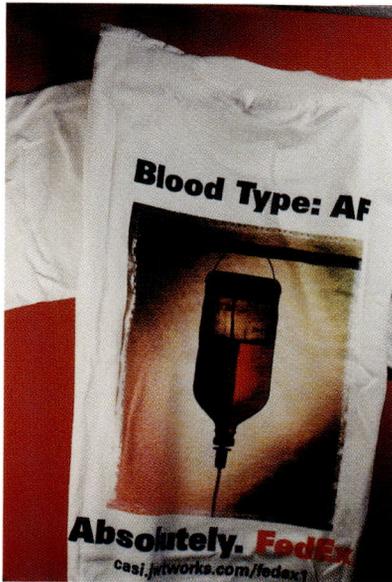

1

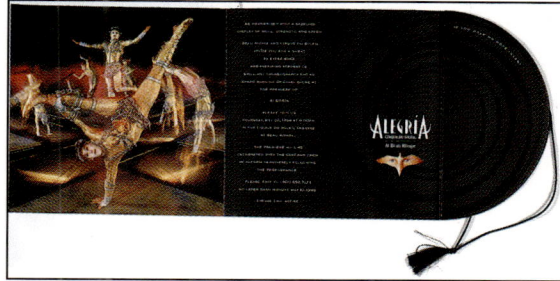

2

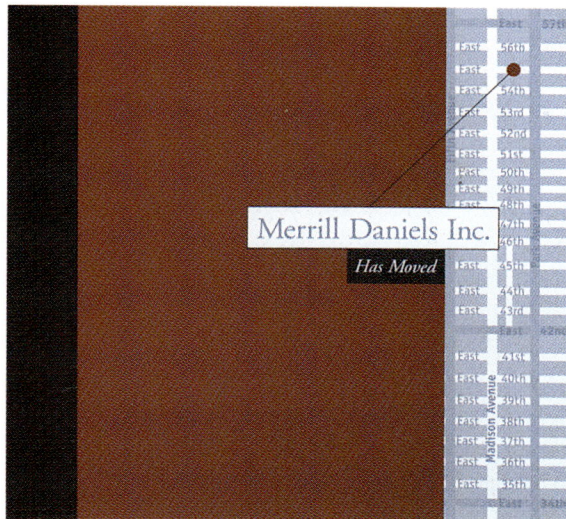

3

4

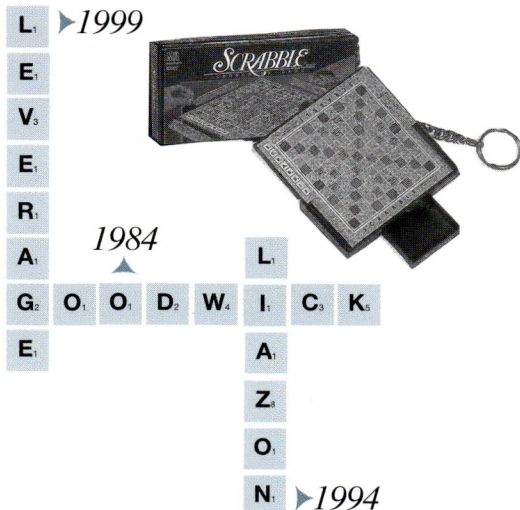

5

1 **Design Firm:** JWT Specialized Communications, St. Louis, MO **Client:** FedEx **Project:** Blood Type T-Shirt **Art Director:** Gene Kuehnle **Creative Director:** Tim Kidwell **Copywriter:** Tim Kidwell

2 **Design Firm:** Laura Tolar Design, Ocean Springs, MS **Client:** Beau Rivage & Cirque du Soleil **Project:** Alegria Opening Invite **Designer:** Laura Tolar

3 **Design Firm:** Leibowitz Communications, New York, NY **Client:** Merrill Daniels Inc. **Project:** Moving Announcement **Art Director:** Paul Leibowitz **Designer:** Rick Bargmann **Illustrator:** Rick Bargmann

4 **Design Firm:** Les Cheneaux Design, Ypsilanti, MI **Project:** Card Series **Designer:** Lori Young **Photographer:** Lori Young

5 **Design Firm:** Leverage Marketing Group, Newtown, CT **Project:** Scrabble Game Key Chain **Art Director:** Heather Patrick **Designer:** David Goodwick

1

2

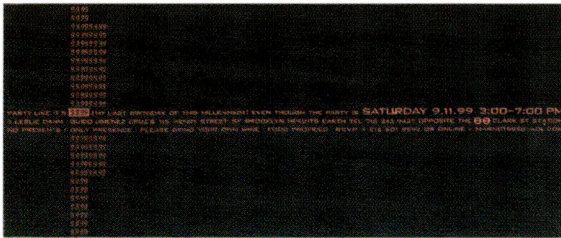

3

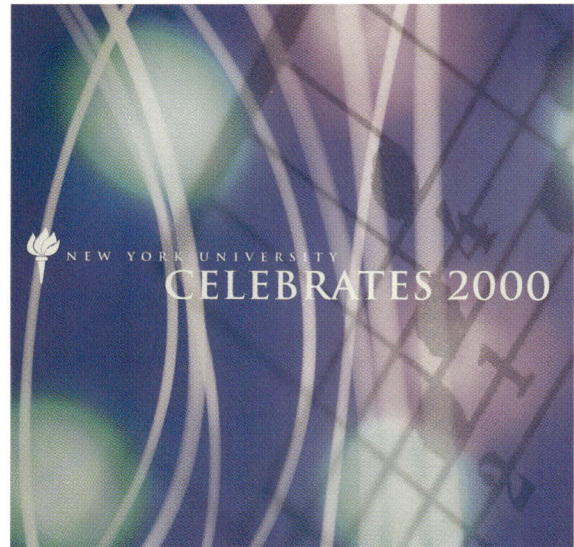

4

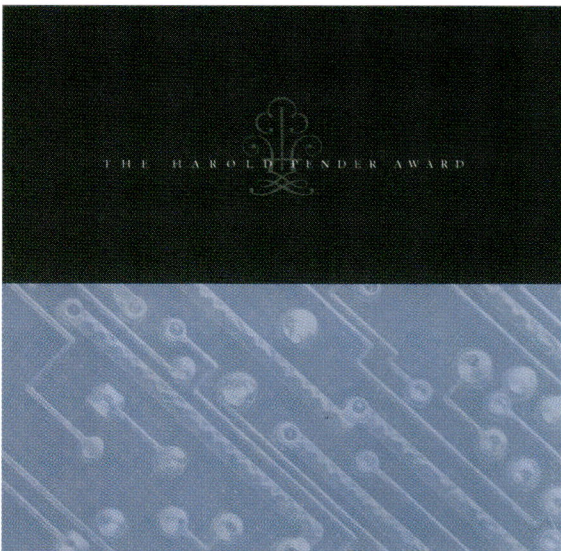

5

1 **Design Firm:** Love Packaging Group, Wichita, KS **Client:** McNeill/West **Project:** Wedding Invite **Art Director:** Chris West **Designer:** Christ West, Lorna McNeill **Illustrator:** Chris West

2 **Design Firm:** Meyers Design, Inc., Chicago, IL **Client:** CNA E & S **Project:** NAPSLO Invitation **Designer:** Kevin Meyers

3 **Design Firm:** Michael P. Arndt, New York, NY **Project:** 9.9.99 Birthday Invitation **Art Director:** Michael P. Arndt **Designer:** Michael P. Arndt

4 **Design Firm:** Mikaelian Design, Philadelphia, PA **Client:** New York University **Project:** Millennium Celebration to Musical Theatre **Art Director:** Allan Espiritu **Designer:** Allan Espiritu

5 **Design Firm:** Mikaelian Design, Philadelphia, PA **Client:** University of Pennsylvania Engineering **Project:** Pender Award Invite **Art Director:** Allan Espiritu **Designer:** Allan Espiritu

1

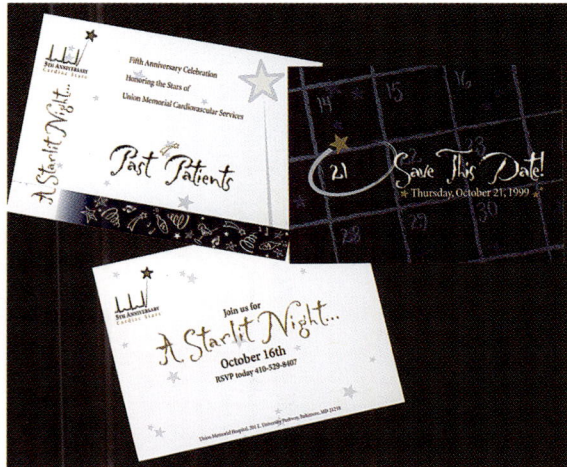

2

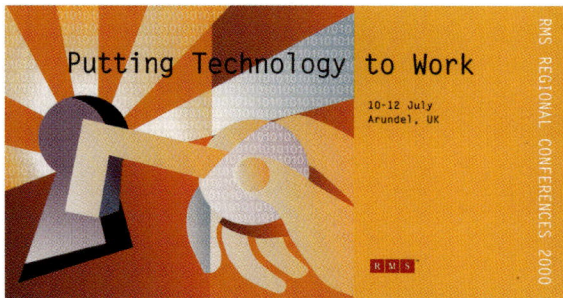

3

4

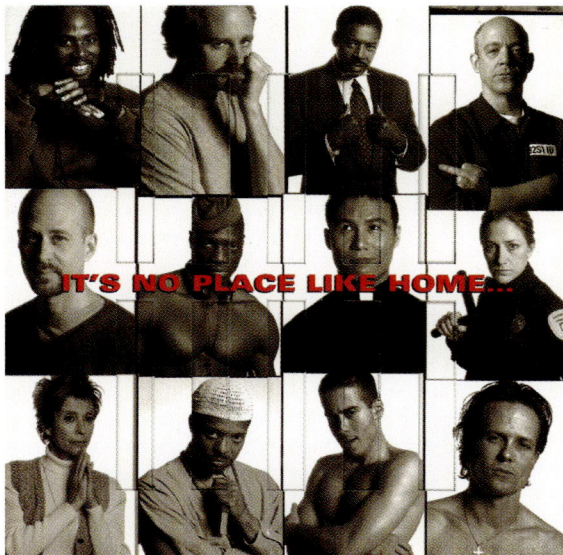

5

1 **Design Firm:** Nassar Design, Brookline, MA **Client:** Sea Dar Enterprises **Project:** Millennium Card **Art Director:** Nelida Nassar **Designer:** Margarita Encomienda

2 **Design Firm:** Pinnacle Communications, Baltimore, MD **Client:** Union Memorial Hospital Heart Institute **Project:** Cardiac Stars Invitation **Art Director:** Tracey Haldeman **Designer:** Michael Blakesley

3 **Design Firm:** Risk Management Solutions, Menlo Park, CA **Project:** Regional Conference Invitation **Art Director:** John Abraham, Lois Kiriu **Designer:** Yapine Xje

4 **Design Firm:** Scott Design Communications, Philadelphia, PA **Project:** Holiday Card **Art Director:** Scott Feuer **Designer:** Erinn Kenney

5 **Design Firm:** SJI Associates Inc., New York, NY **Client:** HBO **Project:** Oz Screening Invitation **Art Director:** Susan Sears **Designer:** Karen Lemcke **Copywriter:** Malcolm Abrams

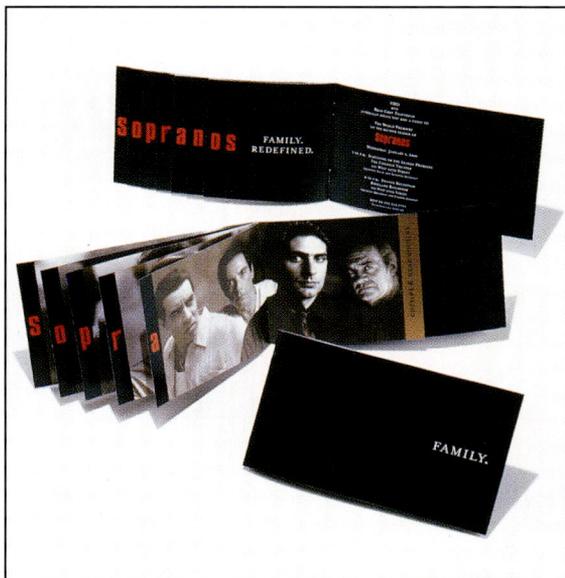

1

2

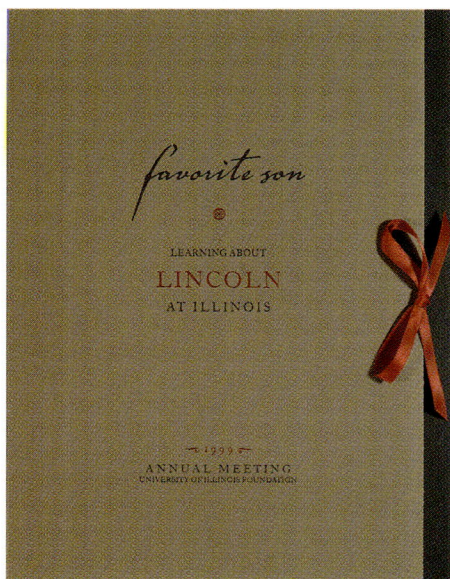

3

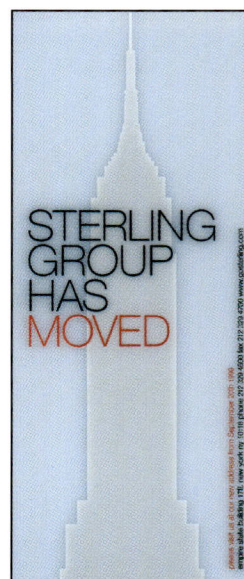

4

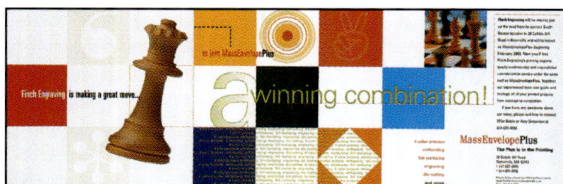

5

1 **Design Firm:** SJI Associates Inc., New York, NY **Client:** HBO
Project: Sopranos Screening Invitation **Art Director:** Jill Vinitsky
Designer: Karen Lemcke

2 **Design Firm:** Spielman Design, LLC, Collinsville, CT **Client:**
Dialogic, LLC **Project:** New Business Announcement **Concept and
Direction:** Sarah DeFilippis **Designer:** Amanda Bedard

3 **Design Firm:** Stan Gellman Graphic Design, St. Louis, MO **Client:**
University of Illinois Foundation **Project:** Favorite Son **Art Director:**
Barry Tilson **Designer:** Mike Donovan

4 **Design Firm:** Sterling Group, New York, NY **Project:** Moving Card
Designer: Marcus Hewitt

5 **Design Firm:** Sullivan Creative, Newton, MA **Client:**
MassEnvelopePlus **Project:** Under One Roof Moving Announcement
Art Director: David Ferreira **Designer:** David Ferreira

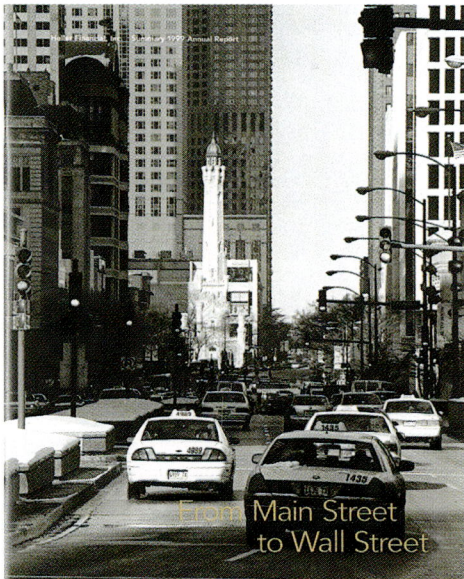

1

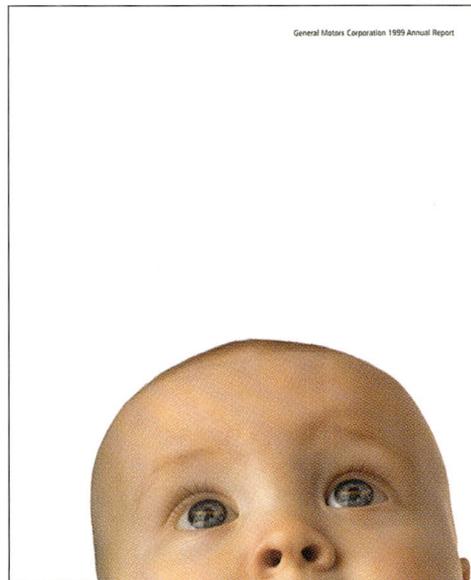

2

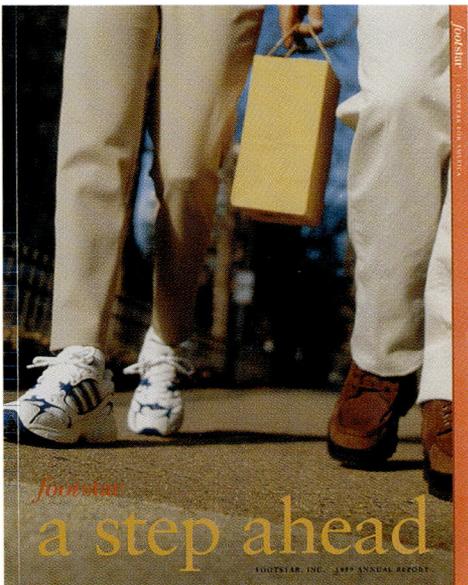

3

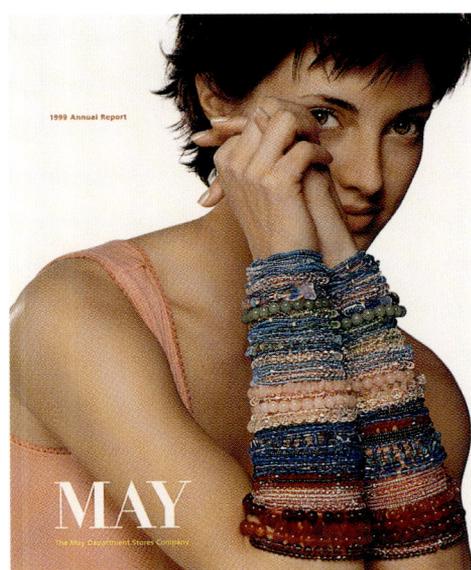

4

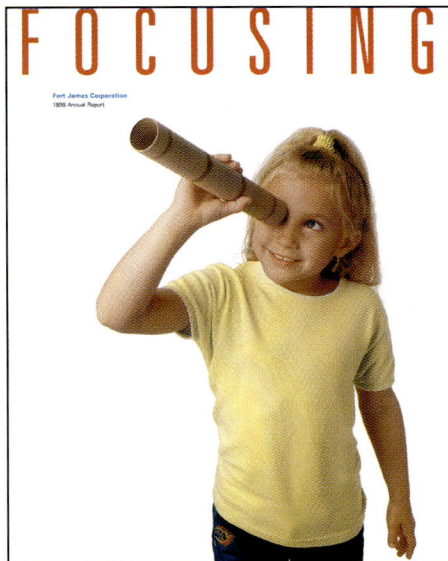

5

1 **Design Firm:** Boller Coates & Neu, Chicago, IL **Client:** Heller Financial, Inc. **Project:** Summary Annual Report **Art Director:** Michael Neu **Designer:** Pete Pona **Photographer:** Tom Tracy, Howard Ash

2 **Design Firm:** Boller Coates & Neu, Chicago, IL **Client:** General Motors Corp. **Project:** Annual Report **Art Director:** Michael Neu, Harri Boller **Designer:** Harri Boller **Photographer:** Sandro Miller, Andrew Goodwin

3 **Design Firm:** Boller Coates & Neu, Chicago, IL **Client:** Footstar, Inc. **Project:** Annual Report **Art Director:** Ron Coates **Designer:** Cara Carpenter **Photographer:** Sandro Miller, Howard Ash

4 **Design Firm:** Boller Coates & Neu, Chicago, IL **Client:** The May Department Stores Co. **Project:** Annual Report **Art Director:** Michael Neu **Designer:** Robert Mileham **Photographer:** Sandro Miller, Andy Goodwin

5 **Design Firm:** Boller Coates & Neu, Chicago, IL **Client:** Fort James Corporation **Project:** Annual Report **Art Director:** Ron Coates **Designer:** Carolin Forsyth **Photographer:** Sandro Miller

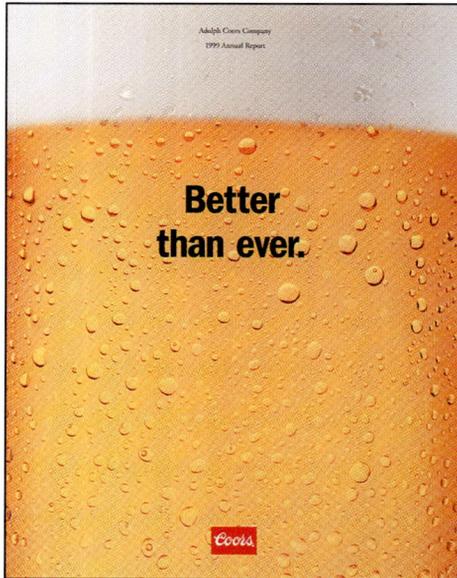

1

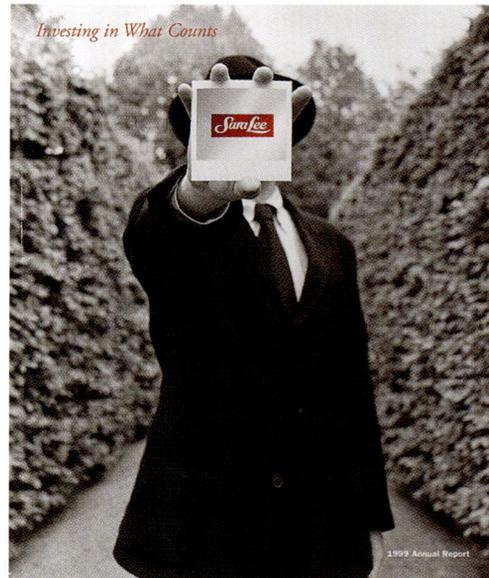

2

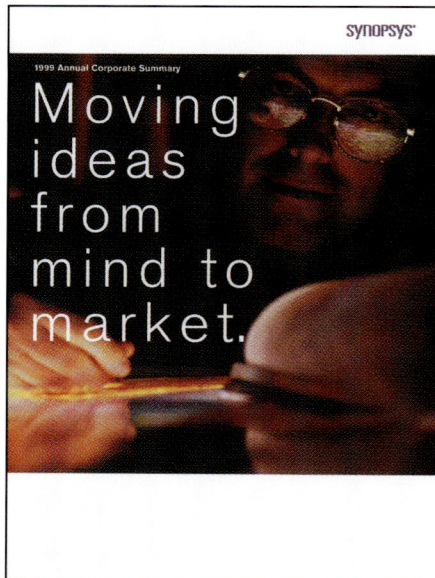

3

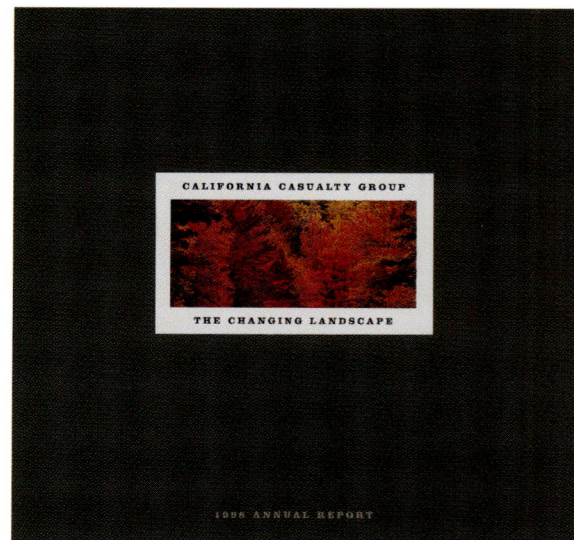

4

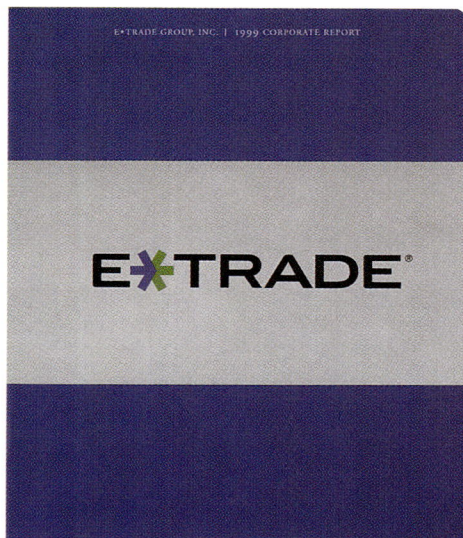

5

1 **Design Firm:** Boller Coates & Neu, Chicago, IL **Client:** Adolph Coors Company **Project:** Annual Report **Art Director:** Ron Coates **Designer:** Carolin Forsyth **Photographer:** Sandro Miller

2 **Design Firm:** Boller Coates & Neu, Chicago, IL **Client:** Sara Lee Corporation **Project:** Annual Report **Art Director:** Ron Coates **Designer:** Ron Coates **Photographer:** Sandro Miller, R. Smith, A. Goodwin

3 **Design Firm:** Broom & Broom, Inc., San Francisco, CA **Client:** Synopsys, Inc. **Project:** Annual Report **Art Director:** Martin McMurray **Designer:** Terri Bogaards **Photographer:** Michael Grecco, Chris Shinn

4 **Design Firm:** Broom & Broom, Inc., San Francisco, CA **Client:** California Casualty Group **Project:** Annual Report **Art Director:** David Broom **Designer:** Terri Bogaards

5 **Design Firm:** Broom & Broom, Inc., San Francisco, CA **Client:** E*TRADE Group, Inc. **Project:** Annual Report **Art Director:** Martin McMurray **Designer:** Dan Chau

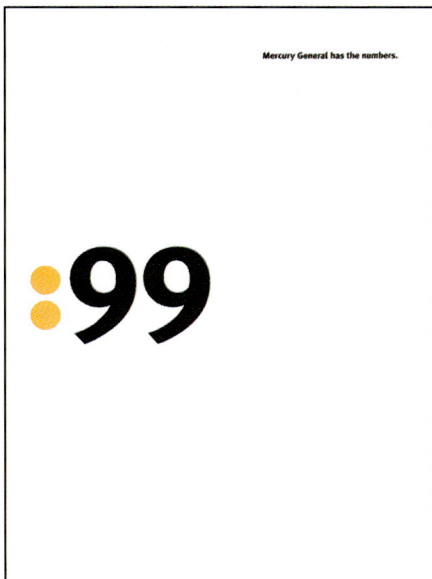

Mercury General has the numbers.

:99

1

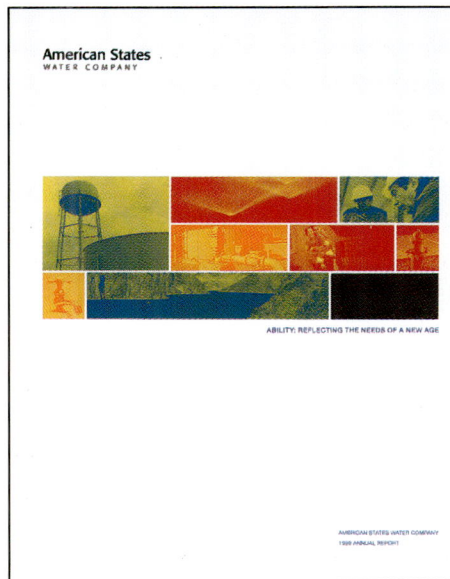

American States
WATER COMPANY

ABILITY: REFLECTING THE NEEDS OF A NEW AGE

AMERICAN STATES WATER COMPANY
1998 ANNUAL REPORT

2

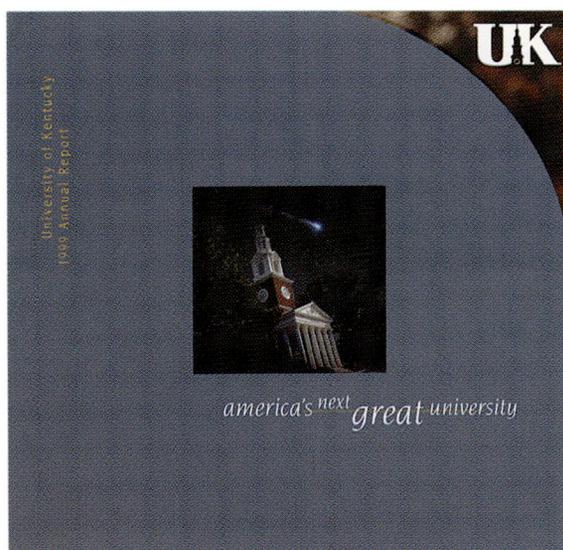

U°K

University of Kentucky
1998 Annual Report

america's next great university

3

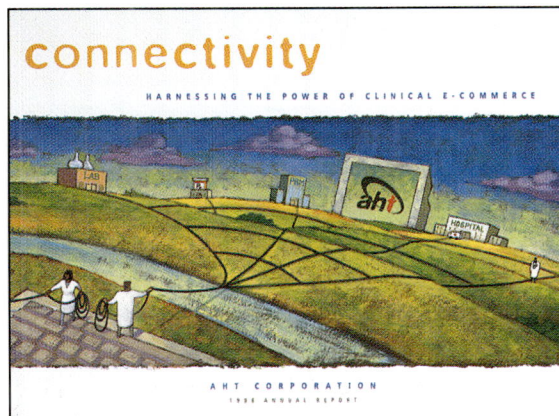

connectivity

HARNESSING THE POWER OF CLINICAL E-COMMERCE

AHT CORPORATION
1998 ANNUAL REPORT

4

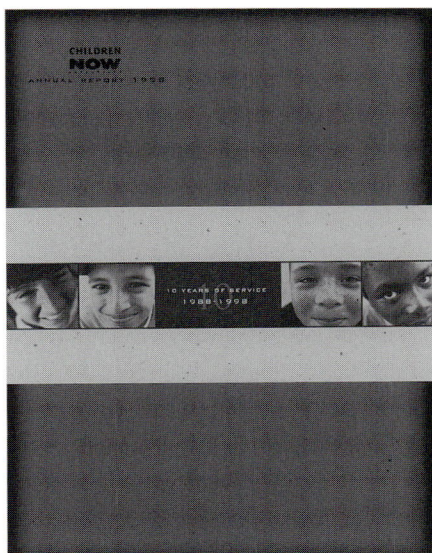

CHILDREN
NOW
ANNUAL REPORT 1998

10 YEARS OF SERVICE
1988-1998

5

1 **Design Firm:** CMg Design Inc., Pasadena, CA **Client:** Mercury General Corporation **Project:** Annual Report **Art Director:** Julie Markfield, Greg Crawford **Designer:** Jean DeAngelis

2 **Design Firm:** CMg Design Inc., Pasadena, CA **Client:** American States Water Company **Project:** Annual Report **Art Director:** Julie Markfield **Designer:** Mary Catherine Walp **Photographer:** Rick Ueda, ASWC

3 **Design Firm:** Cornett Advertising, Lexington, KY **Client:** University of Kentucky **Project:** Annual Report **Art Director:** Paul Blodgett **Designer:** Paul Blodgett **Photographer:** Lee Thomas, Breck Smither

4 **Design Firm:** Dakota Group, Inc., Wilton, CT **Client:** AHT **Project:** Connectivity: Annual Report **Art Director:** Jennifer Fleischmann **Designer:** Laura Offenberg Dague, Jennifer Fleischmann **Photographer:** Bill Hayward **Illustrator:** Paul Schulenberg

5 **Design Firm:** Dennis Johnson Design, Oakland, CA **Client:** Children Now **Project:** Annual Report **Art Director:** Dennis Johnson **Designer:** Jean Sanchirko **Photographer:** Steve Fisch

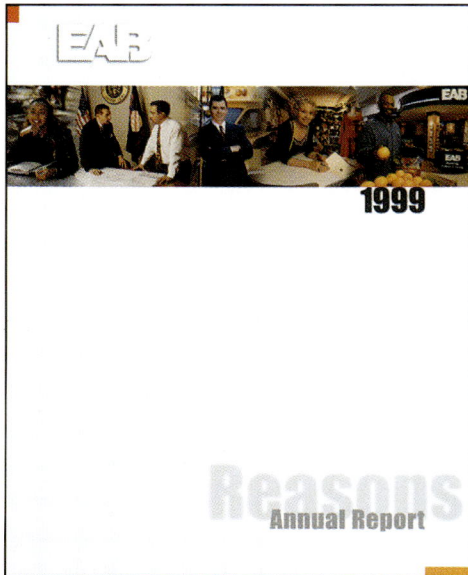

1

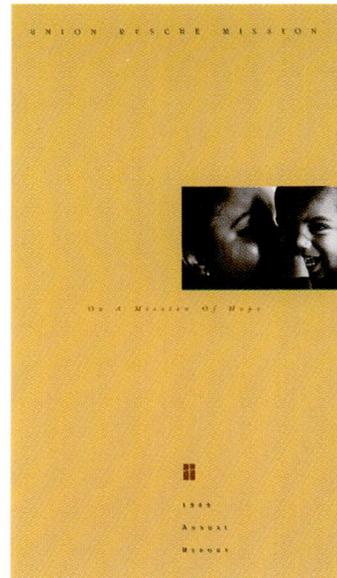

2

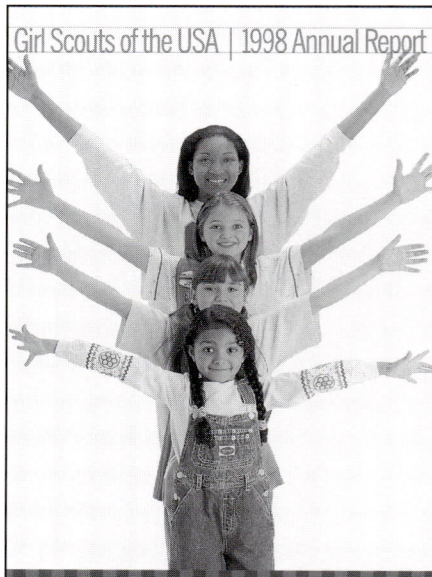

3

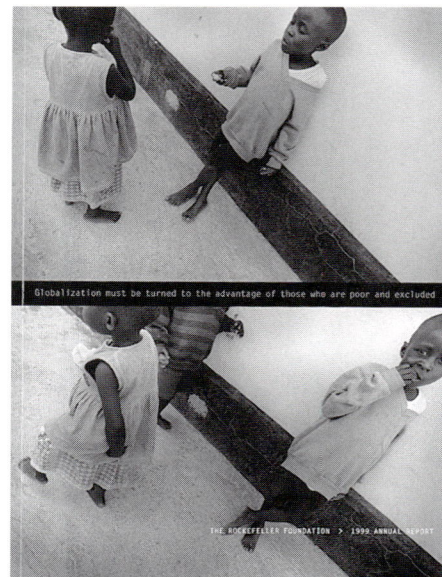

4

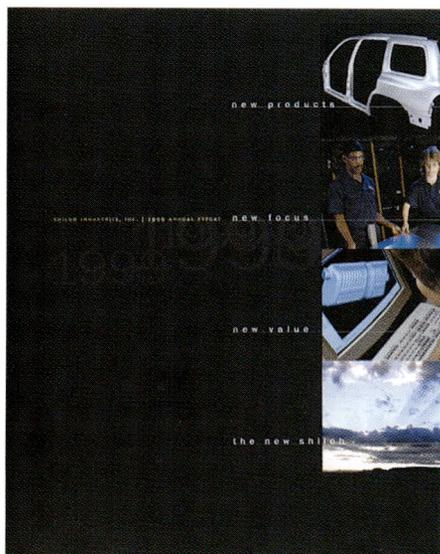

5

1 **Design Firm:** EAB, Uniondale, NY **Project:** Annual Report **Designer:** Virginia Paone **Photographer:** Bob Klein

2 **Design Firm:** Edge Communications, Inc., Hermosa Beach, CA **Client:** Union Rescue Mission **Project:** Annual Report **Art Director:** Phil Sato **Designer:** Judi Woo **Photographer:** Jon Warren, Don Gale

3 **Design Firm:** Emerson, Wajdowicz Studios, New York, NY **Client:** Girl Scouts of the USA **Project:** Annual Report **Art Director:** Jurek Wajdowicz **Designer:** Lisa LaRochelle, Jurek Wajdowicz **Photographer:** Lori Adamski-Peek

4 **Design Firm:** Emerson, Wajdowicz Studios, New York, NY **Client:** The Rockefeller Foundation **Project:** Annual Report **Art Director:** Jurek Wajdowicz **Designer:** Lisa LaRochelle, Jurek Wajdowicz **Photographer:** Antonin Kratochvil

5 **Design Firm:** Ford & Earl Associates, Inc., Troy, MI **Client:** SHILOH Industries, Inc. **Project:** Annual Report **Art Director:** Brian Castle **Designer:** Brian Castle

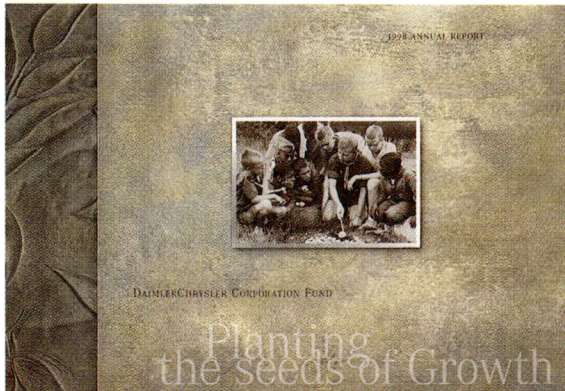

1

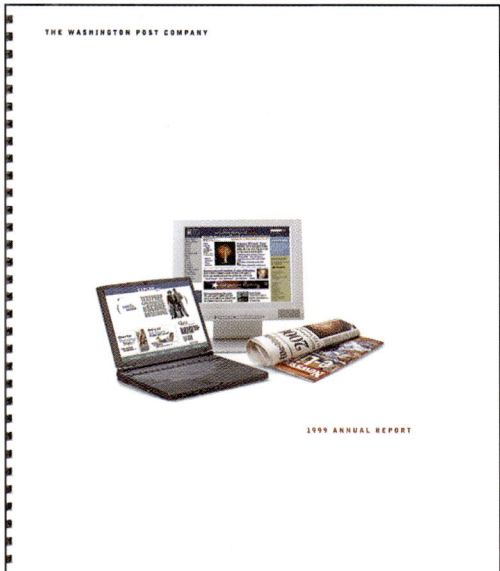

2

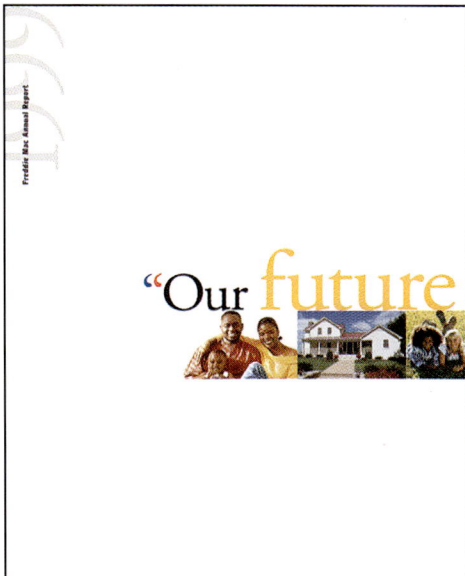

3

4

5

1 **Design Firm:** Full Concept Inc./Turgeon Group, Madison Heights, MI **Client:** DaimlerChrysler **Project:** DaimlerChrysler Fund Annual Report **Art Director:** Mimi Ford **Designer:** Kelly Callender **Illustrator:** Kelly Callender

2 **Design Firm:** HC Creative Communications, Bethesda, MD **Client:** Washington Post Company **Project:** Annual Report **Art Director:** Howard Clare **Designer:** Ann Marie Ternullo **Photographer:** Bill Gallery, David Sharpe

3 **Design Firm:** HC Creative Communications, Bethesda, MD **Client:** Freddie Mac Corporation **Project:** Annual Report **Art Director:** Howard Clare **Designer:** Ann Marie Ternullo **Photographer:** David Sharpe

4 **Design Firm:** Howry Design Associates, San Francisco, CA **Client:** Del Monte Foods **Project:** Annual Report **Art Director:** Jill Howry **Designer:** Ty Whittington **Photographer:** Stuart Schwartz

5 **Design Firm:** Howry Design Associates, San Francisco, CA **Client:** Affymetrix, Inc. **Project:** Annual Report **Art Director:** Jill Howry **Designer:** Todd Richards

1

2

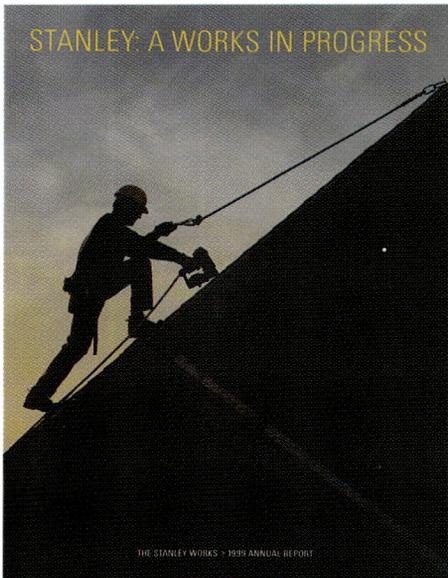

3

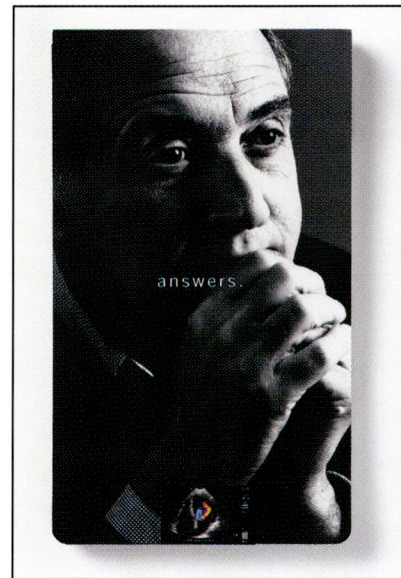

4

5

1 **Design Firm:** Julie Chun Design, Mill Valley, CA **Client:** California Pacific Medical Center **Project:** Annual Report **Art Director:** Julie Chun **Designer:** Julie Chun **Photographer:** Dan Mills **Writer:** Susan Sharpe

2 **Design Firm:** Jupiter Design Group, Inc., Midland Pk, NJ **Client:** Muhlenberg Foundation **Project:** Annual Report **Art Director:** Diane McNamee **Designer:** Alina Wilczynski, Chris Krus **Photographer:** Bob Krasner

3 **Design Firm:** Keiler & Company, Farmington, CT **Client:** The Stanley Works **Project:** Annual Report **Art Director:** James Pettus **Designer:** James Pettus **Photographer:** Jim Coon Photography

4 **Design Firm:** Leimer Cross Design, Seattle, WA **Client:** SonoSite **Project:** answers. **Art Director:** Kerry Leimer **Designer:** Kerry Leimer **Photographer:** James LaBounty

5 **Design Firm:** Leimer Cross Design, Seattle, WA **Client:** Esterline Technologies, Inc. **Project:** Annual Report **Art Director:** Kerry Leimer **Designer:** Kerry Leimer, Marianne Li **Photographer:** David Emmite, Mark Weins

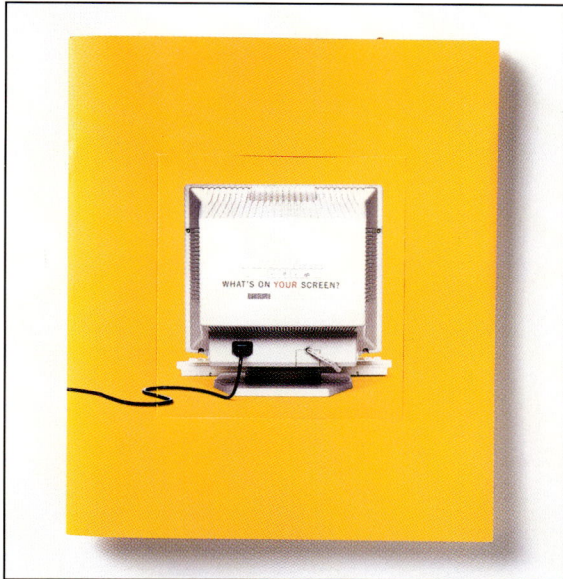

1

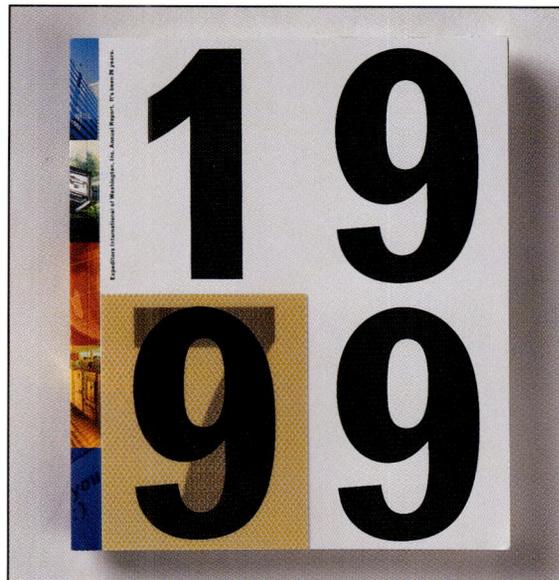

2

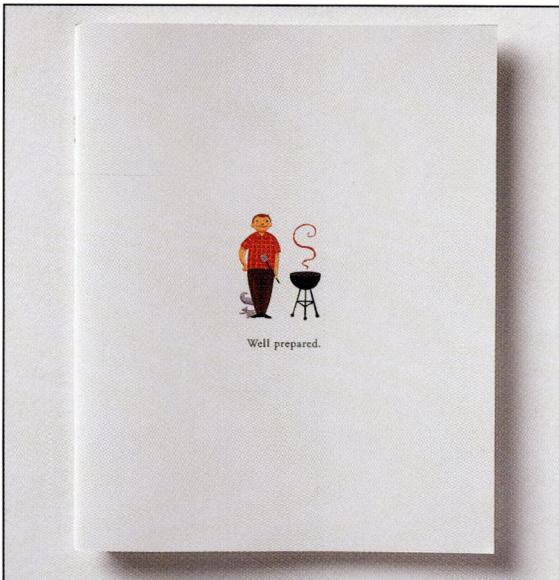

3

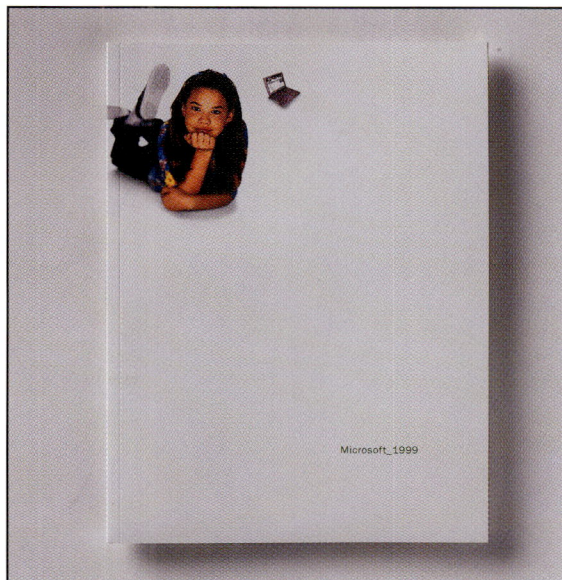

4

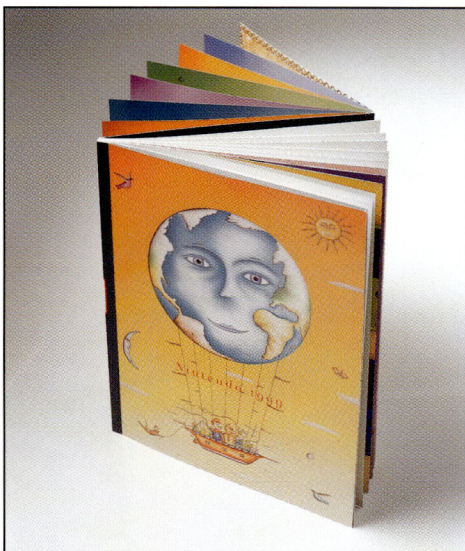

5

1 **Design Firm:** Leimer Cross Design, Seattle, WA **Client:** N2H2 **Project:** What's On Your Screen? **Art Director:** Kerry Leimer **Designer:** Kerry Leimer, Marianne Li **Photographer:** Jeff Corwin

2 **Design Firm:** Leimer Cross Design, Seattle, WA **Client:** Expeditors International of Washington, Inc. **Project:** 1979-99 Expeditors **Art Director:** Kerry Leimer **Designer:** Kerry Leimer, Marianne Li **Photographer:** Tyler Boley

3 **Design Firm:** Leimer Cross Design, Seattle, WA **Client:** Gardenburger **Project:** Well Prepared **Art Director:** Kerry Leimer **Designer:** Kerry Leimer **Illustrator:** Dan Yaccareno

4 **Design Firm:** Leimer Cross Design, Seattle, WA **Client:** Microsoft Corporation **Project:** Microsoft 1999 **Art Director:** Kerry Leimer **Designer:** Kerry Leimer **Photographer:** Eric Myer

5 **Design Firm:** Leimer Cross Design, Seattle, WA **Client:** Nintendo Co., Ltd. **Project:** Nintendo 1999 **Art Director:** Kerry Leimer **Designer:** Kerry Leimer **Photographer:** Jeff Englestad **Illustrator:** Haydn Cornner

1

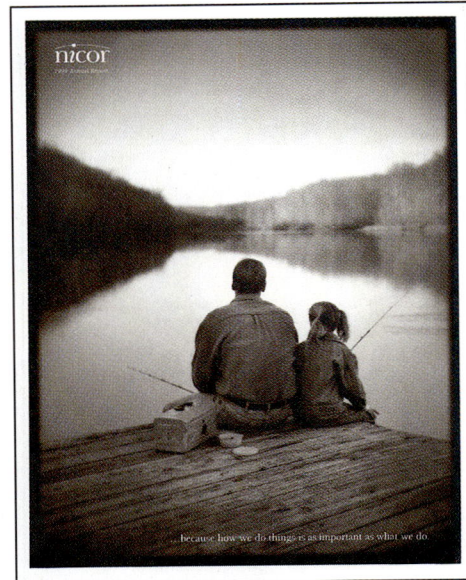

2

3

4

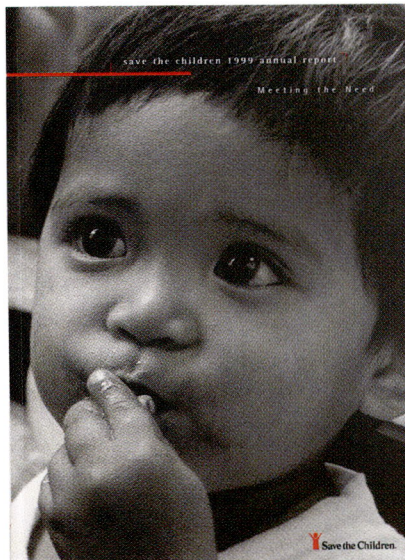

5

1 **Design Firm:** McMillan Associates, West Dundee, IL **Client:** Tellabs Operations, Inc. **Project:** Annual Report **Art Director:** Michael McMillan **Designer:** Tom DeMay, Simone Bonde, Megan Kearney **Photographer:** Kevin Anderson, Walter Hodges, Joseph Pobereskin, VCG Collection, Andy Caulfield

2 **Design Firm:** McMillan Associates, West Dundee, IL **Client:** Nicor Inc. **Project:** Annual Report **Art Director:** Michael McMillan **Designer:** Simone Bonde, Megan Kearney **Photographer:** Greg Whitaker, Jerry Kalyniuk

3 **Design Firm:** Nesnadny & Schwartz, Cleveland, OH **Client:** The Progressive Corporation **Project:** Annual Report **Art Director:** Joyce Nesnadny, Mark Schwartz **Designer:** Joyce Nesnadny, Michelle Moehler **Photographer:** Gregory Crewdson

4 **Design Firm:** NRTC, Herndon, VA **Project:** Annual Report **Art Director:** Jeanine Clough **Designer:** Jason Steiner

5 **Design Firm:** O&J Design, Inc., New York, NY **Client:** Save The Children **Project:** Annual Report **Art Director:** Barbara Olejniczak **Designer:** Heishin Ra

1

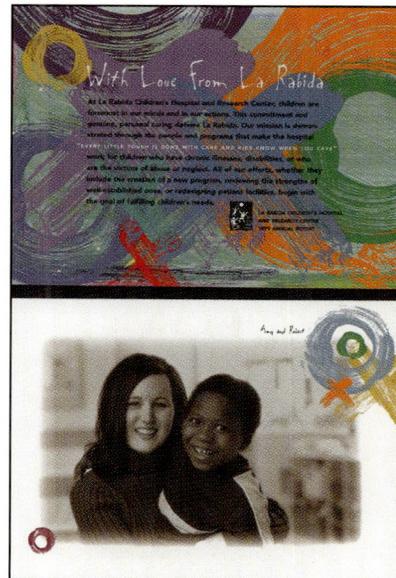

2

3

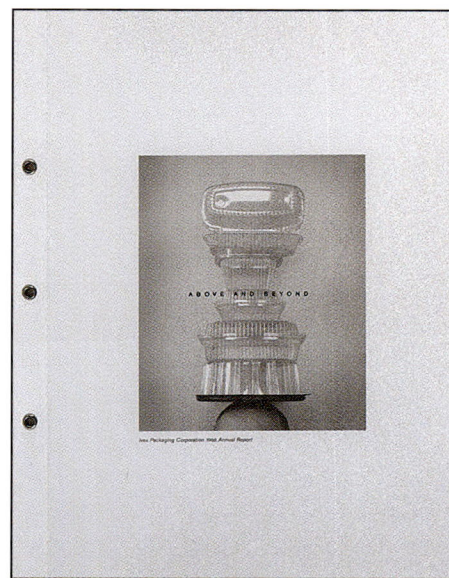

4

5

1 **Design Firm:** Olver Dunlop Associates, Chicago, IL **Client:** Summit Consulting **Project:** Annual Report-CEC **Art Director:** Patricia Kowalczyk **Designer:** Patricia Kowalczyk **Photographer:** Russell Ingram

2 **Design Firm:** Olver Dunlop Associates, Chicago, IL **Client:** La Rabida Children's Hospital **Project:** Annual Report **Art Director:** Kara Kuster **Designer:** Kara Kuster **Photographer:** Steve Ewert

3 **Design Firm:** Page Design, Inc., Sacramento, CA **Client:** GenCorp/Aerojet **Project:** Annual Report **Art Director:** Paul Page, Kimberly Bickel **Designer:** Kimberly Bickel, Sherril Cortez **Photographer:** Kent Lacin Media Services

4 **Design Firm:** Petrick Design, Chicago, IL **Client:** Ivex Packaging Corporation **Project:** Annual Report **Art Director:** Robert Petrick **Designer:** Traci Code **Photographer:** Jeff Stephens

5 **Design Firm:** Posner Advertising, New York, NY **Client:** The Town and Country Trust **Project:** Annual Report **Art Director:** Nancy Merish **Designer:** Nancy Merish **Photographer:** Alan Schindler

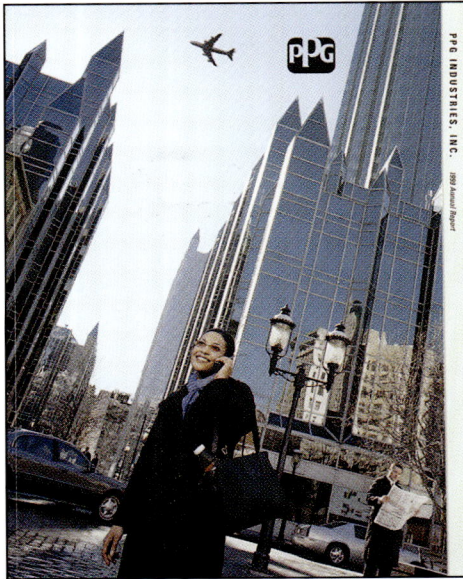

1

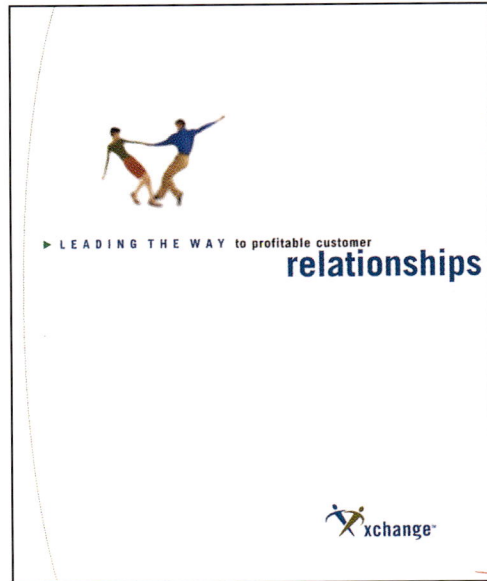

2

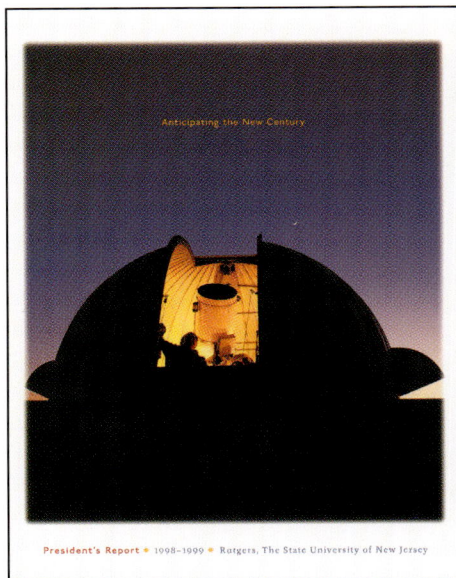

3

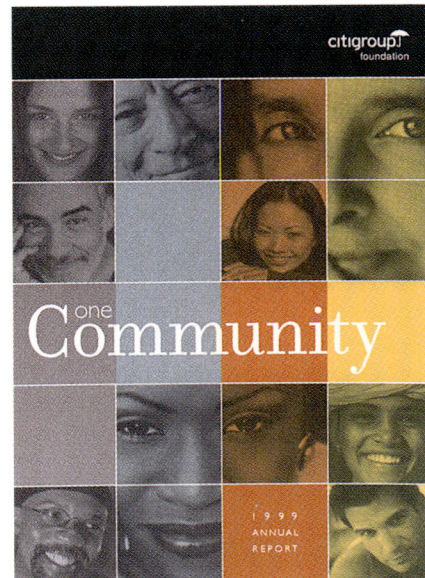

4

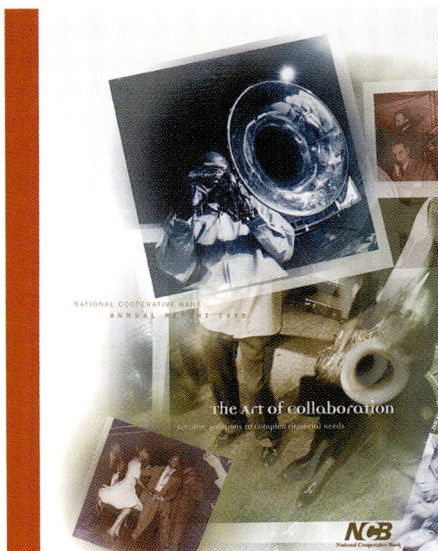

5

1 **Design Firm:** PPG Industries, Pittsburgh, PA **Project:** Annual Report **Art Director:** Donna Harmon **Designer:** Aimee Lazor **Photographer:** Jim Schafer

2 **Design Firm:** Raincastle Communications, Newtown, MA **Client:** Xchange Applications **Project:** Annual Report **Art Director:** Paul Regensburg **Designer:** Jeannine Baldomero **Photographer:** Jeffrey Titcomb

3 **Design Firm:** Rutgers, The State University of New Jersey, New Brunswick, NJ **Client:** Office of the President **Project:** President's Report **Art Director:** Joanne Dus-Zastrow **Designer:** Joanne Dus-Zastrow

4 **Design Firm:** Salomon Smith Barney, New York, NY **Client:** Citigroup Foundation **Project:** One Community **Art Director:** Melita Sussman **Designer:** Frank Gitro **Project Manager:** Carol Tedesco

5 **Design Firm:** TFW Design, Inc., Alexandria, VA **Client:** National Cooperative Bank **Project:** The Art of Collaboration **Art Director:** Sharon Roberts **Designer:** Martin Ittner **Photographer:** Jay Blakesberg **Illustrator:** Martin Ittner

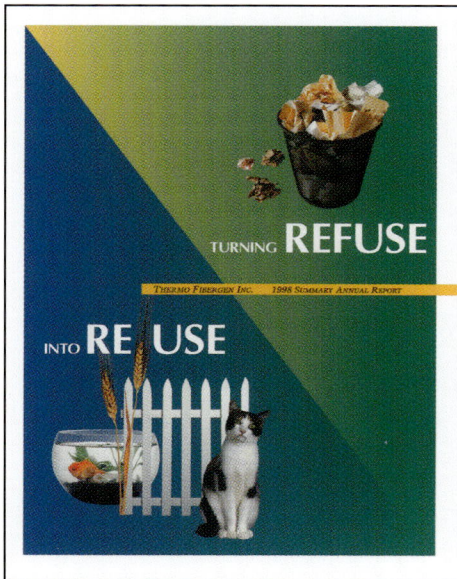

1

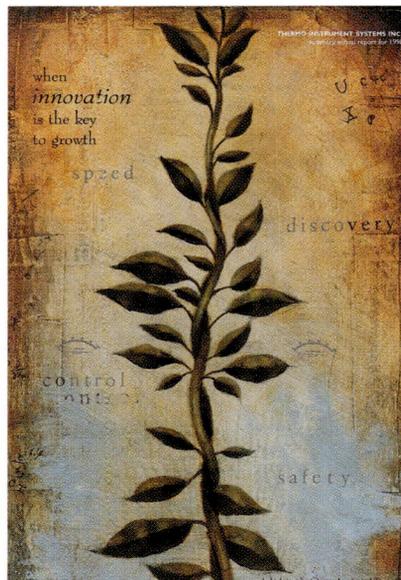

2

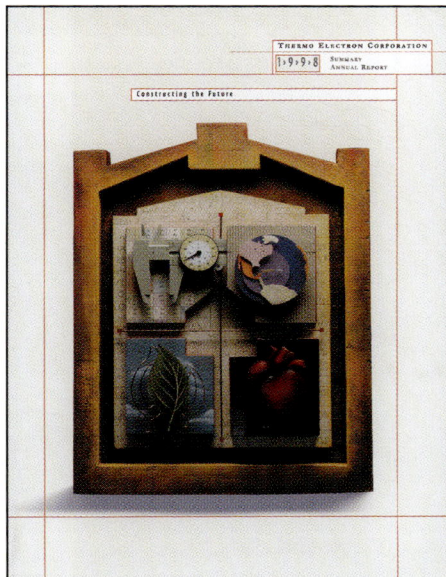

3

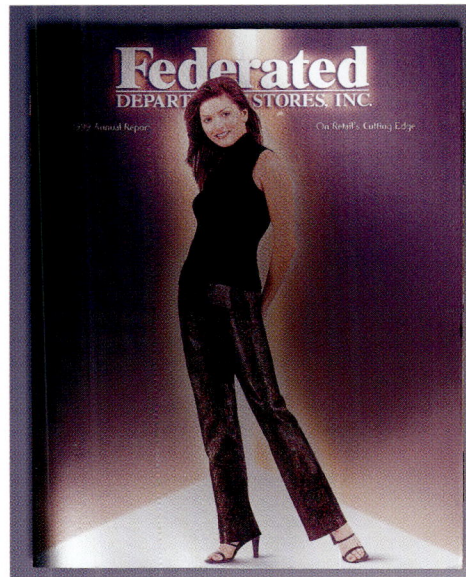

4

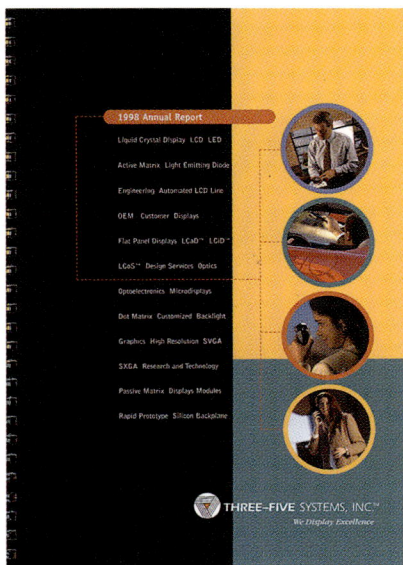

5

1 **Design Firm:** Thermo Electron Corporation, Waltham, MA **Client:** Thermo Fibergen Inc. **Project:** Annual Report **Art Director:** Brianne Hurley **Designer:** Brianne Hurley **Photographer:** Zap, Kindra Clineff

2 **Design Firm:** Thermo Electron Corporation, Waltham, MA **Client:** Thermo Instrument Systems, Inc. **Project:** Annual Report **Designer:** Alicia Hart **Illustrator:** James Fiedler

3 **Design Firm:** Thermo Electron Corporation, Waltham, MA **Project:** Annual Report **Art Director:** Anne Scheer **Designer:** Anne Scheer **Photographer:** John Earle **Illustrator:** Maria Rendon

4 **Design Firm:** Three & Associates, Inc., Cincinnati, OH **Client:** Federated Department Stores, Inc. **Project:** Annual Report **Art Director:** Gordon Cotton **Designer:** Joan Ogle **Photographer:** Trepal Photography **Illustrator:** Joan Ogle

5 **Design Firm:** Three-Five Systems, Inc., Tempe, AZ **Project:** Annual Report **Art Director:** Kimberley S. Bridgford **Designer:** Kimberley S. Bridgford **Photographer:** Dan Coogan, Mark Culbertson

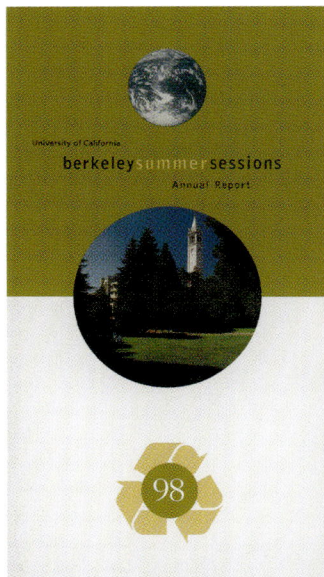

1

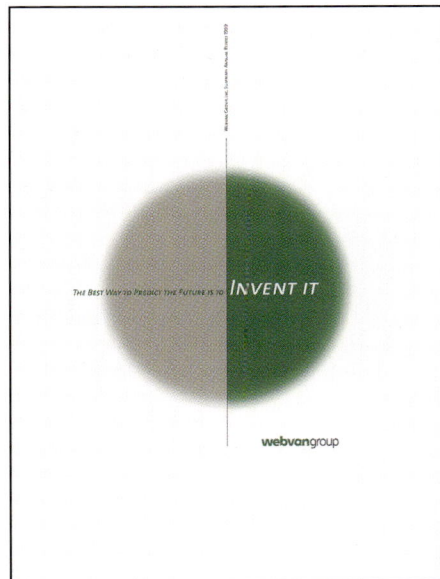

2

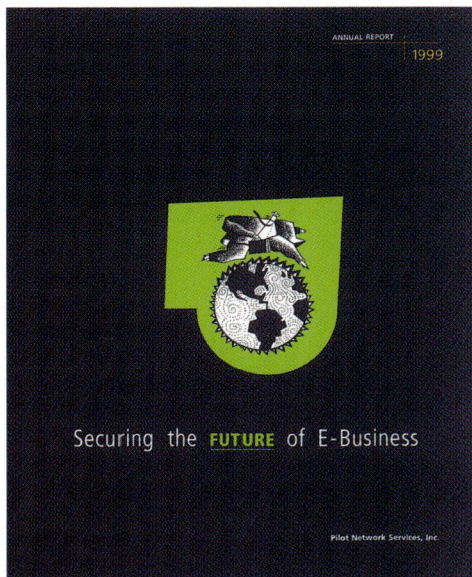

3

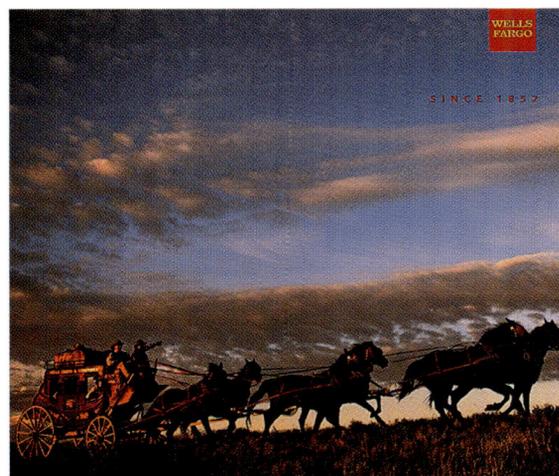

4

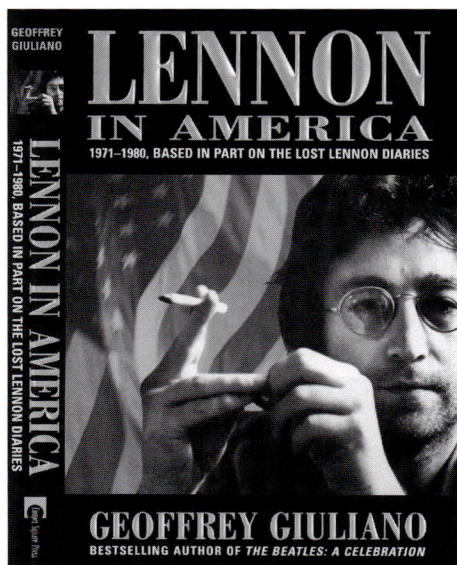

5

1 **Design Firm:** UC Berkeley Summer Sessions, Berkeley, CA **Project:** Summer Sessions Annual Report **Art Director:** Barbara A. Brown **Designer:** Archer Design **Photographer:** Harvey Helfand

2 **Design Firm:** Vinje Design, Inc., San Francisco, CA **Client:** Webvan Group, Inc. **Project:** The Best Way to Predict the Future is to Invent It **Art Director:** Andreas Keller **Designer:** Andreas Keller **Photographer:** Jim Karageorge

3 **Design Firm:** Vinje Design, Inc., San Francisco, CA **Client:** Pilot Network Services, Inc. **Project:** Annual Report **Art Director:** Einar Vinje **Designer:** Andreas Keller **Illustrator:** Darrel Kolosta

Books

4 **Design Firm:** BGDI, Berkeley, CA **Client:** Wells Fargo Bank **Project:** Since 1852 Book **Art Director:** Steven Donaldson **Designer:** Randy Rocchi

5 **Design Firm:** Egad Dzyn, Burbank, CA **Client:** Cooper Square Press **Project:** Lennon in America/Dust Jacket **Art Director:** Giséle Byrd Henry **Designer:** Steve Trapero, Giséle Byrd Henry

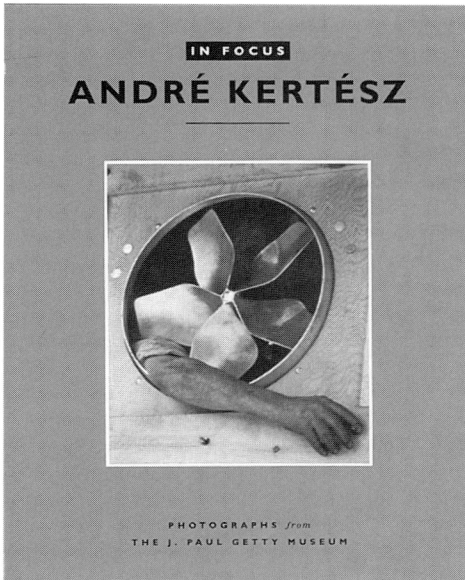

1

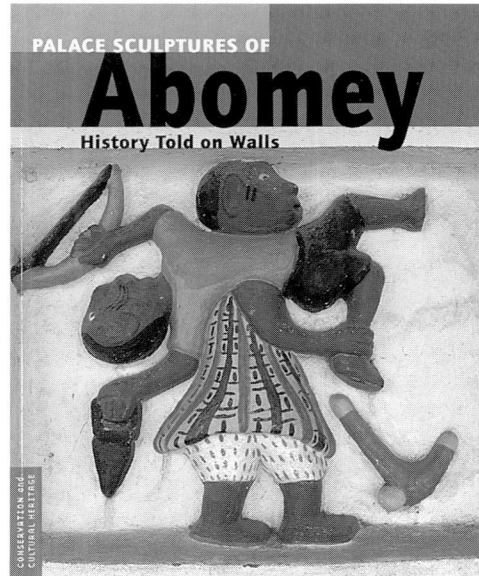

2

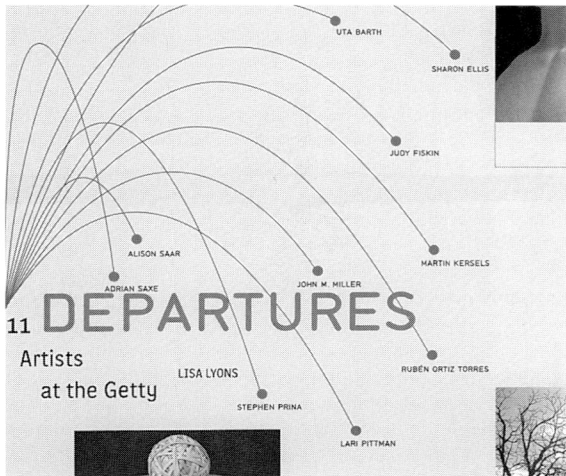

3

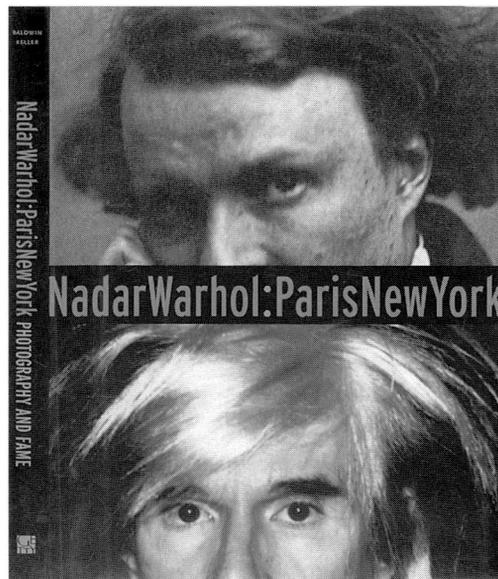

4

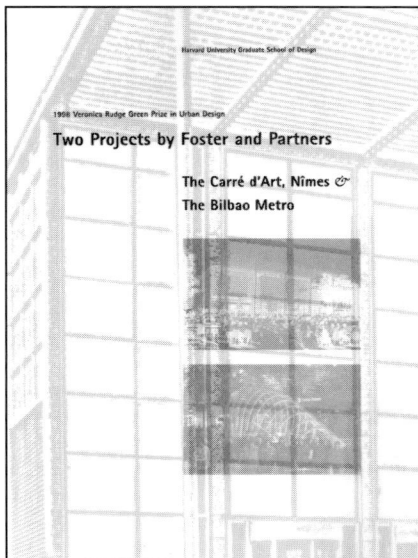

5

1 **Design Firm:** J. Paul Getty Trust-Publications Services, Los Angeles, CA **Client:** J. Paul Getty Museum **Project:** In Focus: Boxed Set **Designer:** Jeffrey Cohen

2 **Design Firm:** J. Paul Getty Trust-Publications Services, Los Angeles, CA **Client:** Getty Conservation Institute **Project:** Palace Sculptures of Abomey **Designer:** Vickie Sawyer Karten

3 **Design Firm:** J. Paul Getty Trust-Publications Services, Los Angeles, CA **Client:** J. Paul Getty Museum **Project:** Departures **Designer:** Lorraine Wild

4 **Design Firm:** J. Paul Getty Trust-Publications Services, Los Angeles, CA **Client:** J. Paul Getty Museum **Project:** NadarWarhol: ParisNew York **Designer:** Pamela Patrusky Mass

5 **Design Firm:** Nassar Design, Brookline, MA **Client:** Harvard University Graduate School of Design **Project:** Two Projects by Foster and Partners **Art Director:** Nelida Nassar **Designer:** Margarita Encomienda

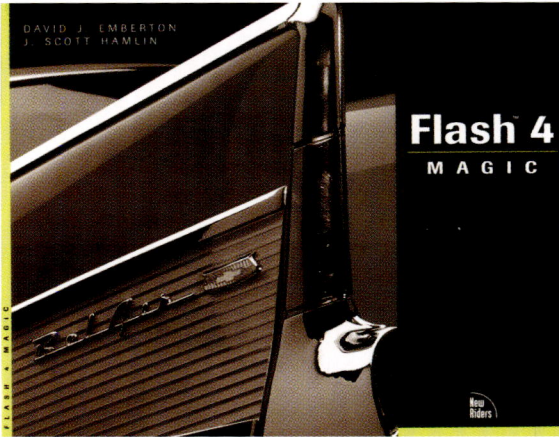

1

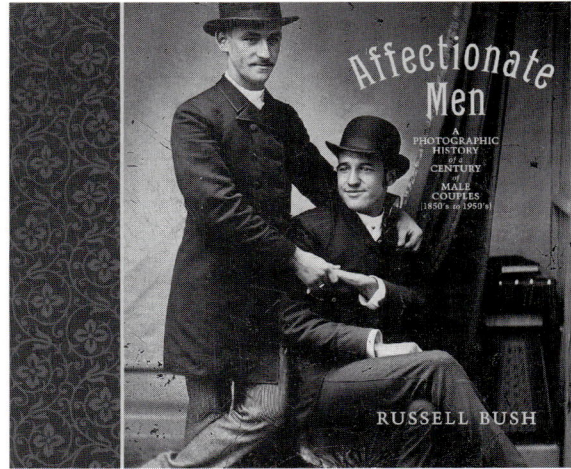

2

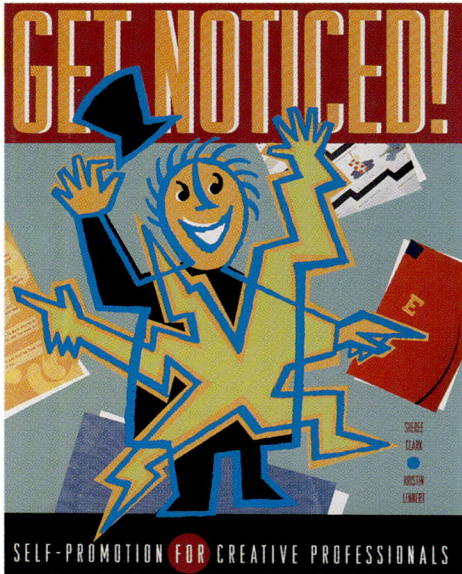

3

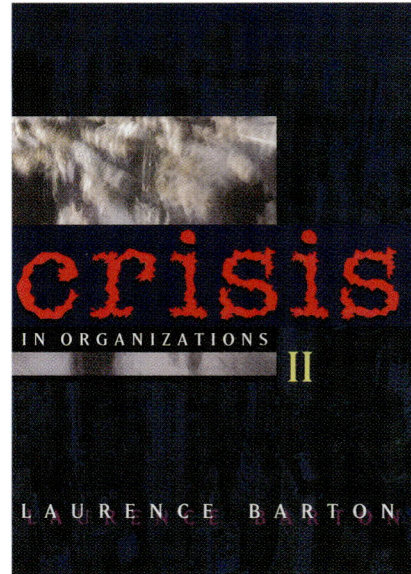

4

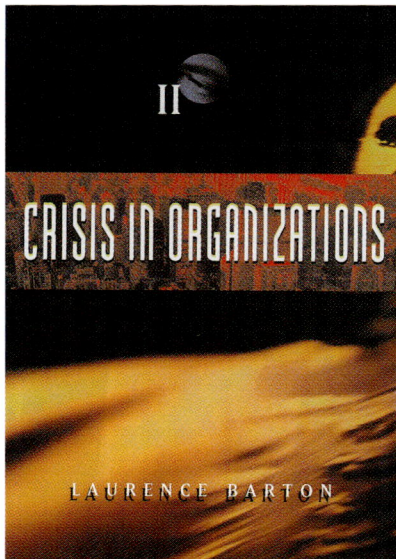

5

1 **Design Firm:** New Riders Publishing, Indianapolis, IN **Client:** New Riders Graphics **Project:** Flash 4 Magic **Designer:** Aren Howell **Illustrator:** Interior **Designer:** Steve Balle-Gifford

2 **Design Firm:** Ron Lieberman Studio, New York, NY **Client:** St. Martin's Press **Project:** Affectionate Men **Art Director:** Ron Lieberman, Russell Bush **Designer:** Ron Lieberman **Photographer:** Unknown Portrait Photographers

3 **Design Firm:** Sayles Graphic Design, Des Moines, IA **Client:** F&W Publications/North Light Books **Project:** Get Noticed! **Art Director:** John Sayles **Designer:** John Sayles **Photographer:** Bill Nellans **Illustrator:** John Sayles

4 **Design Firm:** South-Western College Publishing, Cincinnati, OH **Project:** Crisis, Bartan #1 **Art Director:** Jennifer Mayhall **Designer:** Rick Moore

5 **Design Firm:** South-Western College Publishing, Cincinnati, OH **Project:** Crisis II **Art Director:** Jennifer Mayhall **Designer:** Rick Moore **Illustrator:** Rick Moore

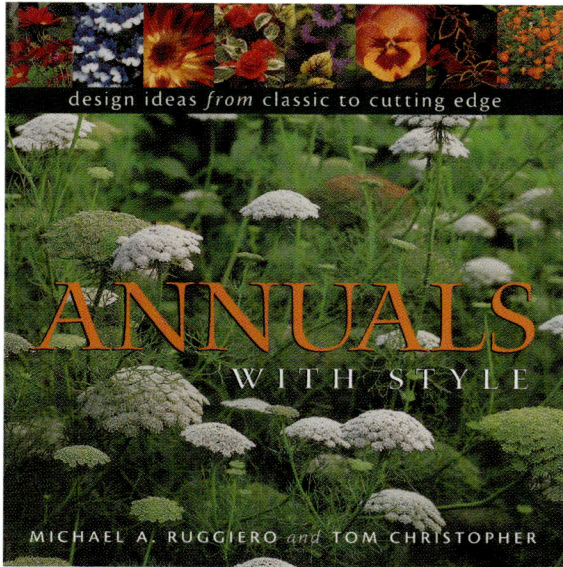

1

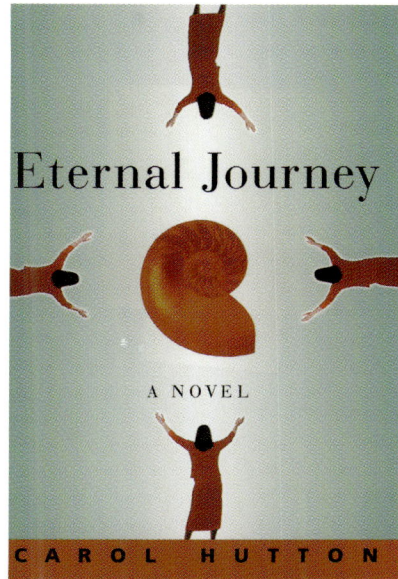

2

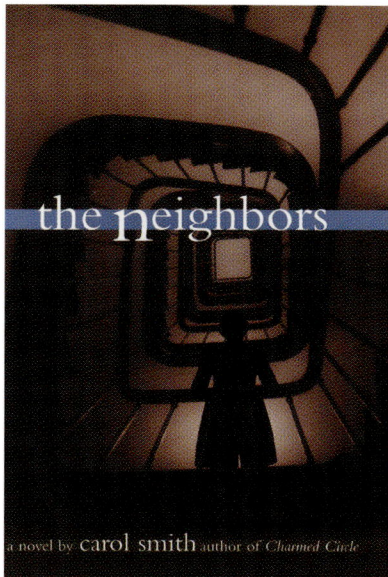

3

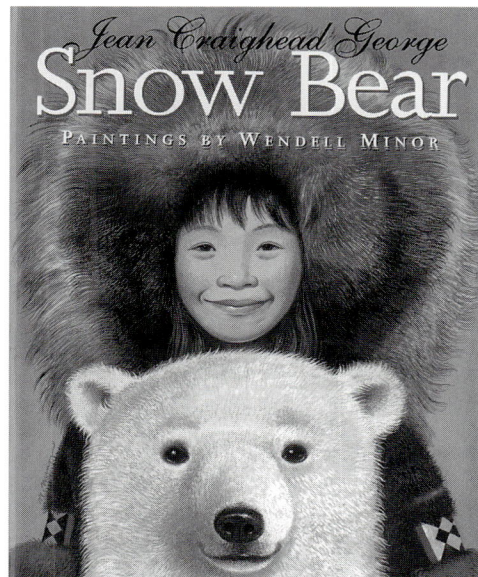

4

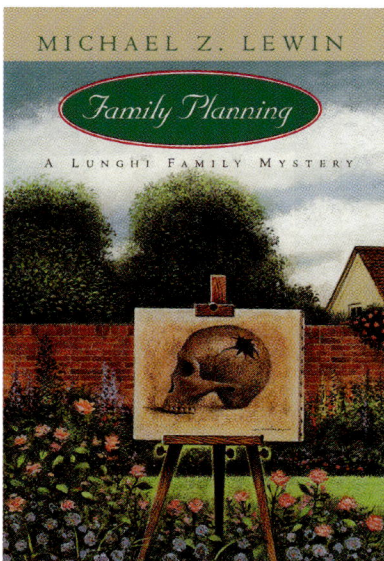

5

1 **Design Firm:** The Taunton Press, Newtown, CT **Publisher:** The Taunton Press **Project:** Annuals with Style **Art Director:** Paula Schlosser **Designer:** Margery Cantor, Lori Wendin, Carol Singer **Illustrator:** Christine Erickson

2 **Design Firm:** Warner Books, New York, NY **Project:** Eternal Journey **Art Director:** Rachel McClain **Designer:** Tom Stvan **Photographer:** Tom Stvan, Harold Sund

3 **Design Firm:** Warner Books, New York, NY **Project:** The Neighbors **Art Director:** Flag, Jackie Merri Meyer **Designer:** Jackie Merri Meyer **Photographer:** Alexa Garbarino

4 **Design Firm:** Wendell Minor Design, Washington, CT **Client:** Hyperion Books For Children **Project:** Snow Bear **Art Director:** Anne Diebel **Designer:** Wendell Minor **Illustrator:** Wendell Minor

5 **Design Firm:** Wendell Minor Design, Washington, CT **Client:** St. Martin's Press **Project:** Family Planning **Art Director:** Sarah Delson **Designer:** Wendell Minor **Illustrator:** Wendell Minor

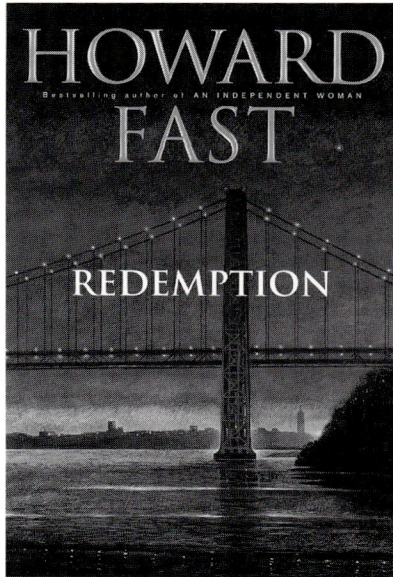

1

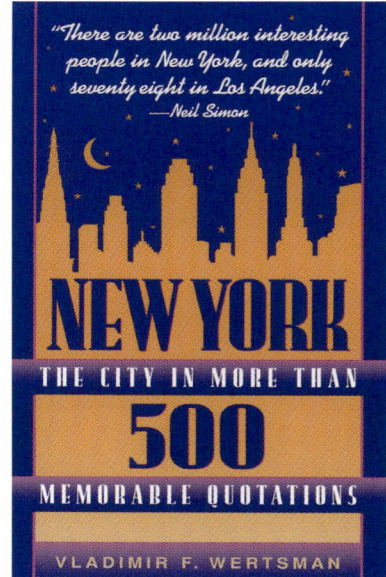

2

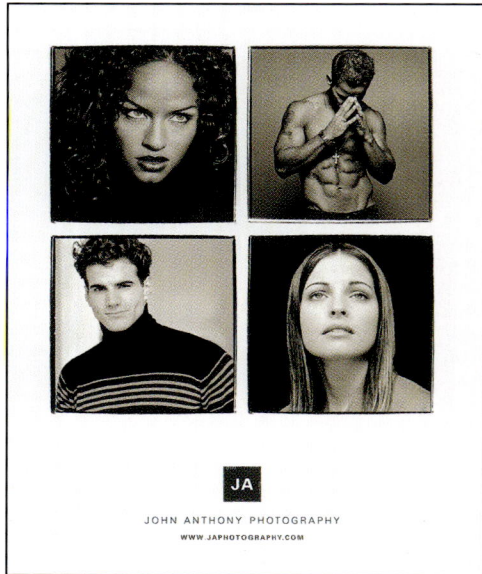

3

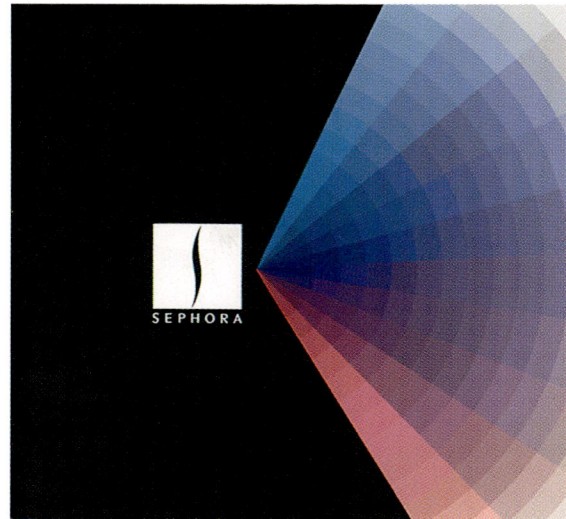

4

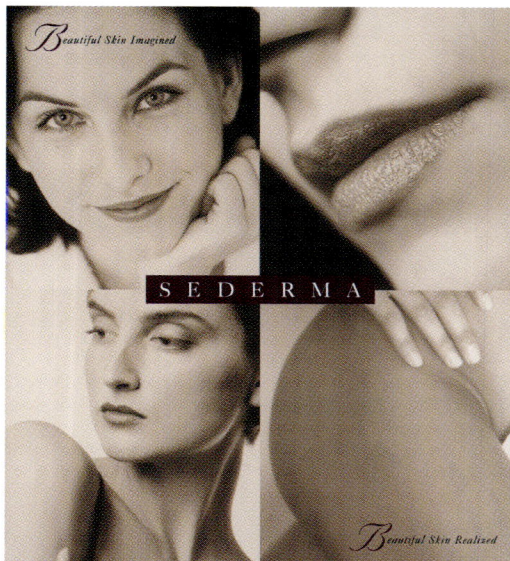

5

1 **Design Firm:** Wendell Minor Design, Washington, CT **Client:** Harcourt Brace **Project:** Redemption **Art Director:** Vaughn Andrews **Designer:** Vaughn Andrews **Illustrator:** Wendell Minor

2 **Design Firm:** Z Design, Olney, MD **Client:** Scarecrow Trade **Project:** New York, The City in More Than 500 Memorable Quotations **Art Director:** Giséle Byrd Henry **Designer:** Irene Zevgolis **Illustrator:** Irene Zevgolis

Brochures/Collateral

3 **Design Firm:** 2 Sisters Design, Redwood Shores, CA **Client:** John Anthony Photography **Project:** John Anthony Photography Promotional Materials **Art Director:** Karen Uhl Vano, Jennifer Uhl Maurry **Designer:** Karen Uhl Vano, Jennifer Uhl Maurry **Photographer:** John Anthony Photography

4 **Design Firm:** Addis Group, Inc., Berkeley, CA **Client:** LVMH Moet Hennessey Louis Vuitton **Project:** Sephora Collateral: Color Wheel **Art Director:** Joanne Hom **Designer:** Lisa Gainor **Production Artist**: Elizabeth Rowell

5 **Design Firm:** AGCD, Montclair, NJ **Client:** Sederma Inc. **Project:** Imagine Beautiful Skin Realized **Art Director:** Allan Gorman **Designer:** Allan Gorman

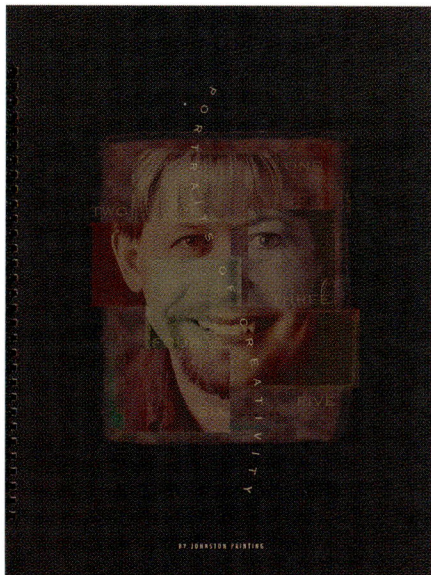

1

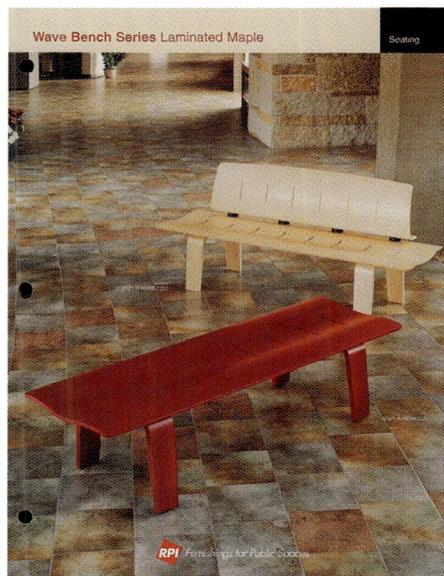

2

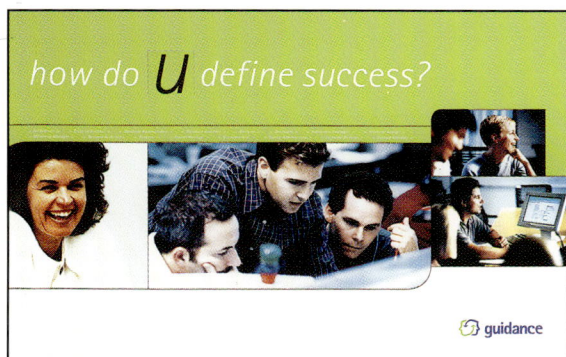

3

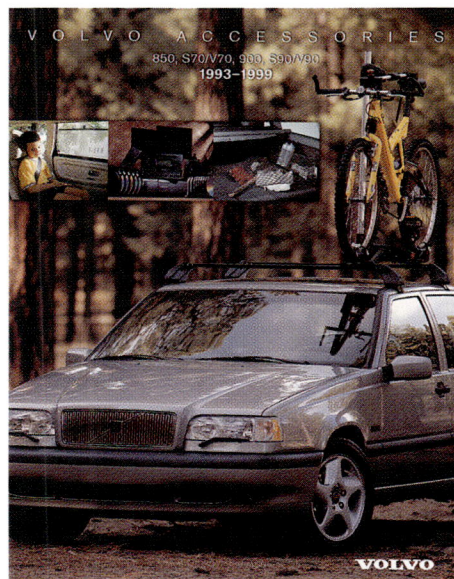

4

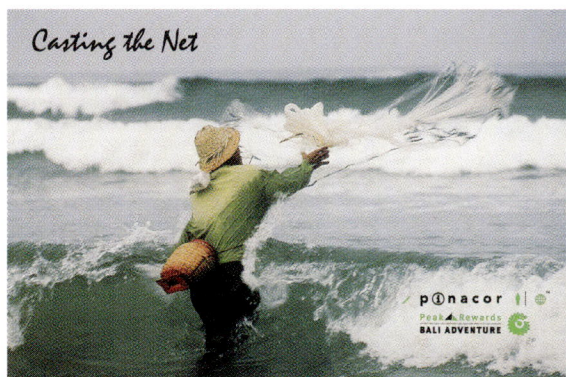

5

1 **Design Firm:** Anderson Mraz Design, Spokane, WA **Client:** Johnston Printing **Project:** Brochure **Art Director:** C.K. Anderson **Designer:** John Mraz, Mike Bold **Photographer:** J. Craig Sweat Photography **Writer:** Sharman Communications

2 **Design Firm:** BachlLees Design, Inc, Boston, MA **Client:** RPI **Project:** Product Brochures **Art Director:** John Bach **Designer:** John Bach **Photographer:** Genesis Photographic

3 **Design Firm:** Baker Designed Communications, Santa Monica, CA **Client:** Guidance **Project:** Recruitment Brochure **Art Director:** Gary Baker **Designer:** Brian Keenan **Photographer:** Eric Myer

4 **Design Firm:** Barnett Design, Inc., Ramsey, NJ **Client:** Volvo Cars of North America, Inc. **Project:** Volvo Accessories Brochure **Art Director:** Debra Barnett **Designer:** Jefferson Ramos

5 **Design Firm:** BI Performance Services, Minneapolis, MN **Client:** Pinacor **Project:** Bali Adventure **Art Director:** John Eastman **Creative Director:** Bill Johnson **Copywriter:** Lara Etnier

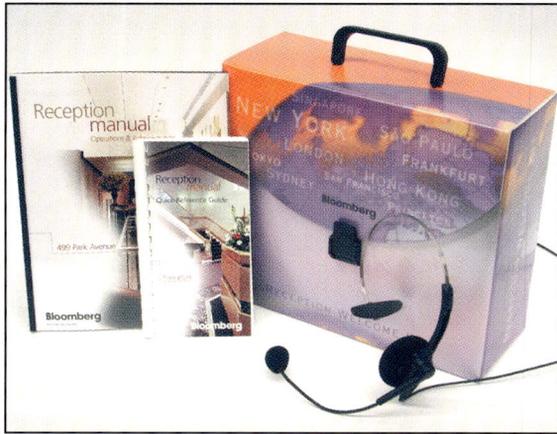

1

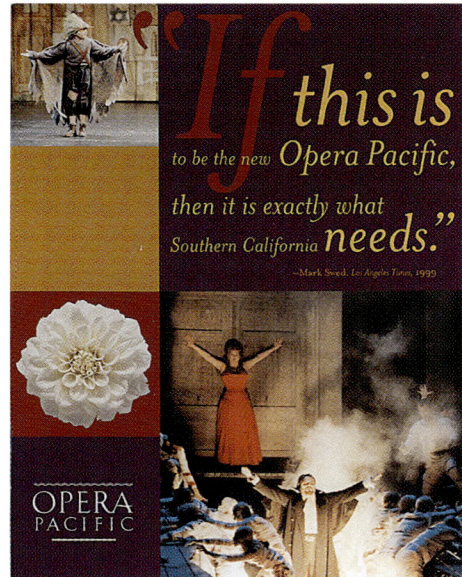

2

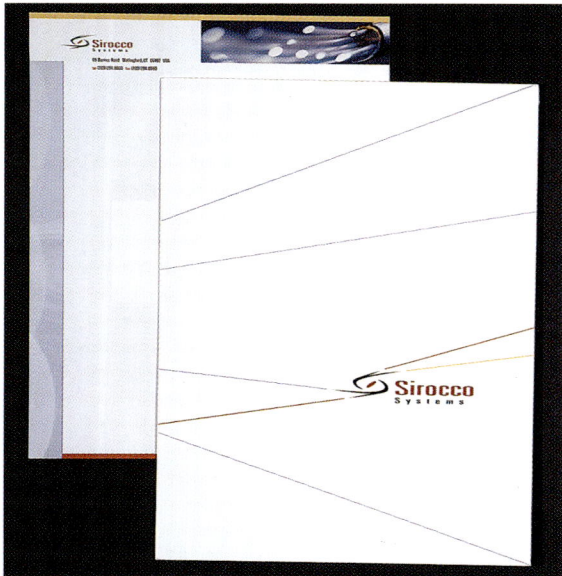

3

4

5

1 **Design Firm:** Bloomberg, Princeton, NJ **Project:** Reception Kit **Art Director:** Sandy O'Connor **Designer:** Lorraine Kuldanek

2 **Design Firm:** BoldFace Design, Los Angeles, CA **Client:** Opera Pacific **Project:** Development Fundraising Brochure **Designer:** Michael Lucas

3 **Design Firm:** Cambridge Design Group, Andover, MA **Client:** Sirocco Systems **Project:** Pocket Folder **Art Director:** Rick Tracy **Designer:** Kim Cilley

4 **Design Firm:** Carla Hall Design Group, New York, NY **Client:** Shattuck Hammond Partners **Project:** Capabilities Brochure **Art Director/Senior Designer:** Michael Wiemeyer **Designer:** Joshua White **Creative Director:** Carla Hall **Illustrator/Photography:** Joshua White, Michael Wiemeyer

5 **Design Firm:** Carla Hall Design Group, New York, NY **Client:** UBS Brinson **Project:** Global Investing Brochure **Art Director/Senior Designer:** Michael Wiemeyer **Designer:** John Stislow **Creative Director:** Carla Hall

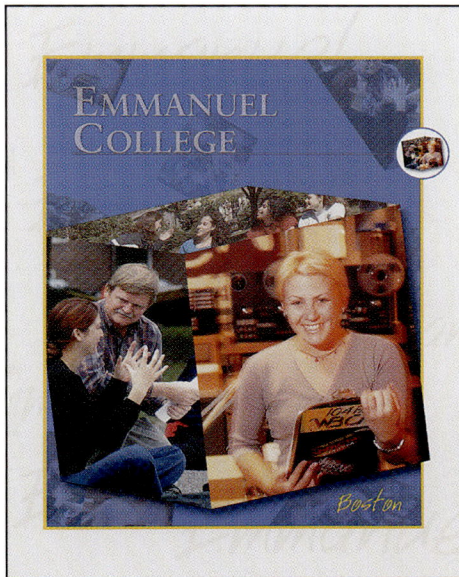

1

2

3

4

5

1 **Design Firm:** Champagne/Lafayette Communications Inc., Natick, MA **Client:** Emmanuel College **Project:** Brochure Series **Art Director:** Linda Luiso **Designer:** Janet Ireland **Photographer:** Patrick O'Connor

2 **Design Firm:** Cinergy Design Services, Plainfield, IN **Client:** Cinergy Global Power **Project:** Capabilities Brochure **Art Director:** Chris Janssen **Designer:** Chris Janssen

3 **Design Firm:** Cinergy Design Services, Plainfield, IN **Client:** Cinergy PAC **Project:** PAC Overview Brochure **Art Director:** Bill Rollison **Designer:** Bill Rollison

4 **Design Firm:** Clarion Marketing & Communications, Atlanta, GA **Client:** General Motors **Project:** Parts That Power Promotion **Art Director:** Greg Hughes, Peter Borowski **Designer:** Heather Mihalic

5 **Design Firm:** CMg Design Inc., Pasadena, CA **Client:** USC Annenberg School **Project:** Entertainment Initiative **Art Director:** Julie Markfield, Greg Crawford **Designer:** Julie Markfield, Jean De Angelis

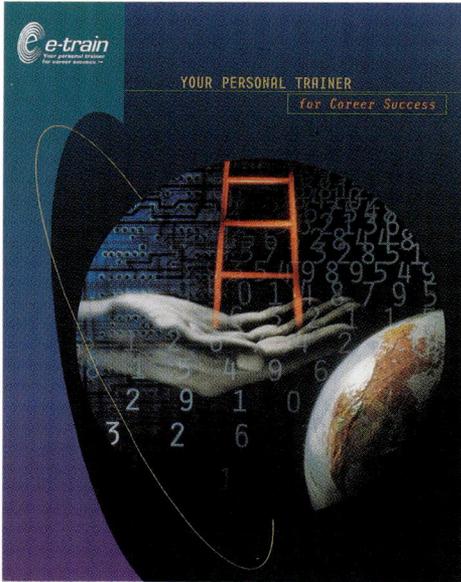

1

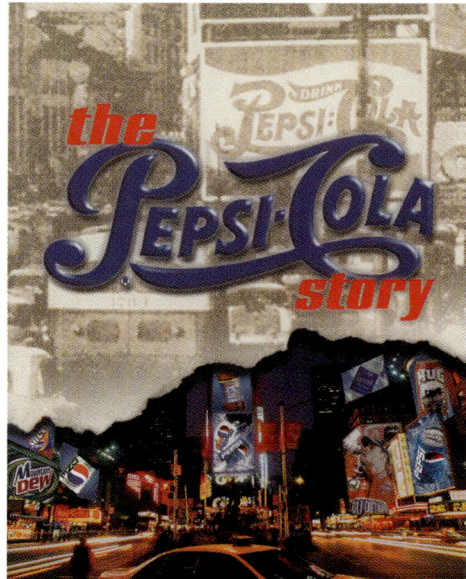

2

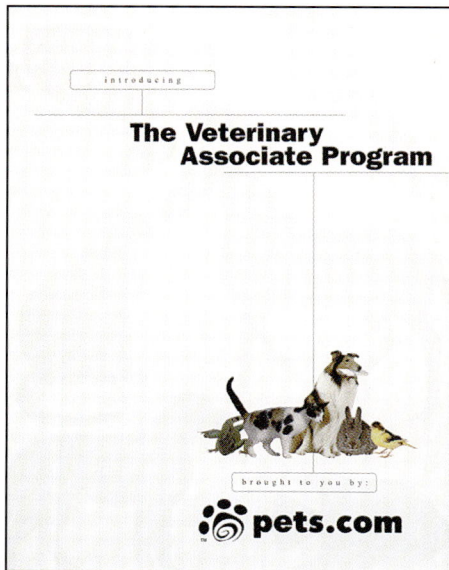

3

4

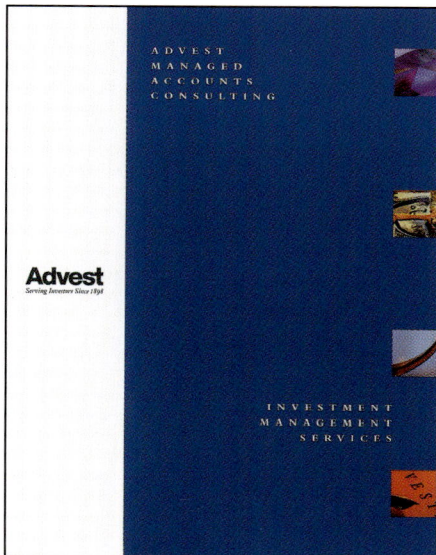

5

1 **Design Firm:** Crawford/Mikus Design, Inc., Atlanta, GA **Client:** e-train **Project:** Corporate Brochure **Art Director:** Elizabeth Crawford **Designer:** Elizabeth Crawford

2 **Design Firm:** Creative Alliance Marketing & Communications, Southport, CT **Client:** Pepsi-Cola Company **Project:** Pepsi Story **Art Director:** Ann Lumpinski **Creative Director:** Tony D'Amico **Photographer:** James Rudnick **Illustrator:** Tony D'Amico

3 **Design Firm:** Creative Alliance Marketing & Communications, Southport, CT **Client:** Pets.com **Project:** Brochure **Art Director:** Ann Lumpinski

4 **Design Firm:** Dakota Group, Inc., Wilton, CT **Client:** William M. Mercer **Project:** Boston Globe Benefits Package **Art Director:** Jim Garber **Designer:** Gerry Hawkins

5 **Design Firm:** Dart Design, Fairfield, CT **Client:** Advest, Inc. **Project:** Managed Accounts Consulting Brochure **Art Director:** Linda Anderson **Designer:** David Anderson

1

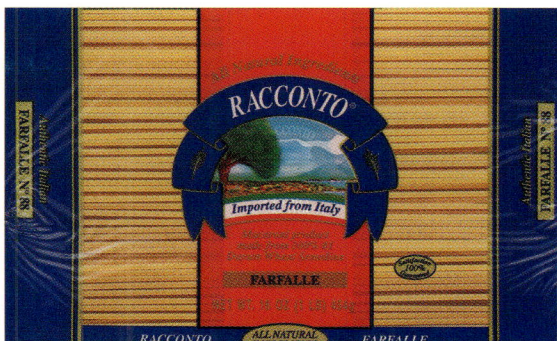

2

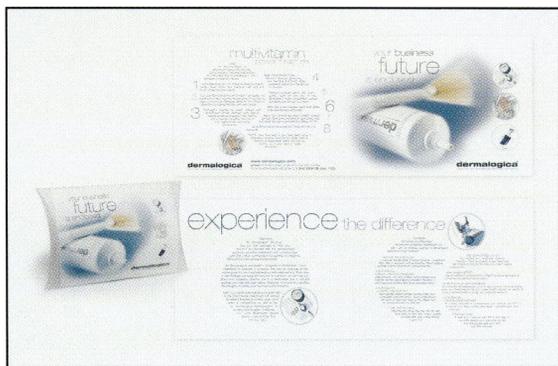

3

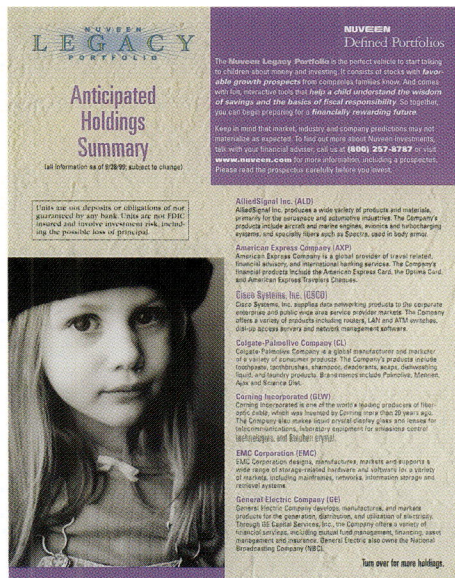

4

5

1 **Design Firm:** David Carter Graphic Design Associates, Dallas, TX **Client:** Mansion at MGM Grand **Project:** Guestroom Graphics **Art Director:** Lori B. Wilson **Designer:** Ashley Barron **Photographer:** Steven Rothfeld

2 **Design Firm:** Davis Harrison Dion, Chicago, IL **Client:** Racconto **Project:** Racconto Pasta **Art Director:** Jennifer Mazzoni, Rob Grogan **Designer:** Bob Dion, Brent Vincent **Photographer:** Patrick Henningfield

3 **Design Firm:** Dermal Group, Torrance, CA **Client:** Dermalogica Australian Division **Project:** Brochure **Art Director:** Claudine Villemure **Designer:** Dijana Marsic

4 **Design Firm:** Design Matters, Inc!, New York, NY **Client:** Nuveen Investments **Project:** Legacy **Art Director:** Stephen M. McAllister **Designer:** Stephen M. McAllister

5 **Design Firm:** Design Source East, Cranford, NJ **Client:** Harvard Press **Project:** Capabilities Brochure **Art Director:** Mark Lo Bello **Designer:** Mark Lo Bello

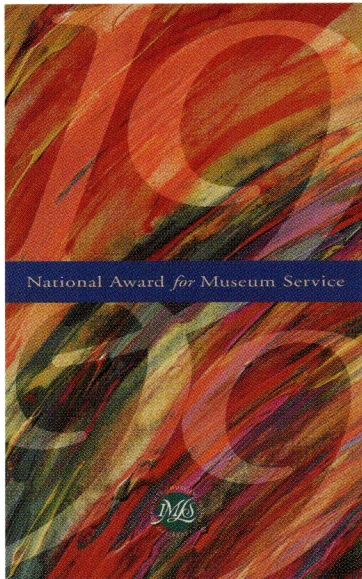

1

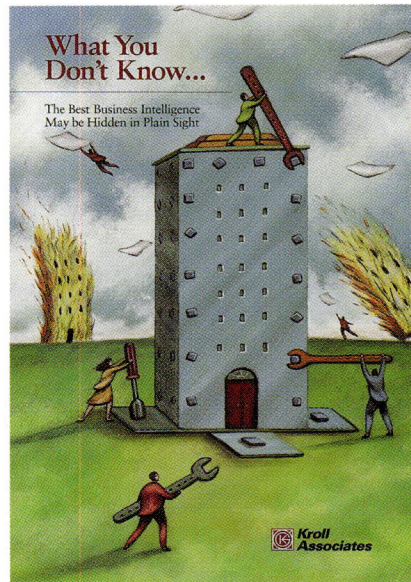

2

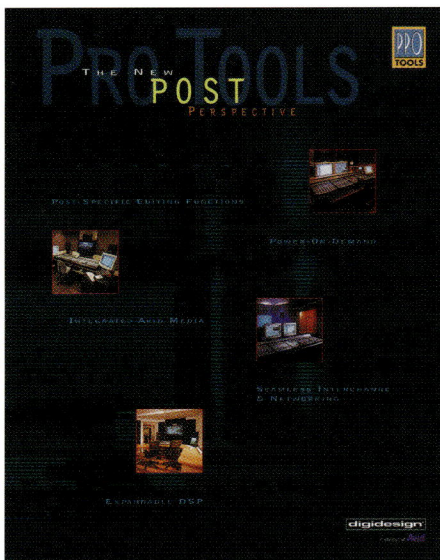

3

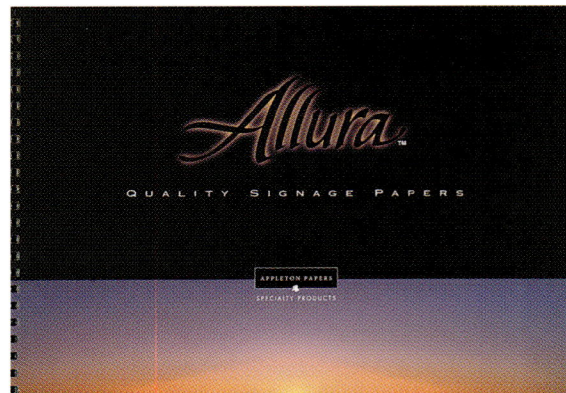

4

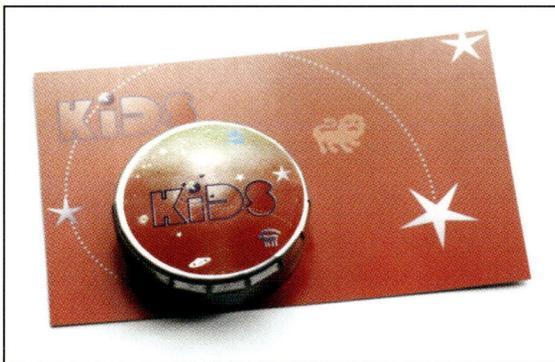

5

1 **Design Firm:** Dever Designs, Laurel, MD **Client:** Institute of Museum & Library Services **Project:** National Award for Museum Service **Art Director:** Jeffrey L. Dever **Designer:** Emily Martin Kendall

2 **Design Firm:** Di Vincenzo Design, Dobbs Ferry, NY **Client:** Kroll Associates **Project:** What You Don't Know... **Art Director:** Dennis Di Vincenzo **Designer:** Dennis Di Vincenzo **Illustrator:** Waren Gebert

3 **Design Firm:** Digidesign, Palo Alto, CA **Project:** Pro Tools Post Brochure **Art Director:** Van Chuchom **Designer:** Van Chuchom **Photographer:** Bill Schwob **Illustrator:** Suzanne Ricca

4 **Design Firm:** Directions Incorporated, Neenah, WI **Client:** Appleton Papers **Project:** Allura Brochure **Art Director:** Chip Ryan **Graphic Artist:** Laura Timm **Photographer:** Munroe Studios **Creative Director:** Lori Daun

5 **Design Firm:** Diversity: Architecture & Design, New York, NY **Client:** KiDS of NYU Medical Center **Project:** Stars & Magic 2000 Benefit **Art Director:** Ian J. Cohn **Designer:** Ian J. Cohn **Illustrator:** Ian J. Cohn

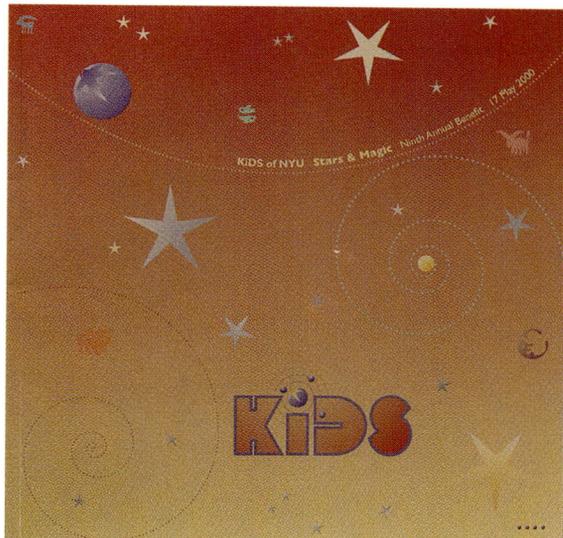

1

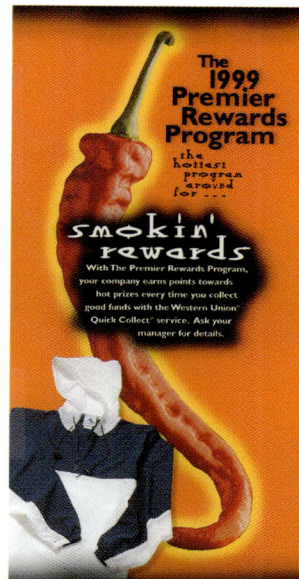

2

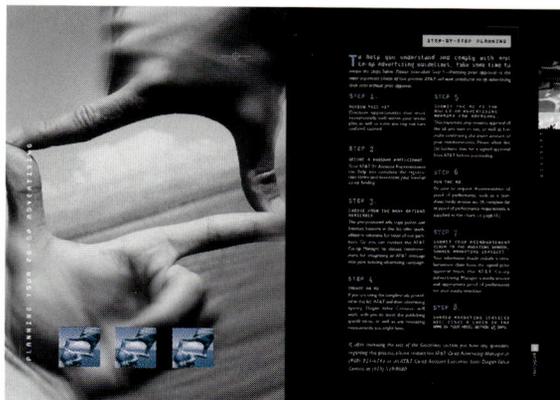

3

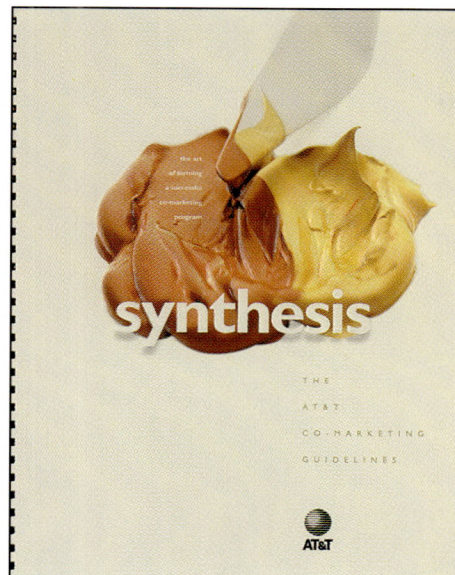

4

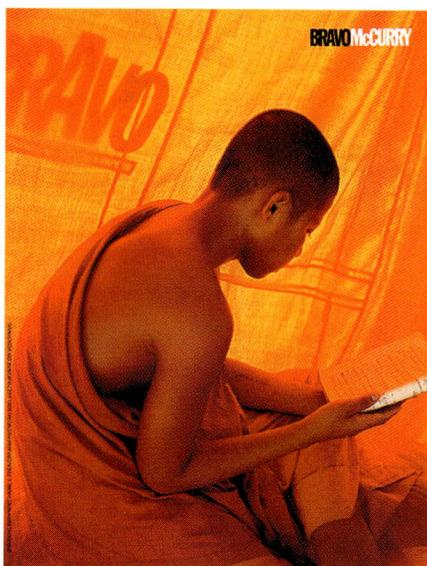

5

1 **Design Firm:** Diversity: Architecture & Design, New York, NY **Client:** KiDS of NYU Medical Center **Project:** Stars & Magic 2000 Benefit Journal **Art Director:** Ian J. Cohn **Designer:** Ian J. Cohn **Illustrator:** Ian J. Cohn

2 **Design Firm:** Dugan Valva Contess, Morristown, NJ **Client:** Western Union Financial Services **Project:** Smokin' Rewards **Art Director:** Lisa Calanni **Photographer:** Iggy Ruggieri

3 **Design Firm:** Dugan Valva Contess, Morristown, NJ **Client:** AT&T **Project:** AT&T Co-op Advertising Support Program **Art Director:** Carl Horosz

4 **Design Firm:** Dugan Valva Contess, Morristown, NJ **Client:** AT&T **Project:** Synthesis **Art Director:** Lisa Calanni **Photographer:** Iggy Ruggieri, Charles Maraia

5 **Design Firm:** Emerson, Wajdowicz Studios, New York, NY **Client:** Domtar, Eddy Specialty Papers **Project:** Bravo McCurry PhotoMasters Series **Art Director:** Jurek Wajdowicz **Designer:** Lisa LaRochelle, Jurek Wajdowicz **Photographer:** Steve McCurry

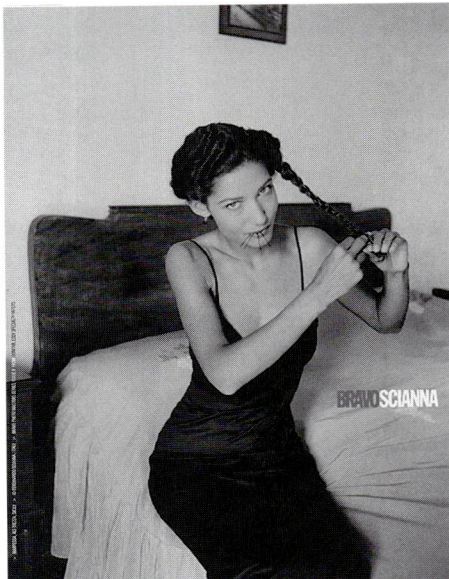

1

2

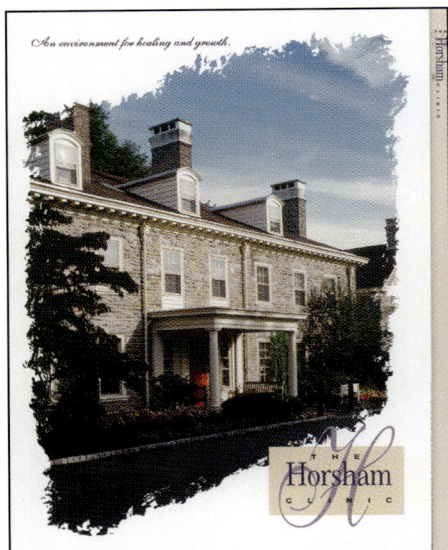

3

4

5

1 **Design Firm:** Emerson, Wajdowicz Studios, New York, NY **Client:** Domtar, Eddy Specialty Papers **Project:** Bravo Scianna PhotoMasters Series **Art Director:** Jurek Wajdowicz **Designer:** Lisa LaRochelle, Jurek Wajdowicz **Photographer:** Ferdinando Scianna

2 **Design Firm:** Evenson Design Group, Culver City, CA **Client:** Universal Studios, Florida **Project:** Escapes Guides **Art Director:** Stan Evenson **Designer:** Peggy Woo **Illustrator:** Dan Cosgrove

3 **Design Firm:** Fitzgerald Esplin Advertising, Doylestown, PA **Client:** Horsham Clinic **Project:** Brochure **Designer:** Vicki Thomas **Photographer:** RVO Photography

4 **Design Firm:** Flourish, Cleveland, OH **Client:** Arhaus Furniture **Project:** Postcard Mailer **Designer:** Jing Lauengco, Christopher Ferranti, Henry Frey **Photographer:** Larry Tuckman, Michael Rogers

5 **Design Firm:** GAF Advertising/Design, Dallas, TX **Client:** CSW Energy Inc. **Project:** Strength in Numbers **Art Director:** Gregg A. Floyd **Designer:** Gregg A. Floyd **Photographer:** Les Woolen

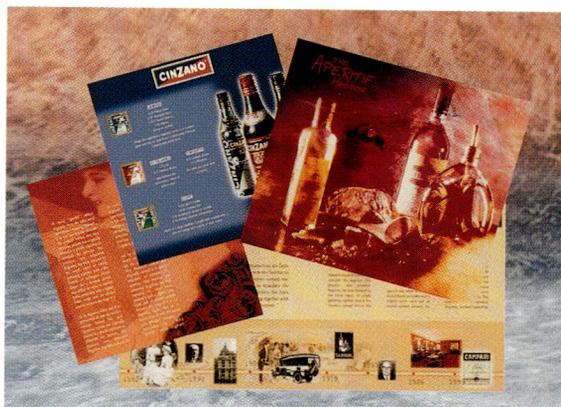

1

2

3

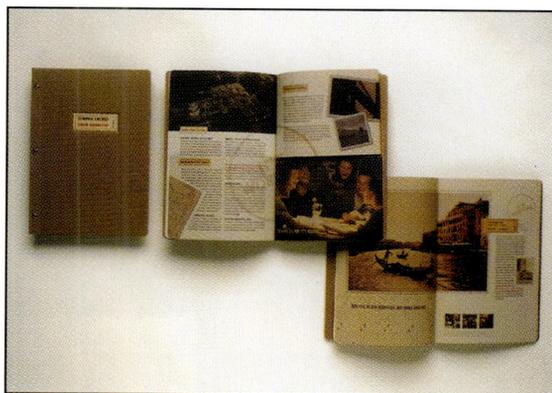

4

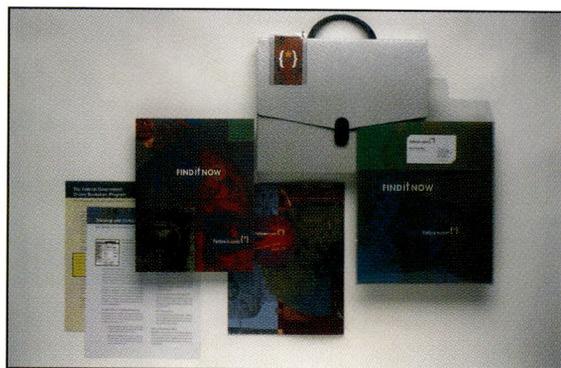

5

1 **Design Firm:** Gammon Ragonesi Associates, New York, NY **Client:** Skyy Spirits **Project:** Cinzano Cocktail Guide **Art Director:** Mary Ragonesi **Designer:** Jill Shellhorn **Photographer:** Greg Lord

2 **Design Firm:** Gibson Design, Middletown, CT **Client:** Plastic Design, Inc. **Project:** Partners in Plastic Source Book **Art Director:** John Gibson **Designer:** John Gibson **Photographer:** Derek Dudek Photography

3 **Design Firm:** GMO/Hill Holliday, San Francisco, CA **Client:** Sempra **Project:** Corporate Capabilities Brochure **Art Director:** Rick Atwood **Designer:** Marc Woollard, Craig Randolph **Copywriter:** Kathy Lemmon

4 **Design Firm:** GMO/Hill Holliday, San Francisco, CA **Client:** Sempra Energy **Project:** Capabilities Brochure **Art Director:** Alec Vianu **Designer:** Kelly Niland **Copywriter:** Amy Caplan

5 **Design Firm:** GMO/Hill Holliday, San Francisco, CA **Client:** Fatbrain **Project:** Corporate Overview Kit **Designer:** Vikee Wong **Copywriter:** Amy Caplan **Illustrator:** Rick Borga

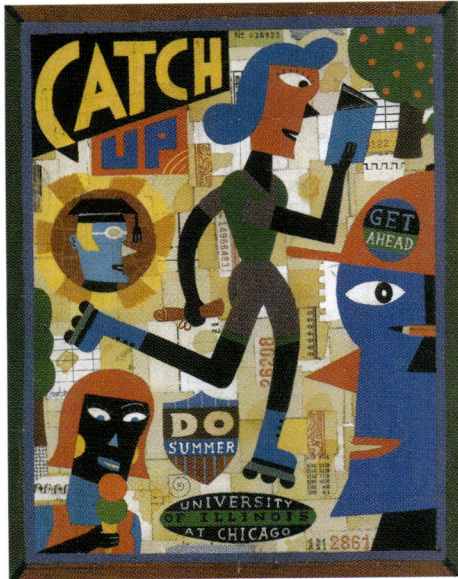

1

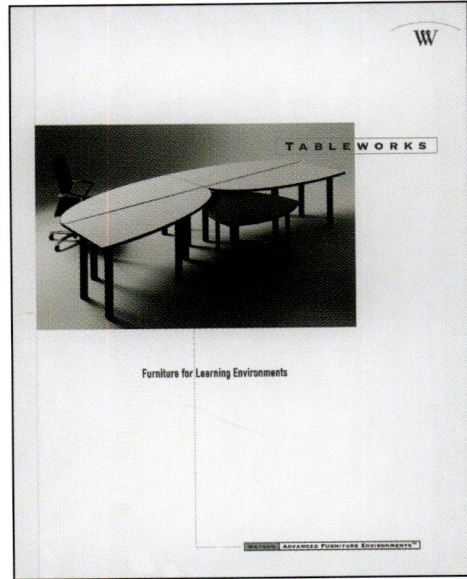

2

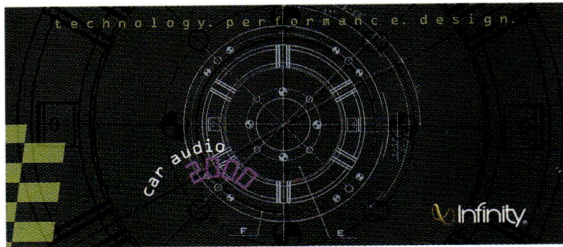

3

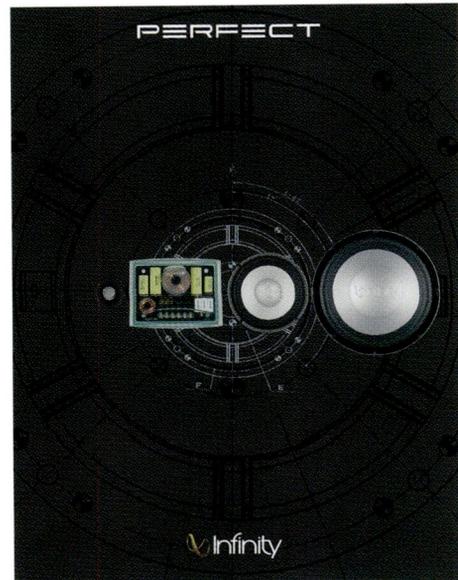

4

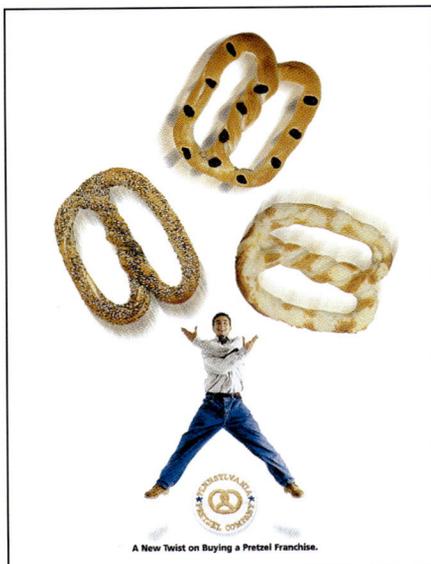

5

1 **Design Firm:** Group Chicago, Chicago, IL **Client:** University of Illinois at Chicago **Project:** Summer Session Brochure **Art Director:** Barbara Lynk **Designer:** Barbara Lynk **Illustrator:** Noah Woods

2 **Design Firm:** Hansen Design Company, Seattle, WA **Client:** Watson Furniture Company **Project:** Tableworks Brochure **Art Director:** Pat Hansen **Designer:** Pat Hansen, Dominic Dunbar

3 **Design Firm:** Harman Consumer Group, Woodbury, NY **Client:** Infinity Car Audio **Project:** Full-Line Consumer Brochure **Art Director:** John Cianti **Designer:** Robin Witt

4 **Design Firm:** Harman Consumer Group, Woodbury, NY **Client:** Infinity Car Audio **Project:** Kappa Perfect Consumer Literature **Art Director:** John Cianti **Designer:** Robin Witt

5 **Design Firm:** Harper & Harper, New Haven, CT **Client:** Pennsylvania Pretzel Company **Project:** Franchise Brochure **Art Director:** Barb Harper, Charlie Harper **Designer:** Barb Harper **Photographer:** Shaffer/Smith **Illustrator:** IM Design

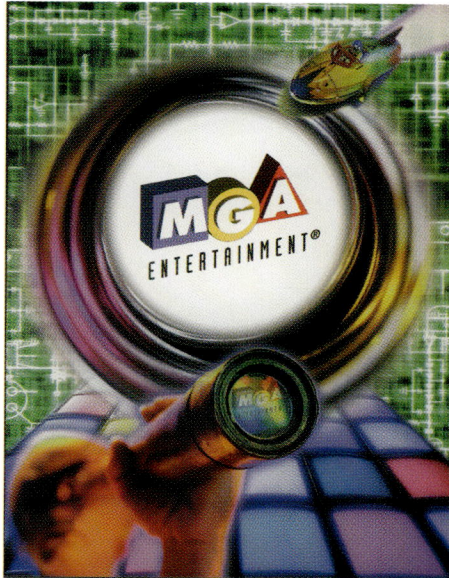

1

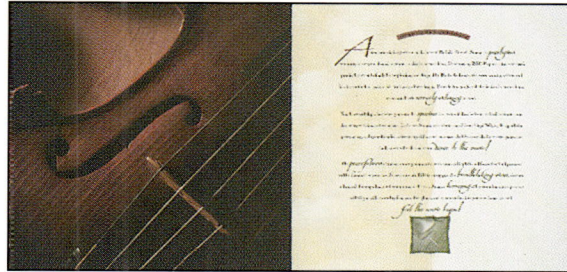

2

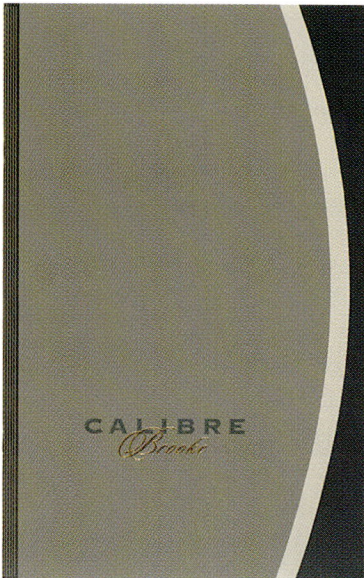

3

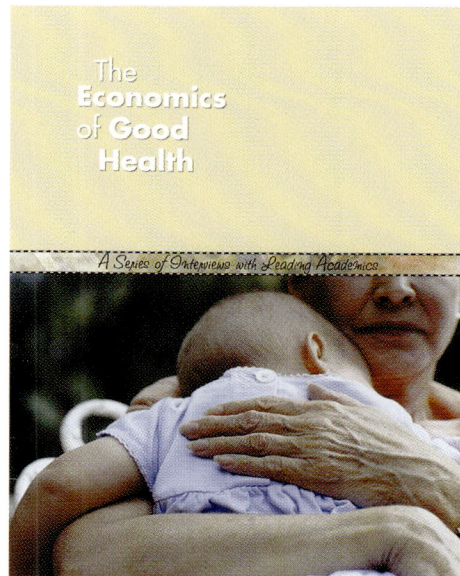

4

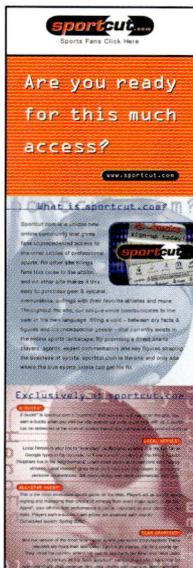

5

1 **Design Firm:** Hill and Knowlton, Los Angeles, CA **Client:** MGA Entertainment **Project:** Press Kit **Art Director:** Joyce Eicholtz **Designer:** Joyce Eicholtz

2 **Design Firm:** Ilium Associates, Inc., Bellevue, WA **Client:** BRE Properties **Project:** Pinnacle Sonata Brochure **Art Director:** Cynthia Lynn **Designer:** Shannon Sharp

3 **Design Firm:** Ilium Associates, Inc., Bellevue, WA **Client:** Sterling Realty Management **Project:** Calibre Brooke Leasing Brochure **Art Director:** Cynthia Lynn **Designer:** Shannon Sharp

4 **Design Firm:** Jacqueline Barrett Design Inc., Oceanport, NJ **Client:** Merck and Co., Inc. **Project:** Economics of Good Health Brochure **Art Director:** Jacqueline Barrett **Designer:** Jacqueline Barrett **Illustrator:** Elise N. Phillips

5 **Design Firm:** JDC Design, Inc., New York, NY **Client:** Sportcut.com **Project:** Promotional Brochure **Creative Director:** Jeff Conway **Designer:** Michael Pring

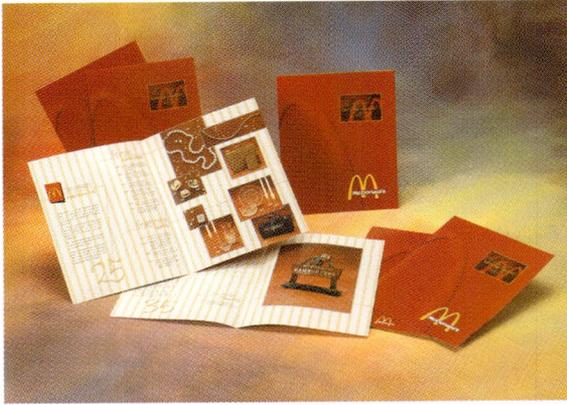

1

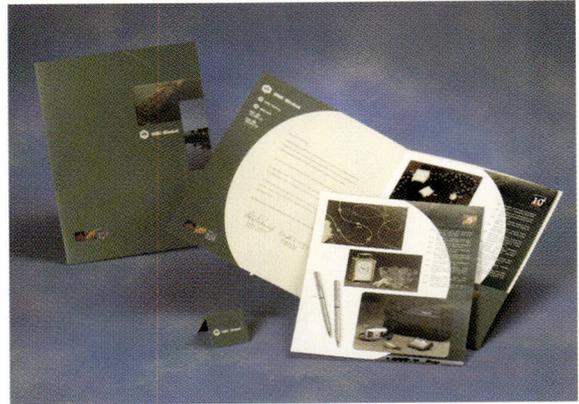

2

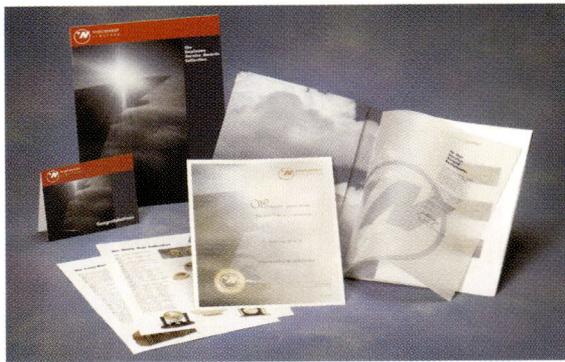

3

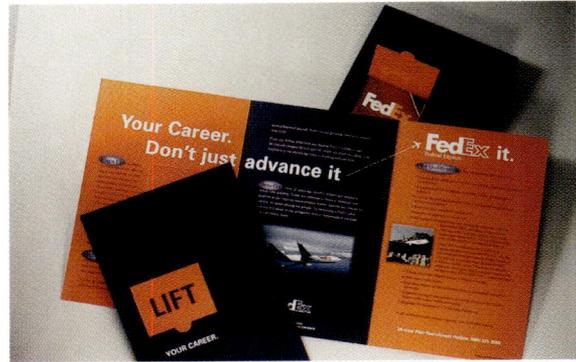

4

5

1 **Design Firm:** Jostens ProMedia, Burnsville, MN **Client:** McDonald's **Project:** Service Awards Catalog **Art Director:** Ginger Flemming **Designer:** Ginger Flemming **Photographer:** Heidi Ehalt

2 **Design Firm:** Jostens ProMedia, Burnsville, MN **Client:** IMC Global **Project:** A Lasting Honor **Art Director:** Cyndi Maas **Designer:** Cyndi Maas **Photographer:** Heidi Ehalt

3 **Design Firm:** Jostens ProMedia, Burnsville, MN **Client:** Northwest Airlines **Project:** Service Awards Catalog **Art Director:** Ginger Flemming **Designer:** Ginger Flemming **Photographer:** Caroline Duffy

4 **Design Firm:** JWT Specialized Communications, St. Louis, MO **Client:** FedEx **Project:** Air Ops Brochure **Art Director:** Gene Kuehnle **Creative Director:** Tim Kidwell **Copywriter:** Tim Kidwell

5 **Design Firm:** Kor Group, Boston, MA **Client:** PTC **Project:** Vision Brochure **Art Director:** Jack Morton Co.: Michael Petan **Designer:** MB Jarosik **Photographer:** Pierre Goavec

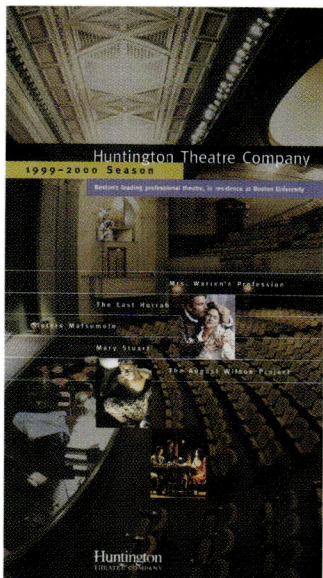

1

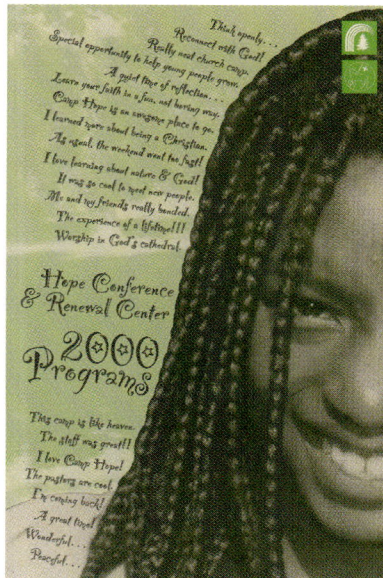

2

3

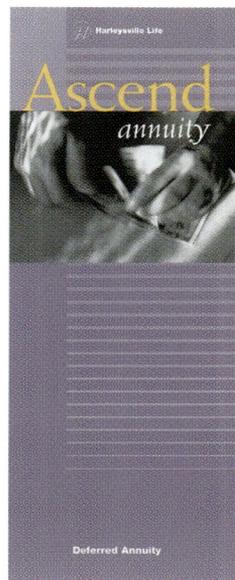

4

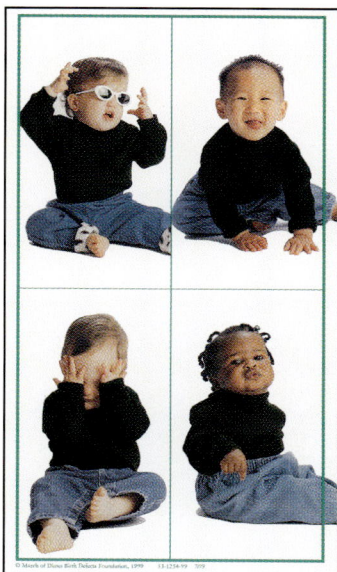

5

1 **Design Firm:** Kor Group, Boston, MA **Client:** Huntington Theatre **Project:** Season Brochure **Art Director:** Anne Callahan **Designer:** Jim Gibson **Photographer:** Huntington Theatre

2 **Design Firm:** Laughing Horse Graphics, Quakertown, PA **Client:** Hope Conference & Renewal Center **Project:** 2000 Programs Booklet **Designer:** Sandy Fay

3 **Design Firm:** Love Packaging Group, Wichita, KS **Client:** Young Life **Project:** Brochure **Art Director:** Chris West **Designer:** Lorna West

4 **Design Firm:** Malish & Pagonis, Philadelphia, PA **Client:** The Harleysville Insurance Companies **Project:** Ascend Annuity Program **Designer:** Demitri Pagonis

5 **Design Firm:** March of Dimes, White Plains, NY **Project:** Get the Ɓ Attitude Postcard **Designer:** Maryanne Kaczmarkiewicz **Photographer:** Jennifer Coate

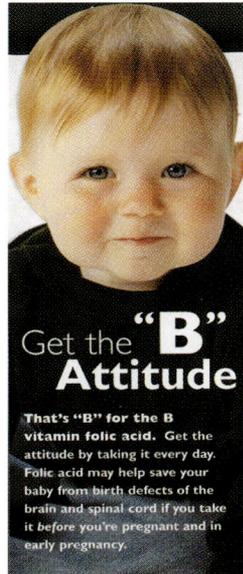

1

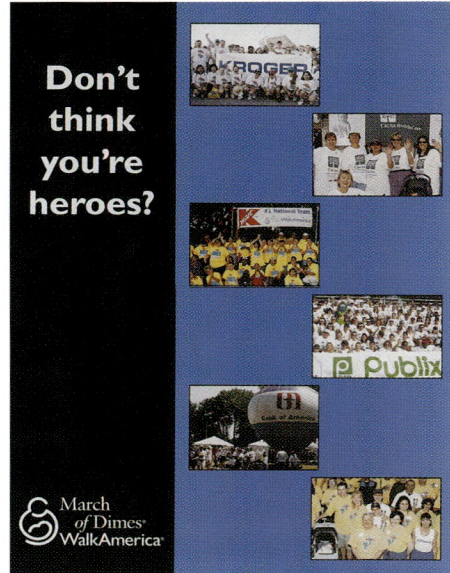

2

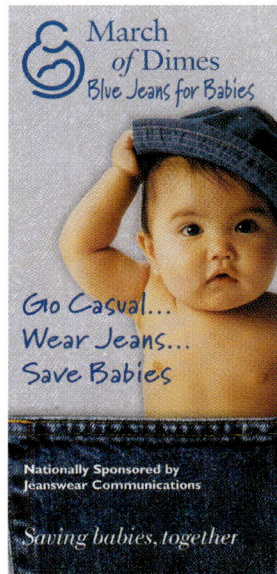

3

4

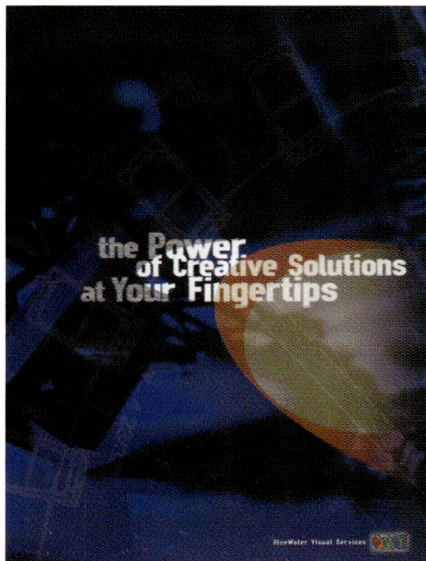

5

1 **Design Firm:** March of Dimes, White Plains, NY **Project:** Get the B Attitude Bookmark **Designer:** Maryanne Kaczmarkiewicz **Photographer:** Jennifer Coate

2 **Design Firm:** March of Dimes, White Plains, NY **Project:** WalkAmerica 2000 Team Brochure **Art Director:** Sharon Mahoney, Barbara Jones **Designer:** Sharon Mahoney **Photographer:** Jennifer Coate **Illustrator:** Kathy D'Aloise

3 **Design Firm:** March of Dimes, White Plains, NY **Project:** Blue Jeans for Babies Brochure **Art Director:** Sharon Mahoney, Barbara Jones **Designer:** Bill Mastro **Photographer:** Jennifer Coate **Illustrator:** Kathy D'Aloise

4 **Design Firm:** Matthew Schmidt Design, Exton, PA **Client:** Astea International **Project:** Service Alliance Datasheets **Art Director:** Matthew Schmidt **Designer:** Matthew Schmidt, Ryan Aungst

5 **Design Firm:** McElfish & Company, Troy, MI **Client:** BlueWater Visual Services **Project:** The Power of Creative Solutions at Your Fingertips **Designer:** Danielle Gutherie, Julius DeChavez

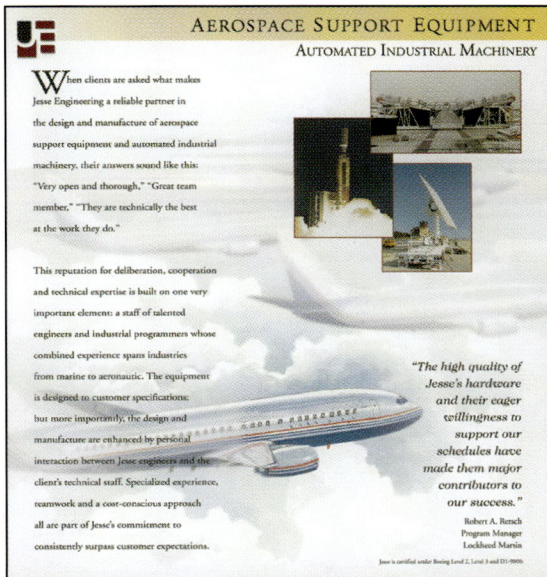

1

2

3

4

5

1 **Design Firm:** McGowan Advertising, Inc., Lakewood, WA **Client:** Jesse Engineering **Project:** Corporate Brochure **Art Director:** Jennifer Adams **Designer:** Jennifer Adams **Photographer:** Strode-McGowan Photography **Illustrator:** Jack Tavener

2 **Design Firm:** Merck Worldwide, Whitehouse Station, NJ **Client:** Zocor Worldwide **Project:** Zocor Symposia Materials **Art Director:** Robert Talarcyk **Designer:** Robert Talarcyk

3 **Design Firm:** Mission House Creative, Raleigh, NC **Client:** MD Everywhere **Project:** Corporate Collateral **Art Director:** Carol Roessner **Designer:** Carol Roessner, Christie Martin, Tamara Timmons **Photographer:** Steven Auboch

4 **Design Firm:** Monaco/Viola Incorporated, Chicago, IL **Client:** Saint Dizier Design **Project:** Brochure **Art Director:** Robert Viola **Designer:** Julie Yonker **Photographer:** Rob Gordon

5 **Design Firm:** NDW Communications, Horsham, PA **Client:** Zanders USA **Project:** Megamorphosis-Third Issue **Art Director:** Bill Healey **Designer:** Bill Healey

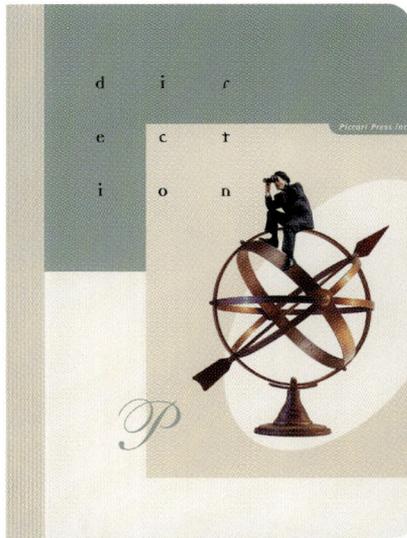

1

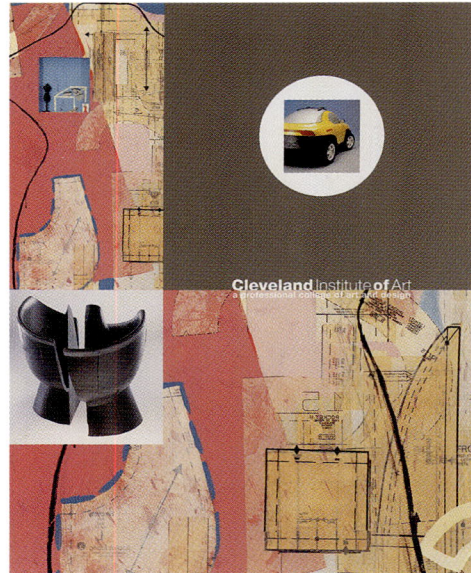

2

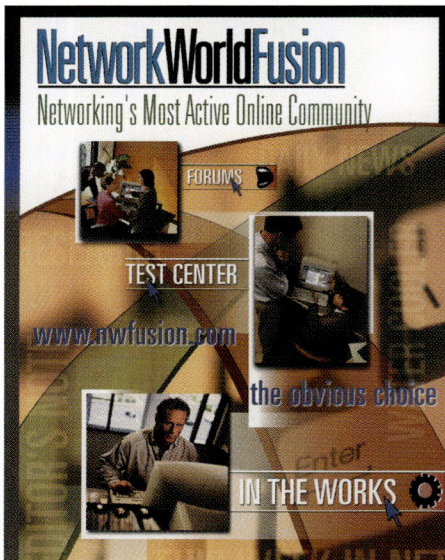

3

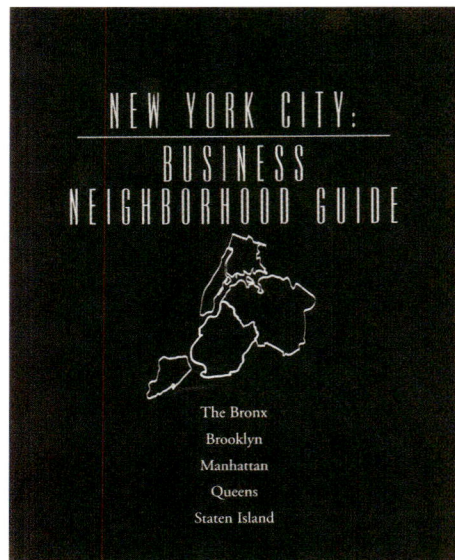

4

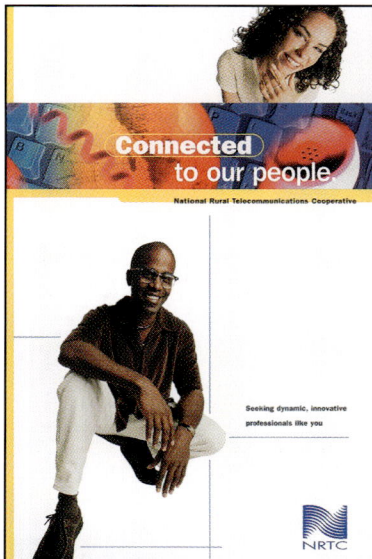

5

1 **Design Firm:** NDW Communications, Horsham, PA **Client:** Piccari Press Inc. **Project:** Capabilities Brochure **Art Director:** Bill Healey **Designer:** Bill Healey **Photographer:** Dan Naylor

2 **Design Firm:** Nesnadny & Schwartz, Cleveland, OH **Client:** Cleveland Institute of Art **Project:** Catalogue **Art Director:** Joyce Nesnadny, Mark Schwartz **Designer:** Joyce Nesnadny, Michelle Moehler **Photographer:** Robert Muller

3 **Design Firm:** Network World, Southborough, MA **Project:** Fusion Brochure **Designer:** Judy Schultz

4 **Design Firm:** New York City Economic Development Corporation, New York, NY **Project:** Business Neighborhood Guide **Art Director:** Abbi Lewis **Designer:** Abbi Lewis

5 **Design Firm:** NRTC, Herndon, VA **Client:** Human Resources Department **Project:** Recruitment Brochure **Art Director:** Jeanine Clough **Designer:** Sherilyn Holmes

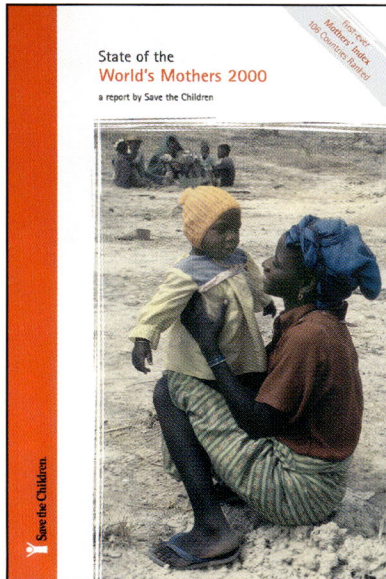

1

2

3

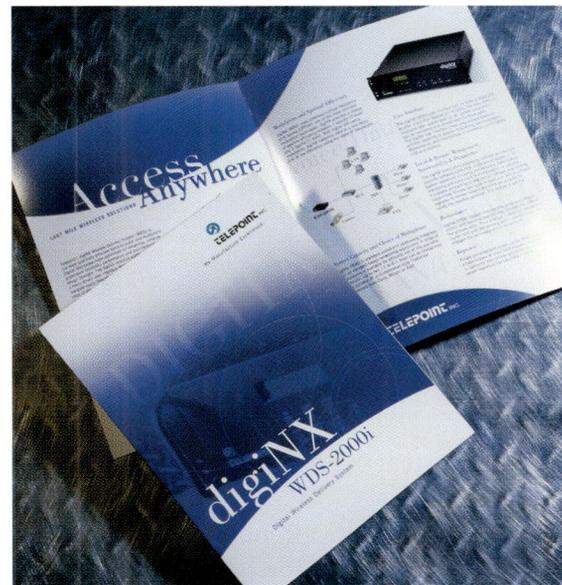

4

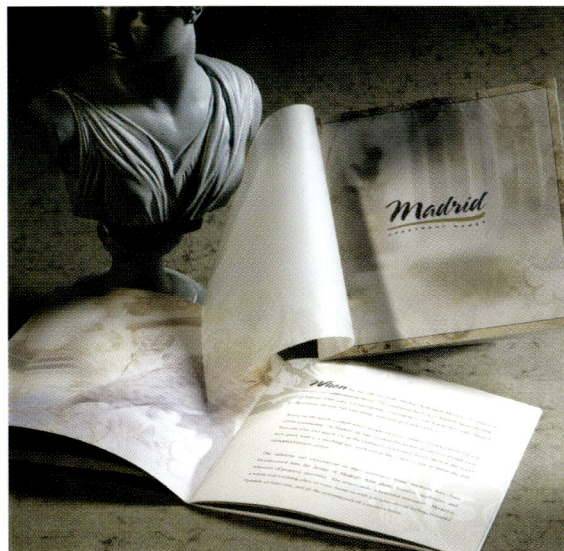

5

1 **Design Firm:** O&J Design Inc., New York, NY **Client:** Save the Children **Project:** Mother's Report **Art Director:** Barbara Olejniczak **Designer:** Christina Mueller

2 **Design Firm:** Odgis & Co., New York, NY **Client:** Towers Perrin **Project:** Corporate Brochure **Art Director:** Janet Odgis **Designer:** Banu Berker **Photographer:** Bill Gallery

3 **Design Firm:** Oliver Kuhlmann, St. Louis, MO **Client:** Mead Coated Papers **Project:** Signature: One For All **Art Director:** Deanna Kuhlmann-Leavitt **Designer:** Deanna Kuhlmann-Leavitt, Monica King **Photographer:** Gregg Goldman

4 **Design Firm:** p11creative, Santa Ana Heights, CA **Client:** Telepoint, Inc. **Project:** digiNX Brochure **Creative Director:** Lance Huante **Senior Designer:** Mike Esperanza **Photographer:** Steve Anderson

5 **Design Firm:** p11creative, Santa Ana Heights, CA **Client:** Shea Properties **Project:** Madrid Brochure **Creative Director:** Lance Huante **Designer:** Daniel Dean Webster, Mike Esperanza

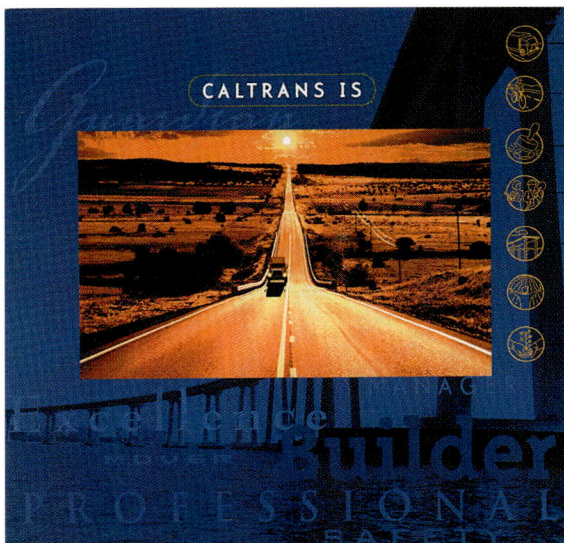

1

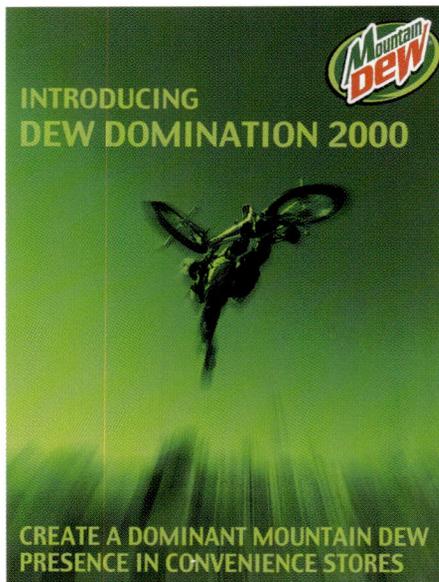

2

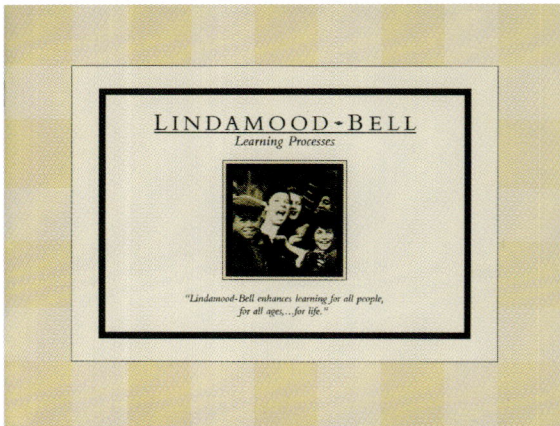

3

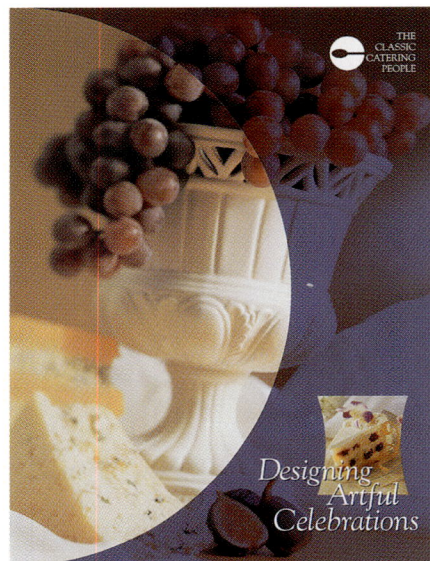

4

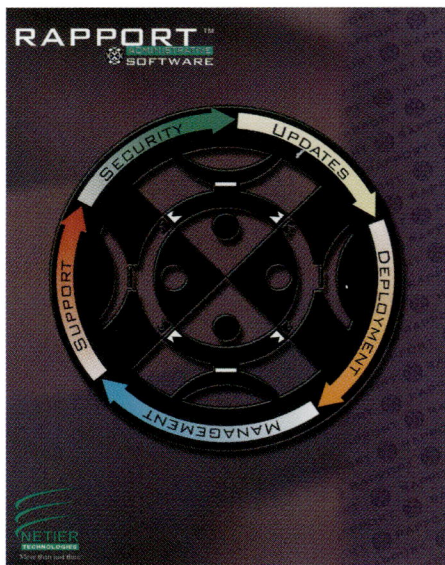

5

1 **Design Firm:** Page Design, Inc., Sacramento, CA **Client:** Caltrans **Project:** Overview Brochure **Art Director:** Tracy Titus, Paul Page, Gene Berthelsen **Designer:** Tracy Titus, Ann Davis, Shelley Morse **Photographer:** Caltrans **Illustrator:** Kurt Kland

2 **Design Firm:** Pepsi-Cola Company, Purchase, NY **Project:** Mountain Dew Presence Kit **Art Director:** Ron Udiskey **Designer:** Ron Udiskey **Photographer:** BLK/MRKT Inc.

3 **Design Firm:** Pierre Rademaker Design, San Luis Obispo, CA **Client:** Lindamood-Bell **Project:** Brochure **Art Director:** Pierre Rademaker **Designer:** Elisa Ahlin

4 **Design Firm:** Pinnacle Communications, Baltimore, MD **Client:** The Classic Catering People **Project:** Corporate Brochure **Art Director:** Tracey Haldeman **Designer:** Michael Blakesley **Photographer:** Michael Pohuski

5 **Design Firm:** Pinnacle Graphics, Addison, TX **Client:** Netier Technologies **Project:** Pocket Folder & Data Sheets **Art Director:** Wendy Hanson **Designer:** Wendy Hanson, Stan Hill, Amy Roever **Photographer:** Darrell Wilke

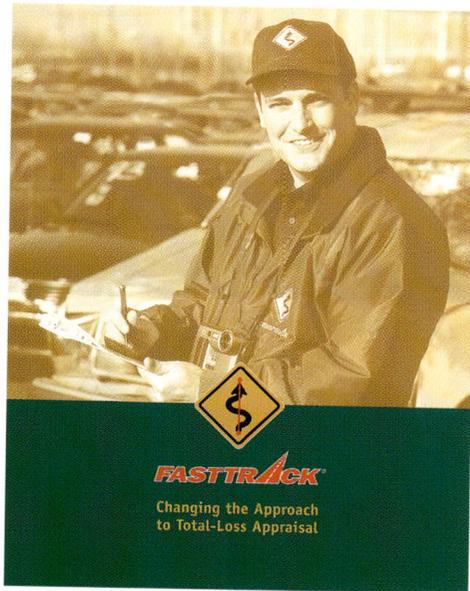

1

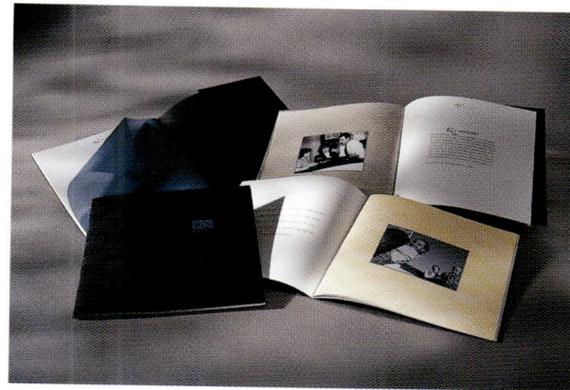

2

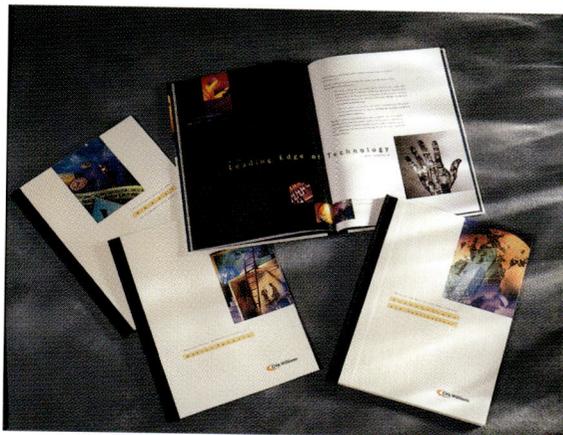

3

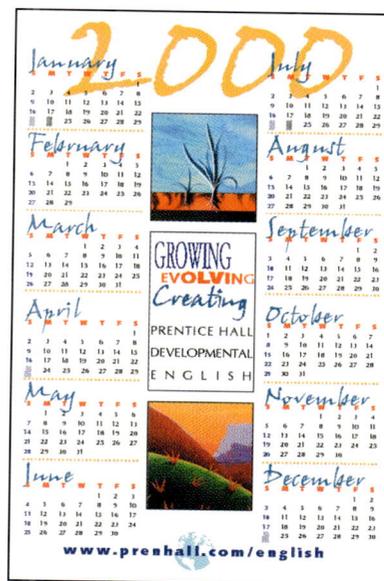

4

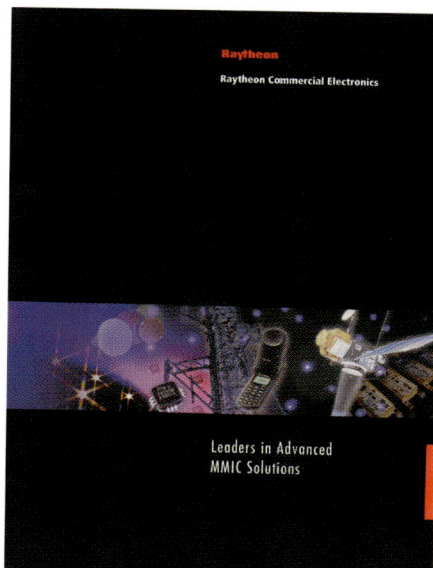

5

1 **Design Firm:** PiperStudiosInc, Chicago, IL **Client:** Insurance Auto Auctions **Project:** FastTrack Media Kit **Art Director:** Mike Piper **Designer:** Brian Trost **Photographer:** Ralph Brunke

2 **Design Firm:** Pisarkiewicz, Mazur & Co., Inc., New York, NY **Client:** KLS Professional Advisors Group, Inc. **Project:** Corporate Brochure **Art Director:** Mary F. Pisarkiewicz **Designer:** Linda Farber

3 **Design Firm:** Posner Advertising, New York, NY **Client:** GVA Williams **Project:** Corporate Brochure System **Art Director:** Nancy Merish **Designer:** Nancy Merish **Photographer:** George Menda **Photo Collage:** Ralph Mercer

4 **Design Firm:** Prentice Hall, Upper Saddle River, NJ **Client:** Brandy Dawson, Marketing **Project:** Growing, Evolving, Creating **Art Director:** Robert Farrar-Wagner **Designer:** Robert Farrar-Wagner **Illustrator:** Barry Scharf, Hal Lose

5 **Design Firm:** Raytheon Technical Services Co., Burlington, MA **Client:** Raytheon Commercial **Project:** MMIC Solutions **Designer:** Susan DeCrosta **Illustrator:** Susan DeCrosta

5

5 **Design Firm:** Sherman Advertising Associates, New York, NY **Client:** S. L. Green **Project:** 90 Broad Brochure **Art Director:** Sharon Elaine Lloyd **Designer:** Sharon Elaine Lloyd

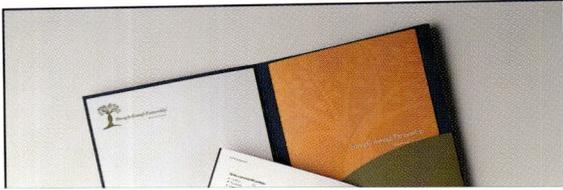

1

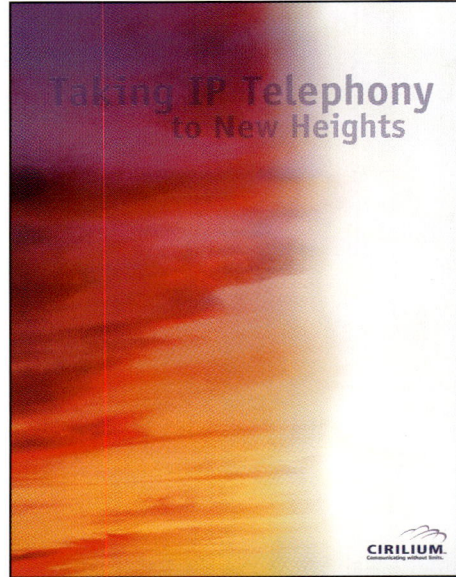

2

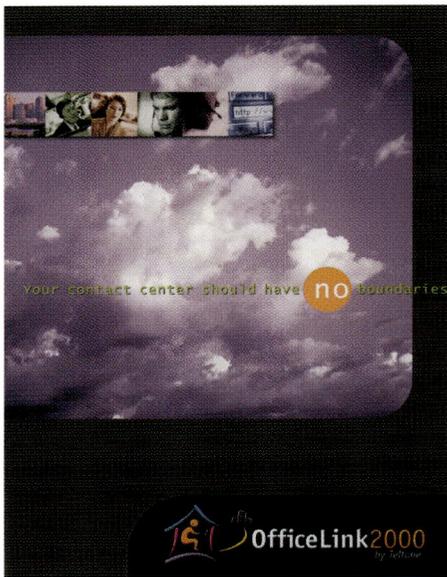

3

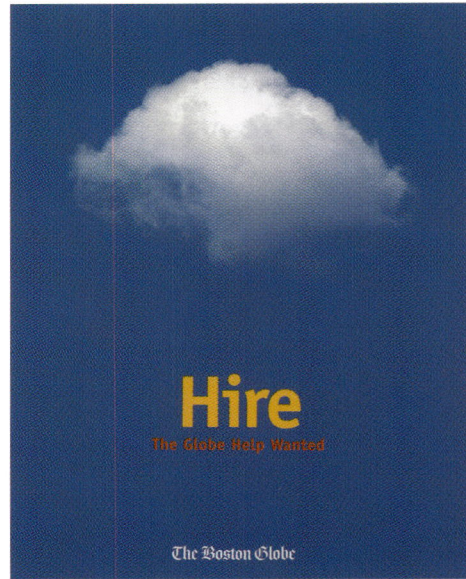

4

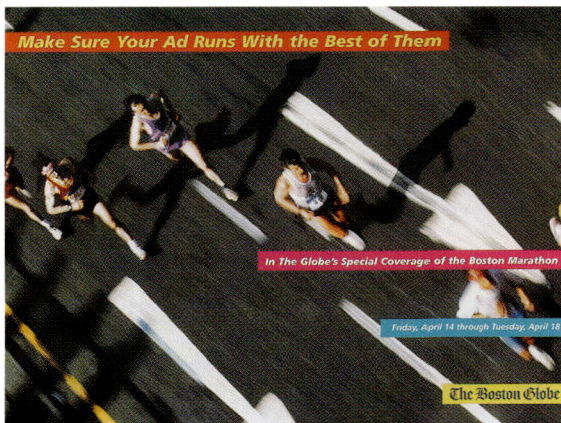

5

1 **Design Firm:** Sherman Advertising Associates, New York, NY **Client:** The Brodsky Organization **Project:** Two Columbus Avenue Brochure **Art Director:** Sharon Elaine Lloyd **Designer:** Sharon Elaine Lloyd **Photographer:** Bill Taylor

2 **Design Firm:** Spark Design, Tempe, AZ **Client:** Cirilium **Project:** Corporate Pocketfolder **Art Director:** Rik Boberg **Designer:** Rik Boberg

3 **Design Firm:** Teltone Corp., Bothell, WA **Project:** OfficeLink 2000 **Art Director:** John Kutz **Designer:** John Kutz **Illustrator:** John Kutz

4 **Design Firm:** The Boston Globe, Boston, MA **Project:** Globe Hire Brochure **Art Director:** Steve Pena, Lisa Sullo **Designer:** Don Norton

5 **Design Firm:** The Boston Globe, Boston, MA **Project:** Boston Marathon Post Card **Art Director:** Steve Pena **Designer:** Mike Togo

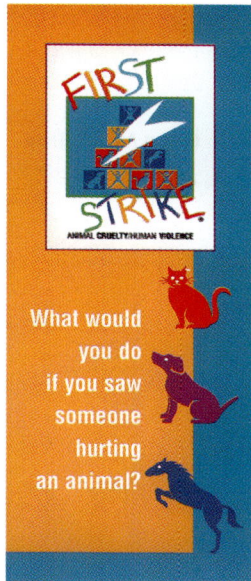

1

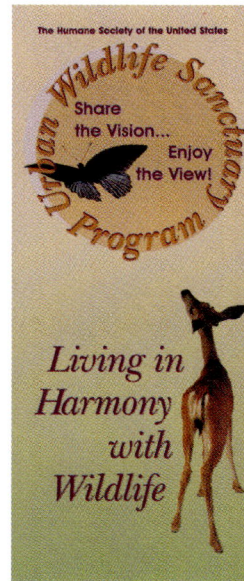

2

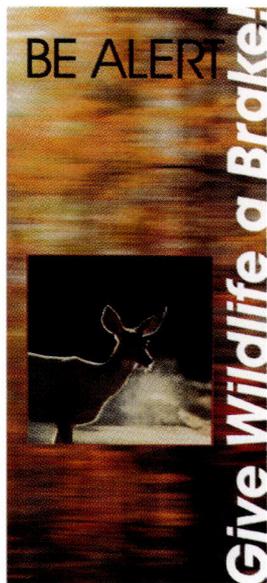

3

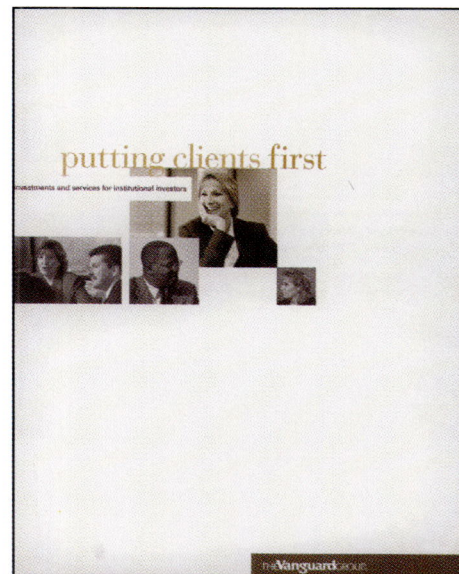

4

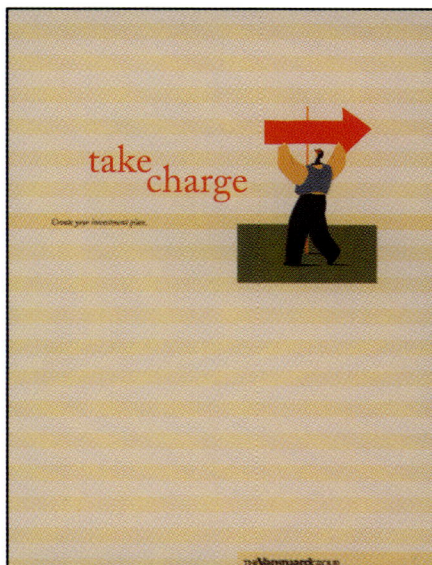

5

1 **Design Firm:** The Humane Society of the United States, Gaithersburg, MD **Project:** First Strike/Kids **Art Director:** Paula Jaworski **Designer:** Diane Johnson

2 **Design Firm:** The Humane Society of the United States, Gaithersburg, MD **Project:** Living in Harmony with Wildlife **Art Director:** Paula Jaworski **Designer:** Diane Johnson

3 **Design Firm:** The Humane Society of the United States, Gaithersburg, MD **Project:** Give Wildlife A Brake! **Art Director:** Paula Jaworski **Designer:** Diane Johnson

4 **Design Firm:** The Vanguard Group, Malvern, PA **Project:** Institutional Investor Capabilities Brochure **Art Director:** Stephen Shackleford **Designer:** Rachel McGuckin **Photographer:** Noah Greenberg

5 **Design Firm:** The Vanguard Group, Malvern, PA **Project:** Take Charge Kit **Art Director:** Stephen Shackleford **Designer:** Vivian Ghazarian **Illustrator:** Craig Frazier

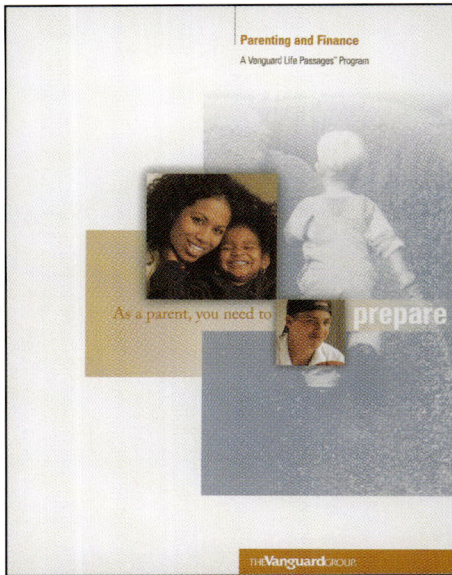

1

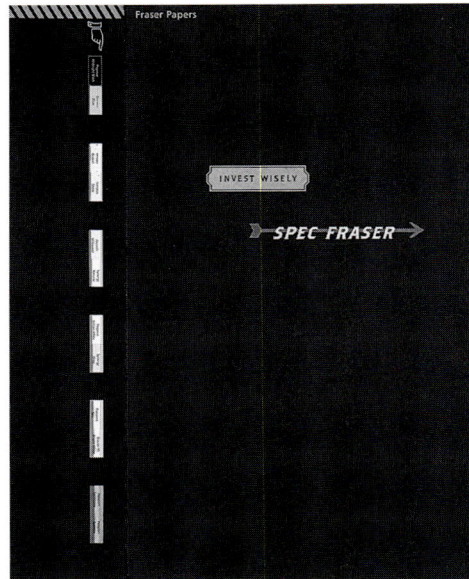

2

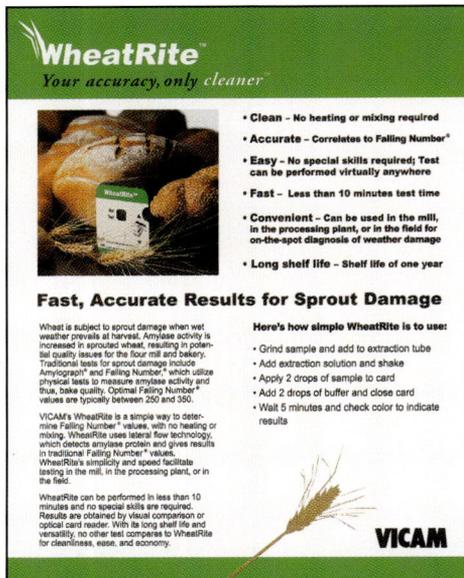

3

4

5

1 **Design Firm:** The Vanguard Group, Malvern, PA **Project:** Life Passages: Parenting and Finances **Art Director:** Stephen Shackleford **Designer:** Rachel McGuckin

2 **Design Firm:** VIA, New York, NY **Client:** Fraser Papers Inc. **Project:** Invest Wisely **Art Director:** Johan Vipper **Designer:** Ruth Diener **Photographer:** Julie Powell, Timothy Greenfield-Sanders, Neal Barr **Illustrator:** Tom Christopher, Elvis Swift, Stuart Patterson

3 **Design Firm:** VICAM, Watertown, MA **Project:** WheatRite Data Sheet **Art Director:** Jennifer A. Smith **Designer:** Amanda Cremona **Photographer:** Christian Delbert Photography **Illustrator:** Amanda Cremona

4 **Design Firm:** Visual Marketing Associates, Inc., Dayton, OH **Client:** Columbus Zoo **Project:** The Zoo Fund **Art Director:** Kenneth Botts, Tom Davie **Designer:** Tom Davie **Illustrator:** Tom Davie

5 **Design Firm:** Warkulwiz Design Associates, Philadelphia, PA **Client:** Dak Associates, Inc. **Project:** Select Client Commitment Kit **Art Director:** Robert J. Warkulwiz **Designer:** Kirsten Engstrom

1

2

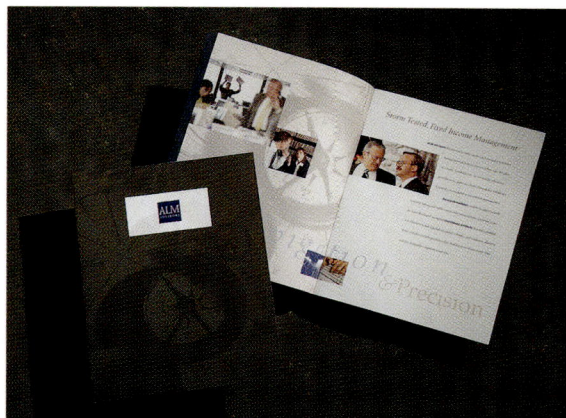

3

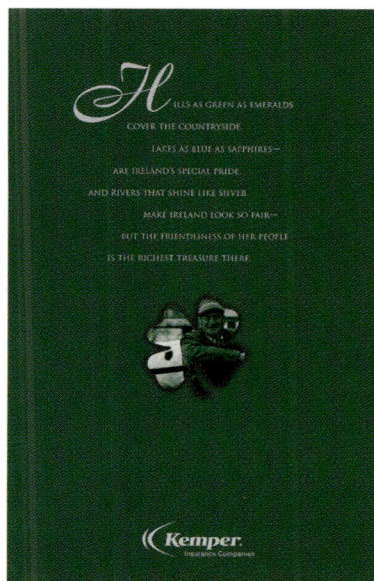

4

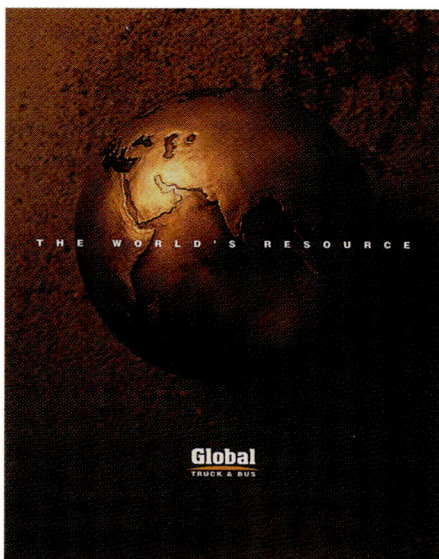

5

1 **Design Firm:** Williams & Stevens, Inc., Seven Hills, OH **Client:** Employers Resource Council **Project:** Brochures/Collateral Material for Annual Conference **Art Director:** Christine Rasey Stevens **Designer:** Christine Rasey Stevens

2 **Design Firm:** Xerox Corporation, Wilsonville, OR **Client:** Tektronix, Inc. **Project:** Color Solutions **Art Director:** Ami Danielson **Designer:** Ami Danielson **Photographer:** Marcus Swanson **Copywriter:** Erin Codazzi

3 **Design Firm:** Zamboo, Marina Del Rey, CA **Client:** ALM Advisors **Project:** Capabilities Brochure **Designer:** Becca Bootes

4 **Design Firm:** ZGraphics, Ltd., East Dundee, IL **Client:** Kemper Insurance **Project:** Mark of Excellence Brochure **Art Director:** Joe Zeller **Designer:** Renee Clark

5 **Design Firm:** ZGraphics, Ltd., East Dundee, IL **Client:** Global Truck & Bus Sales, Ltd. **Project:** Product Brochure **Art Director:** Joe Zeller **Designer:** Mike Girard

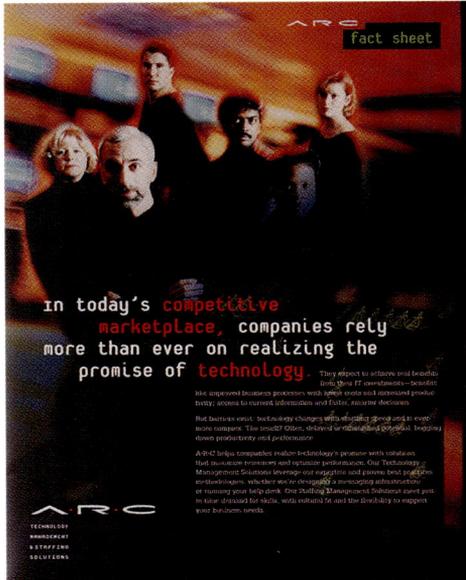

1

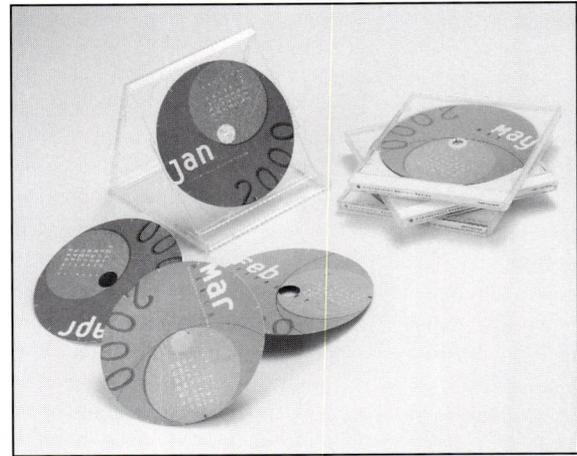

2

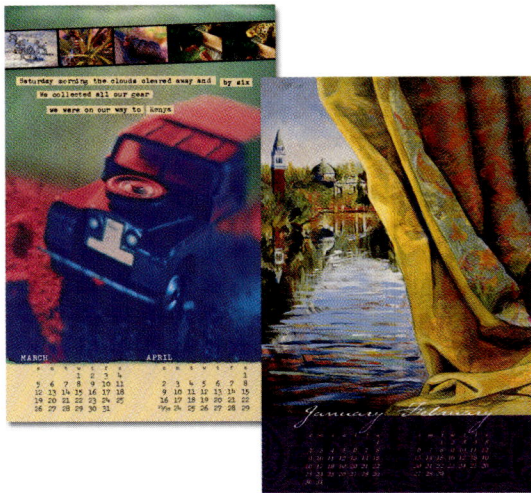

3

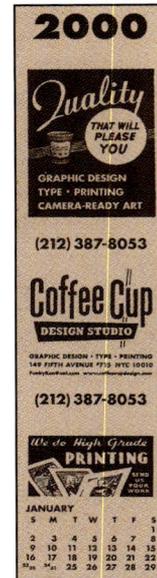

4

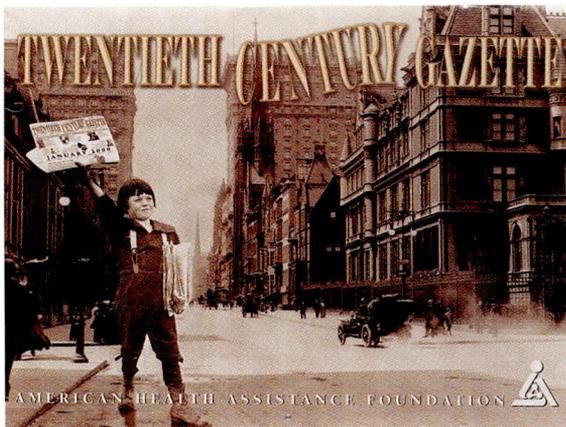

5

1 **Design Firm:** ZGraphics, Ltd., East Dundee, IL **Client:** ARC **Project:** U.S. Fact Sheet **Art Director:** Joe Zeller **Designer:** Renee Clark

Calendars

2 **Design Firm:** Arrowstreet Graphic Design, Somerville, MA **Project:** Calendar **Art Director:** Bob Lowe **Designer:** Dave Cajolet

3 **Design Firm:** Brown Design & Company, Portland, ME **Project:** Y2000 Brown Design & Co. Calendar **Designer:** Mary Brown **Photographer:** Hugh Brantner, Shoshannah White, Mary Brown **Illustrator:** Pat Corrigan, Melissa Sweet, Anne Pondyk

4 **Design Firm:** Coffee Cup Design Studio, New York, NY **Project:** Calendar **Designer:** Kenneth Funk

5 **Design Firm:** Concord Litho Group, Concord, NH **Client:** American Health Assistance Foundation **Project:** Calendar **Art Director:** Deborah Rivero **Designer:** Deborah Rivero

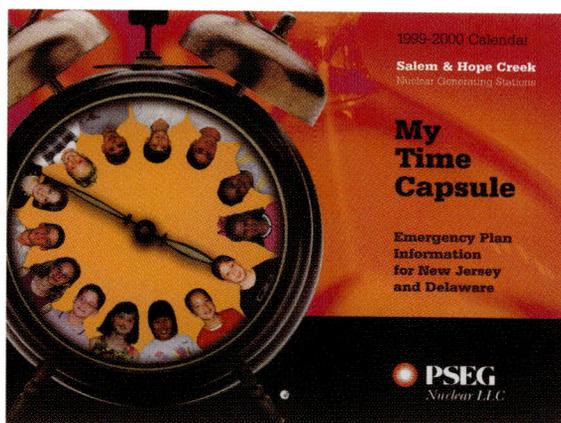

1

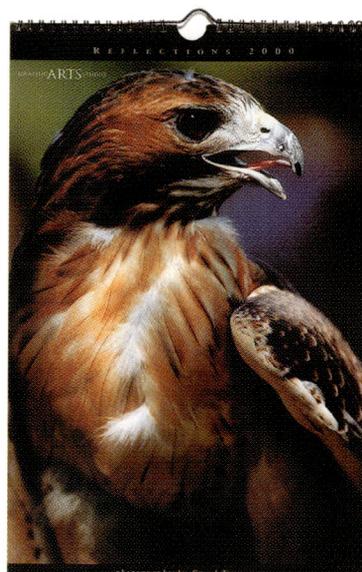

2

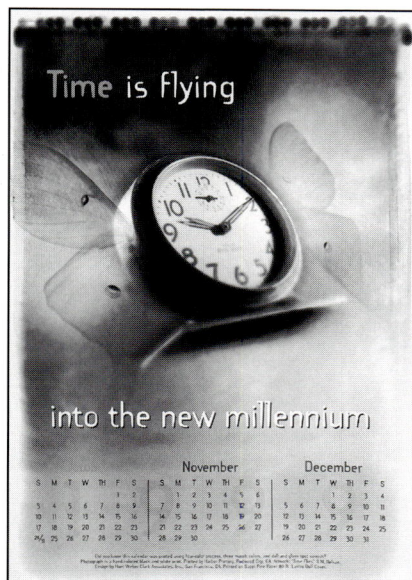

Time is flying

into the new millennium

November December

3

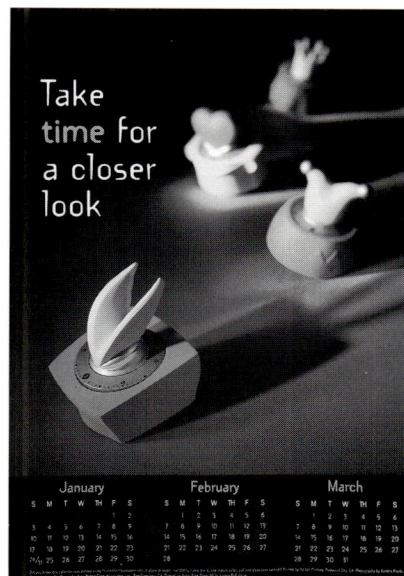

Take time for a closer look

January February March

4

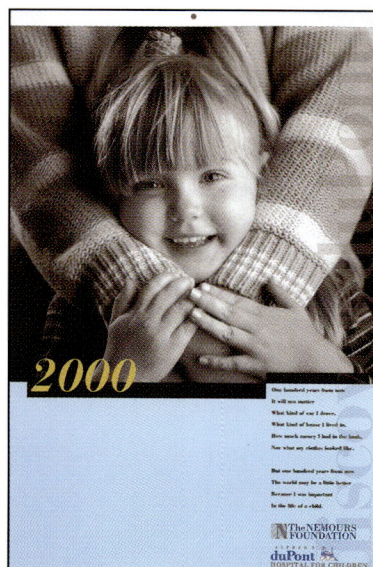

5

1 **Design Firm:** Design Source East, Cranford, NJ **Client:** PSEG Nuclear LLC **Project:** Calendar **Art Director:** Mark Lo Bello **Designer:** Mark Lo Bello **Illustrator:** Area Elementary School Students

2 **Design Firm:** Freeman Design Ltd., Evanston, IL **Client:** Carol Freeman Photography **Project:** Reflections 2000 Calendar **Art Director:** Carol Freeman **Designer:** Carol Freeman **Photographer:** Carol Freeman

3 **Design Firm:** Hunt Weber Clark Associates, Inc., San Francisco, CA **Client:** Harbor Printing **Project:** Fourth Quarter Calendar **Art Director:** Nancy Hunt-Weber **Designer:** Christine Chung **Photographer:** Geoffrey Nelson, Sandra Frank

4 **Design Firm:** Hunt Weber Clark Associates, Inc., San Francisco, CA **Client:** Harbor Printing **Project:** First Quarter Calendar **Art Director:** Nancy Hunt-Weber **Designer:** Leigh Krichbaum **Photographer:** Geoffrey Nelson, Sandra Frank

5 **Design Firm:** Malish & Pagonis, Philadelphia, PA **Client:** Alfred I. DuPont Hospital for Children **Project:** Calendar **Designer:** Penelope Malish **Photographer:** Peter Olson

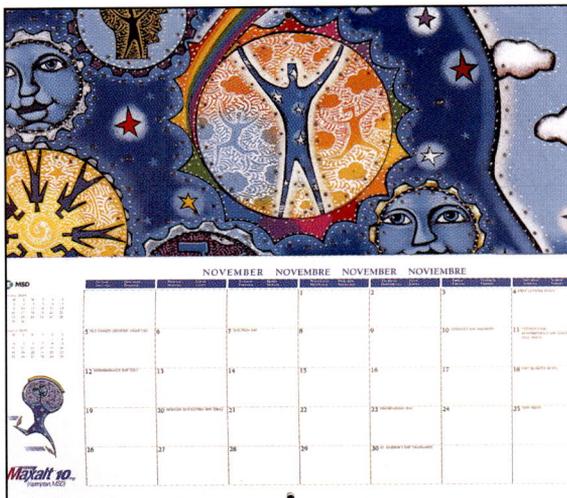

1

2

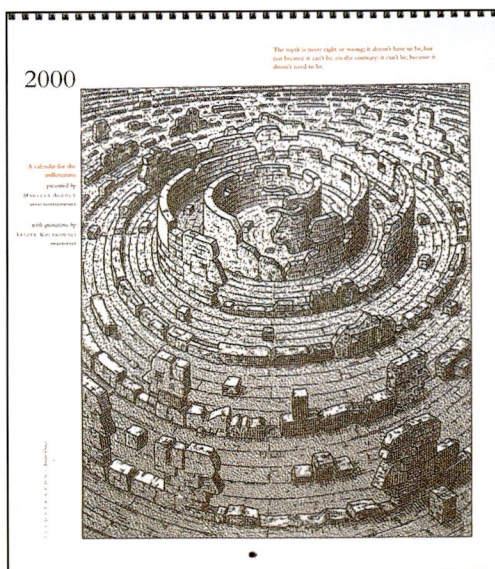

3

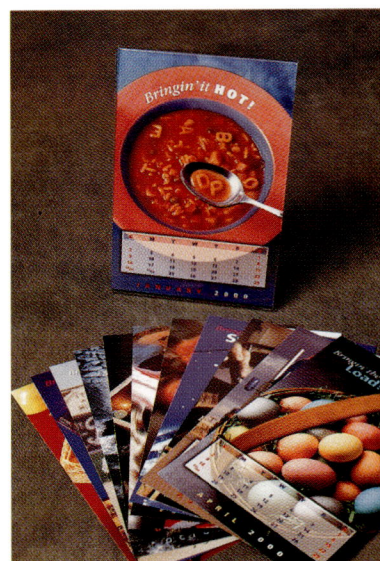

4

1 **Design Firm:** Merck & Co, Inc., Whitehouse Station, NJ **Client:** Maxalt Product Group **Project:** Calendar **Designer:** Jane Harvey-Gibbs **Illustrator:** Joel Nakamura

2 **Design Firm:** O&J Design, Inc., New York, NY **Project:** Calendar **Art Director:** Andrzej Olejniczak **Designer:** Lia Camara-Mariscal

3 **Design Firm:** Olver Dunlop Associates, Chicago, IL **Client:** Marlena Agency **Project:** A Calendar for the Millennium **Art Director:** Patricia Kowalczyk **Designer:** Patricia Kowalczyk

4 **Design Firm:** Page Design, Inc., Sacramento, CA **Client:** Devine & Peters Intermodal **Project:** Calendar **Art Director:** Kimberly Bickel, Paul Page, Dick Coyle **Designer:** Kimberly Bickel **Photographer:** Gordon Lazzarone **Illustrator:** Kurt Kland

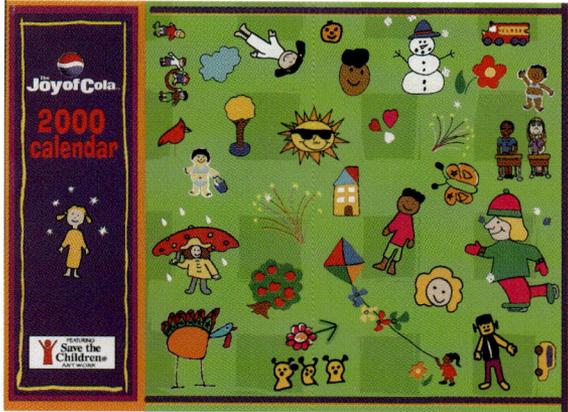

1

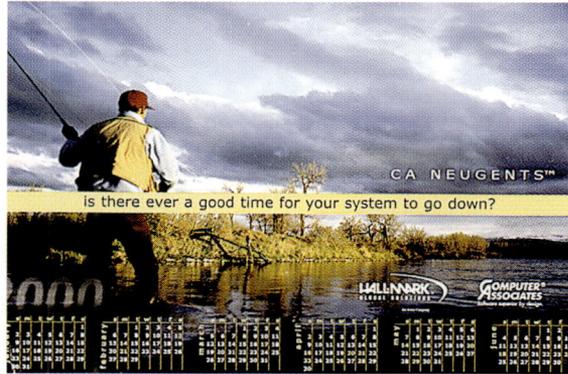

2

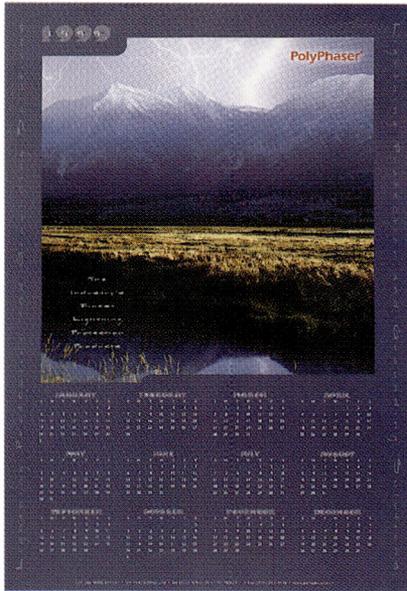

3

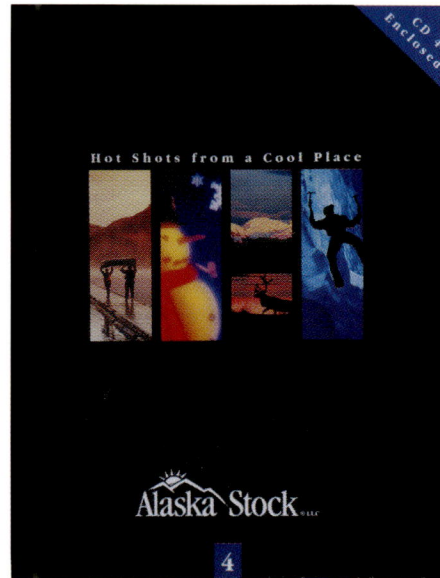

4

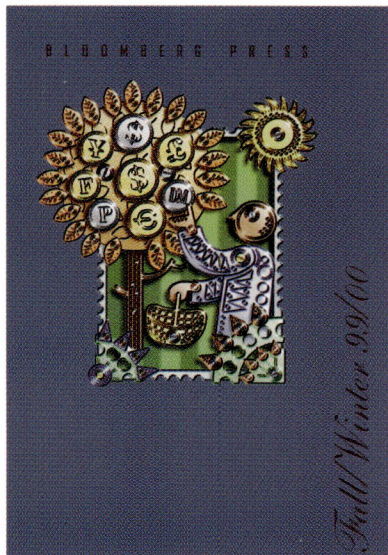

5

1 **Design Firm:** Pepsi-Cola Company, Purchase, NY **Project:** Joy of Cola 2000 Calendar **Art Director:** Adriana Colombo **Designer:** Adriana Colombo **Illustrator:** Save the Children Art

2 **Design Firm:** Spark Design, Tempe, AZ **Client:** Hall-Mark Global Solutions **Project:** Avnet Computer Marketing CA Neugents Calendar **Art Director:** Joe Gunsten **Designer:** Joe Gunsten

3 **Design Firm:** Studio G, Reno, NV **Client:** Poly Phaser **Project:** Calendar **Designer:** Susie Dolak-Cook **Photographer:** Jeff Ross **Photo Manipulation:** Fred Gregovich

Catalogs

4 **Design Firm:** Alaska Stock, Anchorage, AK **Project:** Catalog 4 **Designer:** Trish Rolfe **Photographer:** Alaska Stock

5 **Design Firm:** Bloomberg, Princeton, NJ **Client:** Bloomberg Press **Project:** Catalog Fall/Winter 99/00 **Art Director:** Sandy O'Connor **Designer:** Lorraine Kuldanek

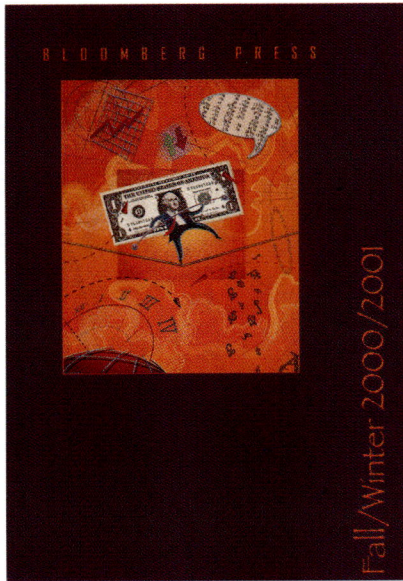

1

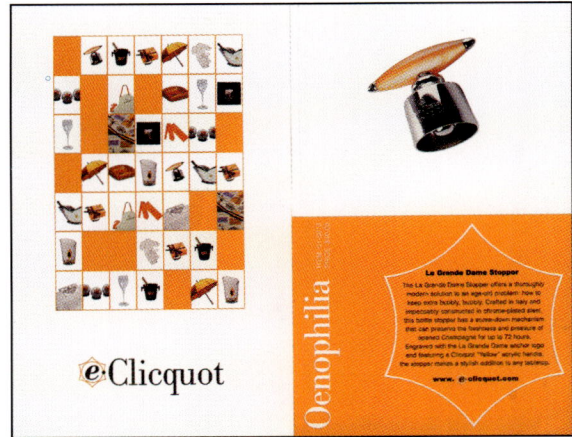

2

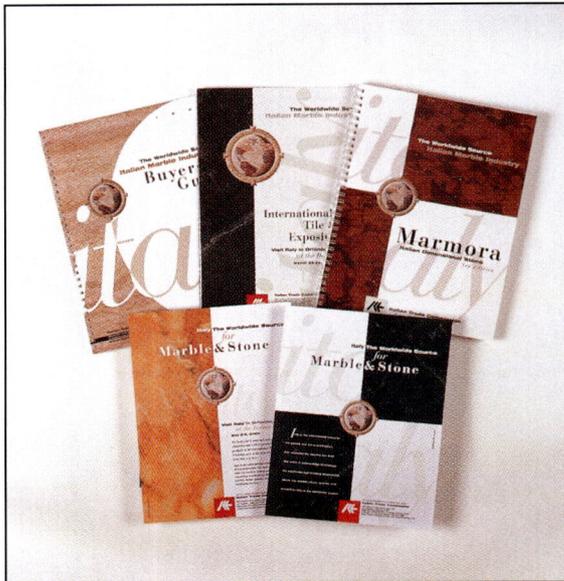

3

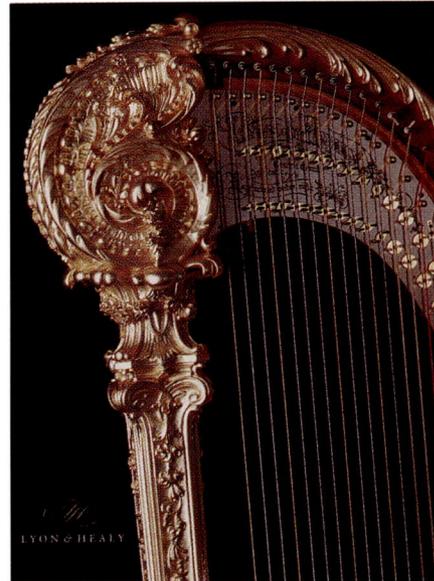

4

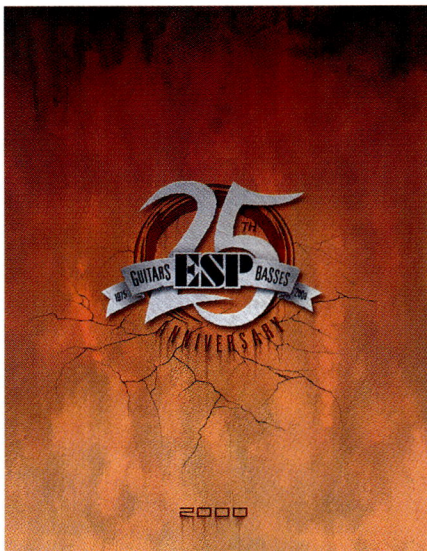

5

1 **Design Firm:** Bloomberg, Princeton, NJ **Client:** Bloomberg Press **Project:** Catalog Fall/Winter 2000/2001 **Art Director:** Sandy O'Connor **Designer:** Lorraine Kuldanek

2 **Design Firm:** Clicquot, Inc., New York, NY **Client:** Champagne Veuve Clicquot **Project:** e-Clicquot Catalog **Art Director:** Danielle DeVoe **Designer:** Richard Smith, Brandon Connors

3 **Design Firm:** Ezzona Design Group, Inc., Burbank, CA **Client:** Italian Trade Commission **Project:** Marble and Stone Campaign **Art Director:** Gina Vivona **Designer:** Jim Pezzullo

4 **Design Firm:** Faust Associates, Chicago, IL **Client:** Lyon & Healy **Project:** Lyon & Healy Pedal Harp Catalog **Art Director:** Bob Faust **Designer:** Bob Faust **Photographer:** Jay Rubinic **Copywriter:** Sally Faust

5 **Design Firm:** Gateway Arts, Thousand Oaks, CA **Client:** ESP Guitars **Project:** 25th Anniversary ESP Guitar Catalog **Art Director:** Dave Carlson **Designer:** Dave Ruhr **Photographer:** Jeff Edelstein **Illustrator:** Dave Ruhr

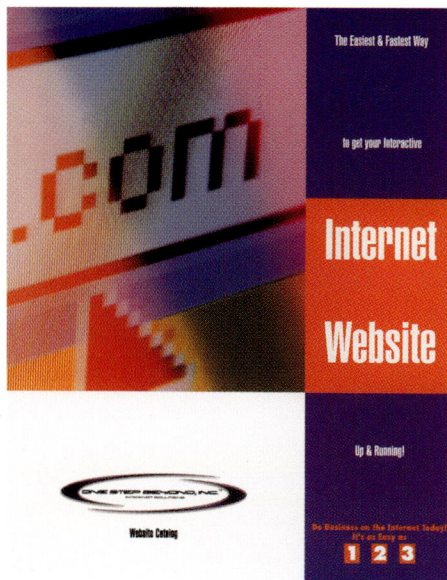

1

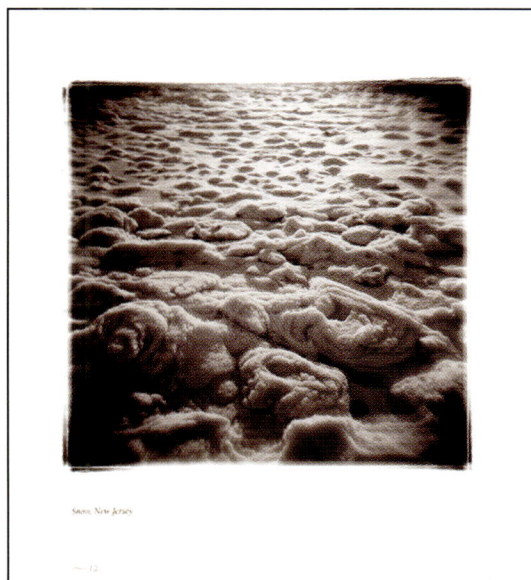

2

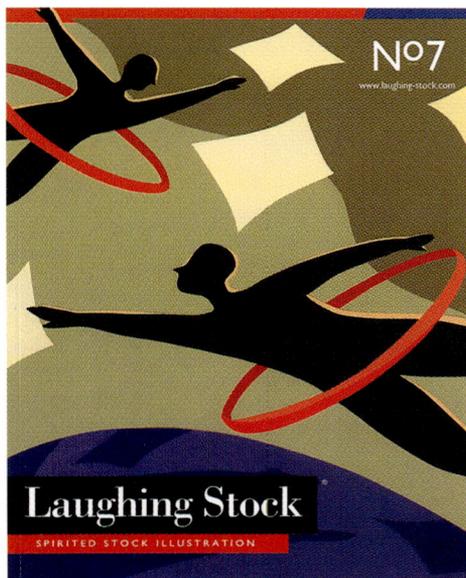

3

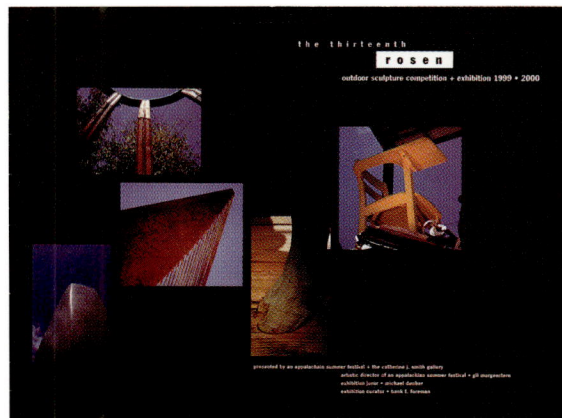

4

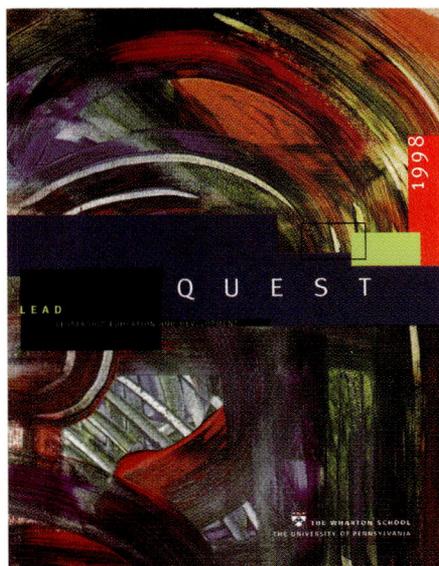

5

1 **Design Firm:** Genghis Design, Lakewood, CO **Client:** One Step Beyond **Project:** Catalog **Art Director:** Dale Monahan **Designer:** Dale Monahan

2 **Design Firm:** Kramer & Larkin, Philadelphia, PA **Client:** Sandy Sorlien **Project:** Sandy Sorlien:Imagining Antarctica **Art Director:** Deborah Larkin **Designer:** Deborah Larkin **Photographer:** Sandy Sorlien

3 **Design Firm:** Laughing Stock, South Newfane, VT **Project:** Catalog No. 7 **Art Director:** Carol Ross **Designer:** Carol Ross **Illustrator:** Linda Fountain

4 **Design Firm:** Michael Fanizza Designs, Haslett, MI **Client:** Catherine J. Smith Gallery Appalachian State University **Project:** Thirteenth Rosen Exhibition Catalog **Art Director:** Michael Fanizza **Designer:** Michael Fanizza **Photographer:** Troy Tuttle

5 **Design Firm:** Mikaelian Design, Philadelphia, PA **Client:** The University of Pennsylvania Wharton School of Business **Project:** 1998 LEAD Book **Art Director:** Jodee Winger **Designer:** Allan Espiritu **Photographer:** Archieve

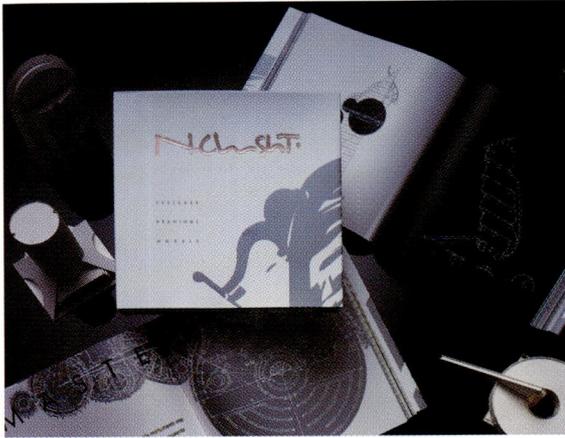

1

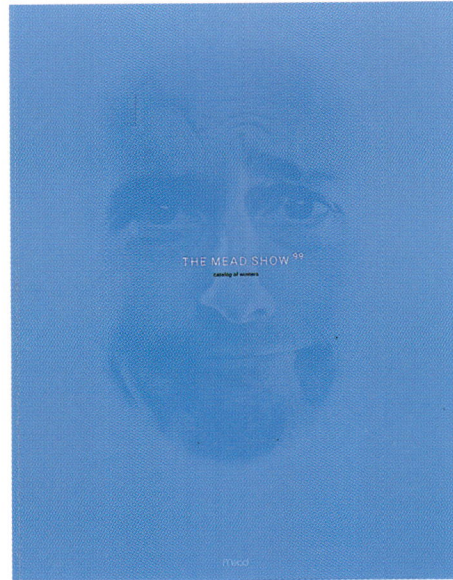

2

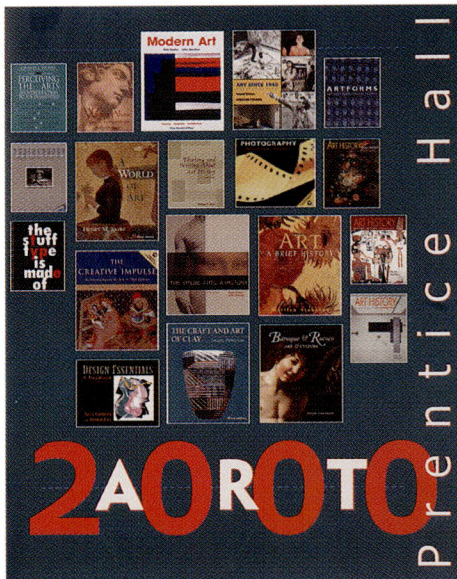

3

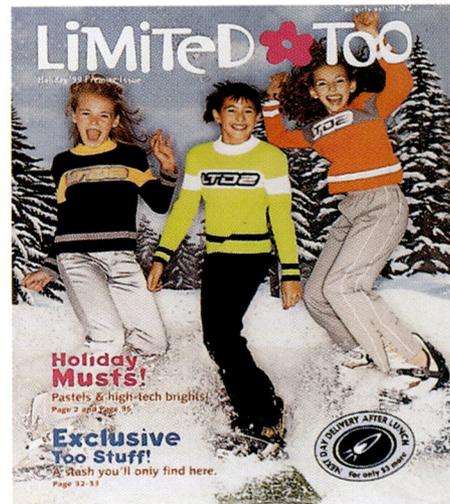

4

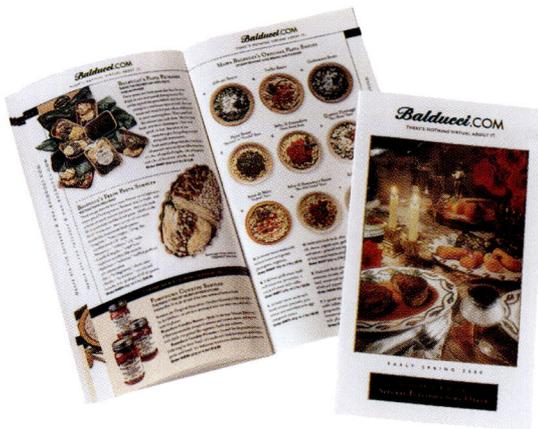

5

1 **Design Firm:** Nicholson Design, Carlsbad, CA **Client:** Charles Slert Associates **Project:** Slert Catalog **Art Director:** Charles Slert, Joe C. Nicholson **Designer:** Joe C. Nicholson **Photographer:** Campos, Slert, Rand **Illustrator:** Joe C. Nicholson

2 **Design Firm:** Petrick Design, Chicago, IL **Client:** Mead Paper Company **Project:** The Mead Show 99 **Art Director:** Robert Petrick **Designer:** Tracy West **Photographer:** Ron Wu, Alec Huff

3 **Design Firm:** Prentice Hall, Upper Saddle River, NJ **Client:** Sheryl Adams, Marketing **Project:** Art 2000 **Art Director:** Robert Farrar-Wagner **Designer:** Robert Farrar-Wagner

4 **Design Firm:** Quad Creative, LLC, Milwaukee, WI **Client:** Limited Too **Project:** Catalog **Art Director:** Tom Campbell **Designer:** Andy Ray, Laura Ray, Brooke Luteyn, Sue Fuentes **Photographer:** John McArthur Photography, Lauren Krysti Photography, Quad/Photo **Copywriter:** Sarah Evans

5 **Design Firm:** Quad Creative, LLC, Milwaukee, WI **Client:** Balducci's **Project:** Balducci's.com Slim Jim **Art Director:** Tom Campbell **Designer:** Andy Ray

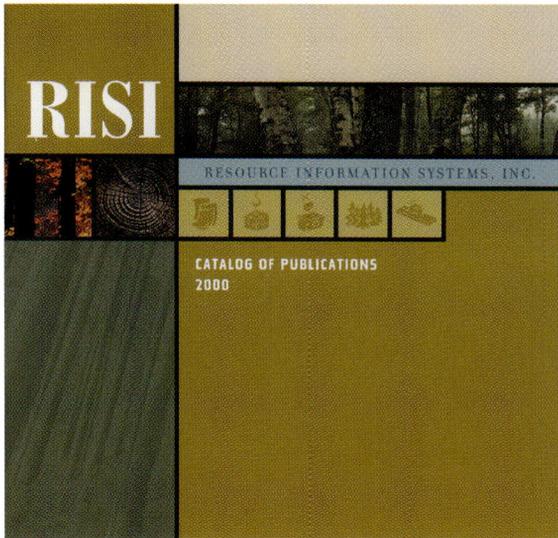

1

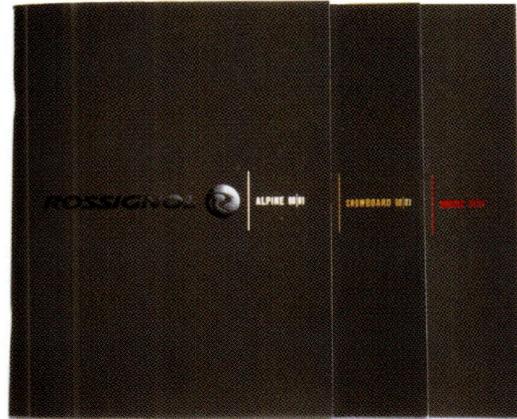

2

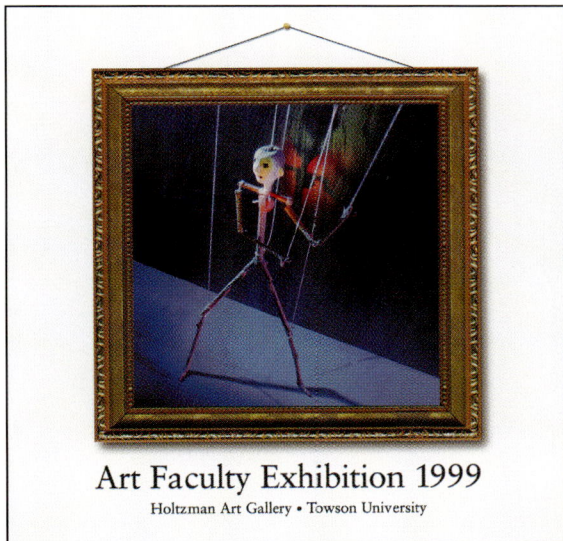

Art Faculty Exhibition 1999
Holtzman Art Gallery • Towson University

3

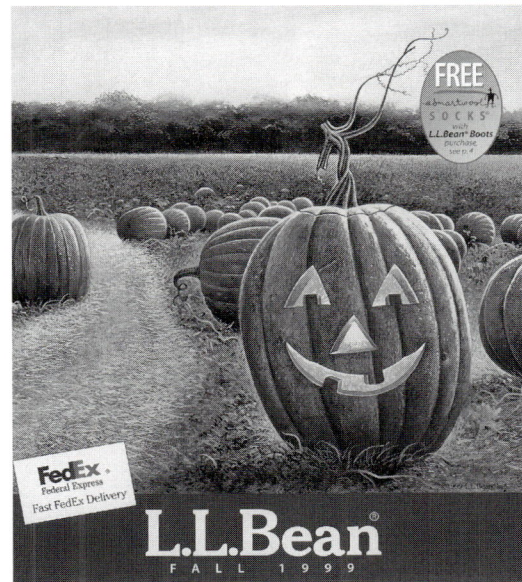

L.L.Bean®
FALL 1999

4

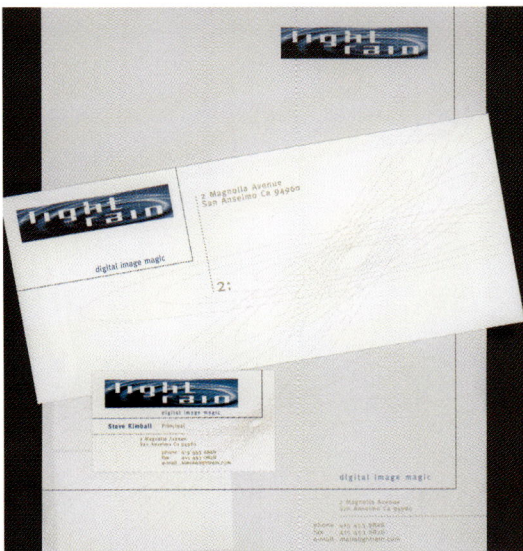

5

1 **Design Firm:** Raincastle Communications, Newtown, MA **Client:** Risi **Project:** Catalog **Art Director:** Paul Regensburg **Designer:** Jeff Deutsch

2 **Design Firm:** Rossignol, Williston, VT **Client:** Rossignol USA **Project:** 2000-2001 Product Catalog **Art Director:** Paula Lukey **Designer:** Paula Lukey

3 **Design Firm:** Towson University, Towson, MD **Client:** Holtzman Art Gallery **Project:** Art Faculty Exhibition Catalog **Art Director:** Christopher Bartlett **Designer:** Kathy Malanowski **Illustrator:** Kathy Malanowski

4 **Design Firm:** Wendell Minor Design, Washington, CT **Client:** L.L. Bean **Project:** Fall Catalog Cover **Art Director:** Kate Geskos **Illustrator:** Wendell Minor

Corporate Identity

5 **Design Firm:** be•design, San Rafael, CA **Client:** Light Rain **Project:** Corporate Identity Program **Art Director:** Will Burke **Designer:** Eric Read, Coralie Russo

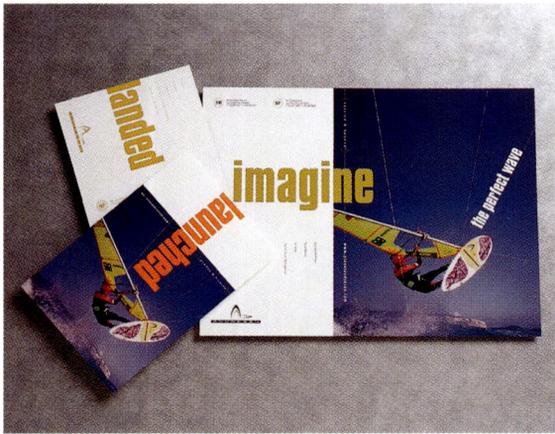

1

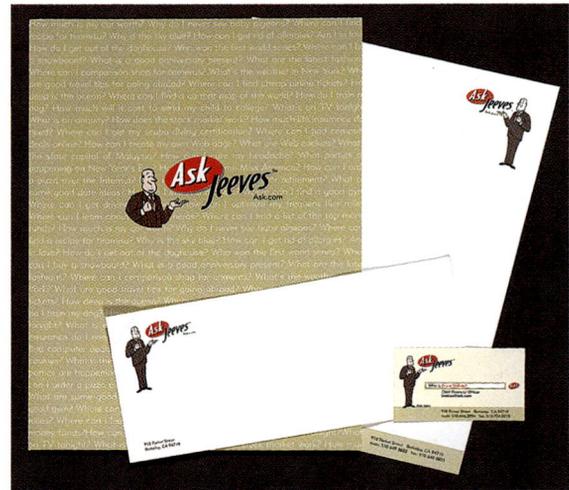

2

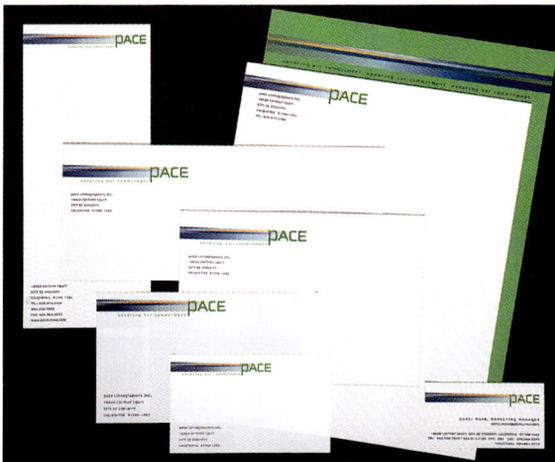

3

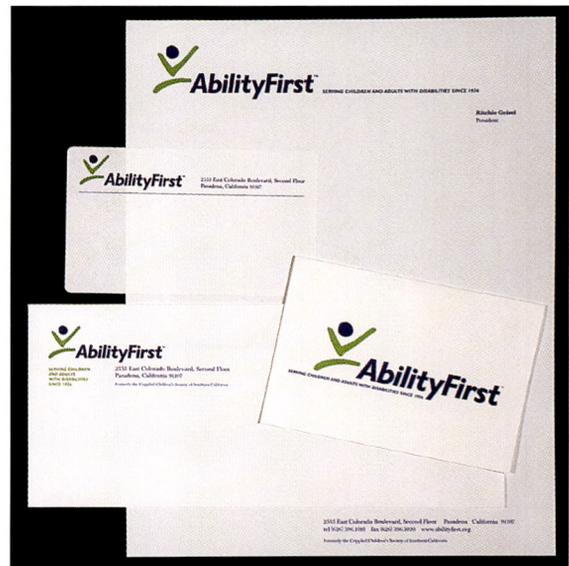

4

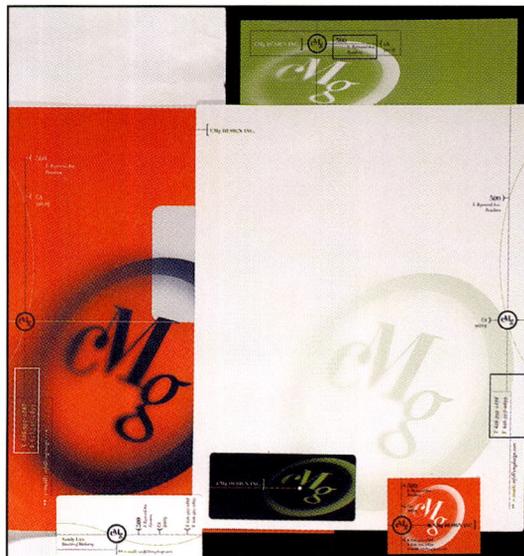

5

1 **Design Firm:** be•design, San Rafael, CA **Client:** Andresen **Project:** Corporate Identity Program **Art Director:** Will Burke **Designer:** Eric Read, Coralie Russo, Yusuke Asaka

2 **Design Firm:** BGDI, Berkeley, CA **Client:** Ask Jeeves **Project:** Identity **Art Director:** Steven Donaldson **Designer:** Jimmy Yeung

3 **Design Firm:** CMg Design Inc., Pasadena, CA **Client:** Pace Lithographers Inc. **Project:** Corporate Identity **Art Director:** Julie Markfield, Greg Crawford **Designer:** Julie Markfield, Greg Crawford

4 **Design Firm:** CMg Design Inc., Pasadena, CA **Client:** Ability First **Project:** Corporate Identity **Art Director:** Julie Markfield, Greg Crawford **Designer:** Mary Catherine Walp, Julie Markfield **Illustrator:** Mary Catherine Walp

5 **Design Firm:** CMg Design Inc., Pasadena, CA **Project:** Corporate Identity **Art Director:** Melissa Sunjaya, Julie Markfield, Greg Crawford **Designer:** Melissa Sunjaya **Illustrator:** Melissa Sunjaya

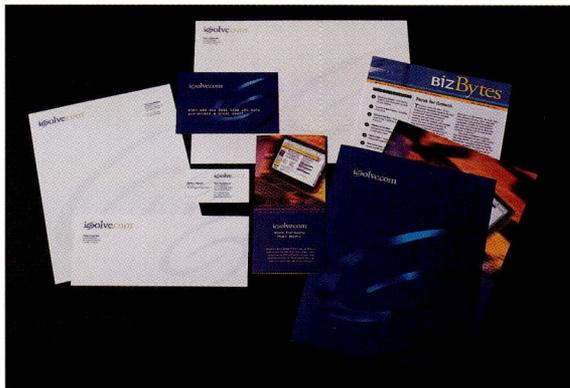

1

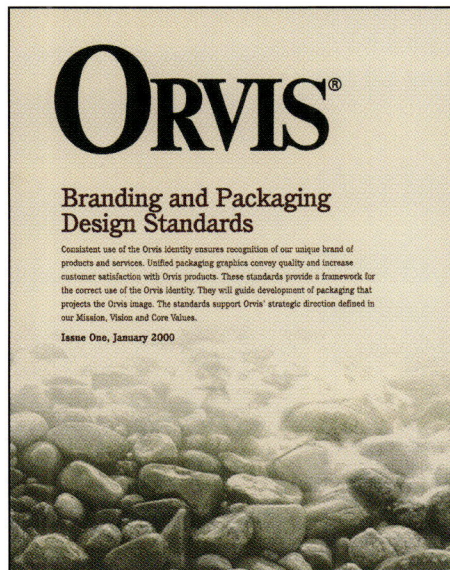

2

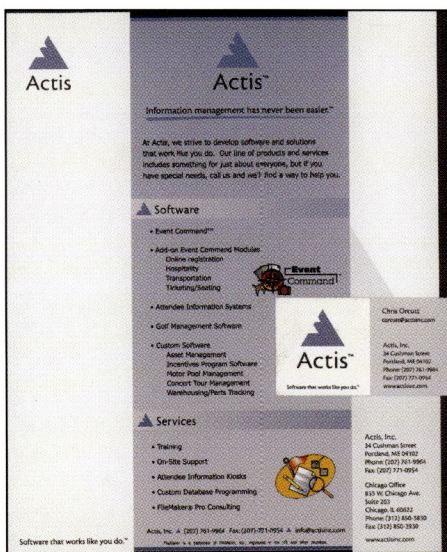

3

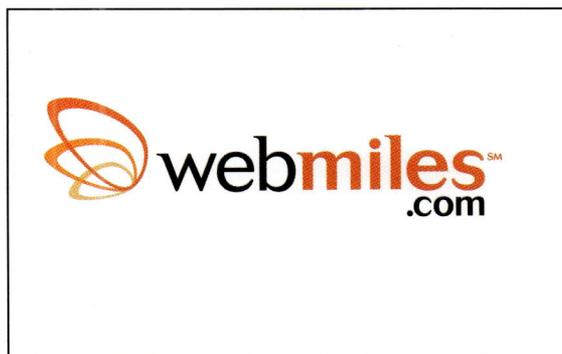

4

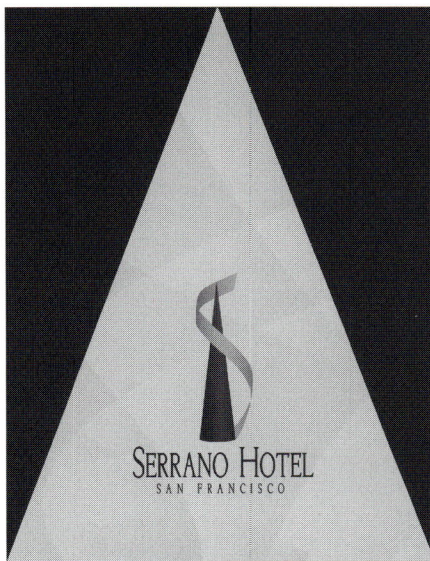

5

1 **Design Firm:** Creative Fusion Design Company, Stony Creek, CT **Client:** iSolve.com **Project:** Identity Program **Art Director:** Craig DesRobert, Chris Walsh **Designer:** Craig DesRobert, Chris Walsh

2 **Design Firm:** Donaldson Makoski Inc., Avon, CT **Client:** ORVIS **Project:** Branding And Packaging Design Standards **Art Director:** Chet Makoski **Designer:** Debby Ryan

3 **Design Firm:** Fusion Media, Inc., Fishkill, NY **Client:** Actis **Project:** Collateral Materials **Art Director:** Ben Wild **Designer:** Mark Foster **Illustrator:** Rich Gelchinsky

4 **Design Firm:** GMO/Hill Holliday, San Francisco, CA **Client:** Webmiles **Project:** Corporate Identity **Art Director:** Rick Atwood **Designer:** Noreen Doherty

5 **Design Firm:** Hunt Weber Clark Associates, Inc., San Francisco, CA **Client:** Kimpton Hotel & Restaurant Group **Project:** Serrano Hotel Press Kit **Art Director:** Nancy Hunt-Weber **Designer:** Leigh Krichbaum, Nancy Hunt-Weber

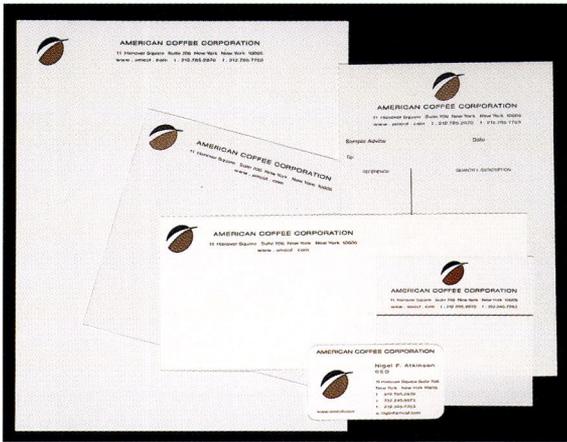

1

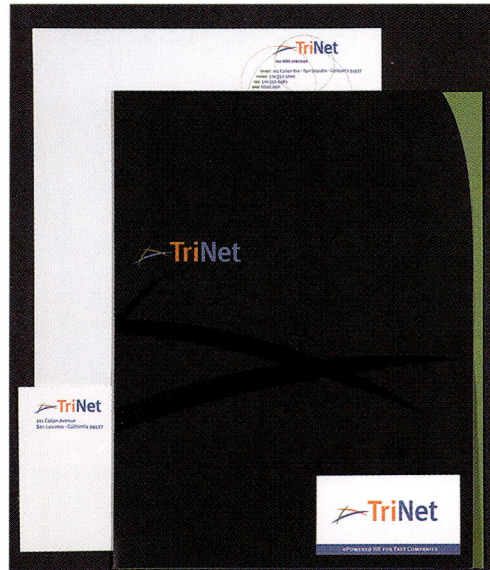

2

3

4

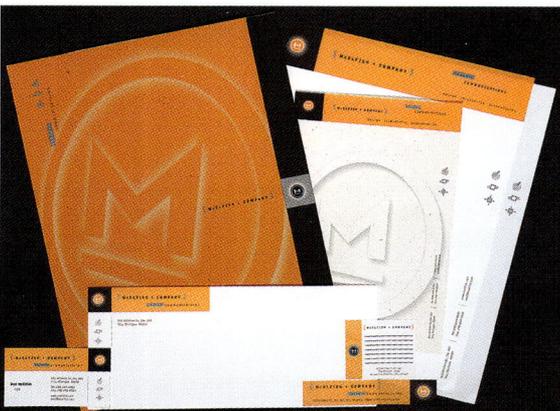

5

1 **Design Firm:** Inkdigital, New York, NY **Client:** American Coffee Corporation **Project:** Corporate Identity **Art Director:** Ramon Espinosa, Anthony Clarizio **Designer:** Ramon Espinosa, Anthony Clarizio

2 **Design Firm:** Kirshenbaum Communications, San Francisco, CA **Client:** TriNet **Project:** Identity & Business System with Folder **Art Director:** Susan Kirshenbaum **Designer:** Jim Neczypor

3 **Design Firm:** Les Cheneaux Design, Ypsilanti, MI **Client:** Noir Homes, Inc. **Project:** Corporate Identity Program **Designer:** Lori Young **Illustrator:** Lori Young

4 **Design Firm:** Malcolm Grear Designers, Providence, RI **Client:** FreemanWhite, Inc. **Project:** Identity **Designer:** Malcolm Grear Designers

5 **Design Firm:** McElfish & Company, Troy, MI **Project:** Corporate Identity **Art Director:** Paul Aiuto, Sara Reeside **Designer:** Paul Aiuto, Sara Reeside

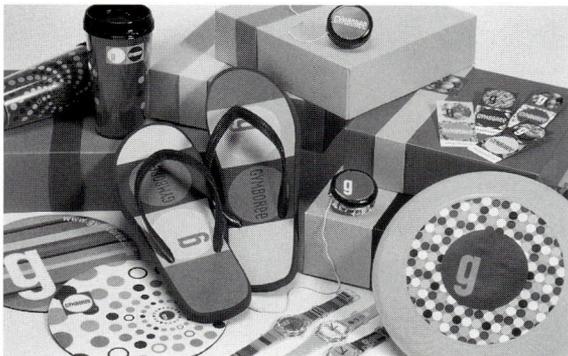

1

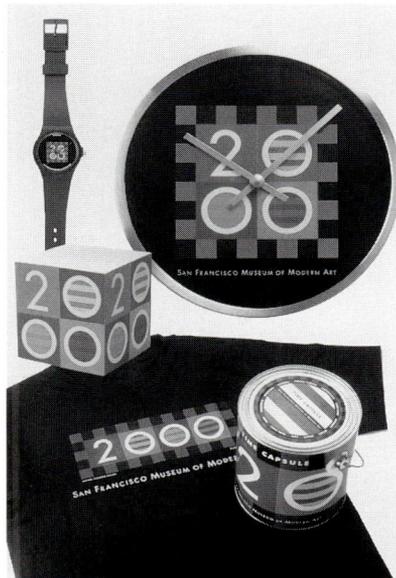

2

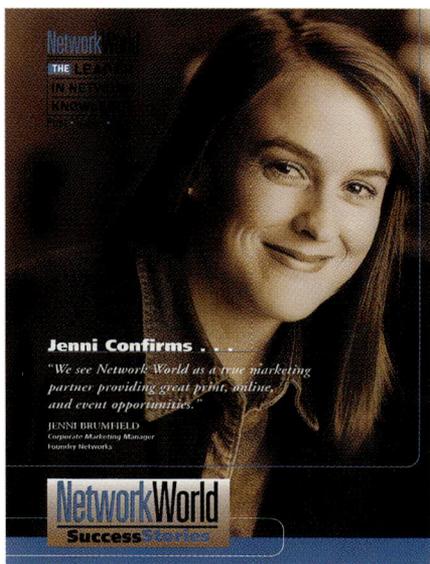

3

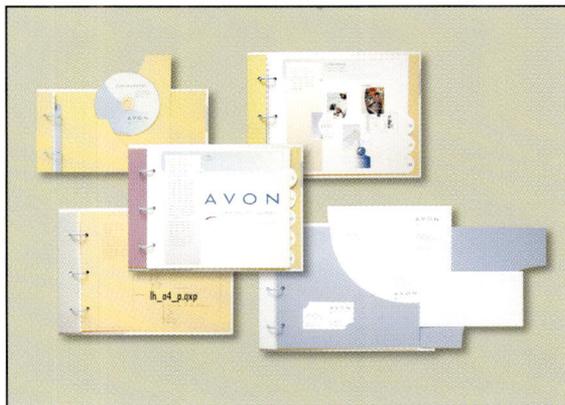

4

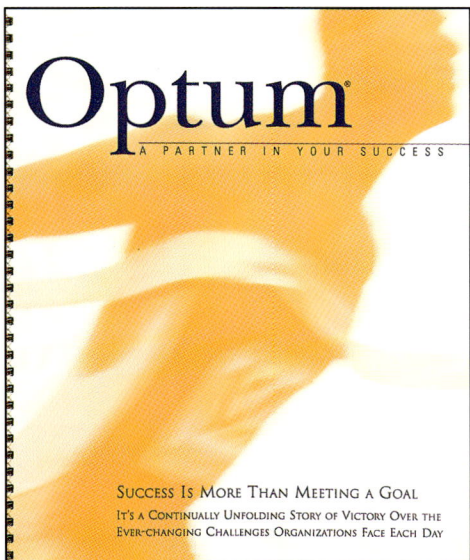

5

1 **Design Firm:** Michael Osborne Design, San Francisco, CA **Client:** Gymboree **Project:** Identity Program **Art Director:** Michael Osborne **Designer:** Paul Kagiwada

2 **Design Firm:** Michael Osborne Design, San Francisco, CA **Client:** SFMOMA Museum Store **Project:** Millennium Identity and Merchandising **Art Director:** Michael Osborne **Designer:** Michelle Regenbogen

3 **Design Firm:** Network World, Southborough, MA **Project:** Branding Ads and Datasheets **Art Director:** Steve Pascal

4 **Design Firm:** O&J Design, Inc., New York, NY **Client:** Avon Products Inc. **Project:** Graphic Standards Manual **Art Director:** Andrzej Olejniczak **Designer:** Lia Camara-Mariscal, Christina Mueller, Sasha Swetschinski

5 **Design Firm:** Optum Communications, McLean, VA **Project:** Corporate Identity **Art Director:** Miya Su Rowe **Designer:** Miya Su Rowe **Writer:** Sara F. Sonntag

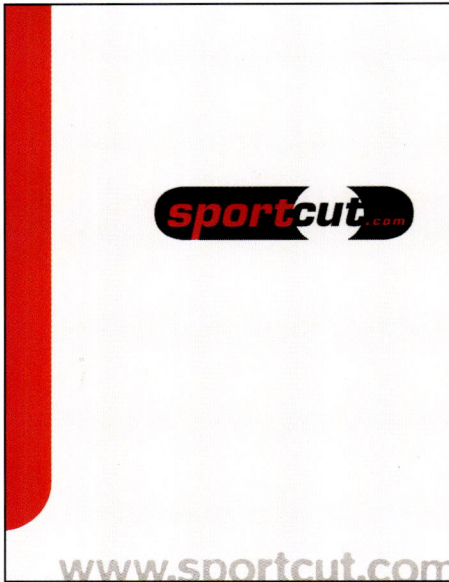

1

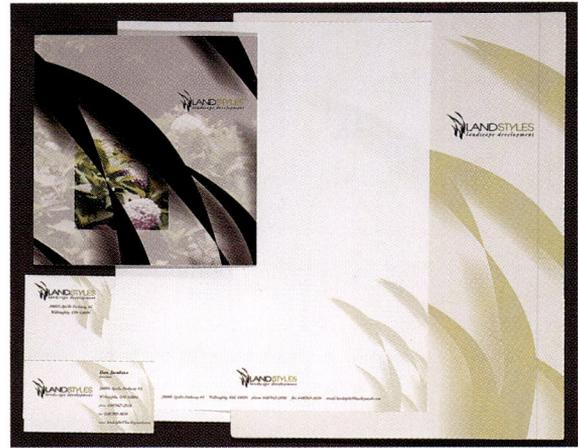

2

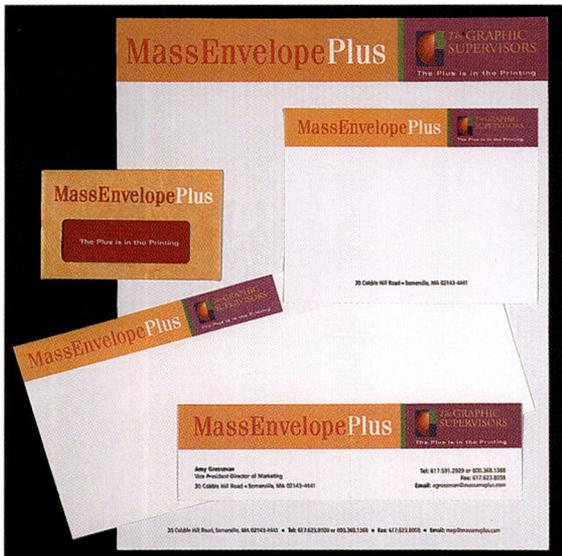

3

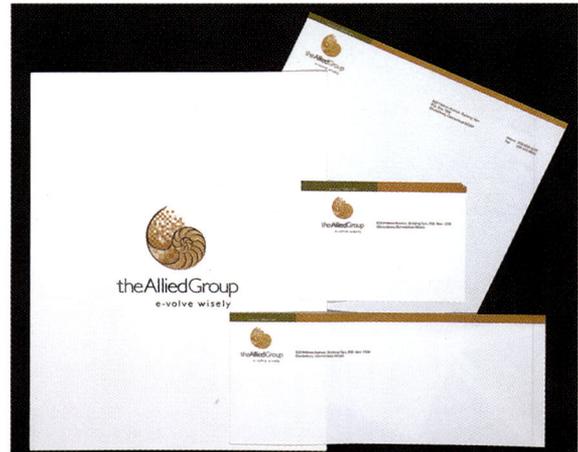

4

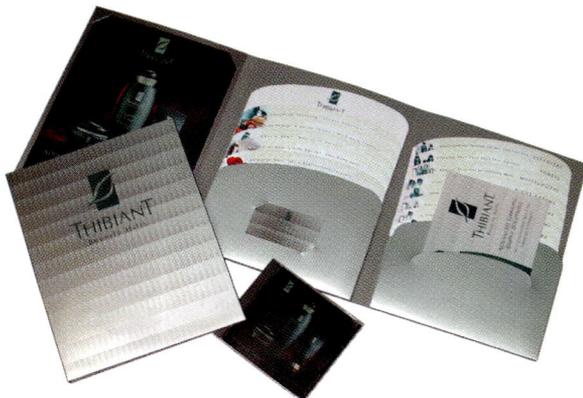

5

1 **Design Firm:** Rappy & Company, Inc., New York, NY **Client:** Bsquared Communications **Project:** Sportcut.com Corporate Identity **Art Director:** Floyd Rappy **Designer:** Floyd Rappy

2 **Design Firm:** SiD studios, Concord, OH **Client:** LandStyles **Project:** Corporate Identity Package **Art Director:** Bill Sintic **Designer:** Gina Bartlett

3 **Design Firm:** Sullivan Creative, Newton, MA **Client:** MassEnvelopePlus **Project:** Corporate Identity Materials **Art Director:** Wendy Wirsig **Designer:** Wendy Wirsig

4 **Design Firm:** The Allied Group, Glastonbury, CT **Project:** Identity **Art Director:** Thomas Hansen **Designer:** Leigh Balducci

5 **Design Firm:** Thibiant International, Inc., Chatsworth, CA **Client:** Thibiant Beverly Hills **Project:** Press Kit **Art Director:** Judith Ann Blair **Designer:** Judith Ann Blair **Photographer:** Derek Rothchild, Richard Radstone

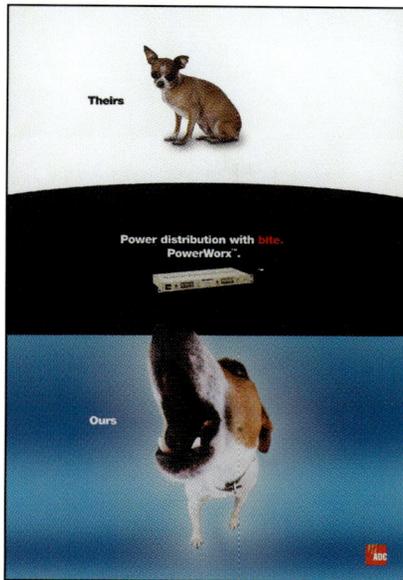

1

2

3

4

5

Direct Mail/Direct Response

1 **Design Firm:** ADC Creative Services Group, Minnetonka, MN **Project:** PowerWorx Direct Mail Campaign **Art Director:** Mark Sexton **Designer:** Mark Sexton

2 **Design Firm:** Belyea, Seattle, WA **Client:** Les Piafs **Project:** Direct Mail Campaign **Art Director:** Patricia Belyea **Designer:** Kelli Lewis **Illustrator:** Kelli Lewis

3 **Design Firm:** BI Performance Services, Minneapolis, MN **Client:** Nortel Networks **Project:** Norstar Valueshares **Art Director:** Mark Geis **Designer:** Mark Geis

4 **Design Firm:** Catalyst Direct, Inc., Rochester, NY **Client:** Eastman Kodak Company **Project:** Mouse on Your Face **Art Director:** Meghan LaBonge **Designer:** Jennifer Wagner

5 **Design Firm:** Champagne/Lafayette Communications Inc., Natick, MA **Client:** Nortel Networks **Project:** Direct Mail **Art Director:** Linda Luiso **Designer:** Erik Klaver

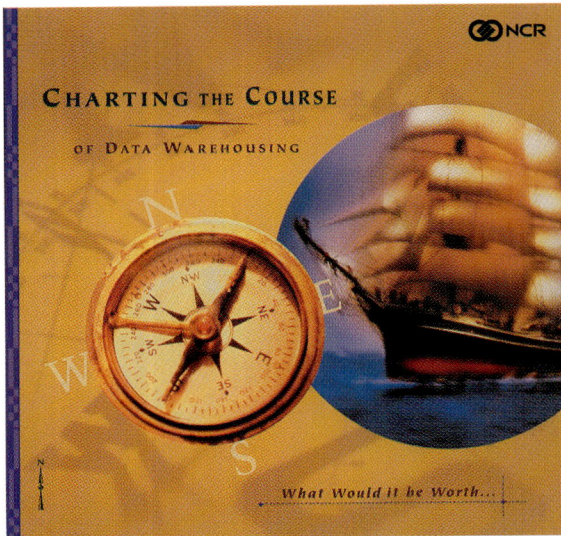

1

2

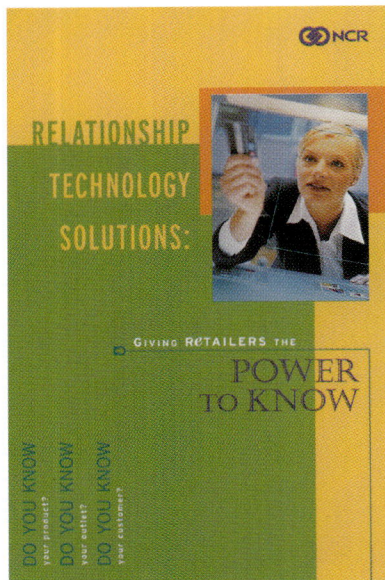

3

4

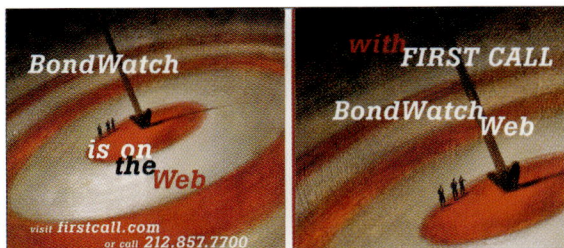

5

1 **Design Firm:** Crawford/Mikus Design, Inc., Atlanta, GA **Client:** NCR **Project:** Partners **Art Director:** Elizabeth Crawford **Designer:** Elizabeth Crawford

2 **Design Firm:** Crawford/Mikus Design, Inc., Atlanta, GA **Client:** NCR **Project:** Executive Seminar **Art Director:** Elizabeth Crawford **Designer:** Elizabeth Crawford, Kathy Wolstenholme

3 **Design Firm:** Crawford/Mikus Design, Inc., Atlanta, GA **Client:** NCR **Project:** Executive Seminar **Art Director:** Elizabeth Crawford **Designer:** Elizabeth Crawford

4 **Design Firm:** Crawford/Mikus Design, Inc., Atlanta, GA **Client:** NCR **Project:** Executive Seminar **Art Director:** Elizabeth Crawford **Designer:** Elizabeth Crawford

5 **Design Firm:** Dart Design, Fairfield, CT **Client:** First Call **Project:** Bond Watch Web DM **Designer:** Kimberly Barney, David Anderson

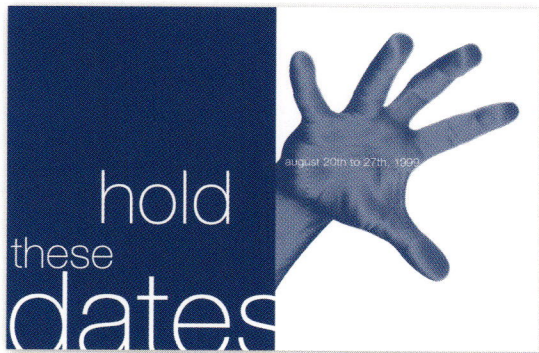

1

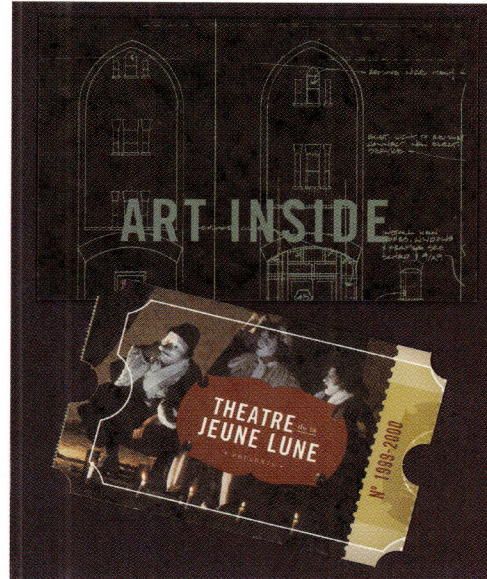

2

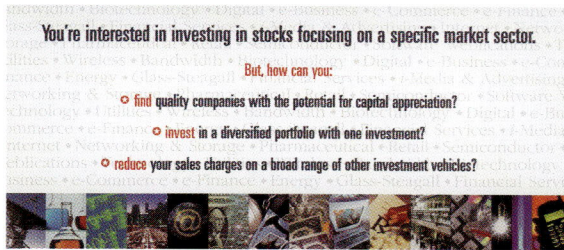

3

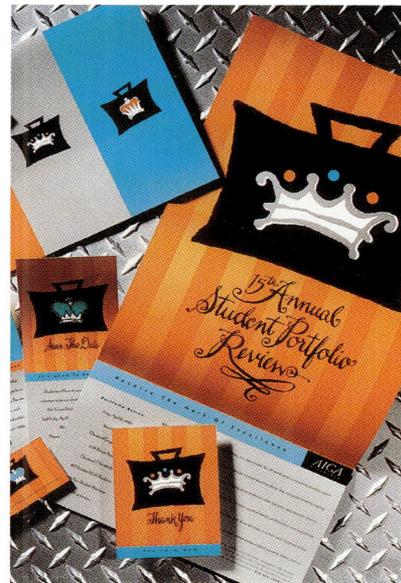

4

5

1 **Design Firm:** Dermal Group, Torrance, CA **Client:** Dermalogica **Project:** Teaser Postcard for International Congress **Art Director:** Claudine Villemure **Designer:** Dijana Marsic

2 **Design Firm:** Design Guys, Minneapolis, MN **Client:** Theatre de la Jeune Lune **Project:** Direct Mail **Art Director:** Steven Sikora **Designer:** Dawn Selg

3 **Design Firm:** Design Matters, Inc!, New York, NY **Client:** Nuveen Investments **Project:** Defined Sector Mailer **Art Director:** Stephen M. McAllister **Designer:** Stephen M. McAllister

4 **Design Firm:** Flourish, Cleveland, OH **Client:** AIGA/Cleveland **Project:** '99 Student Portfolio Review **Art Director:** Jing Lauengco **Designer:** Jing Lauengco **Photographer:** Dina Rossi **Illustrator:** Jing Lauengco

5 **Design Firm:** Hull Creative Group, Boston, MA **Client:** MRO.com **Project:** Exchange Direct Mailer **Art Director:** Caryl H. Hull **Designer:** Michelle Perreault

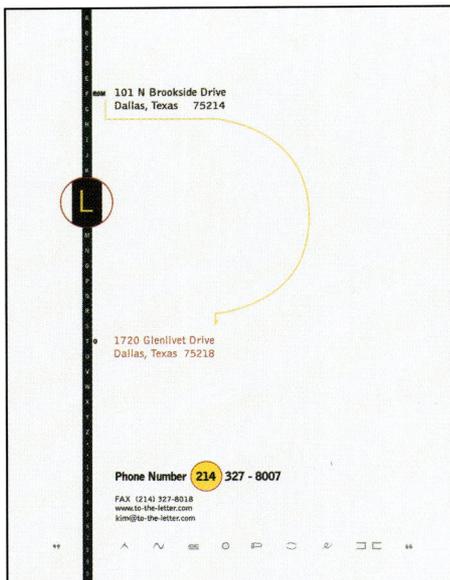

1

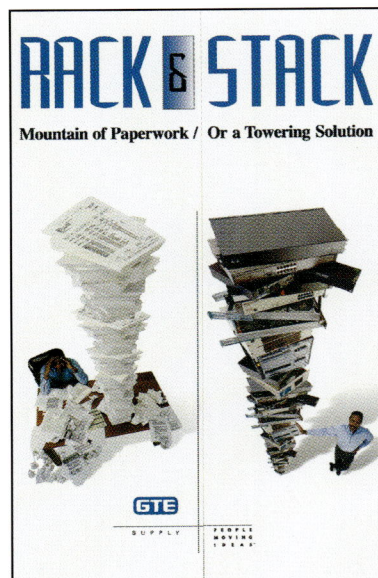

2

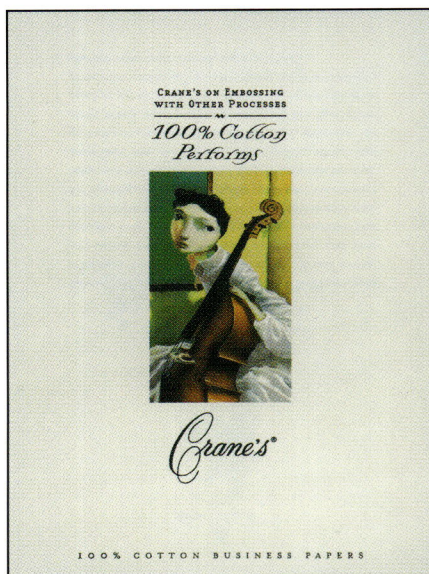

3

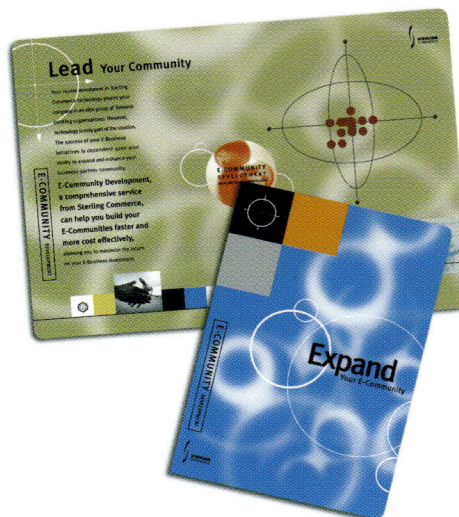

4

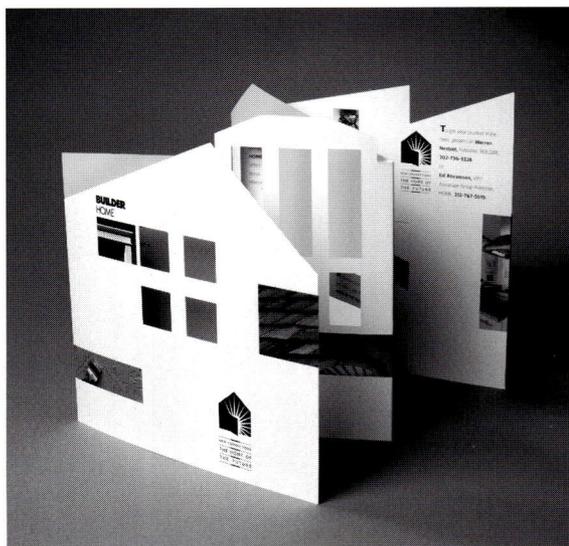

5

1 **Design Firm:** JA Design Solutions, Coppell, TX **Client:** To The Letter **Project:** Direct Mail **Art Director:** Jean Ashenfelter **Designer:** Jean Ashenfelter

2 **Design Firm:** JA Design Solutions, Coppell, TX **Client:** GTE Supply **Project:** Rack-n-Stack Promotion **Art Director:** Jean Ashenfelter **Designer:** Jean Ashenfelter **Photographer:** Scott R. Stevens

3 **Design Firm:** Keiler & Company, Farmington, CT **Client:** Crane & Company **Project:** 100% Cotton Performs Direct Mail **Art Director:** Aaron Dietz **Designer:** Aaron Dietz

4 **Design Firm:** Kelley Communications Group, Dublin, OH **Client:** Sterling Commerce **Project:** e-Community Development-Mailer **Art Director:** Kevin Ronnebaum

5 **Design Firm:** Kircher, Washington, DC **Client:** Hanley-Wood, Inc. **Project:** Direct Mail **Art Director:** Dorothy Rudzik **Designer:** Dorothy Rudzik

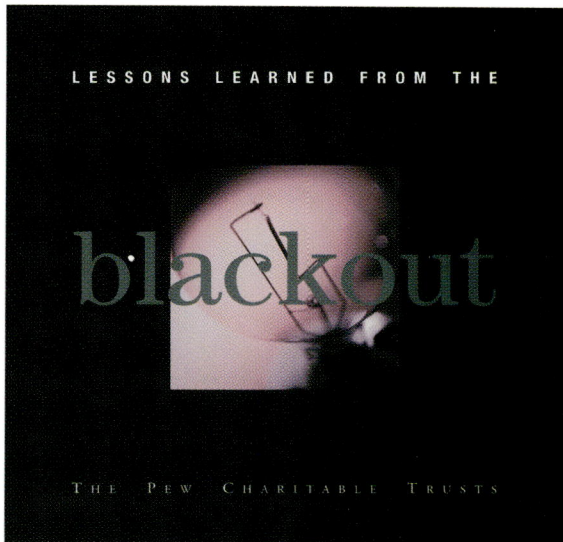

1

2

3

4

5

1 **Design Firm:** Malish & Pagonis, Philadelphia, PA **Client:** The Pew Charitable Trusts **Project:** Direct Mail **Designer:** Demitri Pagonis **Illustrator:** Demitri Pagonis

2 **Design Firm:** Petertil Design Partners, Oak Park, IL **Client:** Johns Byrne Printing **Project:** Direct to Plate Mailings Series **Art Director:** Kerry Petertil **Designer:** Kerry Petertil

3 **Design Firm:** Petrick Design, Chicago, IL **Client:** Consolidated Papers, Inc. **Project:** Big is Beautiful **Art Director:** Robert Petrick **Designer:** Amanda Gentry

4 **Design Firm:** Sharon Elwell Graphic Design, North Reading, MA **Client:** Merrimack College **Project:** Direct Mail **Art Director:** Sharon Elwell **Designer:** Sharon Elwell

5 **Design Firm:** The Boston Globe, Boston, MA **Project:** Wedding Invitation/Reminders **Art Director:** Tim Foley **Designer:** Tim Foley

1

2

3

4

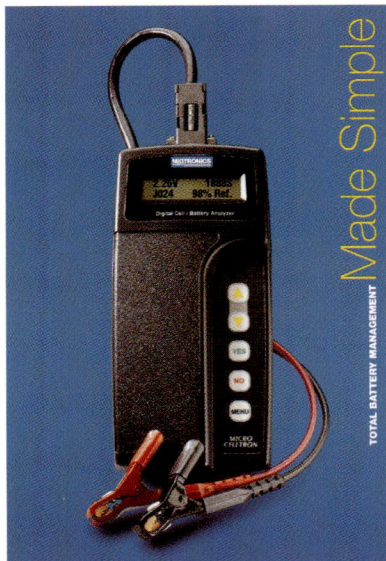

5

1 **Design Firm:** Tieken Design & Creative Services, Phoenix, AZ **Client:** GES Interactive **Project:** Show Manager Direct Mailer **Art Director:** Fred E. Tieken **Designer:** Colleen Hale

2 **Design Firm:** Towson University, Towson, MD **Client:** Maryland Arts Festival **Project:** Direct Mail **Art Director:** Kathy Malanowski **Designer:** Kathy Malanowski **Illustrator:** Kathy Malanowski

3 **Design Firm:** Tribune Media Services, Chicago, IL **Project:** You've Got A Brain **Designer:** Stephani Kuehn

4 **Design Firm:** Zamboo, Marina Del Rey, CA **Client:** Nissan **Project:** Nissan Service Direct **Art Director:** Dave Zambotti **Designer:** Dave Zambotti

5 **Design Firm:** ZGraphics, Ltd., East Dundee, IL **Client:** Midtronics, Inc. **Project:** Micro Celltron Postcard Campaign **Art Director:** Joe Zeller **Designer:** Mike Girard

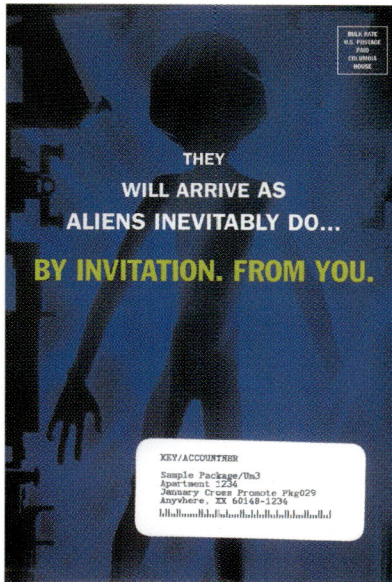

1

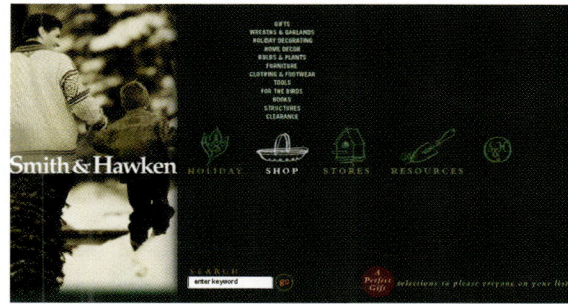

2

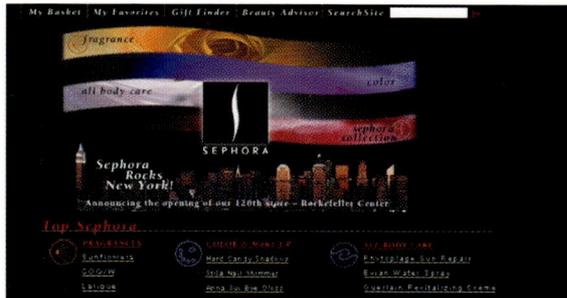

3

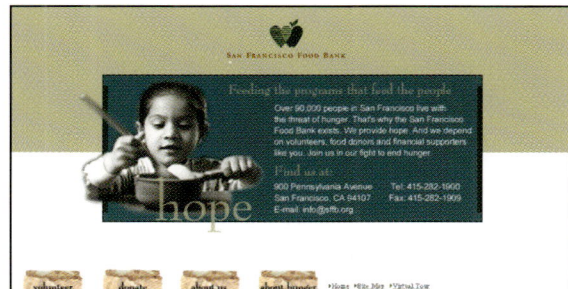

4

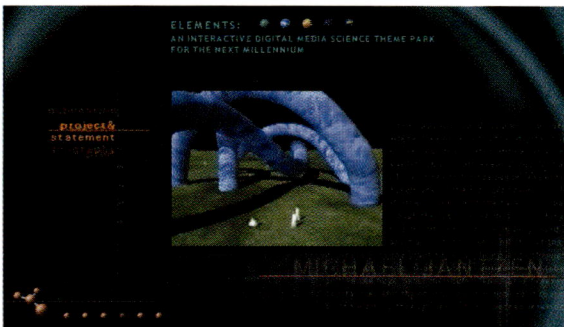

5

1 **Design Firm:** Zinc, New York, NY **Client:** Columbia House Video Library **Project:** Sci-Fi Product Package **Designer:** Felicia Zekauskas, Peter Maloney

Internet/Interactive

2 **Design Firm:** Addis Group, Inc., Berkeley, CA **Client:** Smith & Hawken **Project:** Web Site **Design Director:** Deborah Smith Read **Designer:** Aileen Kendle, Joe Chang **Creative Director:** Ron Vandenberg

3 **Design Firm:** Addis Group, Inc., Berkeley, CA **Client:** LVMH Moet Hennessey Louis Vuitton **Project:** Sephora.com Web Site **Design Director:** Joanne Hom **Designer:** Asha McLaughlin **Account Executive:** Steven Addis **Creative Director:** Ron Vandenberg

4 **Design Firm:** Addis Group, Inc., Berkeley, CA **Client:** SF Food Bank **Project:** Web Site **Design Director:** Rick Atwood **Designer:** Rick Atwood **Account Executive:** Leila Daubert

5 **Design Firm:** Art Center College of Design, Pasadena, CA **Project:** Synthesis CD-ROM **Producer:** Sharon Tani **Designer:** Sharon Tani, Linda Kim, Jinhee Park **Digital Media Department Chair:** Andrew Davidson

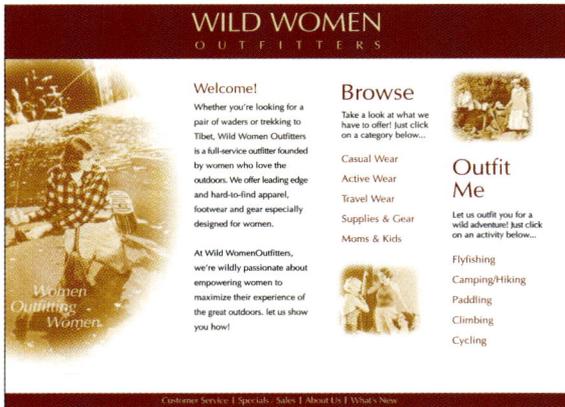

1

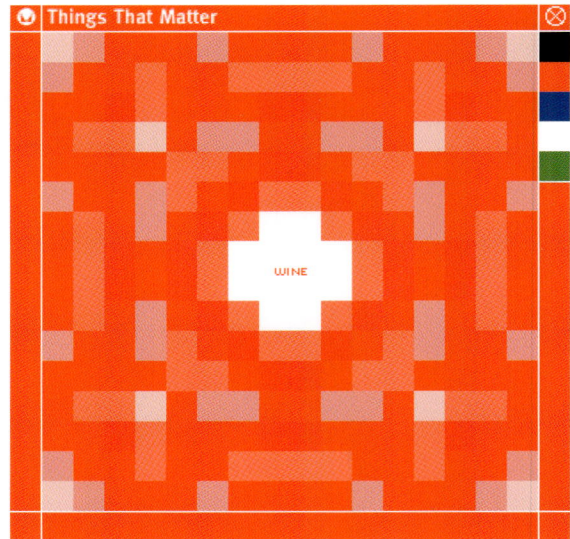

2

3

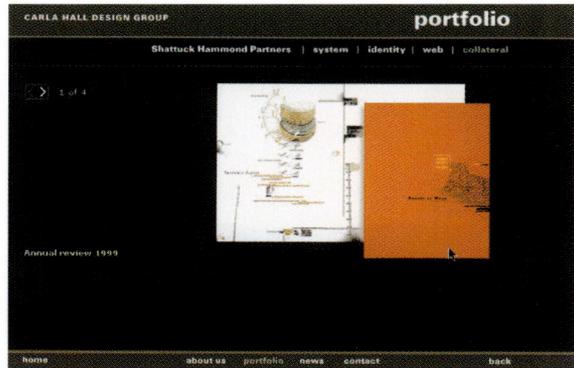

4

5

1 **Design Firm:** BachlLees Design, Inc, Boston, MA **Client:** Wild Women Outfitters **Project:** Women's Apparel and Gear Retailer Web Site **Designer:** John Bach, Eric Lees

2 **Design Firm:** BBK Studio, Inc., Grand Rapids, MI **Client:** Herman Miller, Inc. **Project:** Neocon—Colors **Art Director:** Kevin Budelmann **Designer:** Mike Carnevale

3 **Design Firm:** BWITT.Com, Danbury, CT **Client:** Infodirections, Inc. **Project:** Web Site **Designer:** Brian Wittman, Kevin Kirwan

4 **Design Firm:** Carla Hall Design Group, New York, NY **Project:** Web Site **Art Director/Senior Designer:** Michael Wiemeyer **Contributing Designers:** John Stislow, Joshua White **Creative Director:** Carla Hall

5 **Design Firm:** Clarke & Associates LLC, Somerville, NJ **Project:** Web Solutions **Art Director:** Ken Thorlton

1

2

3

4

5

1 **Design Firm:** Clarke & Associates LLC, Somerville, NJ **Client:** KPMG **Project:** eHR Web Site **Art Director:** Ken Thorlton

2 **Design Firm:** Clarke & Associates LLC, Somerville, NJ **Client:** KPMG **Project:** Work/Life Web Site **Art Director:** Ken Thorlton

3 **Design Firm:** CRSR Designs, Kingston, NY **Client:** Amazing Threads **Project:** Web Site **Art Director:** Constance R. Snyder **Designer:** Lynn Bondar **Illustrator:** Elizabeth Olsen Ketudot

4 **Design Firm:** CRSR Designs, Kingston, NY **Client:** High Land Flings **Project:** Web Site **Art Director:** Constance R. Snyder **Designer:** Lynn Bondar **Photographer:** Carol Clement

5 **Design Firm:** designTHIS!, Napa, CA **Client:** Spiaggia Skin Care **Project:** Web Site **Art Director:** Amy Pradmore **Designer:** Amy Pradmore

1

2

3

4

5

1 **Design Firm:** Eagleye Creative, Littleton, CO **Project:** Web Site **Art Director:** Steve Schader **Designer:** Steve Schader **Illustrator:** Steve Schader

2 **Design Firm:** Gateway Arts, Thousand Oaks, CA **Client:** James Coleman Studios **Project:** Web Site **Art Director:** Dave Carlson **Designer:** Dave Ruhr **Illustrator:** Dave Ruhr

3 **Design Firm:** Greenfield/Belser, Washington, DC **Project:** Web Site **Art Director:** Burkey Belser **Designer:** Terry Burcham, Jason Hendrick, Burkey Belser

4 **Design Firm:** Hull Creative Group, Boston, MA **Project:** Web Site **Art Director:** Caryl H. Hull **Designer:** Carolyn Colonna **Programmer:** OVO

5 **Design Firm:** Idea Integration, Houston, TX **Client:** Momentum Securities **Project:** Internet Graphics **Art Director:** Ed Morrissey **Designer:** Mel Sedat

1

2

3

4

5

1 **Design Firm:** Idea Integration, Houston, TX **Client:** Compaq **Project:** Clip Webzine **Senior Programmer:** Dan Cutts **Director of Corporate Development:** John Clark **Production Manager:** Lance Walker

2 **Design Firm:** MarchFIRST, New York, NY **Client:** Timberland **Project:** Mountain Athletics **Art Director:** Augusta Duffey, Dahrong Lee **Designer:** Nadia Turan **Photographer:** John Huett, Morgan Photography

3 **Design Firm:** MarchFIRST, New York, NY **Client:** Audi of America **Project:** Web Site **Art Director:** Hien Im **Designer:** Robert Wong **Illustrator:** Keith Byrne

4 **Design Firm:** Marriott International, Washington, DC **Client:** Ramada International **Project:** Web Site **Art Director:** Diane Sterman **Designer:** Beth Santos

5 **Design Firm:** Marriott International, Washington, DC **Client:** Marriott Canada **Project:** Microsite **Art Director:** Diane Sterman **Designer:** Heidi Leech

1

2

3

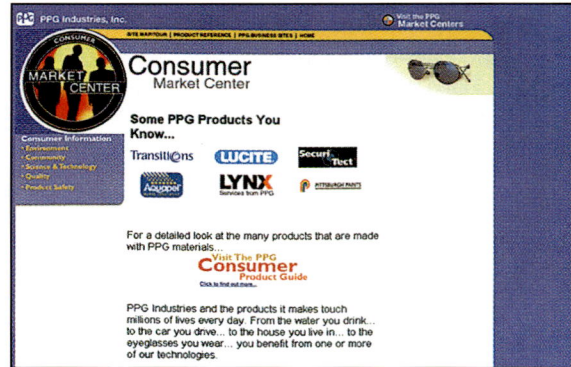

4

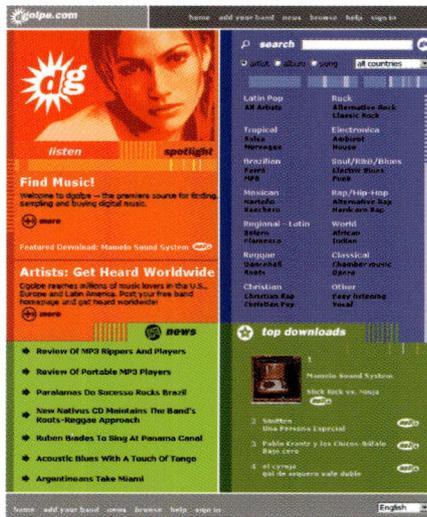

5

1 **Design Firm:** Microware Systems Corp., Des Moines, IA **Project:** Microware Web Site **Designer:** Zach King

2 **Design Firm:** Nesnadny & Schwartz, Cleveland, OH **Client:** Cleveland Institute of Art **Project:** Web Site **Art Director:** Mark Schwartz **Designer:** Tim Lachina, Michelle Moehler, Brian Lavy, Cindy Lowery **Photographer:** Robert Muller

3 **Design Firm:** PiperStudiosInc, Chicago, IL **Client:** Edventions, Inc. **Project:** Web Site **Art Director:** Christine Gravel **Designer:** Donn Ha **Illustrator:** Donn Ha, Allen Crawford, Susan Crawford

4 **Design Firm:** PPG Industries, Pittsburgh, PA **Project:** Web Site **Art Director:** Donna Harmon **Designer:** Aaron Cacali, Lighthouse Interactive

5 **Design Firm:** Rare Medium, Inc., New York, NY **Client:** dGolpe.com **Project:** Web Site

1

2

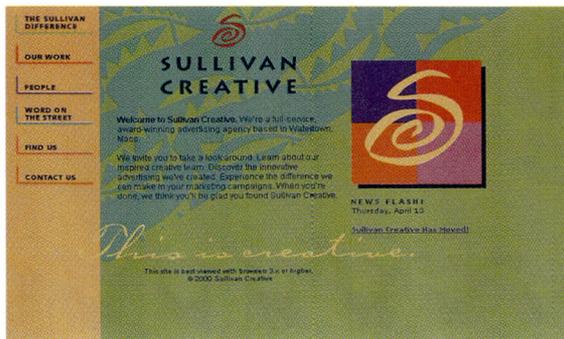

3

4

5

1 **Design Firm:** Rare Medium, Inc., New York, NY **Client:** Smart Online **Project:** Web Site

2 **Design Firm:** Rare Medium, Inc., New York, NY **Client:** Lov: The Original Motion Picture Soundtrack **Project:** Web Site

3 **Design Firm:** Sullivan Creative, Newton, MA **Project:** Web Site **Art Director:** Chuck Provancher **Designer:** Wendy Wirsig

4 **Design Firm:** That's Nice, LLC, New York, NY **Client:** Honeywell, Inc. **Project:** Astorlite.com Web Site **Art Director:** Nigel Walker **Designer:** Phillip Evans **Illustrator:** Joel Santos

5 **Design Firm:** That's Nice, LLC, New York, NY **Client:** Honeywell, Inc. **Project:** Fluorosolutions Web Site **Art Director:** Nigel Walker **Designer:** Andrea Thomas **Illustrator:** Joel Santos

1

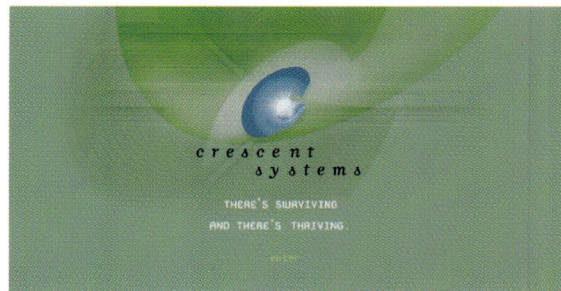

2

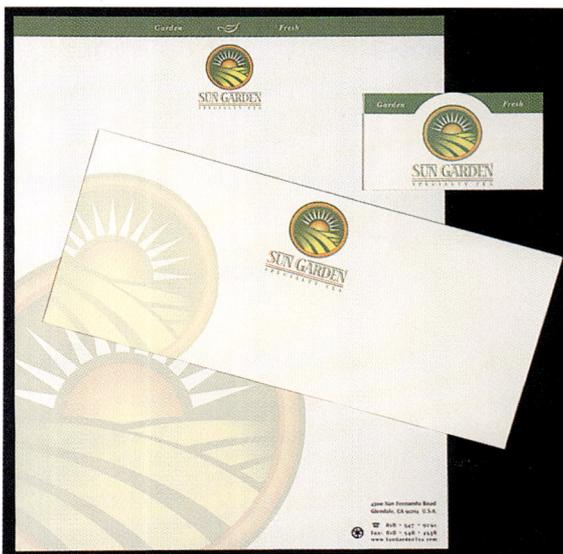

3

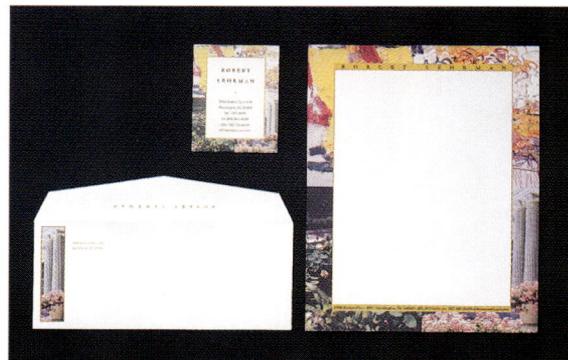

4

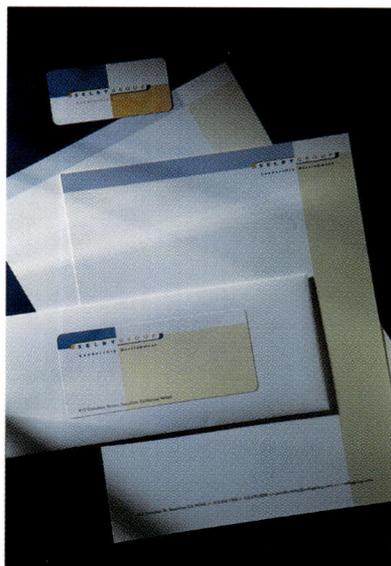

5

1 **Design Firm:** That's Nice, LLC, New York, NY **Client:** Honeywell, Inc. **Project:** Specialty Chemicals Web Site **Art Director:** Nigel Walker **Designer:** Phillip Evans

2 **Design Firm:** Tim Kenney Design Partners, Bethesda, MD **Client:** Crescent Systems **Project:** Internet **Art Director:** Tim Kenney **Designer:** Jamie Stockie

Letterhead/Stationery

3 **Design Firm:** 3D Effects, Los Angeles, CA **Client:** Sun Garden **Project:** Logo and Stationery **Art Director:** Roju Park **Designer:** Roju Park **Illustrator:** Roju Park

4 **Design Firm:** Arts & Letters, Ltd., Falls Church, VA **Client:** Robert Lehrman, Art Collector, President of Hirshhorn Museum Board of Trustees **Project:** Letterhead **Art Director:** Susan Eder **Designer:** Craig Dennis **Photographer:** Mark Gulezian Photography, Susan Eder

5 **Design Firm:** Axion Design Inc., San Anselmo, CA **Client:** The Selby Group **Project:** Stationery System **Art Director:** Ed Cristman **Designer:** Ed Cristman

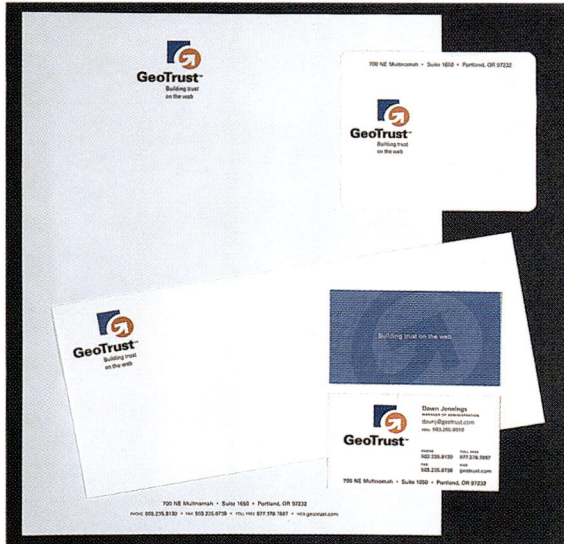

1

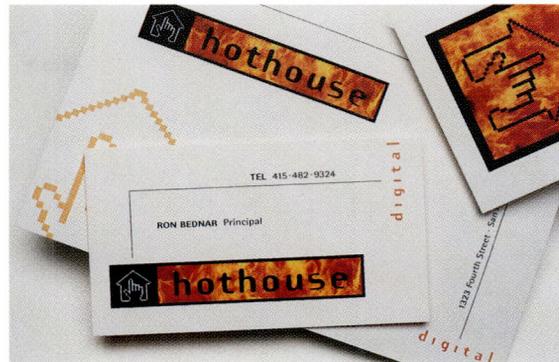

2

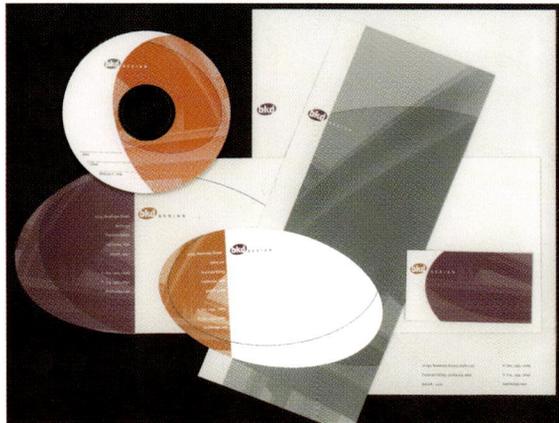

3

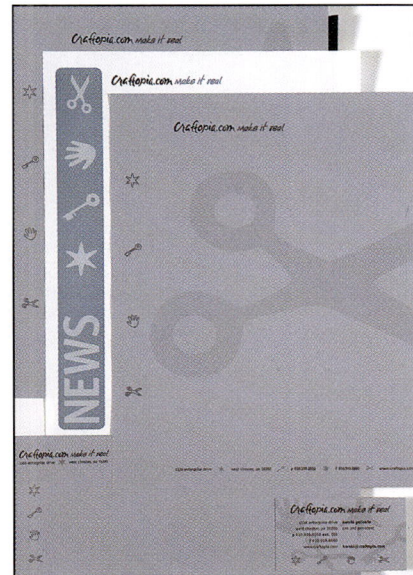

4

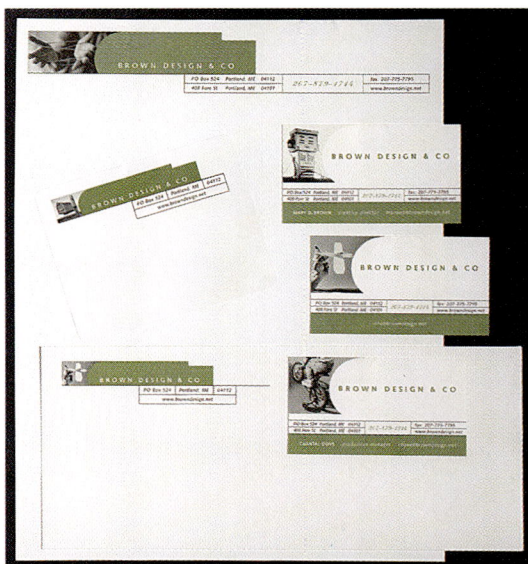

5

1 **Design Firm:** Belyea, Seattle, WA **Client:** GeoTrust **Project:** Letterhead **Art Director:** Patricia Belyea **Designer:** Ron Lars Hansen **Illustrator:** Ron Lars Hansen

2 **Design Firm:** be•design, San Rafael, CA **Client:** Hot House **Project:** Letterhead **Art Director:** Will Burke **Designer:** Eric Read

3 **Design Firm:** BKD Design, Fountain Valley, CA **Project:** Stationery **Art Director:** Jeff Barton **Designer:** Jeff Barton, Craig Peterson **Photographer:** Jeff Barton

4 **Design Firm:** Bonato Design, Berwyn, PA **Client:** Craftopia.com **Project:** Stationery **Art Director:** Donna Bonato Orr **Designer:** Donna Bonato Orr, Jill Majka

5 **Design Firm:** Brown Design & Company, Portland, ME **Client:** Brown Design & Company **Project:** Identity Package **Designer:** Mary Brown

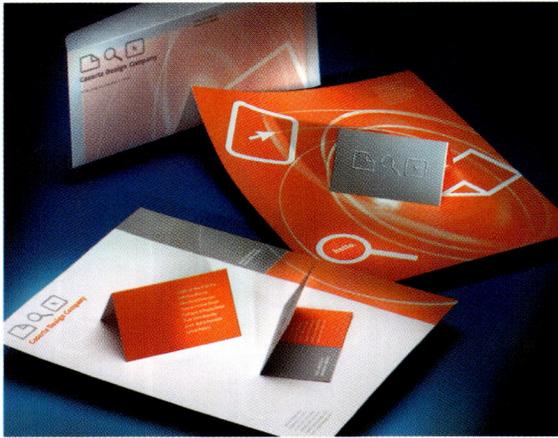

1

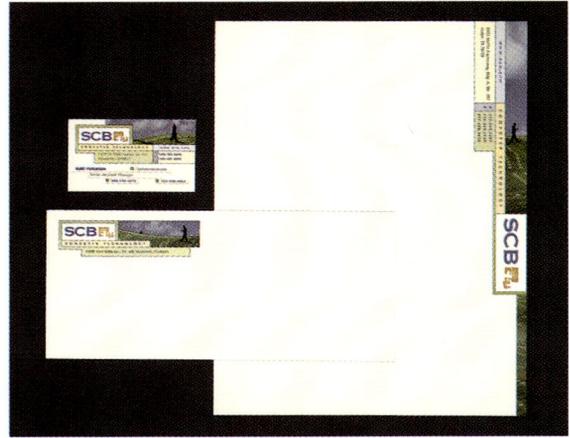

2

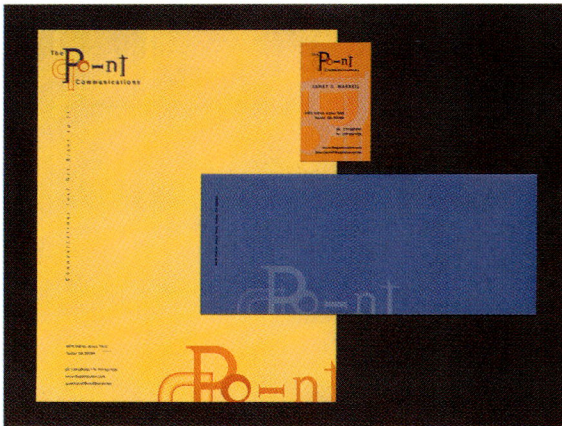

3

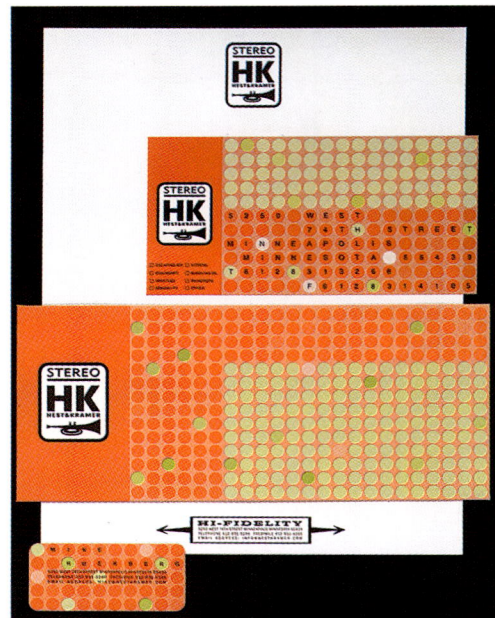

4

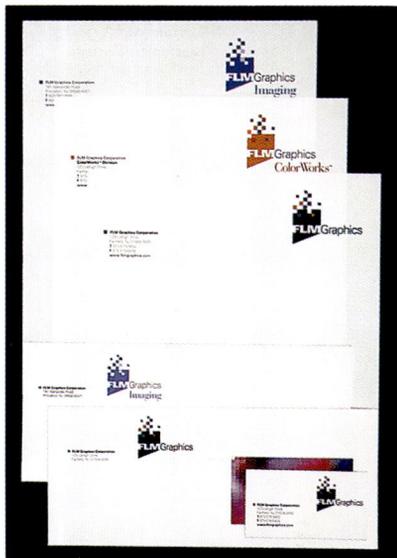

5

1 **Design Firm:** Caserta Design Company, Stratford, CT **Project:** Stationery System **Designer:** Fred Caserta **Illustrator:** Fred Caserta

2 **Design Firm:** Crawford/Mikus Design, Inc., Atlanta, GA **Client:** SCB **Project:** Identity **Art Director:** Elizabeth Crawford **Designer:** Elizabeth Crawford

3 **Design Firm:** Crawford/Mikus Design, Inc., Atlanta, GA **Client:** Point Communications **Project:** Identity **Art Director:** Elizabeth Crawford **Designer:** Elizabeth Crawford, Kathy Wolstenholme

4 **Design Firm:** Design Guys, Minneapolis, MN **Client:** Hest & Kramer **Project:** Identity **Art Director:** Steven Sikora **Designer:** Scott Thares

5 **Design Firm:** Design Source East, Cranford, NJ **Client:** FLM Graphics Corporation **Project:** Stationery **Art Director:** Mark Lo Bello **Designer:** Mark Lo Bello

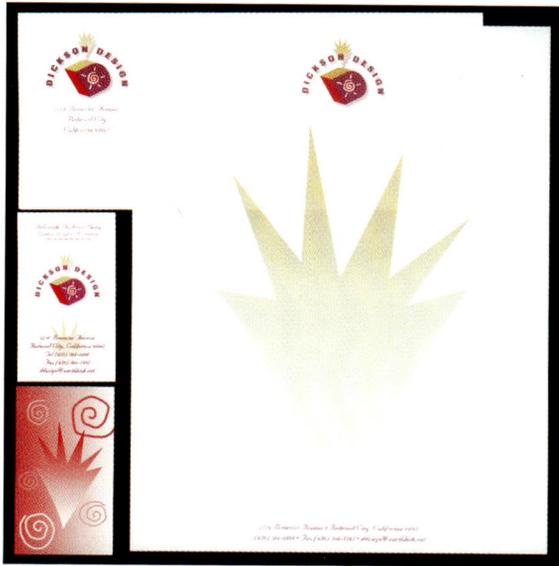

1

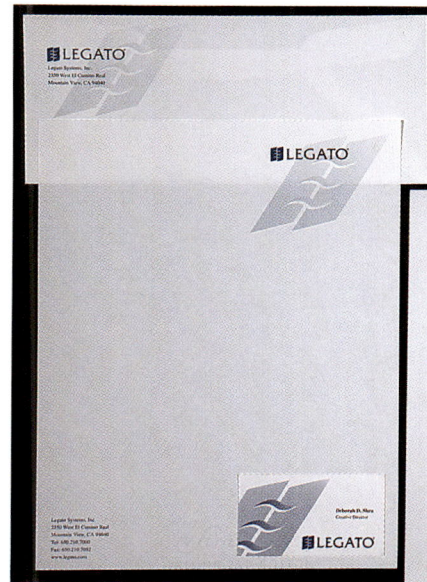

2

3

4

5

1 **Design Firm:** Dickson Design, Redwood City, CA **Project:** Stationery **Designer:** Deborah Shea

2 **Design Firm:** Dickson Design, Redwood City, CA **Client:** Legato Systems **Project:** Stationery **Designer:** Deborah Shea

3 **Design Firm:** Hunt Weber Clark Associates, Inc., San Francisco, CA **Client:** Joie de Vivre Hospitality **Project:** Costanoa Letterhead **Art Director:** Nancy Hunt-Weber **Designer:** Christine Chung **Illustrator:** Nancy Hunt-Weber

4 **Design Firm:** Marketing Communications, New York, NY **Project:** Stationery **Art Director:** Randee Rubin **Designer:** Randee Rubin, Seth McGinnis

5 **Design Firm:** McElfish & Company, Troy, MI **Client:** Betz Trucking **Project:** Letterhead **Designer:** Paul Aiuto

1

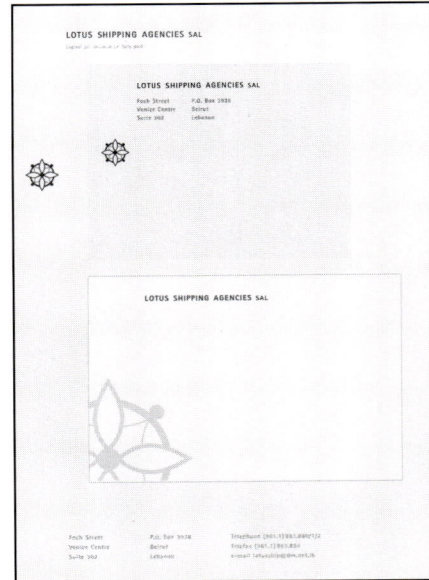

2

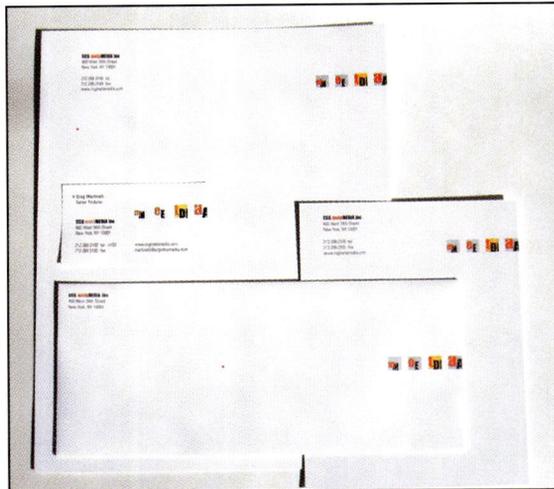

3

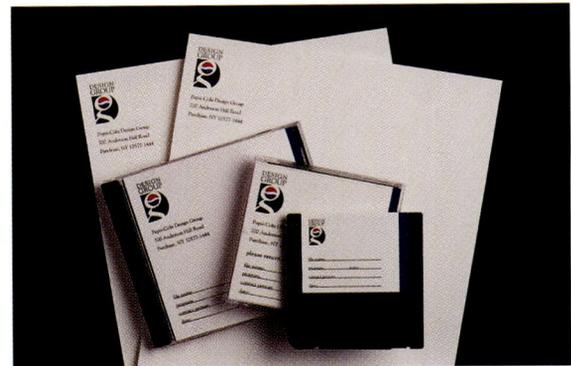

4

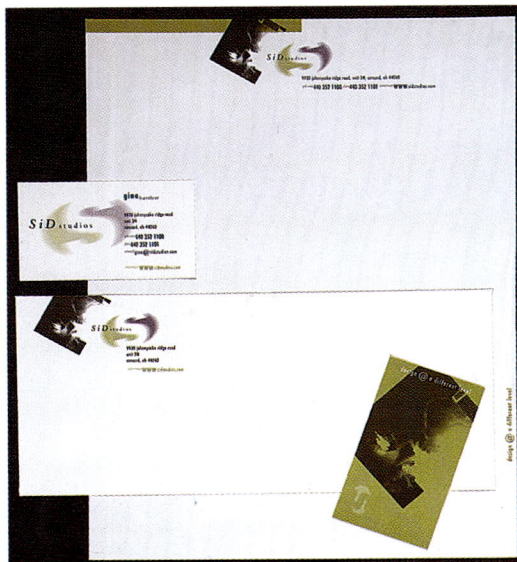

5

1 **Design Firm:** Michael Osborne Design, San Francisco, CA **Client:** Money Heaven Venture Capital **Project:** Business System **Art Director:** Michael Osborne **Designer:** Michael Osborne **Illustrator:** Carolyn Vibbert

2 **Design Firm:** Nassar Design, Brookline, MA **Client:** Lotus Shipping Agencies SAL **Project:** Stationery **Art Director:** Nelida Nassar **Designer:** Margarita Encomienda **Illustrator:** Margarita Encomienda

3 **Design Firm:** O&J Design Inc., New York, NY **Client:** CCG MetaMedia, Inc. **Project:** Letterhead & Stationery **Art Director:** Andrezj Olejniczak **Designer:** Christina Mueller

4 **Design Firm:** Pepsi-Cola Company, Purchase, NY **Project:** Pepsi-Cola Design Group Stationery **Art Director:** Christen K. Gobin **Designer:** Christen K. Gobin

5 **Design Firm:** SiD studios, Concord, OH **Project:** Stationery **Art Director:** Bill Sintic **Designer:** Gina Bartlett, Bill Sintic

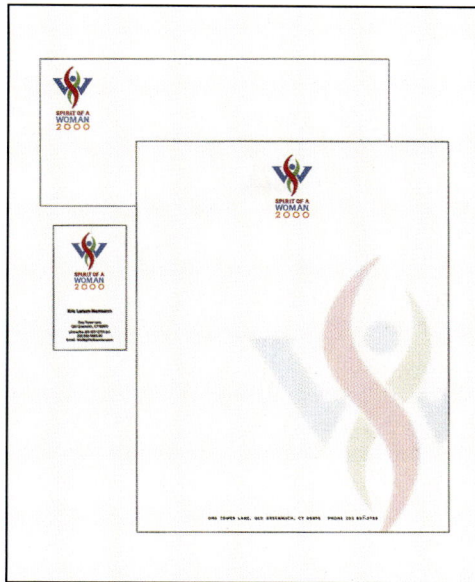

1

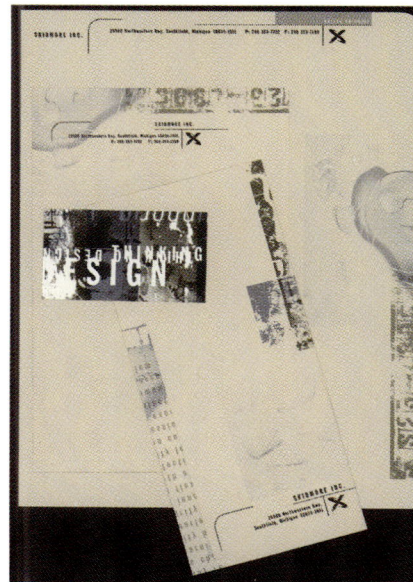

2

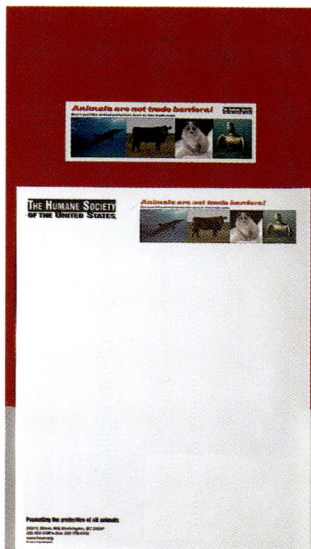

3

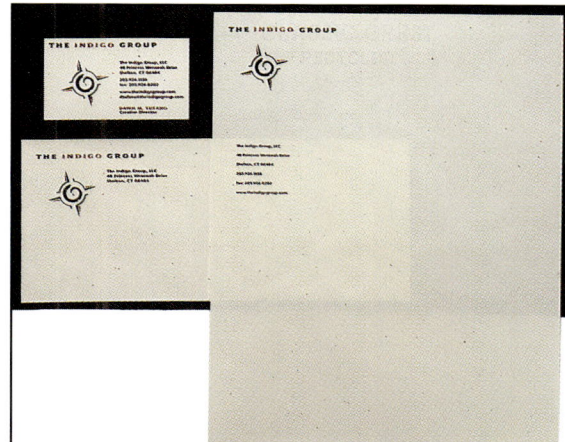

4

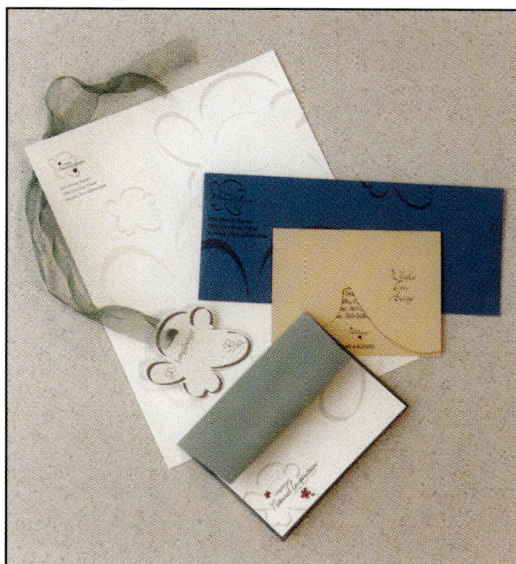

5

1 **Design Firm:** SJI Associates Inc., New York, NY **Client:** Spirit of a Woman **Project:** Stationery **Art Director:** Susan Sears **Designer:** GT Goto

2 **Design Firm:** Skidmore, Inc., Southfield, MI **Project:** Letterhead and Stationery **Designer:** John Latin **Photographer:** Jeff Margis **Illustrator:** Gary Cooley, Steve Macsig, Robert Nixon

3 **Design Firm:** The Humane Society of the United States, Gaithersburg, MD **Project:** Animals Are Not Trade Barriers **Art Director:** Paula Jaworski **Designer:** Paula Jaworski

4 **Design Firm:** The Indigo Group, Shelton, CT **Project:** Indigo Identity **Art Director:** Dawn Tufano **Designer:** Dawn Tufano **Illustrator:** Dawn Tufano

5 **Design Firm:** The Longaberger Company, Newark, OH **Project:** April Advisors Meeting Stationery **Designer:** Tami Miller **Photographer:** Dawn Weber

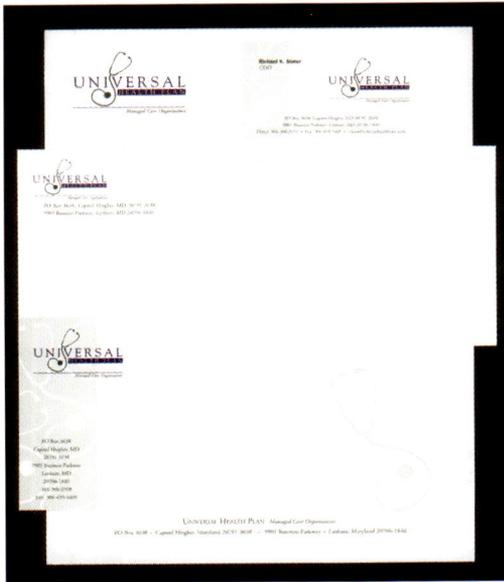

1

2

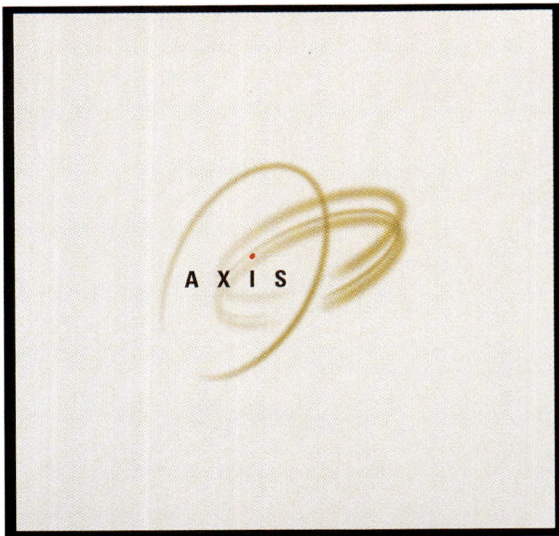

3

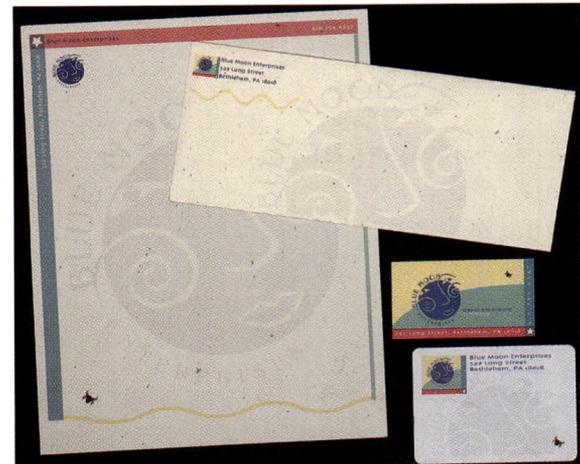

4

5

1 **Design Firm:** Uncommon Design, Laurel, MD **Client:** Colonial Health Care, Inc. **Project:** Universal Health Plan Stationery **Art Director:** Carla Conway **Designer:** Carla Conway **Illustrator:** Carla Conway

2 **Design Firm:** Wallace Church Associates Inc., New York, NY **Client:** Green Media **Project:** Green **Art Director:** Nin Glaister **Designer:** Paula Bunny

3 **Design Firm:** Wallace Church Associates Inc., New York, NY **Client:** Axis Group **Project:** Letterhead & Stationery **Art Director:** Stan Church **Designer:** Wendy Church **Illustrator:** Lucian Toma

4 **Design Firm:** whiteSTARdesign, Bethlehem, PA **Client:** Blue Moon Enterprises **Project:** Stationery **Art Director:** Peter Stolvoort **Designer:** Peter Stolvoort **Illustrator:** Carol Stolvoort

Logos/Trademarks/Symbols

5 **Design Firm:** Addis Group, Inc., Berkeley, CA **Client:** iScribe **Project:** Logo **Art Director:** Ron Vandenberg **Designer:** Bob Hullinger **Account Executive:** Tom Holownia

1

2

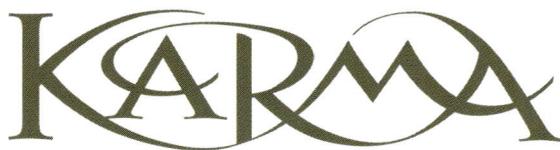

3

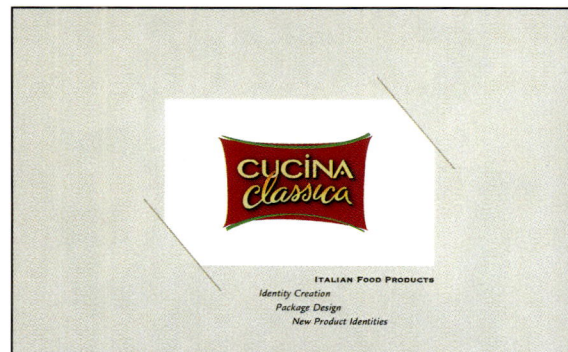

4

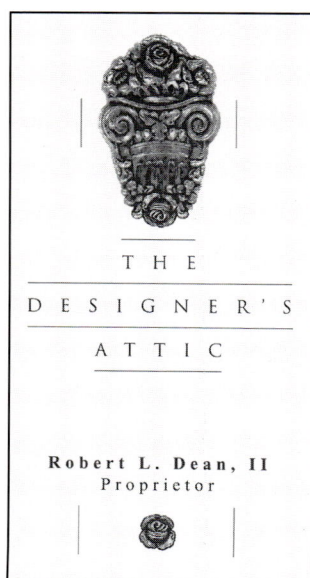

5

1 **Design Firm:** b&j Designs, Richmond, VA **Project:** Logo **Designer:** Bernadine Jones

2 **Design Firm:** Belyea, Seattle, WA **Client:** Les Piafs **Project:** Logo **Art Director:** Patricia Belyea **Designer:** Christian Salas **Illustrator:** Christian Salas

3 **Design Firm:** be•design, San Rafael, CA **Client:** Karma **Project:** Identity Signature **Art Director:** Eric Read **Designer:** Eric Read, Deborah Read

4 **Design Firm:** Brandesign Incorporated, Monroe, NJ **Client:** Classica Group **Project:** Cucina Classica Identity **Art Director:** Barbara Harrington **Designer:** Regina Sherman

5 **Design Firm:** Chris Carline Design, San Francisco, CA **Client:** The Designer's Attic **Project:** Logo **Art Director:** Chris J. Carline **Designer:** Chris J. Carline

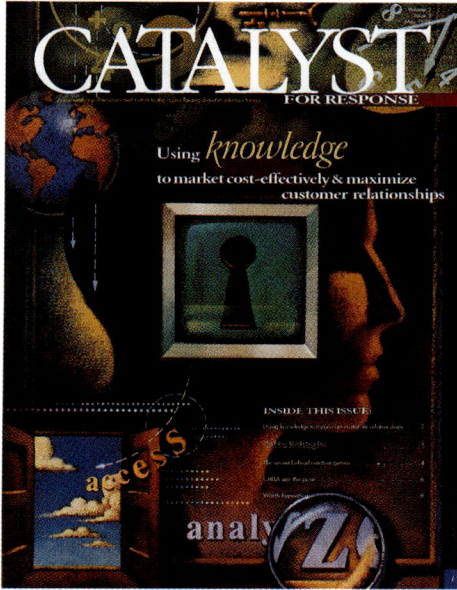

1

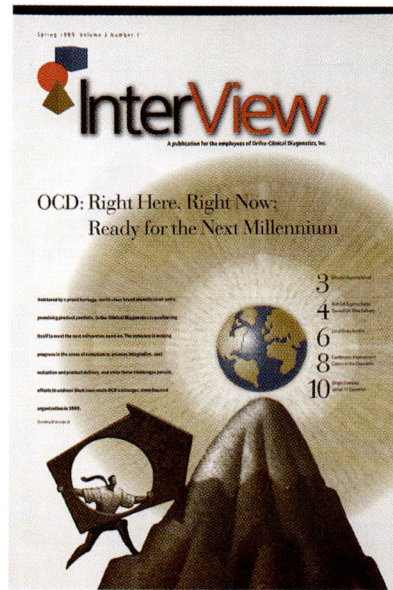

2

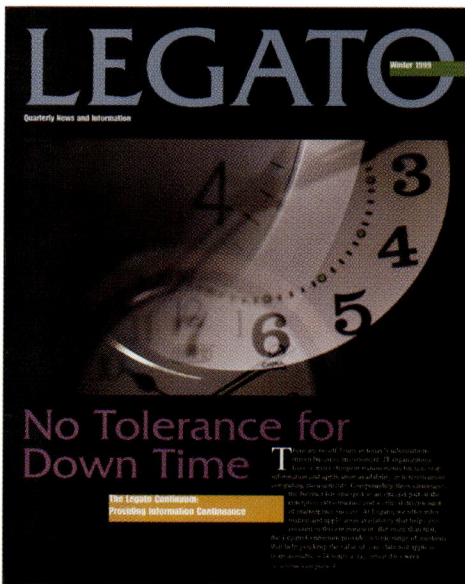

3

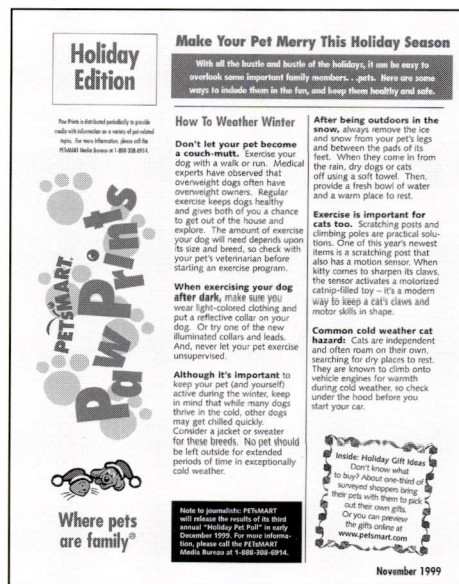

4

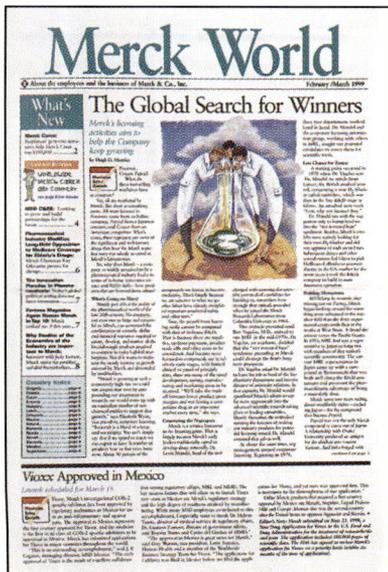

5

1 **Design Firm:** Catalyst Direct, Inc., Rochester, NY **Project:** Catalyst for Response **Art Director:** Meghan LaBonge **Designer:** Jennifer Wagner

2 **Design Firm:** Design Source East, Cranford, NJ **Client:** Ortho-Clinical Diagnostics, Inc. **Project:** InterView, Spring 1999 **Art Director:** Mark Lo Bello **Designer:** H. Dean Pillion

3 **Design Firm:** Dickson Design, Redwood City, CA **Client:** Legato Systems **Project:** Customer Newsletter **Art Director:** Deborah Shea **Designer:** Deborah Shea

4 **Design Firm:** Hill and Knowlton, Los Angeles, CA **Client:** Petsmart **Project:** Paw Prints Newsletter **Art Director:** Joyce Eicholtz **Designer:** Jennifer White

5 **Design Firm:** Jacqueline Barrett Design Inc., Oceanport, NJ **Client:** Merck and Co., Inc. **Project:** Merck World Newsletter **Art Director:** Jacqueline Barrett **Designer:** Jacqueline Barrett **Illustrator:** Elise N. Phillips

1

2

3

4

5

1 **Design Firm:** b&j Designs, Richmond, VA **Project:** Logo **Designer:** Bernadine Jones

2 **Design Firm:** Belyea, Seattle, WA **Client:** Les Piafs **Project:** Logo **Art Director:** Patricia Belyea **Designer:** Christian Salas **Illustrator:** Christian Salas

3 **Design Firm:** be•design, San Rafael, CA **Client:** Karma **Project:** Identity Signature **Art Director:** Eric Read **Designer:** Eric Read, Deborah Read

4 **Design Firm:** Brandesign Incorporated, Monroe, NJ **Client:** Classica Group **Project:** Cucina Classica Identity **Art Director:** Barbara Harrington **Designer:** Regina Sherman

5 **Design Firm:** Chris Carline Design, San Francisco, CA **Client:** The Designer's Attic **Project:** Logo **Art Director:** Chris J. Carline **Designer:** Chris J. Carline

water·color℠

A Southern Coastal Landscape. **FLORIDA**

1

2

3

4

Middle Country Library Foundation Family Place
National Association of Mothers' Centers
The Parent-Child Home Program

5

1 **Design Firm:** David Carter Graphic Design Associates, Dallas, TX **Client:** Watercolor/Arvida **Project:** Logo **Art Director:** Sharon LeJeune **Designer:** Paul Munsterman, Sharon LeJeune

2 **Design Firm:** Davis Harrison Dion, Chicago, IL **Client:** Chicago Convention and Tourism Bureau **Project:** Logos **Art Director:** Dave Paoletti **Designer:** Bob Dion, Brent Vincent, Dave Paoletti **Illustrator:** Dave Paoletti

3 **Design Firm:** Design North, Inc., Racine, WI **Project:** Search Dog Logo **Designer:** Pat Cowan, Bill Johnson

4 **Design Firm:** Directions Incorporated, Neenah, WI **Client:** Sturgeon Bay Chamber **Project:** Logo **Designer:** Lori Daun

5 **Design Firm:** EAB, Uniondale, NY **Client:** Middle Country Library, NA Mothers' Centers, Parent-Child Home Program **Project:** Putting Families First **Designer:** Virginia Paone

1

2

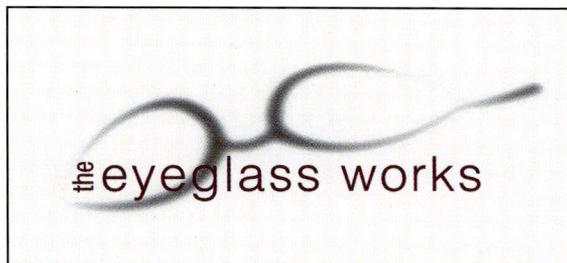

3

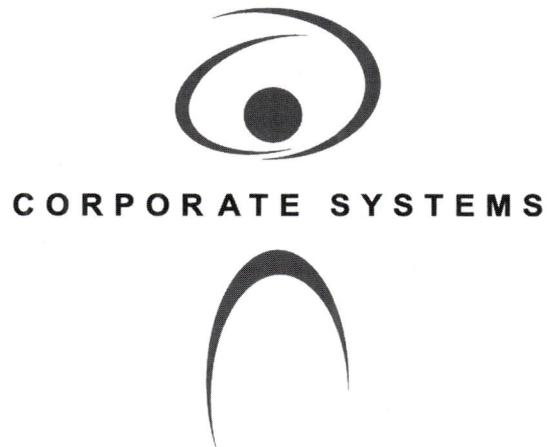

4

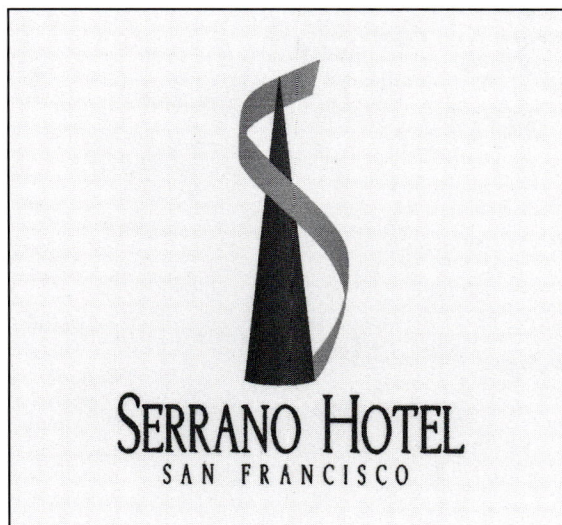

5

1 **Design Firm:** Glory Studios, Dade City, FL **Client:** Lebhar-Friedman **Project:** Best of Century Logo **Art Director:** Melati Smith **Designer:** Melati Smith

2 **Design Firm:** Greenfield/Belser, Washington, DC **Client:** Blue Chair **Project:** Logo **Art Director:** Burkey Belser **Designer:** Stephanie Fernandez

3 **Design Firm:** Hanson Associates, Philadelphia, PA **Client:** Eyeglass Works **Project:** Logo **Art Director:** Gil Hanson

4 **Design Firm:** HC Creative Communications, Bethesda, MD **Client:** Booz, Allen & Hamilton **Project:** Corporate Systems Logo **Art Director:** Howard Clare **Designer:** Ryan Weible

5 **Design Firm:** Hunt Weber Clark Associates, Inc., San Francisco, CA **Client:** Kimpton Hotel & Restaurant Group **Project:** Serrano Hotel Logo **Art Director:** Nancy Hunt-Weber **Designer:** Jim Deeken

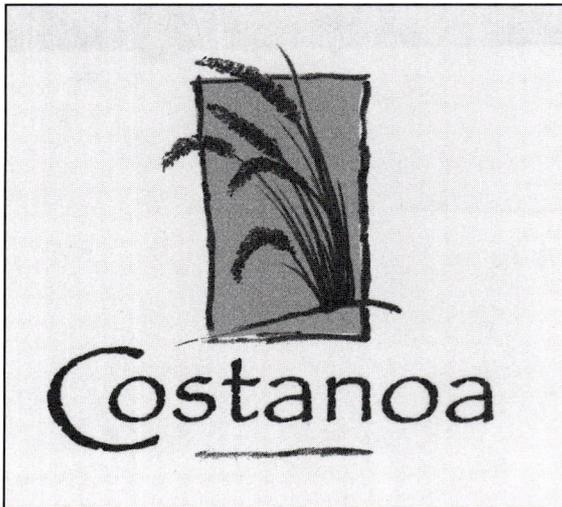

Costanoa

1

TO THE L ETTER

2

Metro

3

cyberphysician.com

4

Little Angels

A Learning Center for Children

5

1 **Design Firm:** Hunt Weber Clark Associates, Inc., San Francisco, CA **Client:** Joie de Vivre Hospitality **Project:** Costanoa Logo **Art Director:** Nancy Hunt-Weber **Designer:** Nancy Hunt-Weber, Christine Chung **Illustrator:** Nancy Hunt-Weber

2 **Design Firm:** JA Design Solutions, Coppell, TX **Client:** To The Letter **Project:** Business Logo **Art Director:** Jean Ashenfelter **Designer:** Jean Ashenfelter

3 **Design Firm:** Joseph Marcou Design Inc. and Marcou/Scheafer, Monroe Township, NJ **Client:** Metro Packaging & Imaging Inc. **Project:** Metro Logo **Art Director:** Joseph Marcou **Designer:** Joseph Marcou

4 **Design Firm:** Karl Kromer Design, San Jose, CA **Client:** Cyber Physician **Project:** Identity **Art Director:** Karl Kromer **Designer:** Karl Kromer **Illustrator:** Karl Kromer

5 **Design Firm:** Karl Kromer Design, San Jose, CA **Client:** Little Angels Day Care **Project:** Identity **Art Director:** Karl Kromer **Designer:** Karl Kromer **Illustrator:** Karl Kromer

see@there ™

1

2

3

4

Wellspring

5

1 **Design Firm:** Karl Kromer Design, San Jose, CA **Client:** See U There **Project:** Identity **Art Director:** Howell Hsiao **Designer:** Karl Kromer, Shepherd Brown **Illustrator:** Karl Kromer

2 **Design Firm:** Landor Associates, San Francisco, CA **Client:** Metabolife **Project:** Logo Design **Art Director:** Nicolas Aparicio **Designer:** Anastasia Laksmi, Kristin Konz **Photographer:** Richard Jung

3 **Design Firm:** Life Time Fitness, Eden Prairie, MN **Client:** Café della vita **Project:** Logo **Art Director:** Anne Denato **Designer:** Jason Hammond **Illustrator:** Jason Hammond

4 **Design Firm:** Love Packaging Group, Wichita, KS **Client:** Heartland Herbal **Project:** Logo **Art Director:** Chris West **Designer:** Lorna West **Illustrator:** Lorna West

5 **Design Firm:** Love Packaging Group, Wichita, KS **Client:** Wellspring **Project:** Logo for Relaxation Products **Art Director:** Chris West **Designer:** Lorna West **Illustrator:** Lorna West

1

2

3

4

5

1 **Design Firm:** Love Packaging Group, Wichita, KS **Client:** Beau Monde **Project:** Logo **Art Director:** Chris West **Designer:** Lorna West **Illustrator:** Lorna West

2 **Design Firm:** Magic Pencil Studios, Orlando, FL **Client:** WineRax.com **Project:** Logo **Art Director:** Scott Feldmann **Designer:** Linda Hartmann **Illustrator:** Linda Hartmann

3 **Design Firm:** Malcolm Grear Designers, Providence, RI **Client:** New Bedford Whaling Museum **Project:** Identity **Designer:** Malcolm Grear Designers

4 **Design Firm:** Marketpartners, Inc. Results by Design, Denver, CO **Client:** Ambeo **Project:** Logo **Art Director:** Dave LaFleur **Designer:** Susan Radetsky

5 **Design Firm:** Marketpartners, Inc. Results by Design, Denver, CO **Client:** Ambeo **Project:** Logo for Web-based Product **Art Director:** Dave LaFleur **Designer:** Julie Washburn

1

2

3

4

5

1 **Design Firm:** McMillian Design, Woodside, NY **Client:** Dr. Richard Belli, Podiatrist **Project:** Logo **Art Director:** William McMillian **Designer:** William McMillian **Illustrator:** William McMillian

2 **Design Firm:** Mitten Design, San Francisco, CA **Client:** Zaphers **Project:** Logo **Art Director:** Marianne Mitten **Designer:** Audrey Dufresne

3 **Design Firm:** Naked Eye Studios, Orlando, FL **Client:** Nouveau Group **Project:** Logo **Art Director:** John Carollo **Designer:** John Carollo

4 **Design Firm:** p11creative, Santa Ana Heights, CA **Client:** Pediatric Cancer Research Foundation **Project:** Identity **Creative Director:** Lance Huante **Designer:** David Salmassian

5 **Design Firm:** Page Design, Inc., Sacramento, CA **Client:** Genovese, Forman & Burford **Project:** Logo **Art Director:** Paul Page **Designer:** Chris Brown **Illustrator:** Chris Brown

1

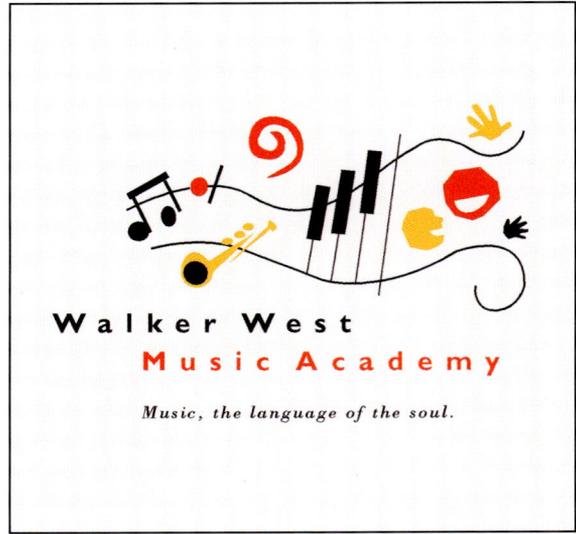

2

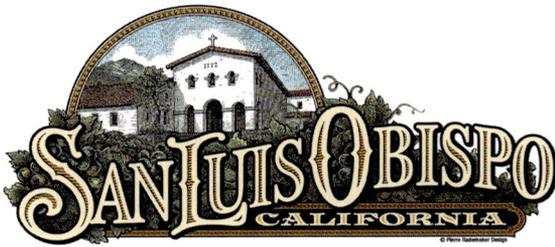

3

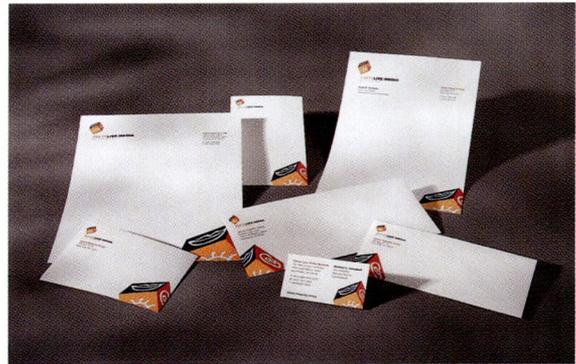

4

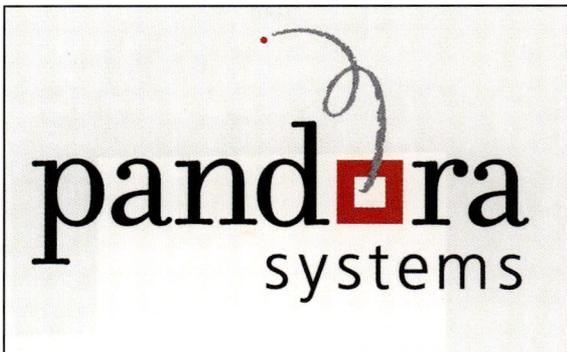

5

1 **Design Firm:** Peggy Lauritsen Design Group, Minneapolis, MN **Client:** Mineral Springs **Project:** Logo **Designer:** John Haines

2 **Design Firm:** Peggy Lauritsen Design Group, Minneapolis, MN **Client:** Walker West Music Academy **Project:** Logo **Art Director:** Peggy Lauritsen **Designer:** John Haines

3 **Design Firm:** Pierre Rademaker Design, San Luis Obispo, CA **Client:** Chamber of Commerce of San Luis Obispo **Project:** Logo **Art Director:** Pierre Rademaker **Designer:** Debbie Shibata **Illustrator:** Pierre Rademaker

4 **Design Firm:** Pisarkiewicz, Mazur & Co., Inc., New York, NY **Client:** Spartan International **Project:** Logo **Art Director:** Mary F. Pisarkiewicz **Designer:** Linda Farber

5 **Design Firm:** Raincastle Communications, Newton, MA **Client:** Pandora Systems **Project:** Logo **Art Director:** Paul Regensburg **Designer:** Micheline Bowu

1

2

3

4

5

1 **Design Firm:** Rappy & Company, Inc., New York, NY **Project:** www.rappyco.com Icons **Art Director:** Floyd Rappy **Designer:** Floyd Rappy **Illustrator:** Floyd Rappy, Soohyen Park

2 **Design Firm:** Raytheon Technical Services Co., Burlington, MA **Project:** Needs Logo **Art Director:** Keith Sturdevant **Designer:** Jim Coletta **Illustrator:** Jim Coletta

3 **Design Firm:** RiechesBaird, Irvine, CA **Client:** Giant Golf **Project:** Logo **Art Director:** Bob Comoglio, Kevin Herr **Designer:** Ray Tarquinio

4 **Design Firm:** Sabre Design & Publishing, Henderson, NV **Client:** Kids Charities.org **Project:** Tree of Life Logo **Art Director:** Christina Wilkinson, Sue Cassidy **Designer:** Christina Wilkinson **Illustrator:** Christina Wilkinson

5 **Design Firm:** SJI Associates Inc., New York, NY **Client:** Spirit of a Woman **Project:** Logo **Art Director:** Susan Sears **Designer:** GT Goto

1

2

3

4

5

1 **Design Firm:** Stephen Loges Graphic Design, New York, NY **Client:** BioNexus Foundation **Project:** Identity **Art Director:** Stephen Loges **Designer:** Stephen Loges

2 **Design Firm:** Stephen Loges Graphic Design, New York, NY **Client:** Electric Stock **Project:** Identity **Art Director:** Stephen Loges **Designer:** Stephen Loges

3 **Design Firm:** t.a. design, Hamilton, NJ **Client:** McGrath Bros. Construction **Project:** Logo **Art Director:** t.a. hahn **Designer:** t.a. hahn

4 **Design Firm:** Tamada Brown & Associates, Chicago, IL **Client:** NetSelector, Inc. **Project:** SmartZones Logo **Art Director:** Robert Brown, Phyllis Tamada-Brown **Designer:** Robert Grennen **Illustrator:** Robert Grennen

5 **Design Firm:** U.S. General Accounting Office, Washington, DC **Client:** GAO Training Institute **Project:** Training for Performance & Results **Designer:** Armetha Liles

1

2

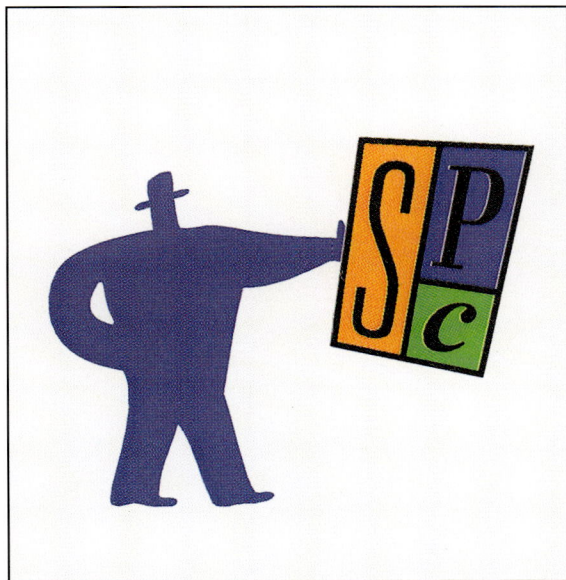

3

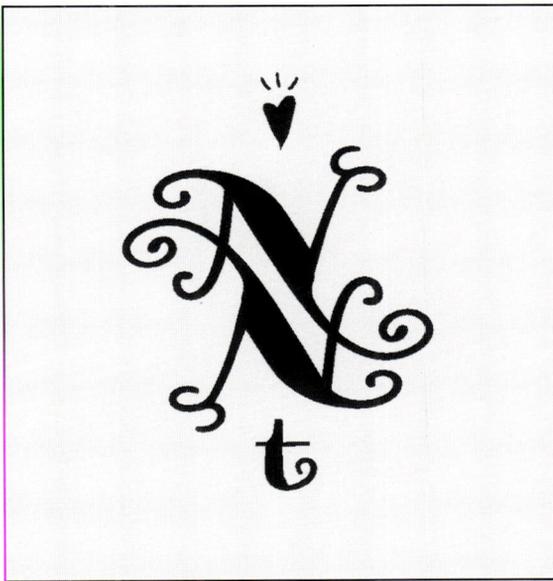

4

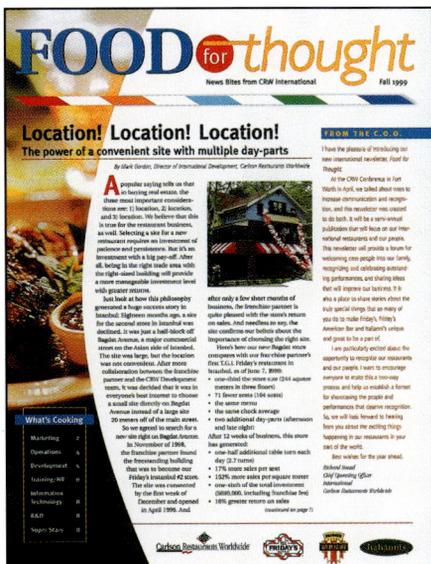

5

1 Design Firm: Westwood Studios, Las Vegas, NV **Project:** Nox Logo **Designer:** Alfred Herczeg

2 Design Firm: whiteSTARdesign, Bethlehem, PA **Client:** Allentown Art Museum **Project:** Art Ways Logo **Art Director:** Peter Stolvoort **Designer:** Peter Stolvoort **Illustrator:** Carol Stolvoort

3 Design Firm: ZGraphics, Ltd., East Dundee, IL **Client:** Service Printing Corporation **Project:** Logo **Art Director:** Joe Zeller **Designer:** Mike Girard

4 Design Firm: Laura Medeiros, Sunnyvale, CA **Client:** Nicole and Niki Trujillo **Project:** Monogram Logo **Designer:** Laura Medeiros

Newsletters

5 Design Firm: 2K Design, Clifton Park, NY **Client:** Carlson Restaurants Worldwide **Project:** CRW International News **Art Director:** Kris Fitzgerald **Designer:** Kris Fitzgerald, Beth Serfilippi

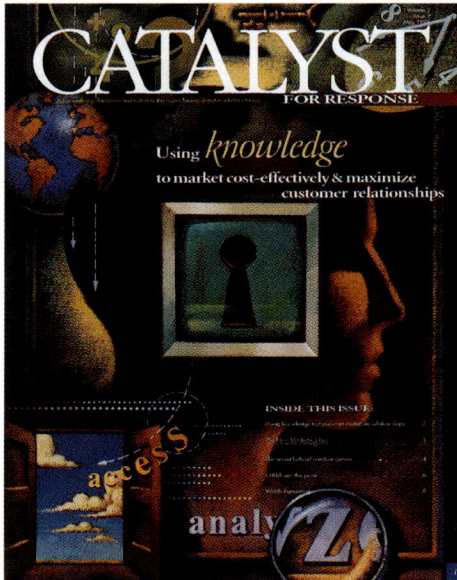

1

2

3

4

5

1 **Design Firm:** Catalyst Direct, Inc., Rochester, NY **Project:** Catalyst for Response **Art Director:** Meghan LaBonge **Designer:** Jennifer Wagner

2 **Design Firm:** Design Source East, Cranford, NJ **Client:** Ortho-Clinical Diagnostics, Inc. **Project:** InterView, Spring 1999 **Art Director:** Mark Lo Bello **Designer:** H. Dean Pillion

3 **Design Firm:** Dickson Design, Redwood City, CA **Client:** Legato Systems **Project:** Customer Newsletter **Art Director:** Deborah Shea **Designer:** Deborah Shea

4 **Design Firm:** Hill and Knowlton, Los Angeles, CA **Client:** Petsmart **Project:** Paw Prints Newsletter **Art Director:** Joyce Eicholtz **Designer:** Jennifer White

5 **Design Firm:** Jacqueline Barrett Design Inc., Oceanport, NJ **Client:** Merck and Co., Inc. **Project:** Merck World Newsletter **Art Director:** Jacqueline Barrett **Designer:** Jacqueline Barrett **Illustrator:** Elise N. Phillips

1

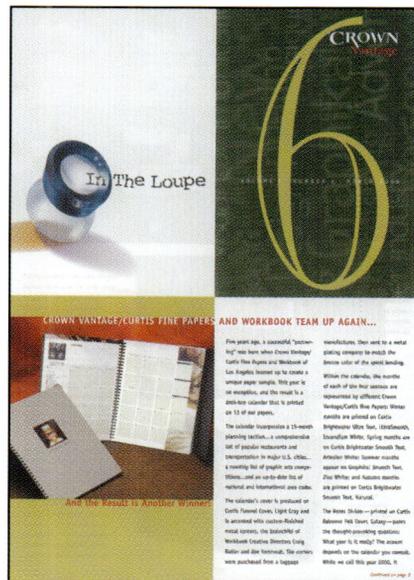

2

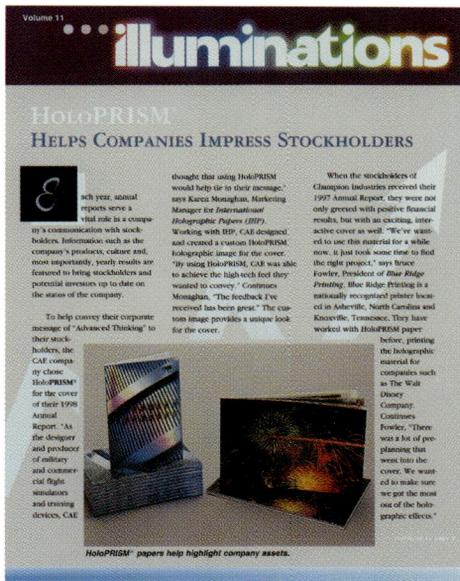

3

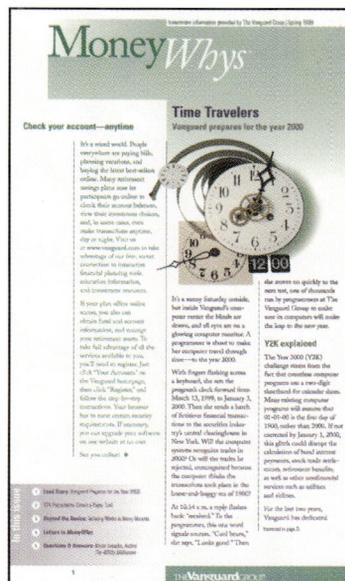

4

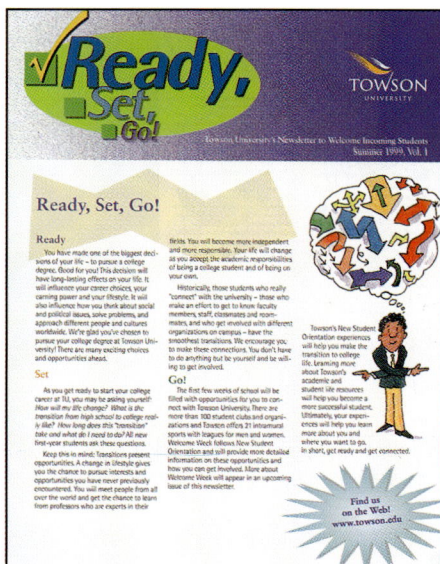

5

1 **Design Firm:** John Kneapler Design, New York, NY **Client:** Fearson Education **Project:** Celebrating The Year That Was **Art Director:** Holly Buckley **Designer:** John Kneapler, Holly Buckley **Photographer:** Jack Deutsch, Paul Schneck **Illustrator:** John Hersey, Ilene Rotheart Pigott

2 **Design Firm:** NDW Communications, Horsham, PA **Client:** Crown Vantage **Project:** In the Loupe Newsletter-Sixth Issue **Art Director:** Bill Healey, Tom Brill **Designer:** Tom Brill **Photographer:** Dan Naylor

3 **Design Firm:** Proma Technologies Co., Franklin, MA **Project:** Illuminations 11 **Art Director:** Darlene Chang **Designer:** Darlene Chang **Photographer:** Bill Durvin

4 **Design Firm:** The Vanguard Group, Malvern, PA **Project:** Money Whys Newsletter: Winter 1999 **Art Director:** Stephen Shackleford **Designer:** Bradford Kear **Photographer:** Mark Weiss

5 **Design Firm:** Towson University, Towson, MD **Client:** Towson University Office of Orientation and New Student Relations **Project:** Ready, Set, Go **Art Director:** Pat Dideriksen **Designer:** Pat Dideriksen

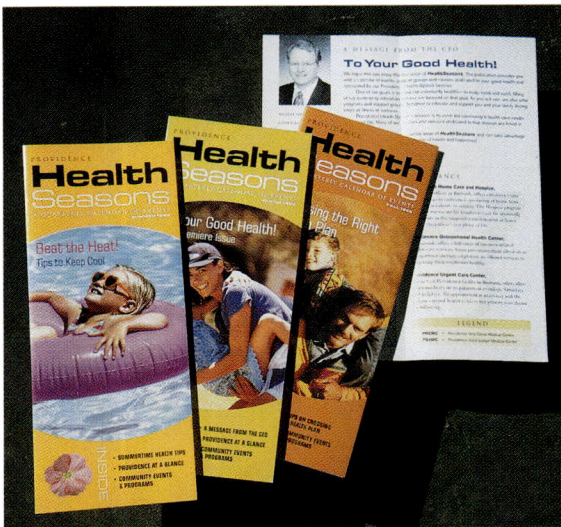

1

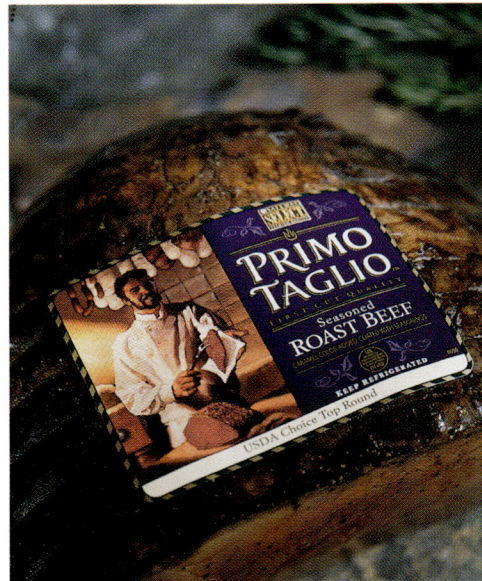

2

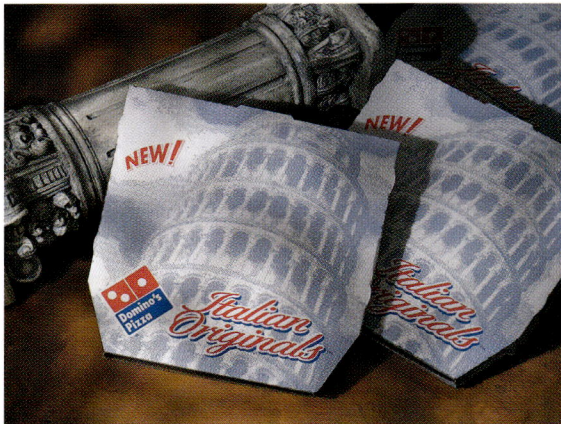

3

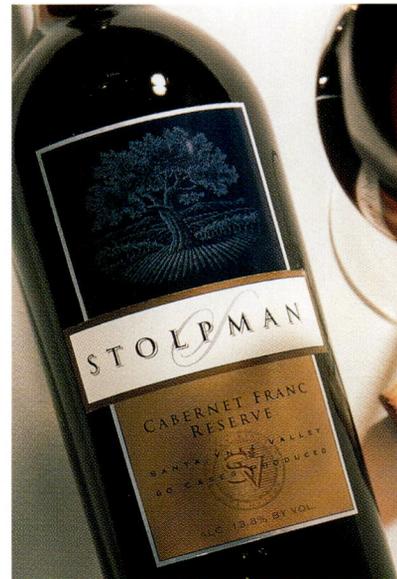

4

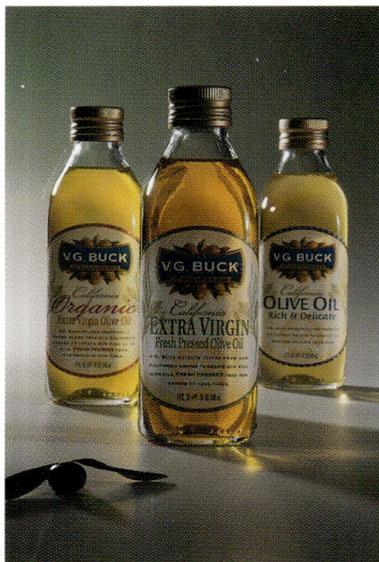

5

1 **Design Firm:** Zamboo, Marina Del Rey, CA **Client:** Providence Health System **Project:** Health Seasons Calendar **Art Director:** Becca Bootes **Designer:** Jeff Allison

Packaging

2 **Design Firm:** Addis Group, Inc., Berkeley, CA **Client:** Safeway Stores **Project:** Primo Taglio Package Design **Art Director:** Steven Addis **Designer:** David Leong **Account Executive:** Eric Ashworth **Design Director:** Joanne Hom

3 **Design Firm:** Addison, San Francisco, CA **Client:** Domino's Pizza Inc. **Project:** Italian Originals Pizza Box **Art Director:** Kraig Kessel **Designer:** Nick Bentley **Photographer:** Kevin Ng

4 **Design Firm:** Axion Design Inc., San Anselmo, CA **Client:** Stolpman Vineyards **Project:** Stolpman Wine **Art Director:** Broderick Hartman **Designer:** Axion Design **Illustrator:** Steven Noble

5 **Design Firm:** Axion Design Inc., San Anselmo, CA **Client:** Calio Groves **Project:** V.G. Buck Olive Oil **Art Director:** Ed Cristman **Designer:** Ed Cristman **Illustrator:** Matthew Holmes, Mary Rich

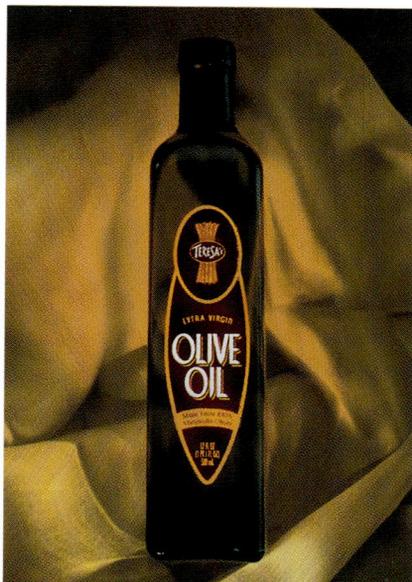

1

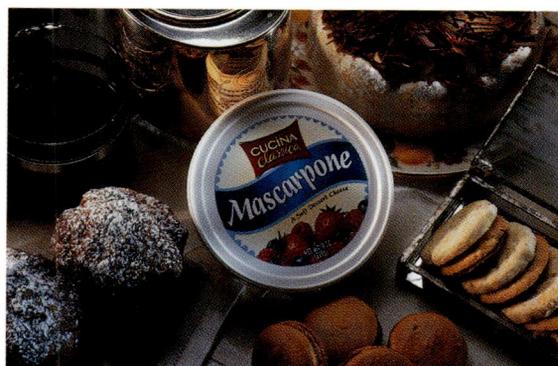

2

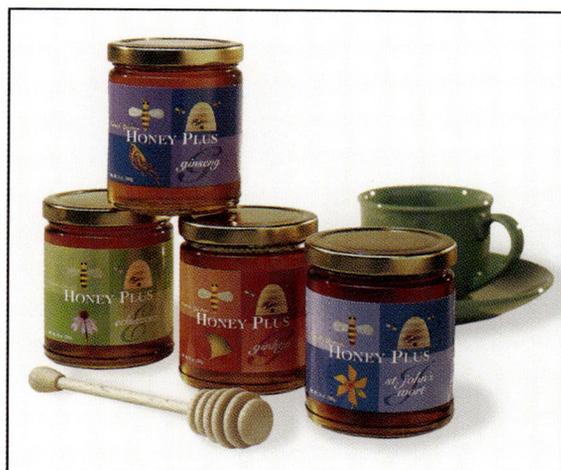

3

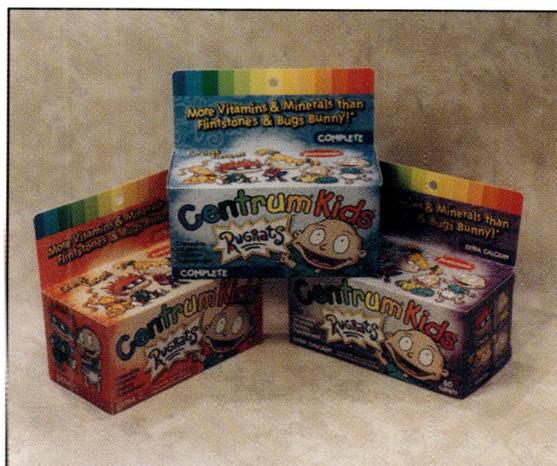

4

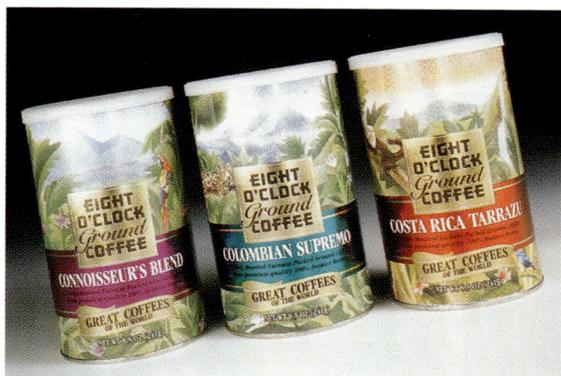

5

1 **Design Firm:** Brandesign Incorporated, Monroe, NJ **Client:** T2 Ventures **Project:** Teresa's Olive Oil **Art Director:** Barbara Harrington **Designer:** Barbara Harrington, Regina Sherman

2 **Design Firm:** Brandesign Incorporated, Monroe, NJ **Client:** Classica Group **Project:** Mascarpone Dessert Cheese **Art Director:** Barbara Harrington **Designer:** Regina Sherman **Illustrator:** Lauren Simeone

3 **Design Firm:** Brown Design & Company, Portland, ME **Client:** Fancy Fare Distributors **Project:** Honey Plus Labels **Designer:** Mary Brown **Illustrator:** Pat Corrigan

4 **Design Firm:** CAG Design, Hackettstown, NJ **Client:** American Home Products **Project:** Centrum Kids Vitamins **Designer:** David Motyl

5 **Design Firm:** Ceradini Design, New York, NY **Client:** Compass Foods **Project:** Eight O'Clock Coffee Varietal **Art Director:** David Ceradini **Designer:** David Ceradini **Illustrator:** Tim Shannon

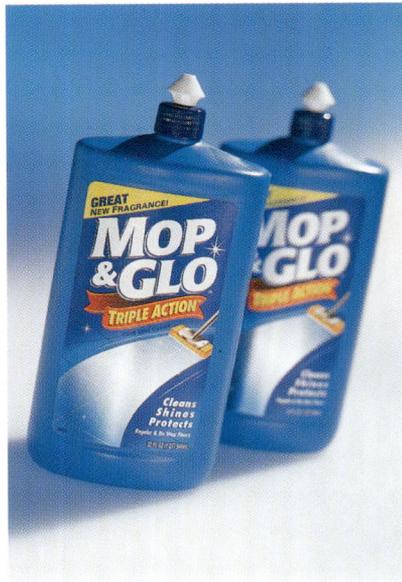

1

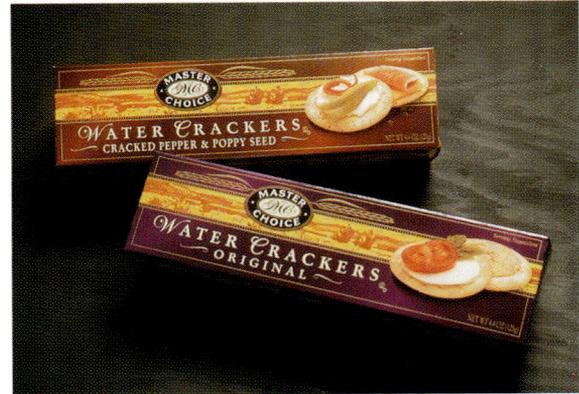

2

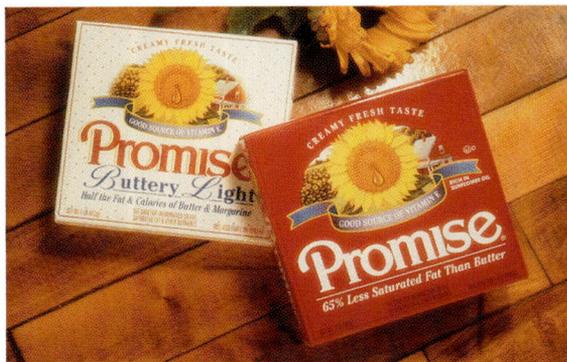

3

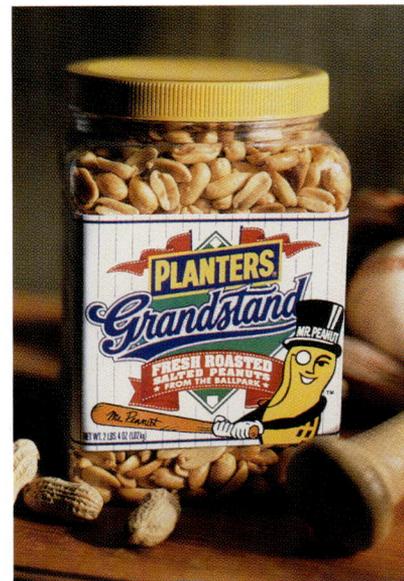

4

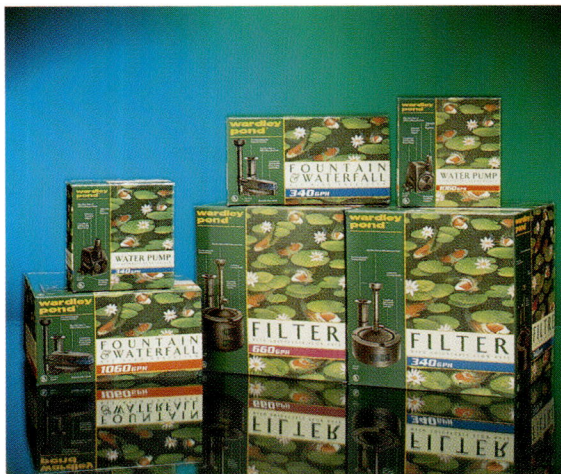

5

1 **Design Firm:** Ceradini Design, New York, NY **Client:** Reckitt and Colman **Project:** Mop & Glow Redesign **Art Director:** David Ceradini, Lori Raymer **Designer:** David Ceradini **Illustrator:** Tim Shannon

2 **Design Firm:** Ceradini Design, New York, NY **Client:** The Great Atlantic & Pacific Tea Company **Project:** Master Choice Water Crackers **Art Director:** David Ceradini, Lori Raymer **Designer:** Peter Novello **Photographer:** Kaz Photography **Illustrator:** Tim Shannon

3 **Design Firm:** Ceradini Design, New York, NY **Client:** Vandenburgh Foods **Project:** Promise Redesign **Art Director:** David Ceradini, Lori Raymer **Designer:** Lori Raymer

4 **Design Firm:** Ceradini Design, New York, NY **Client:** Nabisco **Project:** Planter's Grandstand Peanuts **Art Director:** David Ceradini, Lori Raymer **Designer:** Peter Novello

5 **Design Firm:** Ceradini Design, New York, NY **Client:** Wardley Pond Products **Project:** Fountain **Art Director:** David Ceradini, Lori Raymer **Designer:** Dave Ceradini **Illustrator:** Roger Sainz

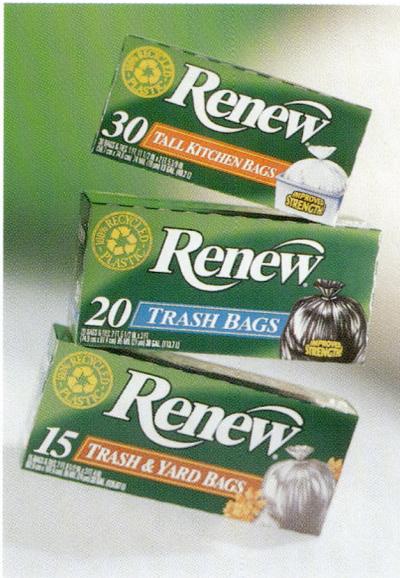

1

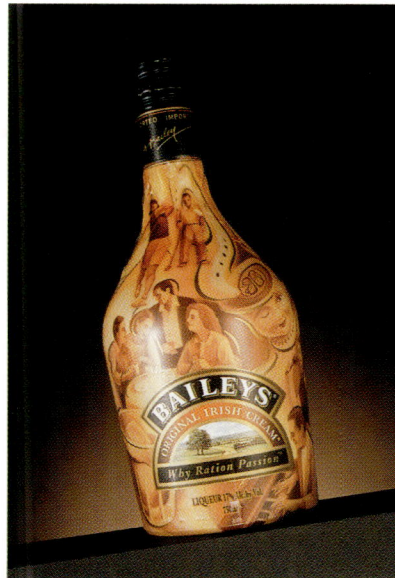

2

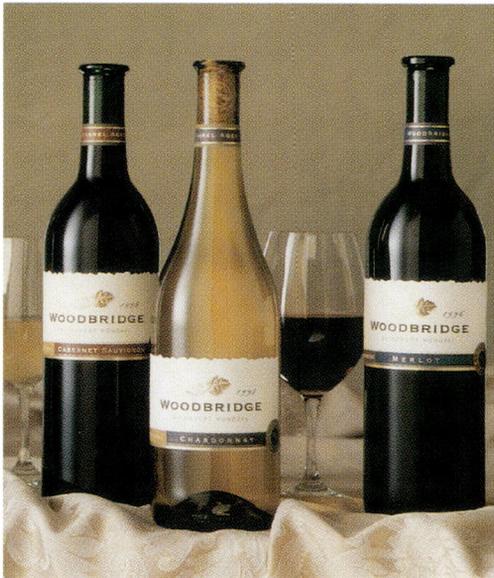

3

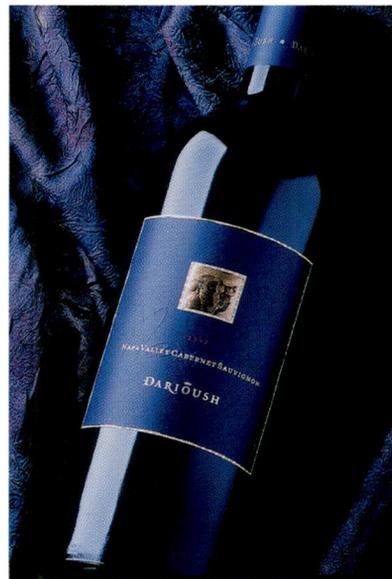

4

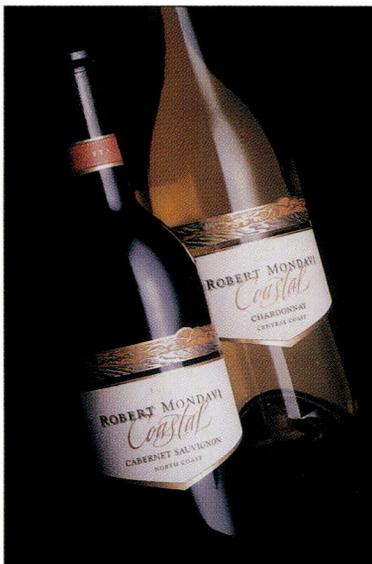

5

1 **Design Firm:** Ceradini Design, New York, NY **Client:** Zeta Consumer Prducts **Project:** Renew Trash Bags **Art Director:** David Ceradini, Lori Raymer **Designer:** David Ceradini **Illustrator:** Michael Scaraglino

2 **Design Firm:** Ceradini Design, New York, NY **Client:** United Distillers & Vintners **Project:** Bailey's Holiday Packaging **Art Director:** Lori Raymer **Designer:** Keri Piatek, Lori Raymer **Illustrator:** Kathy Petrauskas

3 **Design Firm:** CF/NAPA, Napa, CA **Client:** Woodbridge by Robert Mondavi **Project:** Packaging **Art Director:** Christina Baldwin **Designer:** Kim Wedlake **Calligrapher:** Jack Molloy **Illustrator:** Lilly Lee

4 **Design Firm:** CF/NAPA, Napa, CA **Client:** Darioush Khaledi **Project:** Fackaging **Art Director:** Susan Rouzie **Designer:** Kim Wedlake

5 **Design Firm:** CF/NAPA, Napa, CA **Client:** Robert Mondavi Coastal **Project:** Packaging **Art Director:** Christina Baldwin **Designer:** Lisa Hobro **Calligrapher:** John Stevens **Illustrator:** Larry Duke

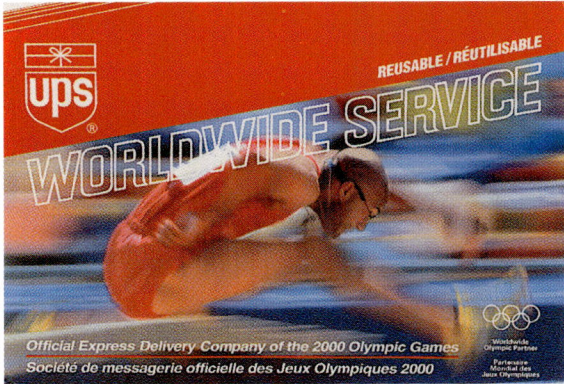

1

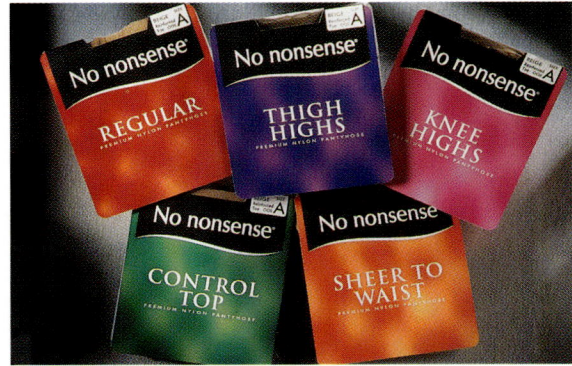

2

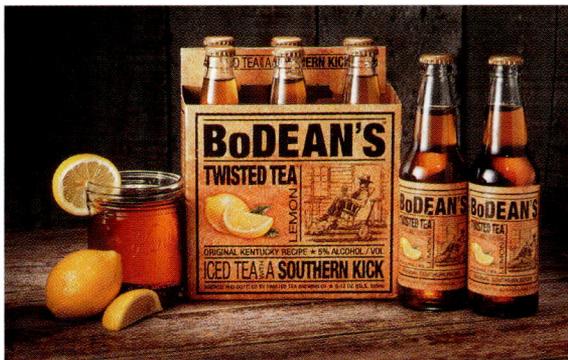

3

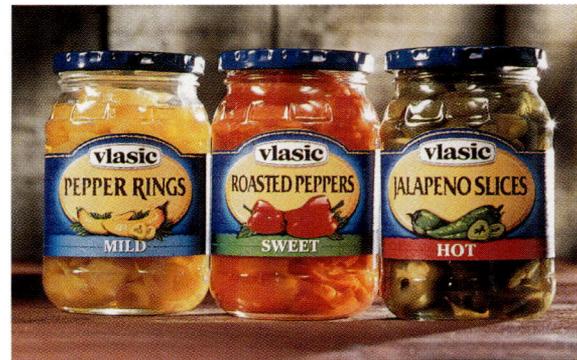

4

5

1 **Design Firm:** Clarion Marketing & Communications, Atlanta, GA **Client:** UPS **Project:** UPS Olympic Packaging **Art Director:** Peter Borowski **Designer:** Kimberly Tyner **Photographer:** Mark Gamba

2 **Design Firm:** Cornerstone Design Associates, New York, NY **Client:** Kayser Roth **Project:** No-Nonsense Brand Identity Development **Art Director:** Keith Steimel, Sally Clarke **Designer:** Sally Clarke, Sarah Sansum, Julia Smith

3 **Design Firm:** Cornerstone Design Associates, New York, NY **Client:** Boston Beer Co. **Project:** Bodean's Twisted Tea **Art Director:** Keith Steimel, Sally Clarke **Illustrator:** Clint Hawsen, Lorian Zaione

4 **Design Firm:** Cornerstone Design Associates, New York, NY **Client:** Vlasic Foods **Project:** Vlasic Peppers Packaging **Art Director:** Keith Steimel, Sally Clarke **Designer:** Julia Smith, Sally Clarke **Illustrator:** Julia Smith

5 **Design Firm:** Design Guys, Minneapolis, MN **Client:** Target Stores **Project:** Graves Kitchen Gadget Packaging **Art Director:** Steven Sikora **Designer:** Gary Patch

1

2

3

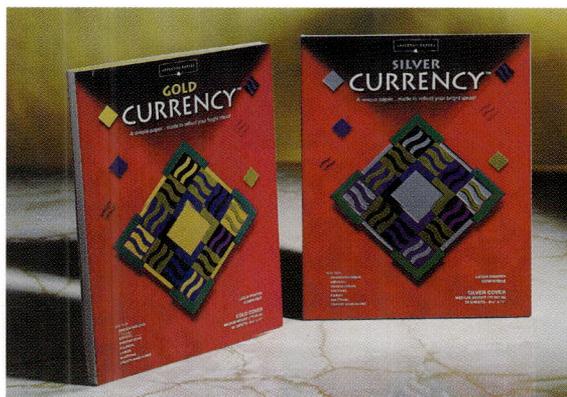

4

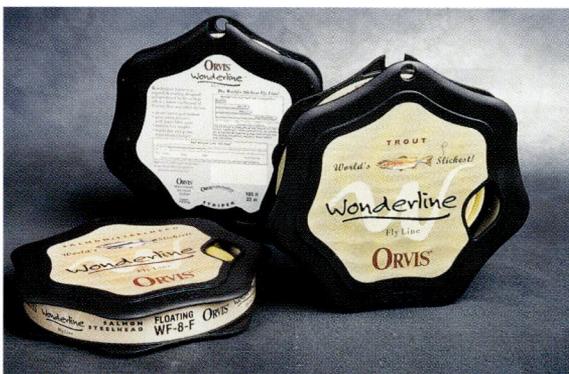

5

1 **Design Firm:** Design Guys, Minneapolis, MN **Client:** Target Stores **Project:** Bon Appetit Packaging **Art Director:** Steven Sikora **Designer:** Jay Theige

2 **Design Firm:** Design North, Inc., Racine, WI **Client:** Gardetto & Co., Inc. **Project:** Snack-Ens **Art Director:** Gwen Granzow **Designer:** Pat Cowan, Jane Marcussen, Jackie Langenecker

3 **Design Firm:** Design North, Inc., Racine, WI **Client:** Heinz Frozen Foods **Project:** Budget Gourmet **Designer:** Gwen Granzow, Jackie Langenecker

4 **Design Firm:** Directions Incorporated, Neenah, WI **Client:** Appleton Papers **Project:** Currency Package **Art Director:** Kent Perrin

5 **Design Firm:** Donaldson Makoski Inc., Avon, CT **Client:** ORVIS **Project:** ORVIS-Wonderline Flyline **Art Director:** Chet Makoski **Designer:** Jane Heft, James Aresco **Illustrator:** Chuck Primeau, Mike Stidham

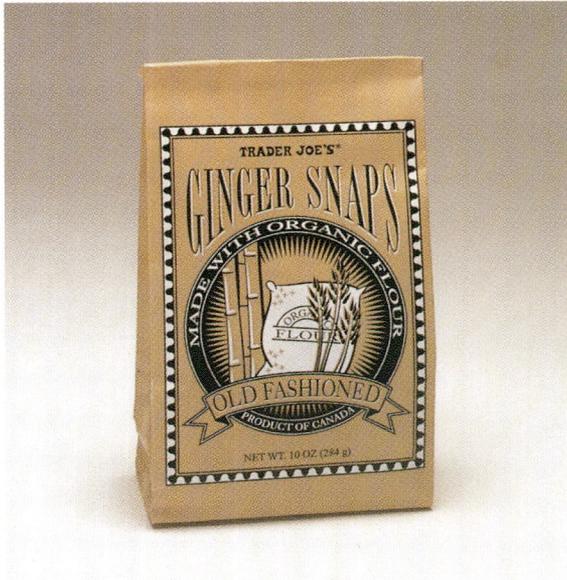

1

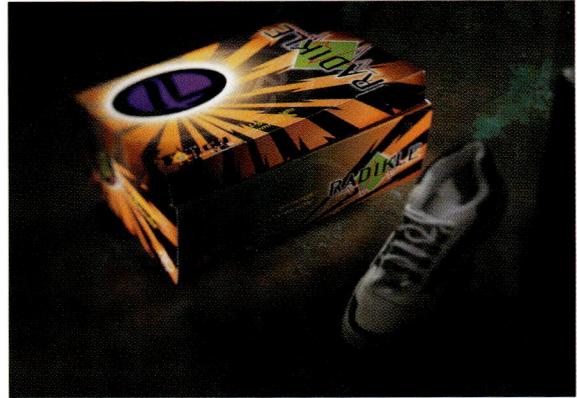

2

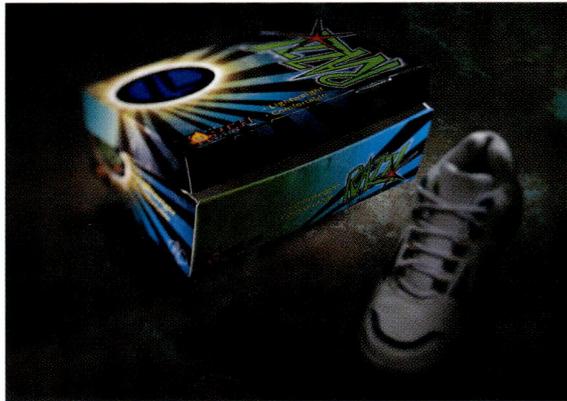

3

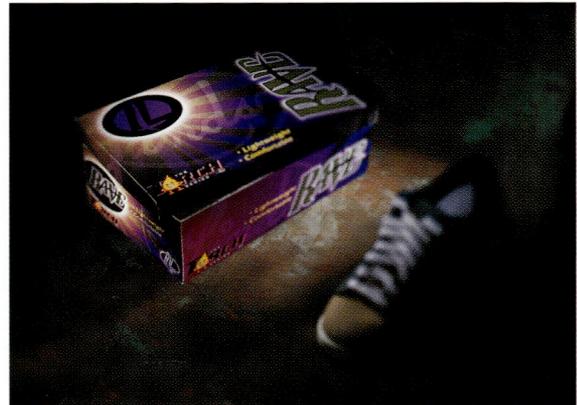

4

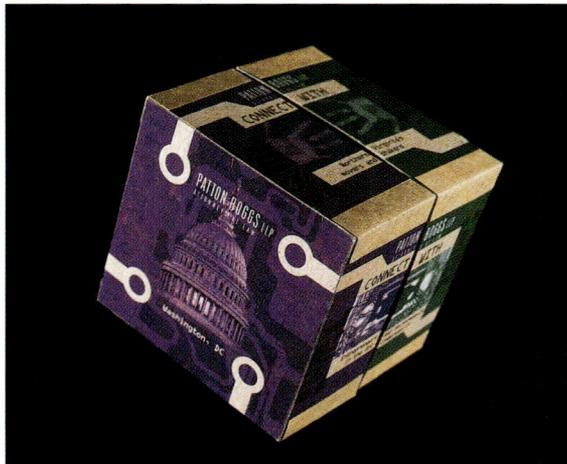

5

1 **Design Firm:** Ezzona Design Group, Inc., Burbank, CA **Client:** Trader Joe's Company **Project:** Ginger Snaps **Art Director:** Sonny De Guzman **Designer:** Gina Vivona

2 **Design Firm:** Genysis Creative Services, Scottsdale, AZ **Client:** Lind Shoe Company **Project:** Radikle Shoebox/Logo **Art Director:** Stuart T. Wright **Designer:** Stuart T. Wright

3 **Design Firm:** Genysis Creative Services, Scottsdale, AZ **Client:** Lind Shoe Company **Project:** Razz Shoebox/Logo **Art Director:** Stuart T. Wright **Designer:** Stuart T. Wright

4 **Design Firm:** Genysis Creative Services, Scottsdale, AZ **Client:** Lind Shoe Company **Project:** Rave Shoebox/Logo **Art Director:** Stuart T. Wright **Designer:** Stuart T. Wright

5 **Design Firm:** Greenfield/Belser, Washington, DC **Client:** Patton Boggs **Project:** Connect with Coffee Promotion **Art Director:** Burkey Belser **Designer:** Tom Cameron

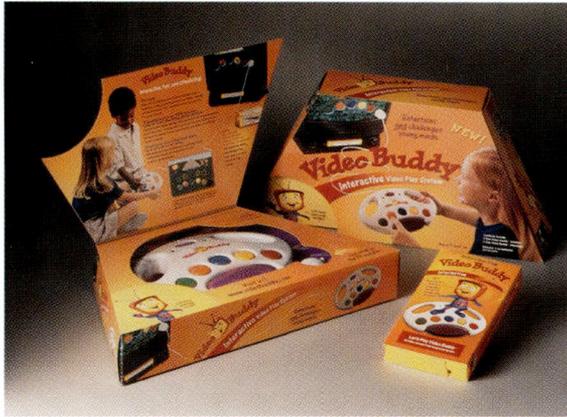

1

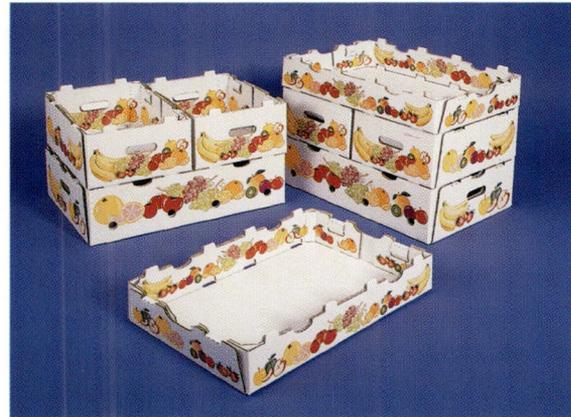

2

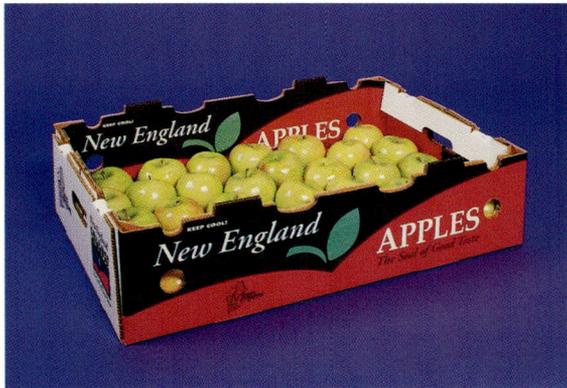

3

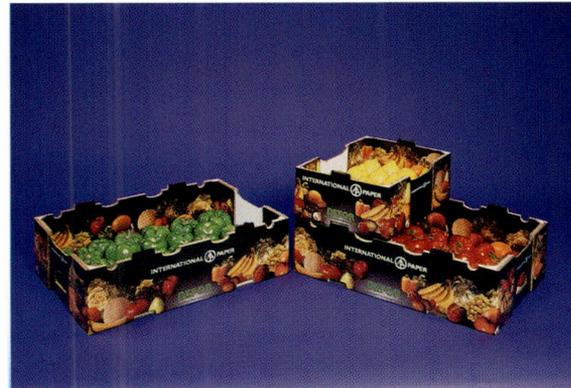

4

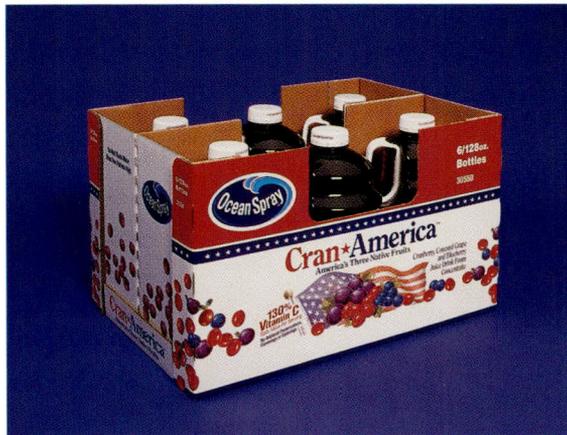

5

1 **Design Firm:** Hedstrom/Blessing, Inc., Minneapolis, MN **Client:** Interactive Learning Group **Project:** Video Buddy Packaging **Art Director:** Pam Goebel **Designer:** Pam Goebel **Photographer:** Jack Revoir

2 **Design Firm:** International Paper, Memphis, TN **Client:** Albertson's **Project:** Produce Display **Art Director:** Roger Rasor **Designer:** Shea Morgan **Illustrator:** Shea Morgan, Terry Jarred

3 **Design Firm:** International Paper, Memphis, TN **Client:** New England Apples **Project:** Apple Tray **Art Director:** Roger Rasor **Designer:** Terry Jarred **Illustrator:** Terry Jarred

4 **Design Firm:** International Paper, Memphis, TN **Project:** Produce Display Tray **Art Director:** Roger Rasor **Designer:** Terry Jarred

5 **Design Firm:** International Paper, Memphis, TN **Client:** Ocean Spray **Project:** Cran-America Juice Display Packaging **Art Director:** Roger Rasor **Designer:** Terry Jarred

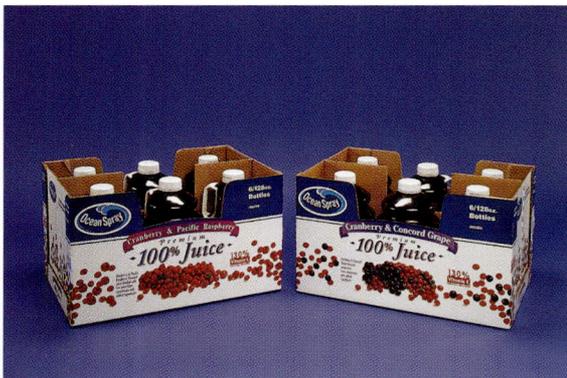

1

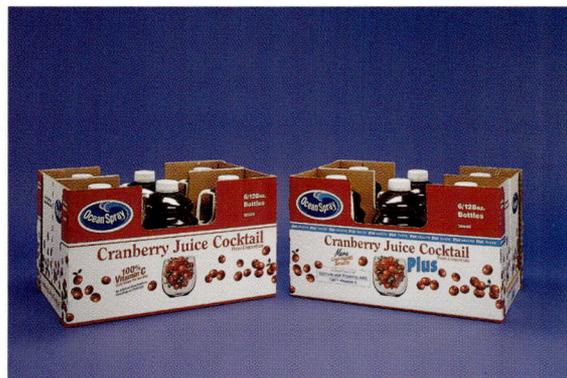

2

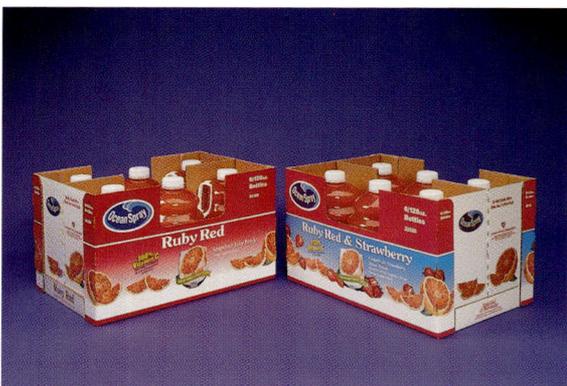

3

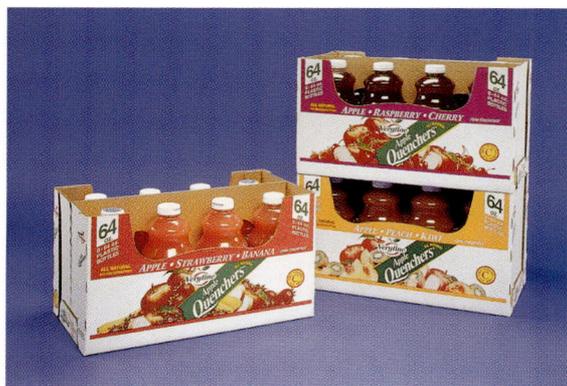

4

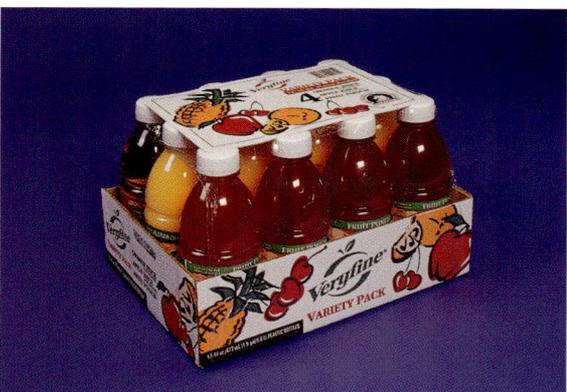

5

1 **Design Firm:** International Paper, Memphis, TN **Client:** Ocean Spray **Project:** 100% Juice Display Packaging **Art Director:** Roger Rasor **Designer:** Terry Jarred

2 **Design Firm:** International Paper, Memphis, TN **Project:** Cranberry Juice Cocktail Display Packaging **Art Director:** Roger Rasor **Designer:** Terry Jarred

3 **Design Firm:** International Paper, Memphis, TN **Client:** Ocean Spray **Project:** Ruby Red Juice Display **Art Director:** Roger Rasor **Designer:** Terry Jarred

4 **Design Firm:** International Paper, Memphis, TN **Client:** Very Fine **Project:** Apple Quenchers Drink **Art Director:** Roger Rasor **Designer:** Shea Morgan

5 **Design Firm:** International Paper, Memphis, TN **Client:** Very Fine **Project:** Fruit Drink Tray **Art Director:** Roger Rasor **Designer:** Shea Morgan **Illustrator:** Shea Morgan

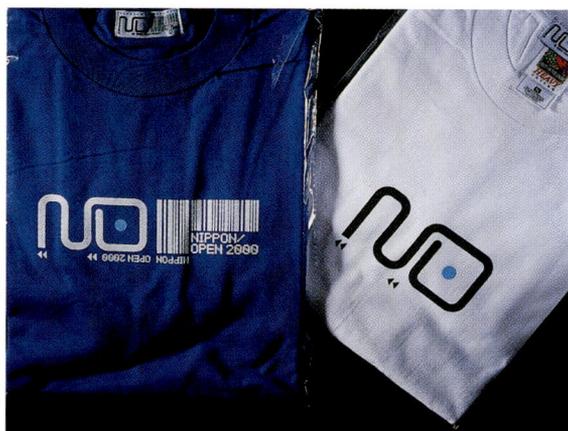

1

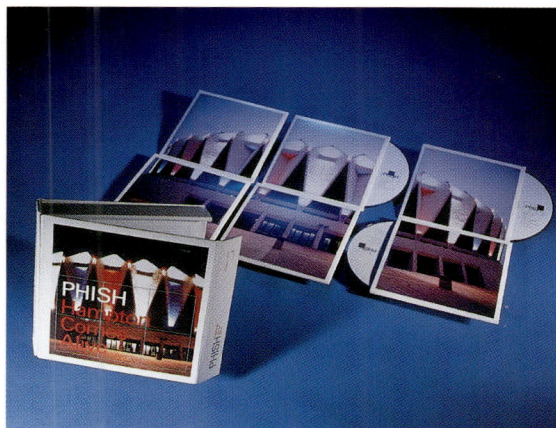

2

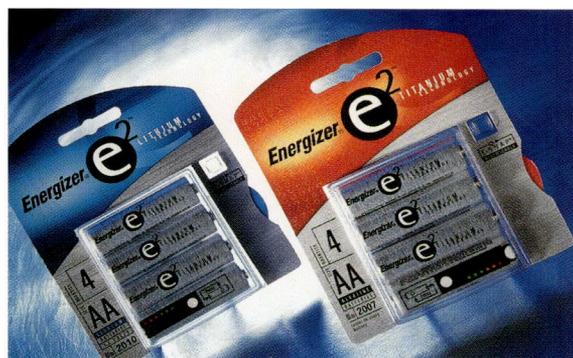

3

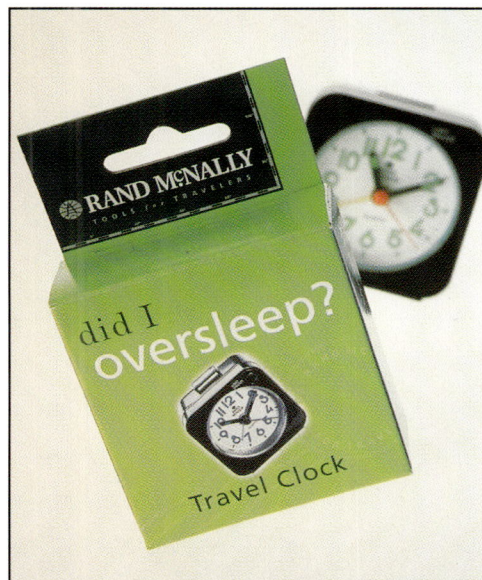

4

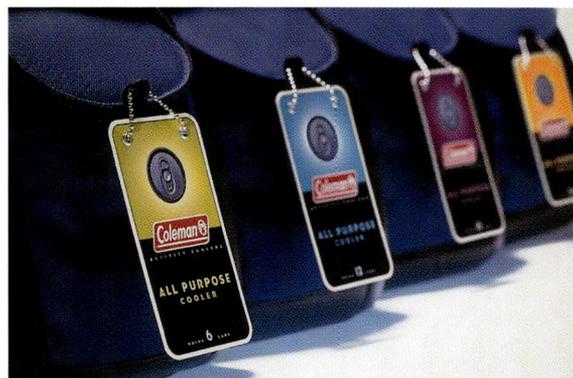

5

1 **Design Firm:** Jager Di Paola Kemp Design, Burlington, VT **Client:** Burton Snowboards **Project:** Nippon Open T-Shirts/Box **Art Director:** Jared Eberhardt **Designer:** Malcolm Buick, Cody Hudson

2 **Design Firm:** Jager Di Paola Kemp Design, Burlington, VT **Client:** Dionysian Productions **Project:** Phish Hampton Comes Alive **Art Director:** Jared Eberhardt **Designer:** Todd Wender **Photographer:** Neehar Parikh, Carl Brooks, Taylor Crothers, Bart Stephens, Mike McNamara, Pete Sitzman

3 **Design Firm:** Landor Associates, San Francisco, CA **Client:** Eveready Battery Company **Project:** Energizer e2 **Art Director:** Nicolas Aparicio, Jeff Carino **Designer:** Andrew Otto

4 **Design Firm:** Landor Associates, San Francisco, CA **Client:** Rand McNally **Project:** Travel Accessories **Art Director:** Nicolas Aparicio **Designer:** Ann Asche **Photographer:** Michael Friel

5 **Design Firm:** Landor Associates, San Francisco, CA **Client:** The Coleman Company **Project:** Coleman Coolers **Art Director:** Nicolas Aparicio, Chris Lehmann **Designer:** Anastasia Laksmi **Photographer:** Michael Friel

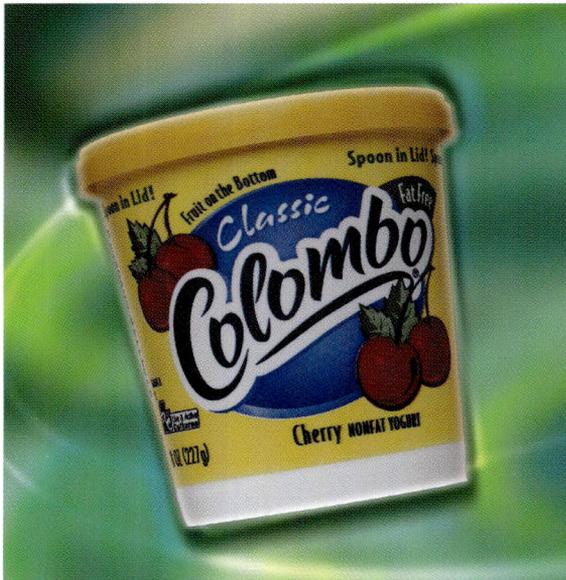

1

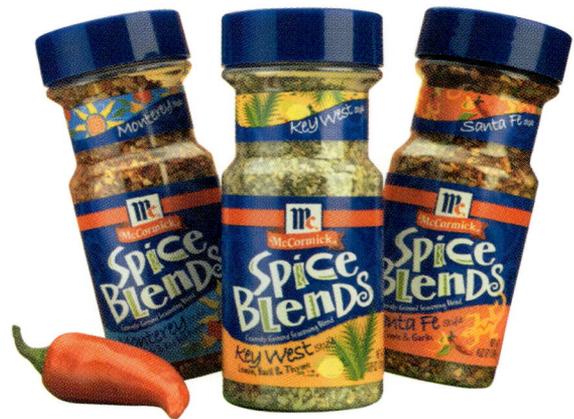

2

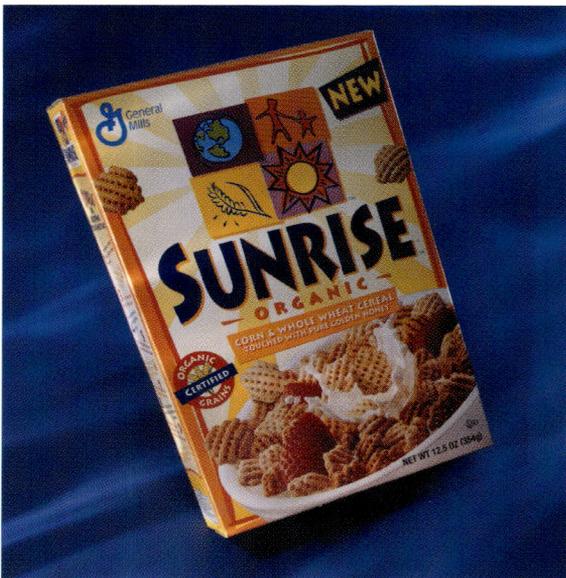

3

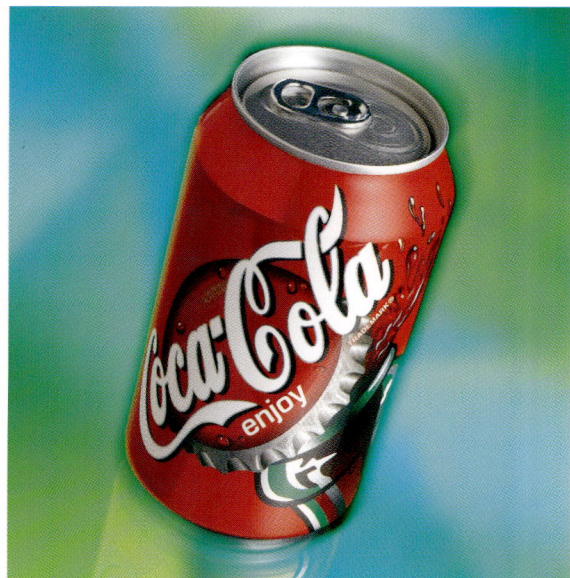

4

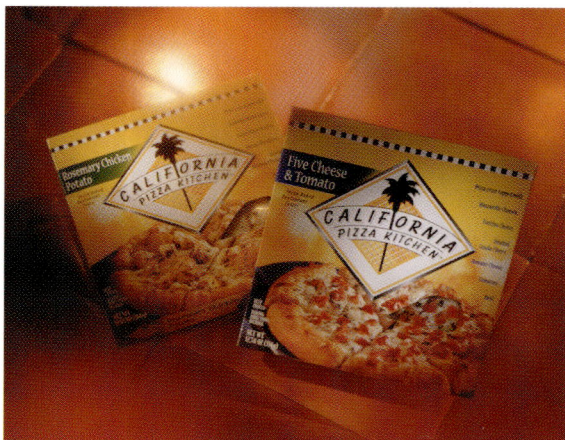

5

1 **Design Firm:** Lipson Alport Glass, Northbrook, IL **Client:** General Mills, Inc. **Project:** Colombo Yogurt **Art Director:** Lynn Mueller **Designer:** Lori Cerwin **Creative Director:** Sam Ciulla

2 **Design Firm:** Lipson Alport Glass, Northbrook, IL **Client:** McCormick & Co., Inc. **Project:** Spice Blends **Art Director:** Don Childs **Designer:** S. Smith, T. Binzer, J. Posy

3 **Design Firm:** Lipson Alport Glass, Northbrook, IL **Client:** General Mills, Inc. **Project:** Sunrise Cereal **Designer:** Kara Fleming **Creative Director:** Sam Ciulla

4 **Design Firm:** Lipson Alport Glass, Northbrook, IL **Client:** The Coca-Cola Company **Project:** Coca-Cola Global Package Redesign **Art Director:** Tracy Bacilek **Designer:** Jon Shapiro, Lori Cerwin **Creative Director:** Sam Ciulla

5 **Design Firm:** Lipson Alport Glass, Northbrook, IL **Client:** Kraft Foods, Inc. **Project:** California Pizza Kitchen **Art Director:** Candy Piemonte **Designer:** Rob Heimbrock **Creative Director:** Lynn Mueller

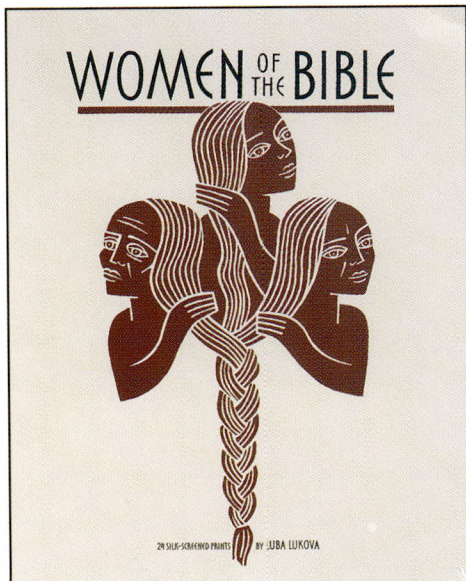

1

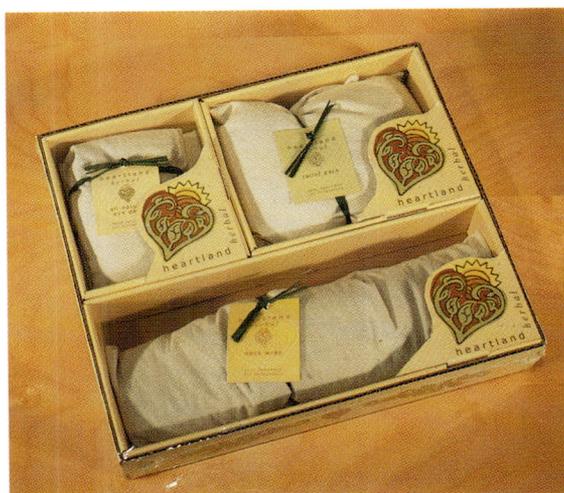

2

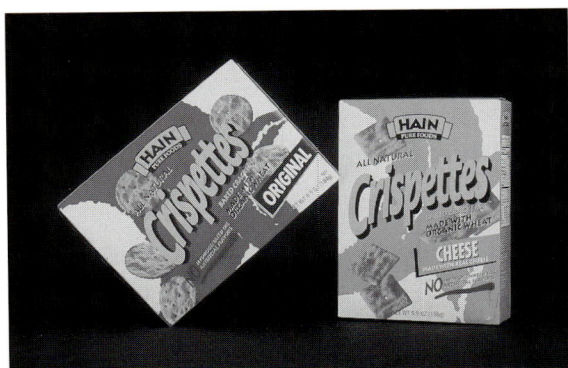

3

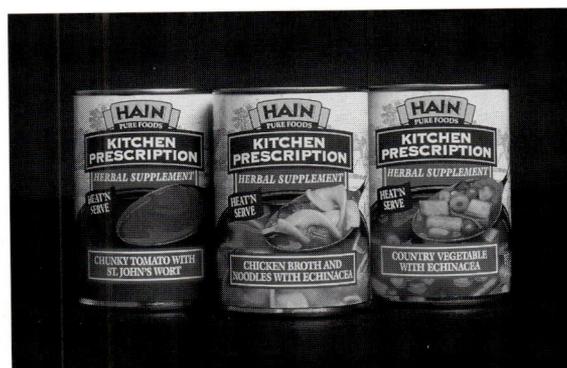

4

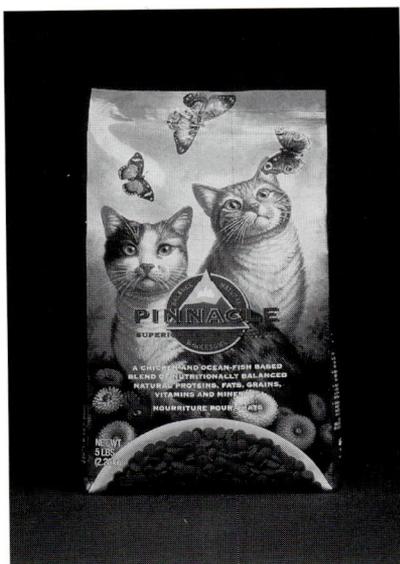

5

1 **Design Firm:** Liturgy Training Publications, Chicago, IL **Project:** Women of the Bible **Designer:** Lucy Smith **Illustrator:** Luba Lukova

2 **Design Firm:** Love Packaging Group, Wichita, KS **Client:** Heartland Herbal **Project:** Gift Box Packaging **Art Director:** Chris West **Designer:** Lorna West **Illustrator:** Lorna West

3 **Design Firm:** Mark Oliver, Inc., Santa Barbara, CA **Client:** Hain Food Group **Project:** Crispettes **Art Director:** Mark Oliver **Designer:** Mark Oliver, Brenna Pierce **Photographer:** DeGennaro

4 **Design Firm:** Mark Oliver, Inc., Santa Barbara, CA **Client:** Hain Food Group **Project:** Kitchen Prescriptions **Art Director:** Mark Oliver **Designer:** Mark Oliver, Patty Driskel **Photographer:** James Chen

5 **Design Firm:** Mark Oliver, Inc., Santa Barbara, CA **Client:** Breeder's Choice **Project:** Pinnacle Cat **Art Director:** Mark Oliver **Designer:** Mark Oliver, Patty Driskel **Photographer:** Burke/Triolo **Illustrator:** Dan Craig

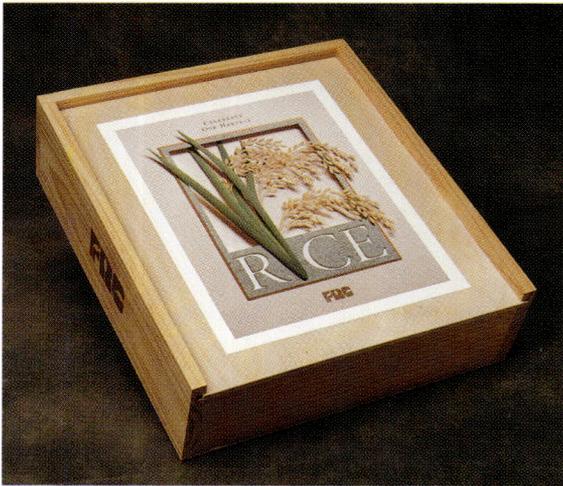

1

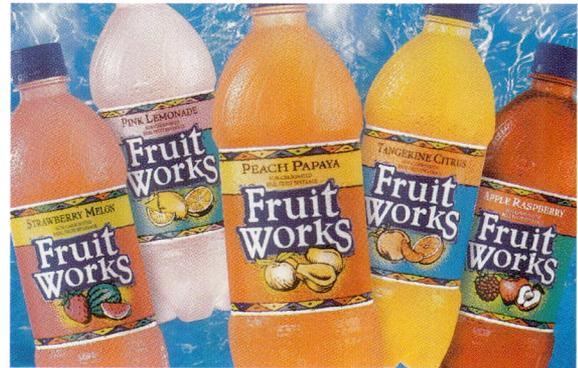

2

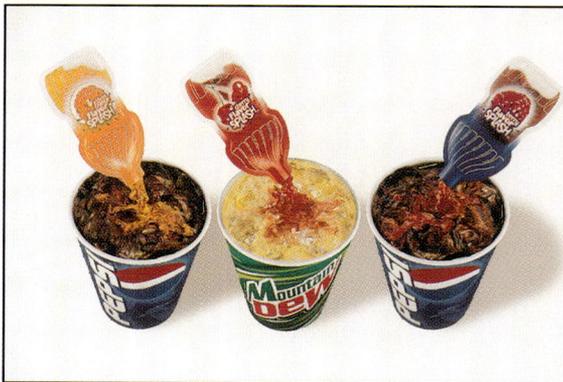

3

4

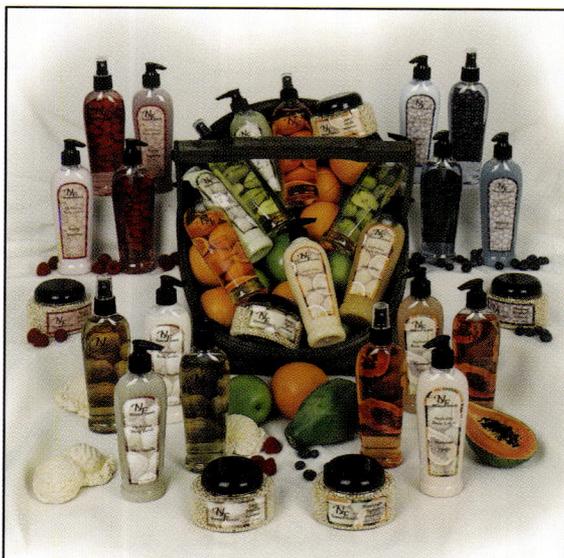

5

1 **Design Firm:** Page Design, Inc., Sacramento, CA **Client:** Farmers Rice Cooperative **Project:** Gift Box **Art Director:** Paul Page, Heather Orr **Designer:** Heather Orr, Sherril Cortez **Illustrator:** Jeff Nishinaka

2 **Design Firm:** Pepsi-Cola Company, Purchase, NY **Project:** Fruitworks **Art Director:** Gina Romero **Designer:** Pepsi Cola Design Group **Illustrator:** Klaus Spitzenberger

3 **Design Firm:** Pepsi-Cola Company, Purchase, NY **Project:** Flavor Splash Packaging **Art Director:** Christen K. Gobin **Designer:** Christen K. Gobin

4 **Design Firm:** Pepsi-Cola Company, Purchase, NY **Client:** Pepsi-Cola Design Group **Project:** Logo **Art Director:** Christen K. Gobin **Designer:** Christen K. Gobin

5 **Design Firm:** Pinnacle Graphics, Addison, TX **Client:** Nature's Formula **Project:** Bath & Body Products **Art Director:** Wendy Hanson **Designer:** Wendy Hanson, Stan Hill **Photographer:** Darrell Wilke

1

2

3

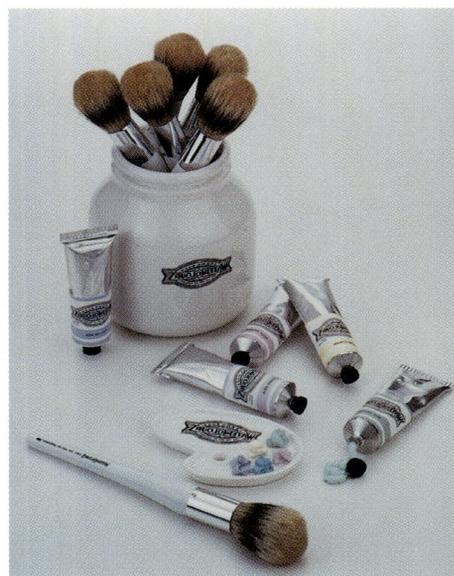

4

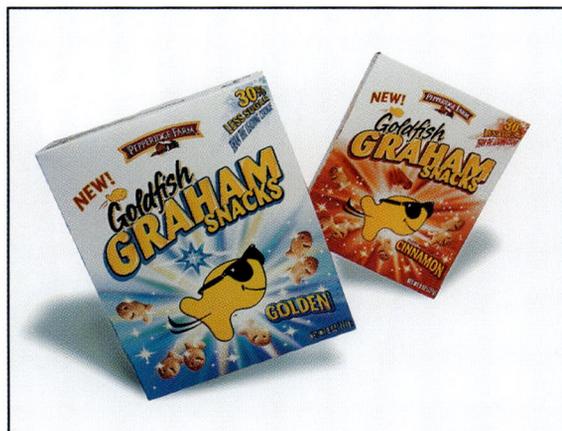

5

1 **Design Firm:** Premier Design Studio, Inc., Royal Oak, MI **Client:** DMB&B Public Relations **Project:** GM Media Information Kit **Art Director:** Pete Pultz **Designer:** Pete Pultz

2 **Design Firm:** Propeller Works, Stamford, CT **Client:** Miles Wine Cellars **Project:** Labels **Designer:** Regina Vorgang

3 **Design Firm:** Robideaux! Advertising & Marketing, Spokane, WA **Client:** Coeur d' Alene Brewing Co. **Project:** CDA Brewing Co. **Art Director:** Toni Robideaux **Designer:** Shawn Davis **Photographer:** Bruce Andre **Illustrator:** Shawn Davis

4 **Design Firm:** Sayles Graphic Design, Des Moines, IA **Client:** Gianna Rose **Project:** Watercolour Packaging **Art Director:** John Sayles **Designer:** John Sayles **Illustrator:** John Sayles

5 **Design Firm:** Sterling Group, New York, NY **Client:** Pepperidge Farm **Project:** Goldfish Grahams **Art Director:** Amanda Lawrence **Designer:** Peggy Lo

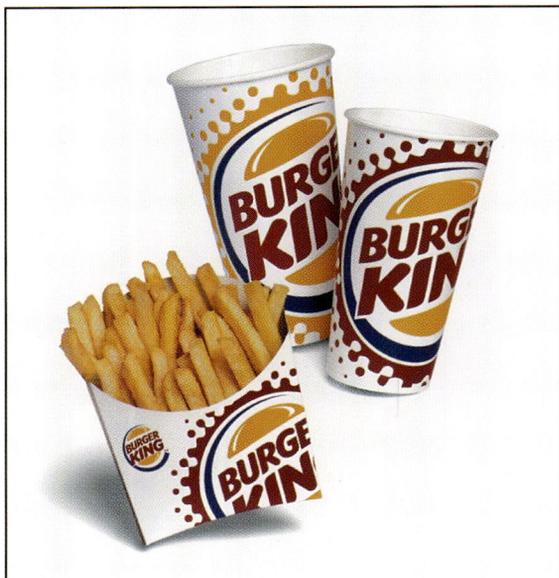

1

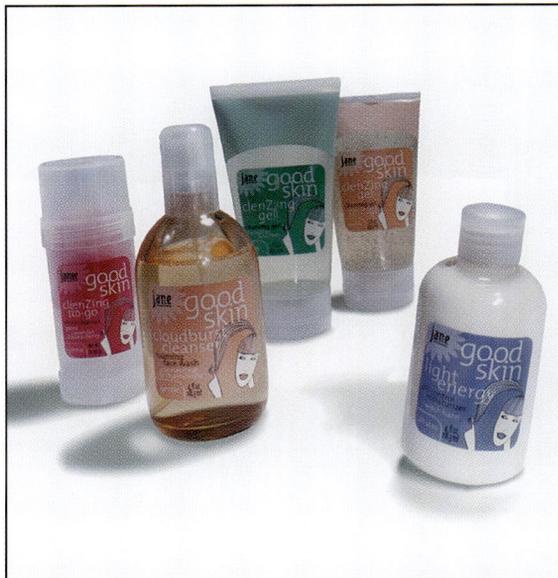

2

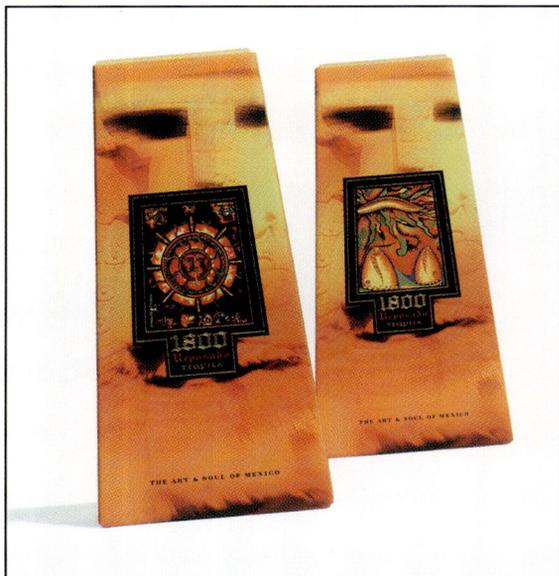

3

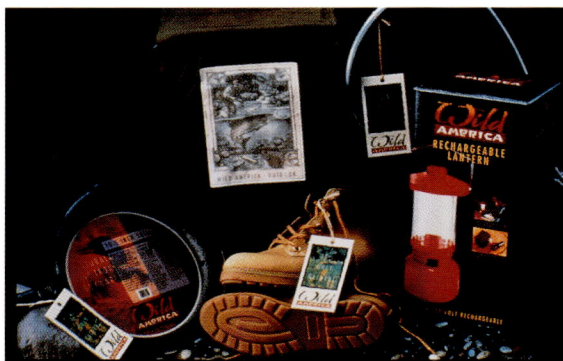

4

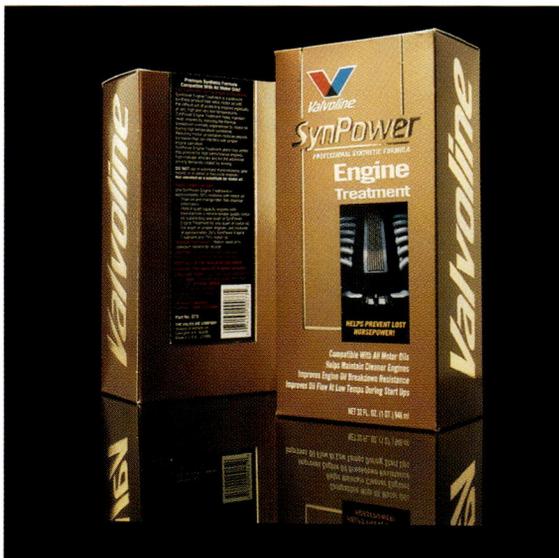

5

1 **Design Firm:** Sterling Group, New York, NY **Client:** Burger King Corporation **Project:** Package **Art Director:** Marcus Hewitt **Designer:** James Grant

2 **Design Firm:** Sterling Group, New York, NY **Client:** Estée Lauder **Project:** Jane Goodskin Package **Designer:** Marcus Hewitt

3 **Design Firm:** Sterling Group, New York, NY **Client:** UDV **Project:** Jose Cuervo 1800 Gift **Art Director:** Amanda Lawrence **Designer:** Amanda Lawrence

4 **Design Firm:** Target Packaging, Minneapolis, MN **Project:** Wild America **Art Director:** Christopher Everett, Julie Lyrek **Designer:** Baker Associates **Creative Director:** Scott Baker

5 **Design Firm:** The Valvoline Company, Lexington, KY **Project:** Syn Power Engine Treatment Box **Art Director:** Larry Schrock **Designer:** Larry Schrock

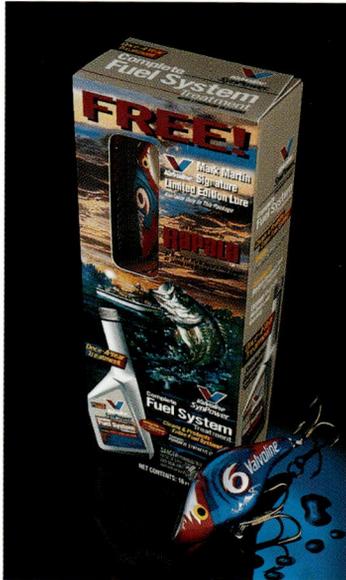

1

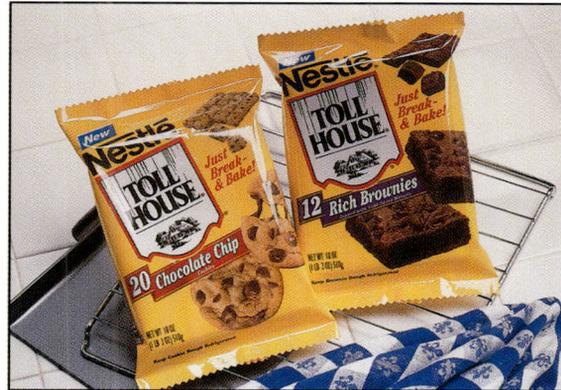

2

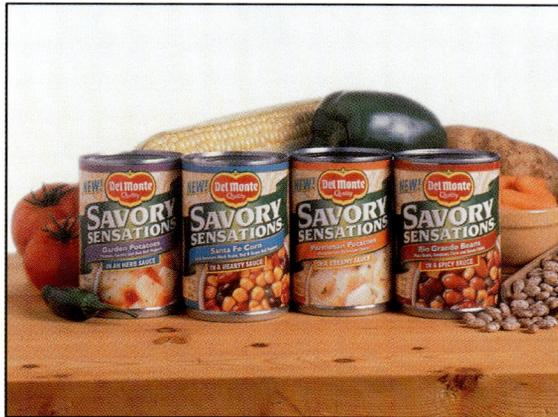

3

4

5

1 **Design Firm:** The Valvoline Company, Lexington, KY **Project:** Syn Power/Rapala Promotion **Art Director:** Larry Schrock **Designer:** Larry Schrock

2 **Design Firm:** Thompson Design Group, San Francisco, CA **Client:** Nestlé USA Confections & Snacks Division **Project:** Toll House Break & Bake **Art Director:** Dennis Thompson **Designer:** Veronica Denny **Photographer:** Aaron Rezny

3 **Design Firm:** Thompson Design Group, San Francisco, CA **Client:** Del Monte Foods **Project:** Savory Sensations **Art Director:** Dennis Thompson **Designer:** Patrick Faser **Photographer:** Bob Montesclaros **Illustrator:** Barbara Maslen

4 **Design Firm:** Thompson Design Group, San Francisco, CA **Client:** B oright **Project:** Arizona Sun **Art Director:** Dennis Thompson **Designer:** Felicia Utomo

5 **Design Firm:** Wallace Church Associates Inc., New York, NY **Client:** The Gillette Co. **Project:** Mach 3 **Art Director:** Stan Church **Designer:** David Minkley **Illustrator:** Lucian Toma

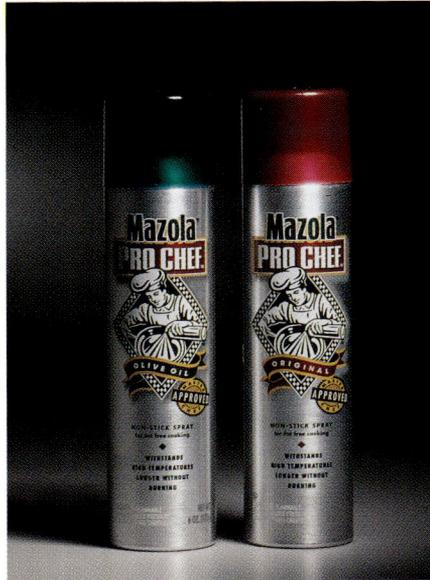

1

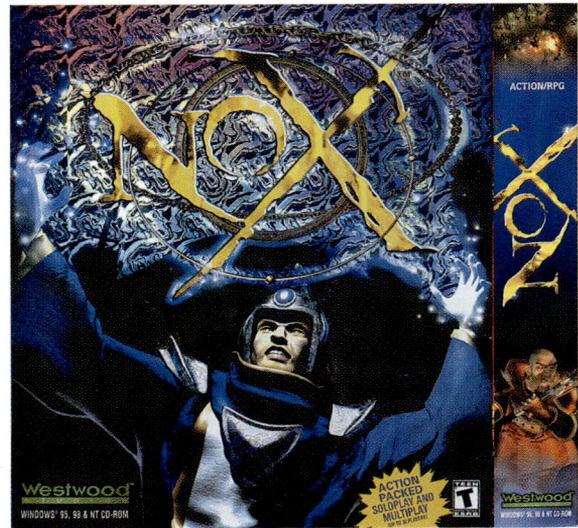

2

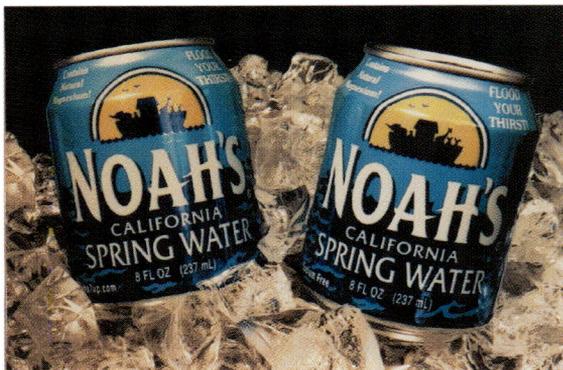

3

4

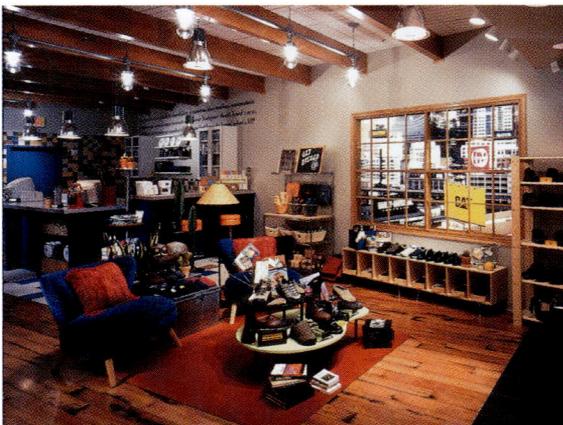

5

1 **Design Firm:** Wallace Church Associates Inc., New York, NY
Client: Best Foods **Project:** Mazola Pro-Chef **Art Director:** Wendy
Church **Designer:** Jae Cuticone **Illustrator:** Tracy Sabon

2 **Design Firm:** Westwood Studios, Las Vegas, NV **Project:** Nox Box
Art Director: Victoria Hart **Designer:** Eddie Roberts

3 **Design Firm:** William M. Gould Design, Scottsdale, AZ **Client:** 7-Up
Bottling **Project:** Noah's California Spring Water **Art Director:** Tony
Varni, Jr. **Designer:** William M. Gould **Illustrator:** William M. Gould

Point-of-Purchase/Displays/Signs

4 **Design Firm:** Callison, Seattle, WA **Client:** Games Unlimited
Project: Illusionz **Designer:** Callison **Photographer:** Chris Eden

5 **Design Firm:** Chute Gerdeman, Inc., Columbus, Ohio **Client:**
Wolverine World Wide **Project:** UP Footgear, Grandville MI
Designer: Doug Smith, Maribeth Gatchalian, Lee Peterson, Chris
Brandewie, Heidi Brandewie, Jennifer Bajec, Lori Frame, Susan
Siewny, Steve Malone, Carmen Costinescu **Photographer:** Mark
Steele Photography

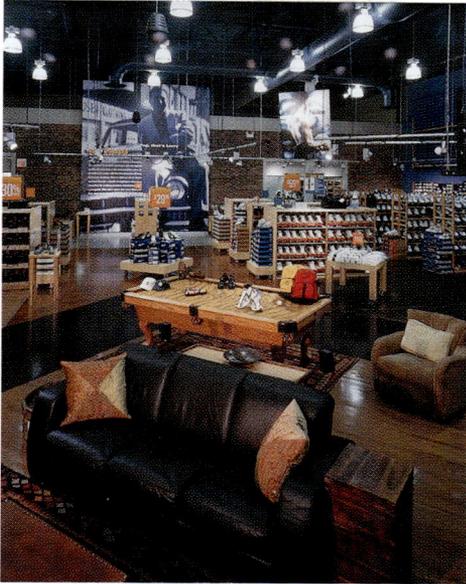

1

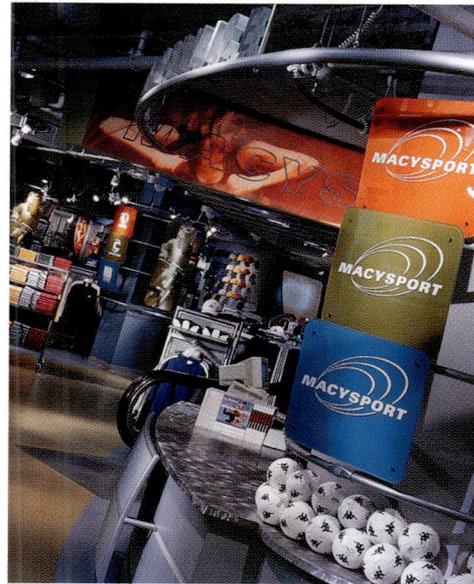

2

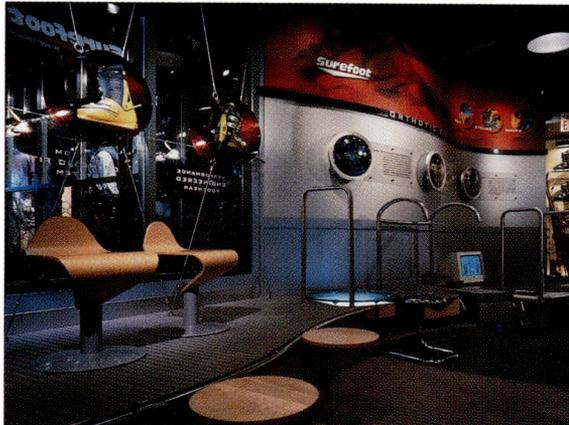

3

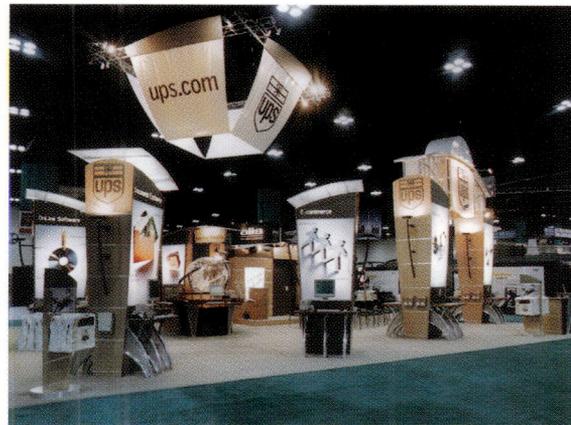

4

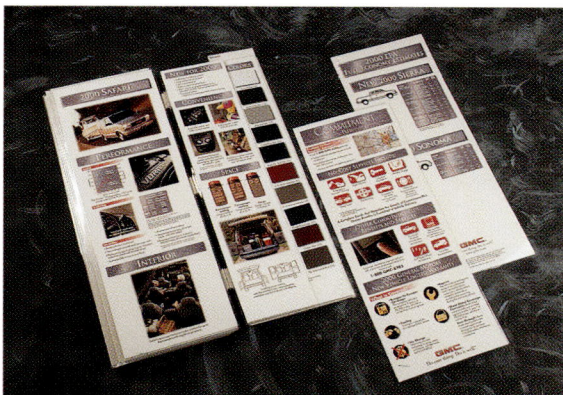

5

1 **Design Firm:** Chute Gerdeman, Inc., Columbus, Ohio **Client:** Larry's Shoes **Project:** Authentic Outlet Store **Designer:** Adam Limbach, Glennon Schaffner, Michelle Isroff, Bob Welty, Brian Shafley **Photographer:** Tom Jenkins Photography **Illustrator:** Brad Smith

2 **Design Firm:** Chute Gerdeman, Inc., Columbus, Ohio **Client:** Federated Department Stores **Project:** Macysport, Macy's Herald Square **Designer:** Eric Daniel, Bob Welty **Photographer:** Mark Steele Photography

3 **Design Firm:** Chute Gerdeman, Inc., Columbus, Ohio **Client:** Surefoot **Project:** Surefoot, Whistler, B.C. **Designer:** Eric Daniel, Bob Welty **Photographer:** Mark Steele Photography

4 **Design Firm:** Clarion Marketing & Communications, Atlanta, GA **Client:** UPS **Project:** Trade Show Graphics **Creative Director:** Peter Borowski **Designer:** Leslie Ogino **Photographer:** Greg Slater

5 **Design Firm:** DCI Marketing, Milwaukee, WI **Client:** GMC Truck **Project:** Product Information Center **Art Director:** Tom Bruckbauer **Designer:** Tom Bruckbauer

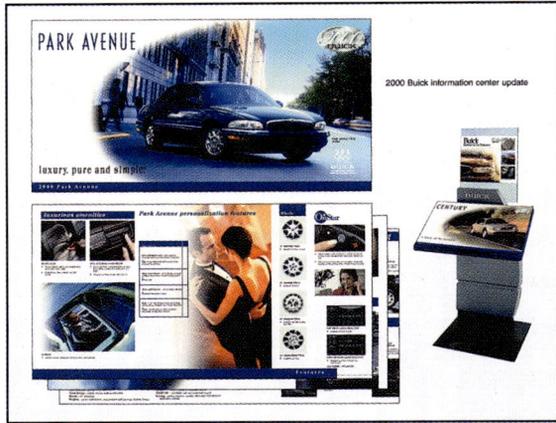

1

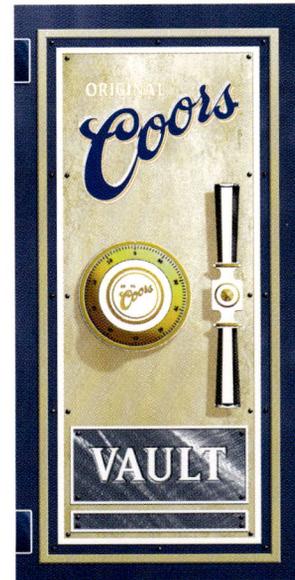

2

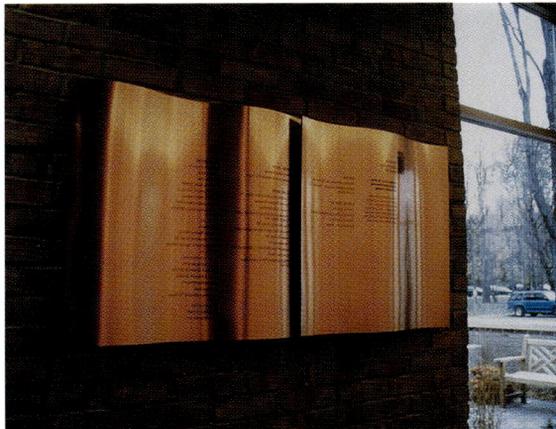

3

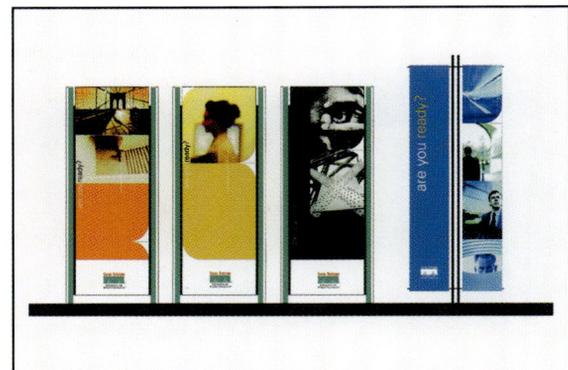

4

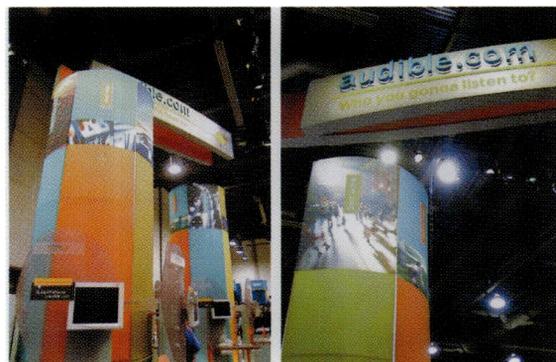

5

1 **Design Firm:** DCI Marketing, Milwaukee, WI **Client:** Buick **Project:** 2000 Buick Info Center Updates **Art Director:** Robert Moss **Designer:** Robert Moss

2 **Design Firm:** Eagleye Creative, Littleton, CO **Client:** The Integer Group **Project:** Coors Vault POS **Art Director:** Tom Pounders **Designer:** Tom Pounders **Illustrator:** Steve Schader

3 **Design Firm:** Ford & Earl Associates, Inc., Troy, MI **Client:** Chelsea Community Hospital Donor Recognition **Project:** Signage **Art Director:** Francheska Guerrero **Designer:** Francheska Guerrero **Photographer:** Francheska Guerrero

4 **Design Firm:** GMO/Hill Holliday, San Francisco, CA **Client:** Cisco Systems **Project:** Exhibit/Trade Show Graphics **Art Director:** Rick Atwood, Eric McClellan **Designer:** Marc Woollard

5 **Design Firm:** GMO/Hill Holliday, San Francisco, CA **Client:** Audible.com **Project:** Exhibit/Trade Show Graphics **Art Director:** Rick Atwood **Designer:** Marc Woollard **Copywriter:** Amy Caplan

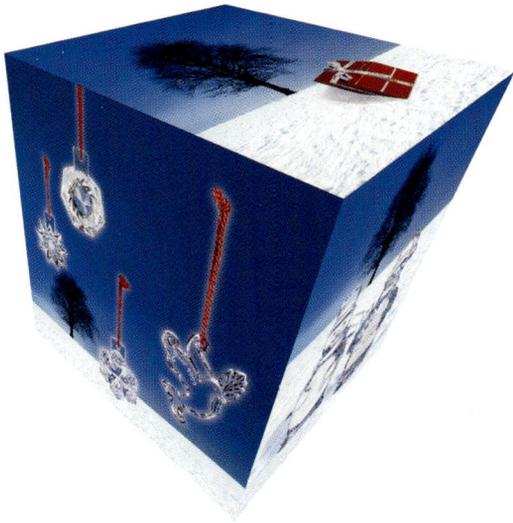

1

2

3

4

5

1 **Design Firm:** Greenhouse Design, Highland Park, NJ **Client:** Baccarat **Project:** POP **Art Director:** Miriam Grunhaus **Designer:** Miriam Grunhaus **Photographer:** Ken Skalski

2 **Design Firm:** Household International Employee Communications, Prospect Heights, IL **Project:** Our Success Story Exhibits **Art Director:** Heather Johnson **Designer:** Chris Tomsic, Heather Johnson

3 **Design Firm:** Ilium Associates, Inc., Bellevue, WA **Client:** Monterey-Salinas Transit **Project:** Busmobile **Art Director:** Cynthia Lynn **Designer:** Iris Ocean, Cynthia Lynn, Jennifer Comer **Photographer:** David Gubernick **Illustrator:** Cynthia Lynn

4 **Design Firm:** Laura Coe Design Associates, San Diego, CA **Client:** Taylor Made Golf Co. **Project:** Nubbins Putter Booklet for POP Display Base **Art Director:** Laura Coe Wright **Designer:** Jenny Goddard **Illustrator:** Tom Richman

5 **Design Firm:** Love Packaging Group, Wichita, KS **Client:** Jack Jacobs **Project:** Y'et Yet Salsa Counter Display **Art Director:** Chris West **Designer:** Dustin Commer

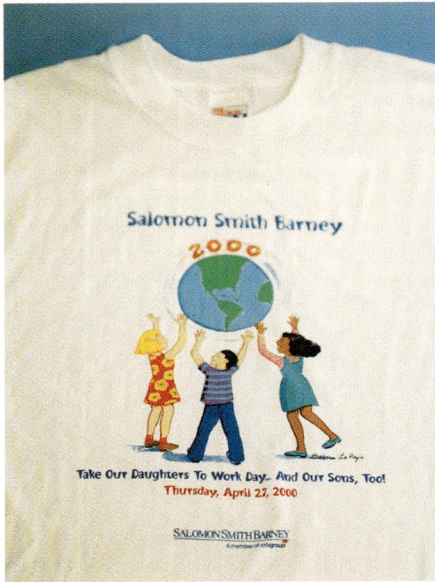

1

2

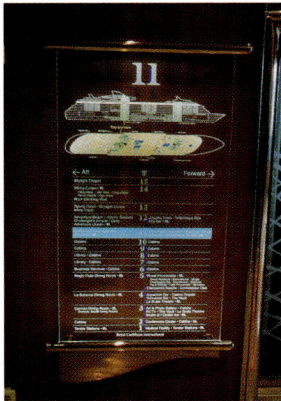

3

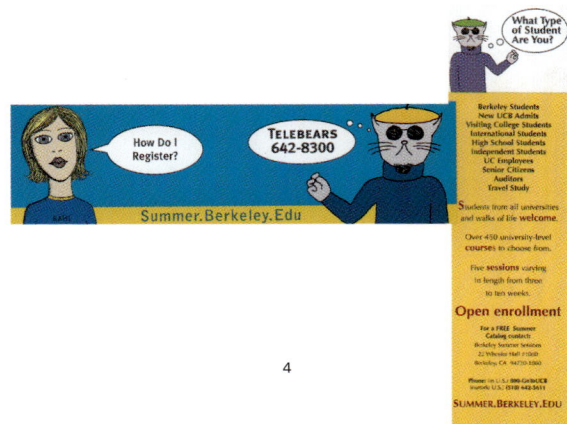

4

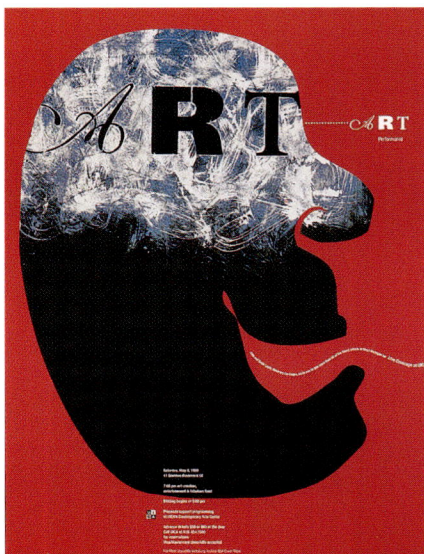

5

1 **Design Firm:** Salomon Smith Barney, New York, NY **Project:** Take Our Daughters To Work Tee **Art Director:** Melita Sussman, Diane Laraja **Designer:** Diane Laraja **Illustrator:** Diane Laraja

2 **Design Firm:** Tom Graboski Associates Inc. Design, Coral Gables, FL **Client:** Universal Studios Development Partners **Project:** Islands of Adventure Port of Entry **Art Director:** Tom Graboski **Designer:** Mary Rosseland **Project Manager and Senior Designer:** Chris Rogers, Peter A. Zorn, Jr., Charlie Calderin, Yasmine Samimy, Attila Laczko, Jr. **Universal's Port of Entry Design Team:** Mark Woodbury, Steve Leff, Adrian Gordon, Wayne Clark, Mary Mingin

3 **Design Firm:** Tom Graboski Associates Inc. Design, Coral Gables, FL **Client:** Royal Caribbean International **Project:** Voyager of the Seas **Art Director:** Tom Graboski **Designer:** Tom Graboski, Peter A. Zorn, Chris Rogers, Mary Rosseland, Alicia Bellini-Sobchak, Yasmine Samimy, Kenny Rasco, Lisa Ryu, Alex Vera **Photographer:** Chris Rogers **Sign Fabricators:** Holiday S.A.S, Forme et Signe, Bunting Graphics, Inc., Graphic Systems, Inc., Design Communications Ltd., Hangmen, Inc.

4 **Design Firm:** UC Berkeley Summer Sessions, Berkeley, CA **Project:** Cool Cat Bookmarks **Art Director:** Barbara A. Brown **Designer:** Barbara A. Brown **Illustrator:** Ran Bolton

Posters

5 **Design Firm:** BBK Studio, Inc., Grand Rapids, MI **Client:** The Urban Institute for Contemporary Art **Project:** Performance Poster **Art Director:** Michael Barile **Designer:** Michael Barile **Photographer:** Graphic Impressions **Illustrator:** Michael Barile

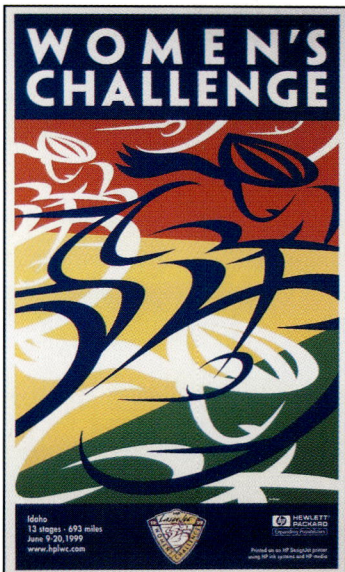

1

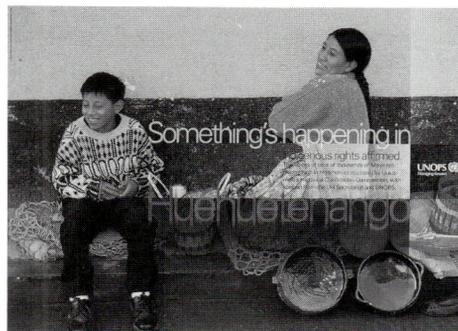

2

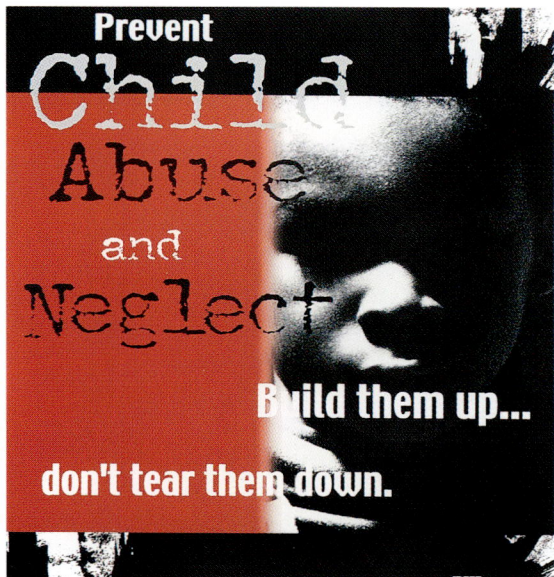

3

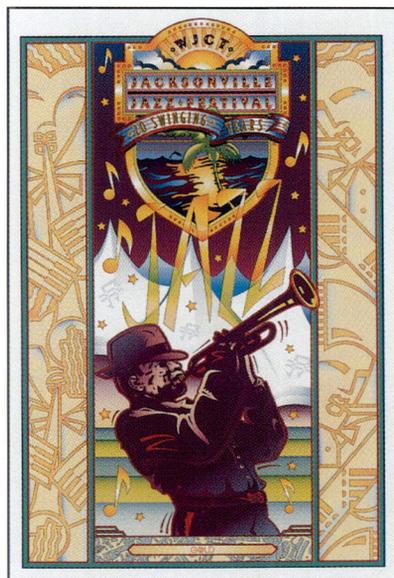

4

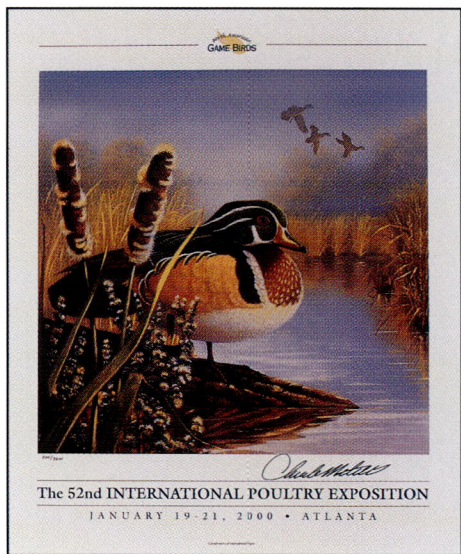

5

1 **Design Firm:** be•design, San Rafael, CA **Client:** Women's Challenge **Project:** Poster **Art Director:** Will Burke **Designer:** Will Burke, Yusuke Asaka

2 **Design Firm:** Emerson, Wajdowicz Studios, New York, NY **Client:** United Nations Office for Project Services **Project:** Something's Happening in Huehuetenango **Art Director:** Jurek Wajdowicz **Designer:** Lisa LaRochelle, Jurek Wajdowicz, Manuel Mendez **Photographer:** Victor Mello

3 **Design Firm:** Gardner Group, Montgomery Village, MD **Client:** Maryland Department of Human Resources **Project:** Prevent Child Abuse & Neglect Campaign **Designer:** Donna Gardner **Photographer:** Tom Nappi

4 **Design Firm:** Gold & Associates, Inc., Ponte Vedra Beach, FL **Client:** WJCT/Jazz Festival **Project:** Jacksonville Jazz Festival Poster **Art Director:** Joe Vavra, Keith Gold **Designer:** Keith Gold

5 **Design Firm:** International Paper, Memphis, TN **Project:** Poultry Exposition Souvenir Posters **Art Director:** Roger Rasor **Designer:** Roger Rasor **Illustrator:** Charlie Mitchell

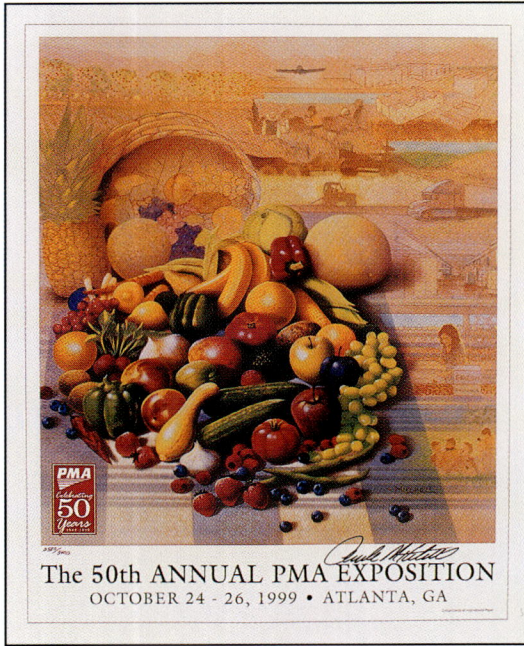

1

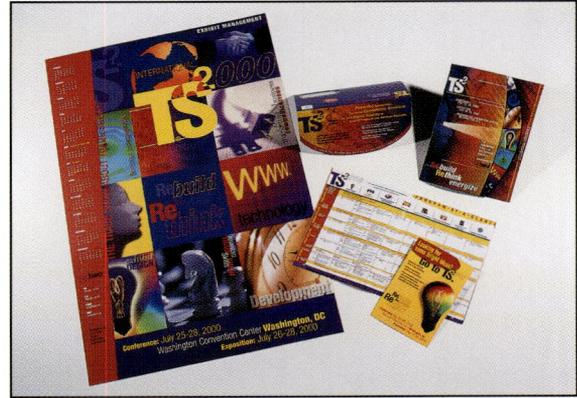

2

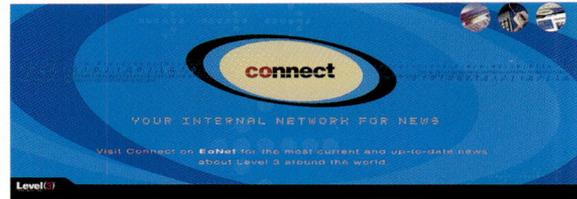

3

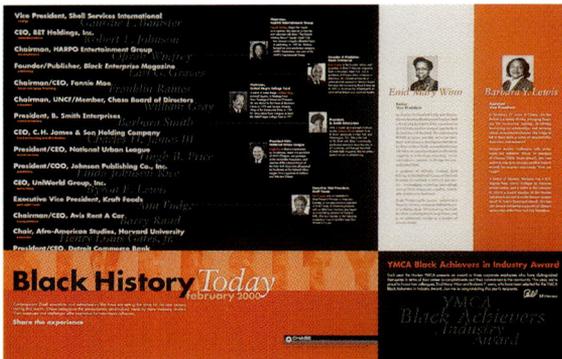

4

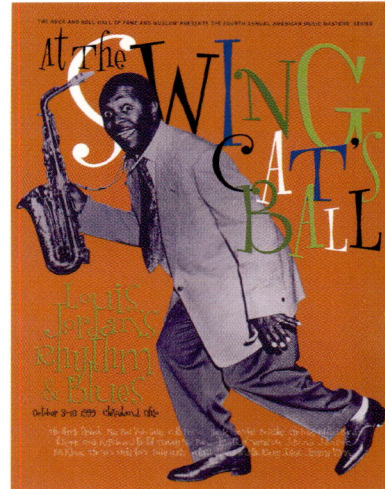

5

6

1 **Design Firm:** International Paper, Memphis, TN **Project:** Produce Expo Souvenir **Art Director:** Roger Rasor **Designer:** Roger Rasor **Illustrator:** Charlie Mitchell

2 **Design Firm:** Kittner Design, Takoma Park, MD **Client:** National Trade Productions **Project:** TS2000 Poster & Collateral Material **Art Director:** Roberta Kittner **Designer:** Kristin Kaineg, Bobbie Kittner **Photographer:** Sam Kittner

3 **Design Firm:** Level 3 Communications, Broomfield, CO **Project:** Connect Poster **Designer:** Sean Heisler

4 **Design Firm:** Marketing Communications, New York, NY **Client:** Chase Manhattan Bank **Project:** Black History Today **Art Director:** Randee Rubin **Designer:** Nici von Alvensleben, Randee Rubin

5 **Design Firm:** Morgan Stanley Dean Witter: IBD Creative Services, New York, NY **Project:** Enterprise Infrastructure Poster **Art Director:** Tony Tharae **Designer:** Tony Tharae

6 **Design Firm:** Nesnadny & Schwartz, Cleveland, OH **Client:** The Rock and Roll Hall of Fame **Project:** Louis Jordan Poster **Art Director:** Tim Lachina **Designer:** Tim Lachina

1

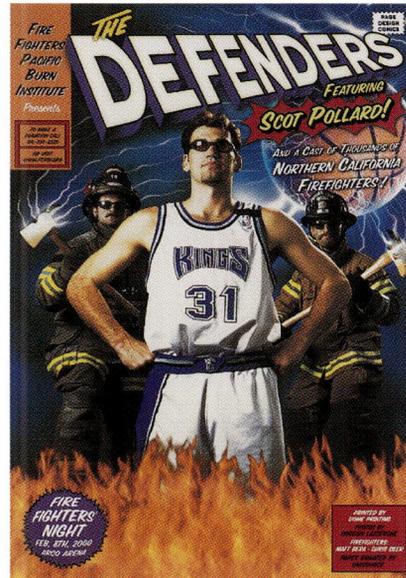

2

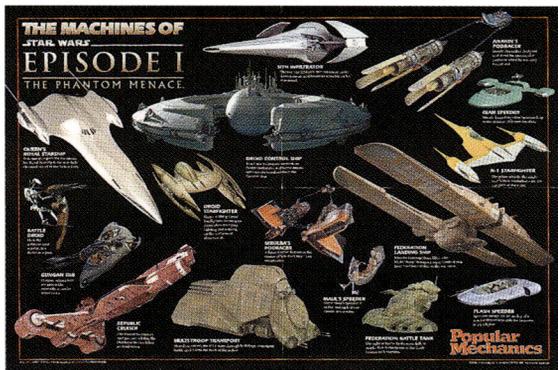

3

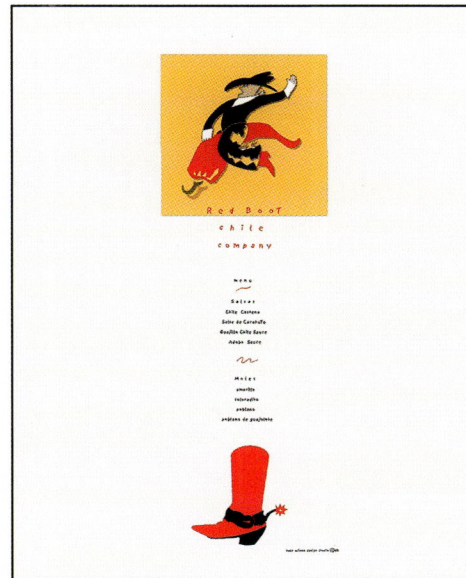

4

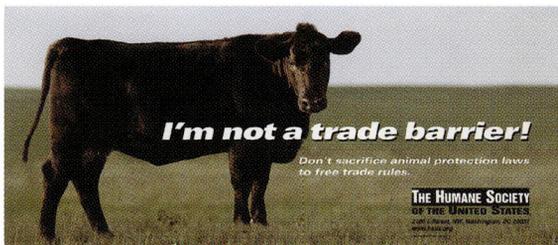

5

1 **Design Firm:** Oliver Kuhlmann, St. Louis, MO **Client:** Mead Coated Papers **Project:** Mead Promotion **Art Director:** Deanna Kuhlmann-Leavitt **Designer:** Michael Thede **Photographer:** Valerie Shaff

2 **Design Firm:** Page Design, Inc., Sacramento, CA **Client:** Fire Fighters Pacific Burn Institute **Project:** Burn Brigade Poster 2000 **Art Director:** Paul Page **Designer:** Justin Panson, Kurt Kland **Photographer:** Gordon Lazzarone **Illustrator:** Kurt Kland

3 **Design Firm:** Popular Mechanics, New York, NY **Project:** Star Wars Poster **Art Director:** Bryan Canniff **Designer:** Bryan Canniff

4 **Design Firm:** Suze Wilson Design Studio, Mill Valley, CA **Client:** Red Boot Chile Company **Project:** Logo **Art Director:** Suze Wilson **Designer:** Suze Wilson **Illustrator:** Suze Wilson

5 **Design Firm:** The Humane Society of the United States, Gaithersburg, MD **Project:** I'm Not A Trade Barrier! Poster Series **Art Director:** Paula Jaworski **Designer:** Paula Jaworski

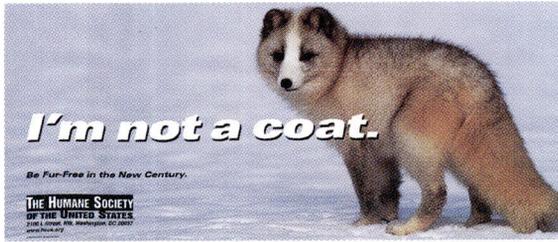

1

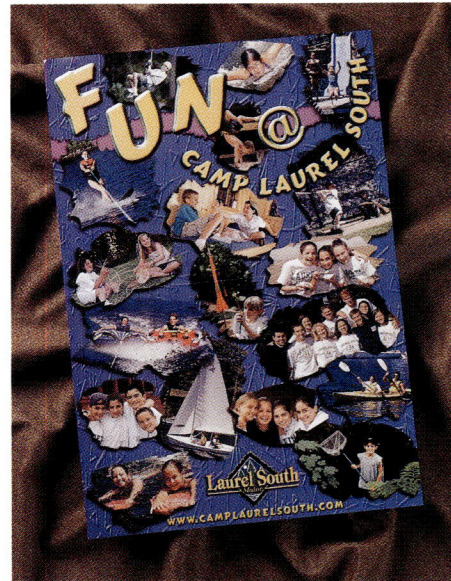

2

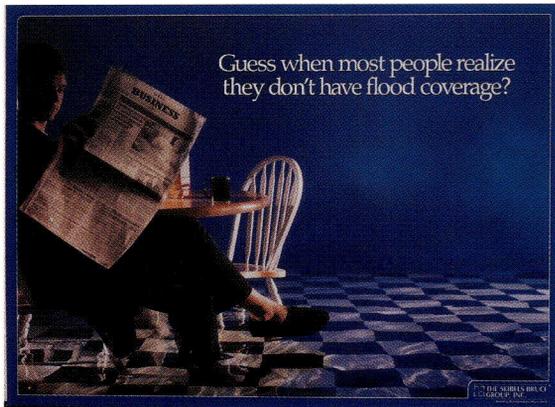

3

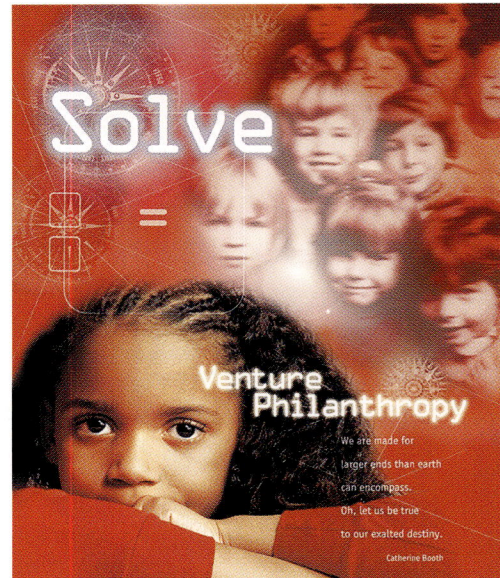

4

5

1 **Design Firm:** The Humane Society of the United States, Gaithersburg, MD **Project:** I'm Not A Coat Poster Series **Art Director:** Paula Jaworski **Designer:** Paula Jaworski

2 **Design Firm:** The Indigo Group, Shelton, CT **Client:** Camp Laurel South **Project:** Laurel South Promo Poster **Art Director:** Dawn Tufano **Designer:** Dawn Tufano **Illustrator:** Dawn Tufano

3 **Design Firm:** The Siebels Bruce Group, Inc., Columbia, SC **Project:** Flood Poster **Art Director:** Ward Bates **Photographer:** George Fulton

4 **Design Firm:** Tim Kenney Design Partners, Bethesda, MD **Client:** Morino Group **Project:** Morino Posters **Art Director:** Tim Kenney **Designer:** Shelley Young

5 **Design Firm:** Trained Eye Graphics, El Sobrante, CA **Client:** Cuisinart/Macy's **Project:** Features and Benefits Poster **Art Director:** Barry Barnes **Designer:** Barry Barnes

1

2

3

4

5

1 **Design Firm:** U.S. General Accounting Office, Washington, DC **Client:** GAO Diversity Month-June 1999 **Project:** The Key to Success is People **Designer:** Theresa Mechem

Pro Bono/Public Service

2 **Design Firm:** Andersen Worldwide, West Chicago, IL **Client:** United Way of St. Charles **Project:** United Way 2000 **Art Director:** Shannon Young **Designer:** Shannon Young

3 **Design Firm:** Arrowstreet Graphic Design, Somerville, MA **Client:** Office of Business Development **Project:** Boston Main Streets Self Promo **Art Director:** Michele Phelan **Designer:** Michele Phelan, John Bates **Illustrator:** Jim Starr

4 **Design Firm:** Dennis Johnson Design, Oakland, CA **Client:** Children Now **Project:** California Report Card '99 **Art Director:** Dennis Johnson **Designer:** Dennis Johnson **Photographer:** Steve Fisch

5 **Design Firm:** Dennis Johnson Design, Oakland, CA **Client:** Children Now **Project:** Boys to Men: Sports Media **Art Director:** Dennis Johnson **Designer:** Dennis Johnson **Photographer:** Steve Fisch

1

2

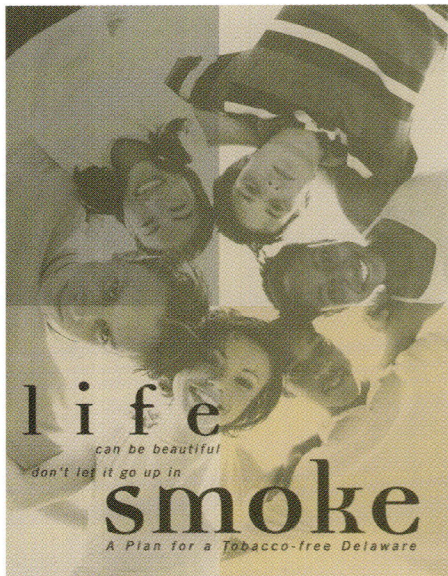

3

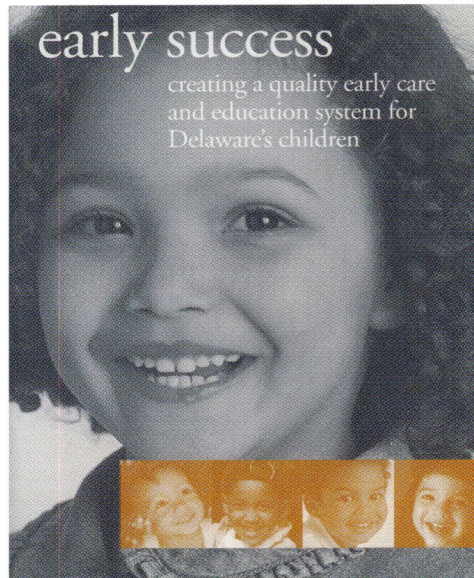

4

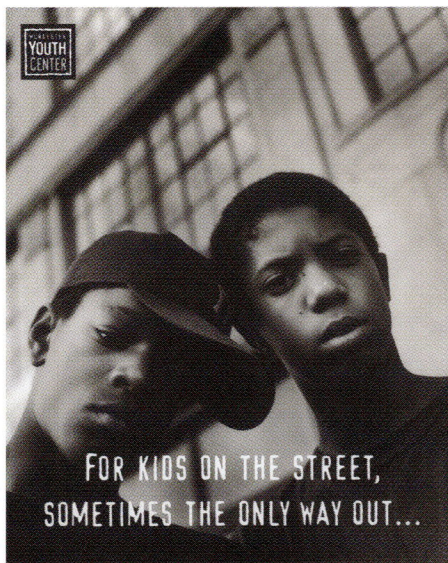

5

1 **Design Firm:** Flaherty Sabol Carroll Marketing Communications, Pittsburgh, PA **Client:** Westmoreland Fayette Council, B.S.A. **Project:** We Teach Boys the Ropes **Art Director:** Regis Sabol, Jack Perry **Photographer:** Harry Giglio

2 **Design Firm:** Hansen Design Company, Seattle, WA **Client:** National Multiple Sclerosis Society-Greater WA Chapter **Project:** 2000 Auction Materials **Art Director:** Pat Hansen **Designer:** Pat Hansen, Jacqueline Smith

3 **Design Firm:** Janet Hughes and Associates, Wilmington, DE **Project:** Plan for a Tobacco-Free Delaware **Art Director:** Peter Stolvoort **Designer:** Peter Stolvoort

4 **Design Firm:** Janet Hughes and Associates, Wilmington, DE **Client:** Delaware Department of Services for Children, Youth, and Their Families **Project:** Early Success **Art Director:** Peter Stolvoort **Designer:** Peter Stolvoort

5 **Design Firm:** Keiler & Company, Farmington, CT **Client:** Worcester Youth Center **Project:** Kids on the Street Brochure **Art Director:** Paul Kingsford **Designer:** Linda Olender **Photographer:** Frank Marchese Photography

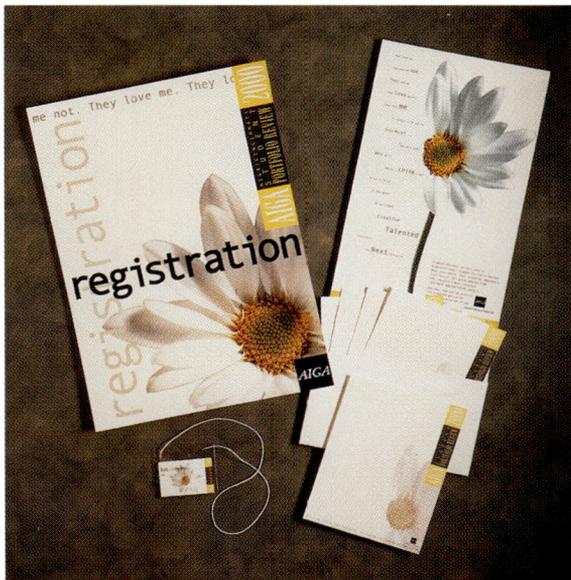

1

2

3

4

5

1 **Design Firm:** Libby Perszyk Kathman, Cincinnati, OH **Client:** AIGA/Cincinnati **Project:** Student Portfolio Review **Art Director:** Robert E. Johnson **Designer:** Robert E. Johnson **Photographer:** Kuchik Photography

2 **Design Firm:** Malcolm Grear Designers, Providence, RI **Client:** Rhode Island Restoration Society **Project:** RI State House Commemorative Ball Program & Invitation **Designer:** Malcolm Grear Designers **Photographer:** Warren Jaggar, Sandor Bodo, Eric Gould

3 **Design Firm:** Petertil Design Partners, Oak Park, IL **Client:** Alzheimer's Association **Project:** Dementia Care Guide Book **Art Director:** Kerry Petertil **Designer:** Kerry Petertil

4 **Design Firm:** Saraceno Design Inc., Bethlehem, PA **Client:** Touchstone Theatre **Project:** Steel Festival Promo Materials **Art Director:** Kellie Pypiuk, Liz Nicholas, Anne Schauer **Designer:** Kellie Pypiuk, Dean Smith, Anne Schauer **Illustrator:** Dean Smith, Anne Schauer

5 **Design Firm:** The Humane Society of the United States, Gaithersburg, MD **Project:** I'm Not A Coat **Art Director:** Paula Jaworski **Designer:** Paula Jaworski

1

2

3

4

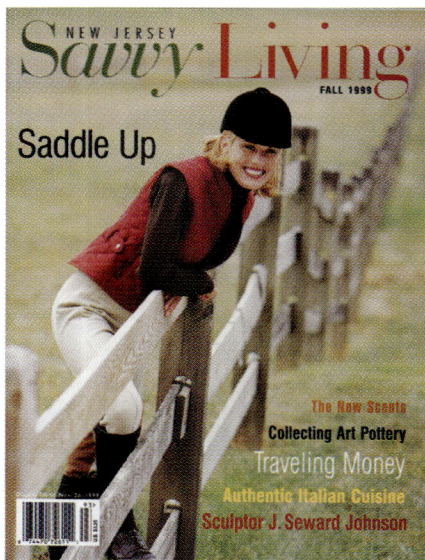

5

Publications

1 **Design Firm:** Bell & Howell Information and Learning, Ann Arbor, MI **Client:** UMI **Project:** 2000 UMI® SIM/NIM Catalog **Art Director:** Mark Howell **Designer:** Mark Howell **Photographer:** Bob Foran **Project Manager:** Kathie McLain

2 **Design Firm:** Business Travel News, New York, NY **Project:** 1999 Business Travel Buyer's Handbook **Art Director:** Teresa M. Carboni **Designer:** Teresa M. Carboni **Illustrator:** Teresa M. Carboni

3 **Design Firm:** Business Travel News, New York, NY **Project:** 2000 Black Book **Art Director:** Teresa M. Carboni **Designer:** Teresa M. Carboni

4 **Design Firm:** Business Travel News, New York, NY **Project:** 1999 Business Travel Survey **Art Director:** Teresa M. Carboni **Designer:** Teresa M. Carboni **Illustrator:** Bill Westheimer

5 **Design Firm:** C&C Graphics, Malverne, NY **Client:** CTB Publishing **Project:** New Jersey Savvy Living, Fall 1999 **Creative Director:** Lisa L. Cangemi **Designer:** Lisa L. Cangemi **Photographer:** Lane Pederson

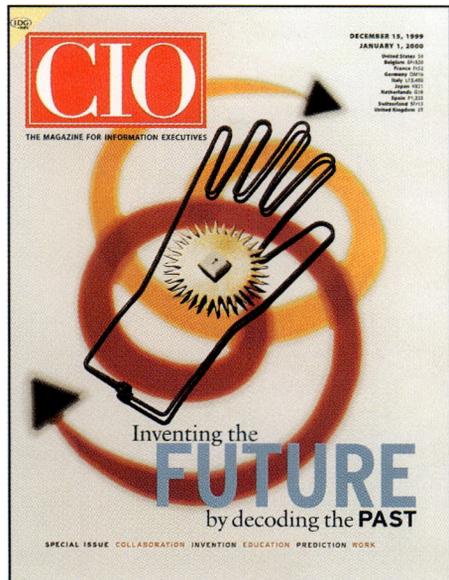

1

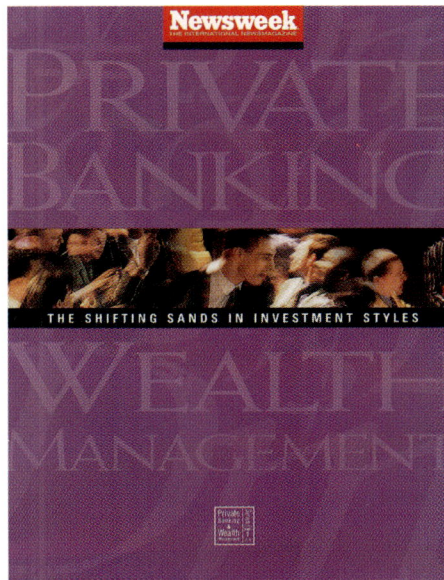

2

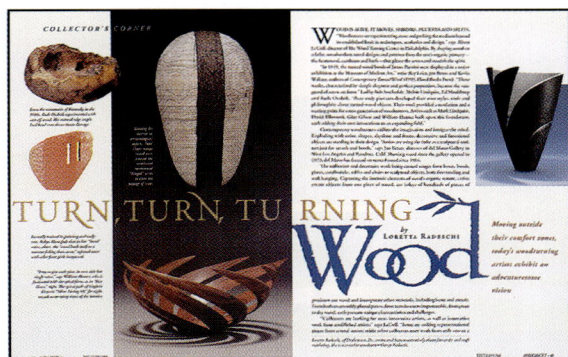

3

4

5

1 **Design Firm:** CIO Magazine, Framingham, MA **Project:** December 15/January 1 Issue **Art Director:** Mary Lester **Designer:** Jessica Sepe

2 **Design Firm:** Courtney & Company, New York, NY **Client:** Newsweek **Project:** Special Advertising Section **Art Director:** Lynette Simmons

3 **Design Firm:** Dever Designs, Laurel, MD **Client:** AmericanStyle Magazine **Project:** Turning Wood **Art Director:** Jeffrey L. Dever **Designer:** Jeffrey L. Dever

4 **Design Firm:** Dever Designs, Laurel, MD **Client:** AmericanStyle Magazine **Project:** Colorful Characters **Art Director:** Jeffrey L. Dever **Designer:** Jeffrey L. Dever

5 **Design Firm:** Dever Designs, Laurel, MD **Client:** AmericanStyle Magazine **Project:** Natural Resources **Art Director:** Jeffrey L. Dever **Designer:** Jeffrey L. Dever **Photographer:** Tim Barnwell

1

2

3

4

5

1 **Design Firm:** Dever Designs, Laurel, MD **Client:** Niche Magazine/Rosen Group **Project:** A Look Back-2000 Forging the Future **Art Director:** Jeffrey L. Dever **Designer:** Jeffrey L. Dever, Chris Ledford

2 **Design Firm:** Gazette Newspapers, Gaithersburg, MD **Client:** Business Gazette Magazine **Project:** Associations Special Publication **Art Director:** Laura E. Lloyd-Henry **Designer:** Laura E. Lloyd-Henry

3 **Design Firm:** Grayton Integrated Publishing, Grosse Pointe, MI **Client:** Farm Progress Co. **Project:** California Farmer **Designer:** Jim Van Fleteren

4 **Design Firm:** Greenhouse Design, Highland Park, NJ **Client:** PriceWaterhouseCoopers **Project:** HR Advisory **Art Director:** Miriam Grunhaus **Designer:** Miriam Grunhaus

5 **Design Firm:** Hadassah Magazine, New York, NY **Project:** October 1999 **Art Director:** Jodie B. Rossi **Designer:** Jodie B. Rossi **Photographer:** Ari Baltinester

1

2

3

4

5

1 **Design Firm:** Intertec Publishing, Overland Park, KS **Client:** Video Systems **Project:** Buyer's Guide **Art Director:** Elisabeth Nord **Designer:** Elisabeth Nord

2 **Design Firm:** Intertec Publishing, Overland Park, KS **Client:** Video Systems **Project:** Apple Orchard **Art Director:** Elisabeth Nord **Designer:** Elisabeth Nord

3 **Design Firm:** Jacqueline Barrett Design Inc., Oceanport, NJ **Client:** National Association of Recording Merchandisers **Project:** 98/99 Year in Review **Art Director:** Jacqueline Barrett **Designer:** Jacqueline Barrett

4 **Design Firm:** Jacqueline Barrett Design Inc., Oceanport, NJ **Client:** Merck and Co., Inc. **Project:** The Future of Health Care **Art Director:** Jacqueline Barrett **Designer:** Jacqueline Barrett **Illustrator:** Elise N. Phillips

5 **Design Firm:** Jacqueline Barrett Design Inc., Oceanport, NJ **Client:** Merck and Co., Inc. **Project:** Economics of Good Health Brochure **Art Director:** Jacqueline Barrett **Designer:** Jacqueline Barrett **Illustrator:** Elise N. Phillips

1

2

3

4

5

1 **Design Firm:** John Kallio Graphic Design, New Haven, CT **Client:** CRN International **Project:** Ski Watch Atlas **Art Director:** John Kallio **Designer:** John Kallio

2 **Design Firm:** Kor Group, Boston, MA **Client:** Wentworth Institute of Technology **Project:** Continuing Studies **Art Director:** MB Jarosik **Designer:** Anne Callahan, MB Jarosik, Jim Gibson **Photographer:** Len Rubenstein

3 **Design Firm:** Litton Data Systems, Agoura Hills, CA **Project:** Air Force Ball Program **Art Director:** Una Vere Katter **Designer:** Tom Fritz **Illustrator:** Tom Fritz

4 **Design Firm:** Litton Data Systems, Agoura Hills, CA **Project:** AADC Cover **Art Director:** Tom Fritz **Designer:** Tom Fritz **Illustrator:** Tom Fritz

5 **Design Firm:** Litton Data Systems, Agoura Hills, CA **Project:** Egypt COC Cover **Art Director:** Tom Fritz **Designer:** Tom Fritz **Illustrator:** Tom Fritz

1

2

3

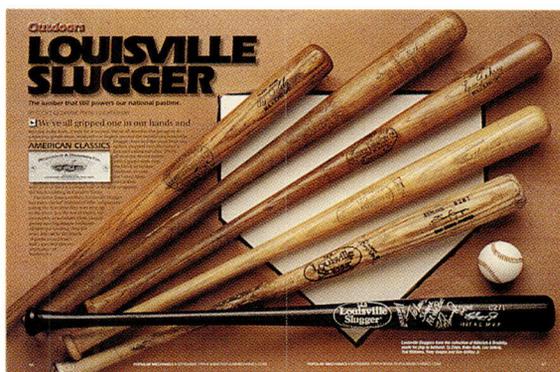

4

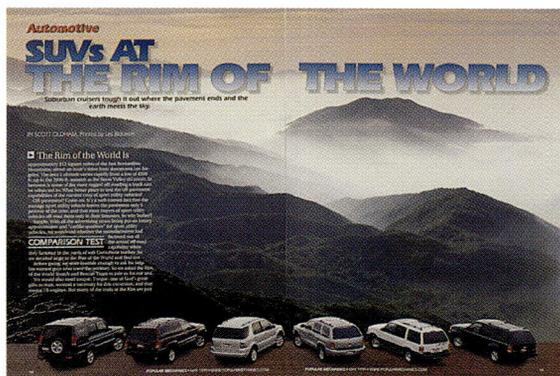

5

1 **Design Firm:** Messiah College, Grantham, PA **Project:** Visual & Theatrical Arts Viewbook **Art Director:** Kathy T. Hettinga **Designer:** Messiah College Students **Photographer:** Messiah College Students **Illustrator:** Messiah College Students

2 **Design Firm:** p11creative, Santa Ana Heights, CA **Client:** Pediatric Cancer Research Foundation **Project:** 4th Annual Rod Carew Children's Cancer Golf Classic Event Program **Creative Director:** Lance Huante **Designer:** Daniel Dean Webster **Photographer:** Adam De Vito

3 **Design Firm:** Popular Mechanics, New York, NY **Project:** The Machines of Star Wars **Art Director:** Bryan Canniff **Illustrator:** Richard Chasemore

4 **Design Firm:** Popular Mechanics, New York, NY **Project:** Louisville Slugger **Art Director:** Bryan Canniff **Photographer:** Earl Fansler

5 **Design Firm:** Popular Mechanics, New York, NY **Project:** SUV's at the Rim of the World **Art Director:** Bryan Canniff **Photographer:** Les Biorawn

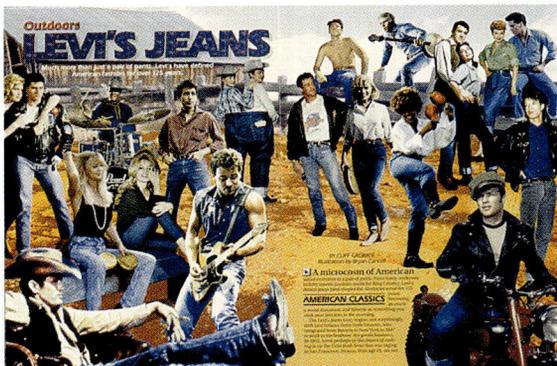

1

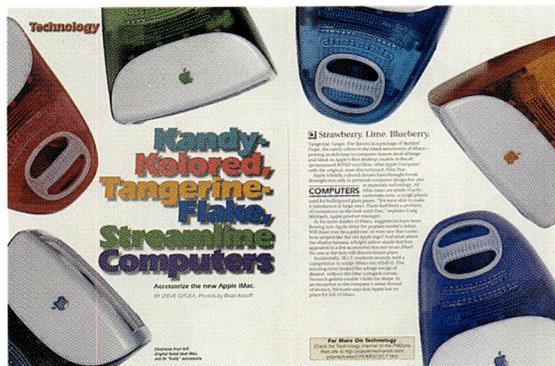

2

3

4

5

1 **Design Firm:** Popular Mechanics, New York, NY **Project:** Levi's Jeans **Art Director:** Bryan Canniff **Illustrator:** Bryan Canniff

2 **Design Firm:** Popular Mechanics, New York, NY **Project:** Kandy-Kolored, Tangerine, Flake, Streamline Computers **Art Director:** Bryan Canniff **Photographer:** Brian Kosoff

3 **Design Firm:** Popular Mechanics, New York, NY **Project:** Legomania **Art Director:** Bryan Canniff **Designer:** Bryan Canniff **Photographer:** David Dowhurst

4 **Design Firm:** Primedia Enthusiast Group, Leesburg, VA **Project:** Military History Magazine, October 1999 Cover **Creative Director:** Barbara Sutliff **Designer:** Barbara Sutliff **Illustrator:** Angus McBride

5 **Design Firm:** Primedia Enthusiast Group, Leesburg, VA **Project:** World War II Magazine, February 1999 Cover **Art Director:** Nicholas Schrenk **Designer:** Nicholas Schrenk **Creative Director:** Barbara Sutliff **Illustrator:** Vincent Wai

1

2

3

4

5

1 **Design Firm:** Primedia Enthusiast Group, Leesburg, VA **Project:** Military History Quarterly Autumn 1999 **Art Director:** Marty Jones **Designer:** Marty Jones **Creative Director:** Barbara Sutliff

2 **Design Firm:** Rutgers, The State University of New Jersey, New Brunswick, NJ **Project:** Institute of Marine and Coastal Studies **Art Director:** John Van Cleaf **Designer:** John Van Cleaf **Photographer:** Nick Romanenko **Illustrator:** Frank Miller

3 **Design Firm:** Rutgers, The State University of New Jersey, New Brunswick, NJ **Client:** Mason Gross School of the Arts **Project:** Brochure **Art Director:** Joanne Dus-Zastrow **Designer:** Joanne Dus-Zastrow

4 **Design Firm:** Rutgers, The State University of New Jersey, New Brunswick, NJ **Client:** Undergraduate Admissions **Project:** Where Ideas Take Shape **Art Director:** Joanne Dus-Zastrow **Designer:** Joanne Dus-Zastrow **Photographer:** Dennis Connors **Illustrator:** Bob Conge

5 **Design Firm:** The New York Times Company Magazine Group, Trumbull, CT **Client:** Augusta National Golf Club **Project:** 2000 Masters Journal **Art Director:** Deborah Chute **Designer:** Deborah Chute

1

2

3

4

1 **Design Firm:** Tieken Design & Creative Services, Phoenix, AZ **Client:** SCG Publishing **Project:** Tycoon Magazine **Art Director:** Fred E. Tieken **Designer:** Fred E. Tieken

2 **Design Firm:** Tieken Design & Creative Services, Phoenix, AZ **Client:** SCG Publishing **Project:** Ritz-Carlton Magazine **Art Director:** Fred E. Tieken **Designer:** Fred E. Tieken

3 **Design Firm:** Warkulwiz Design Associates, Philadelphia, PA **Client:** Wharton School of Business **Project:** Alumni Magazine/Winter 2000 **Art Director:** Robert J. Warkulwiz **Designer:** Kirsten Engstrom **Illustrator:** Paul Zwolak, Gary Clement

Sales Promotion

4 **Design Firm:** Ann Hill Communications, San Rafael, CA **Client:** Plath & Co. **Project:** Allen House Brochure **Art Director:** Ann Hill **Designer:** Jack Zoog **Illustrator:** Greg Kerwin

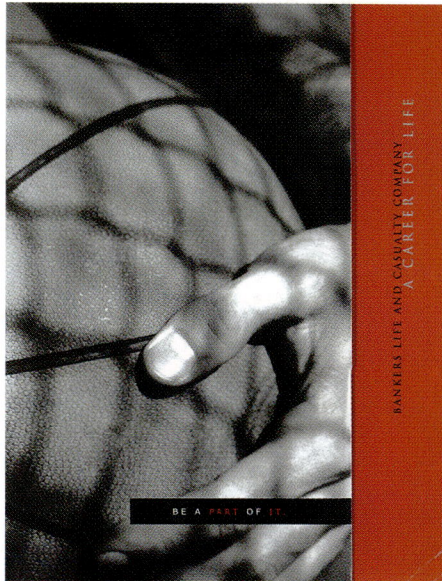

1

2

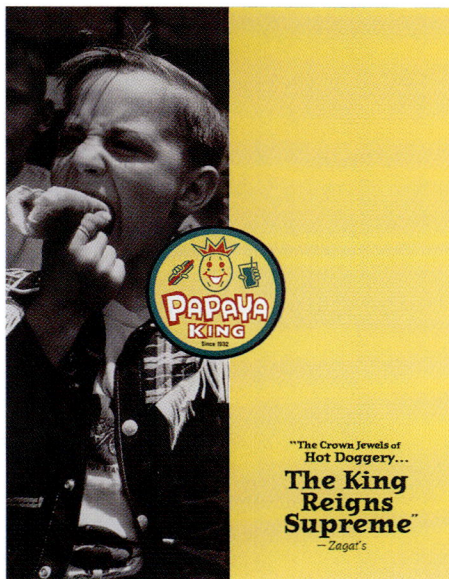

3

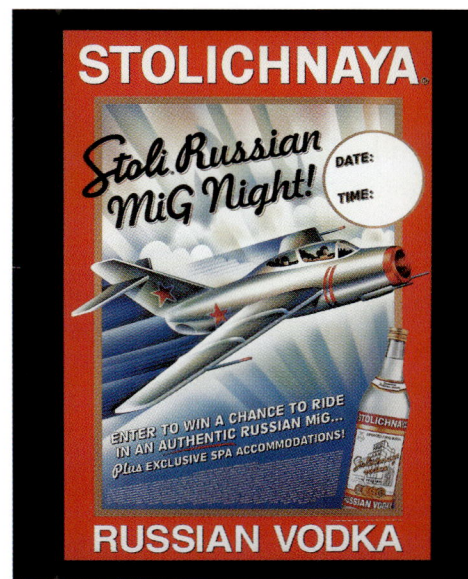

4

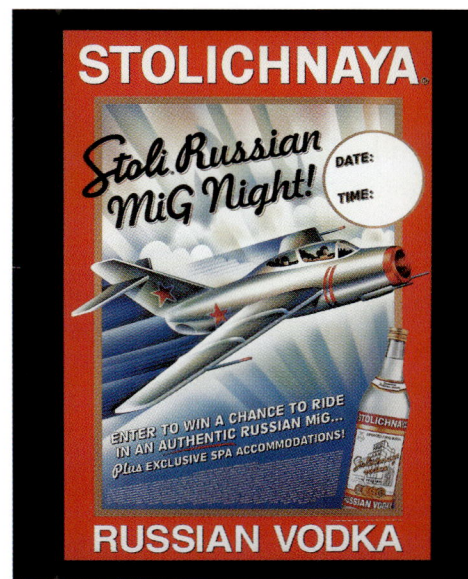

5

1 **Design Firm:** Bankers Life and Casualty Company, Chicago, IL
Project: 1999-2000 Recruiting Materials **Art Director:** Nathan Post
Designer: Nick Lo Bue **Copywriter:** Carl Leader

2 **Design Firm:** Brodeur Worldwide, Boston, MA **Client:** New
England Business Center **Project:** NEBC Press Kit **Art Director:**
Andrew Seletz **Designer:** Eric D. Stich, Angel Cruz

3 **Design Firm:** Courtney & Company, New York, NY **Client:** Papaya
King **Project:** Media Kit **Art Director:** Mark Courtney **Designer:**
Lynette Simmons

4 **Design Firm:** Creative Alliance Marketing & Communications,
Southport, CT **Client:** United Distillers & Vintners **Project:** Stoli MiG
Promotion **Art Director:** Ann Lumpinski **Illustrator:** Boris Lyubner

5 **Design Firm:** Fresh Fish Design, San Diego, CA **Project:** Kinexsis
Business Card **Art Director:** Diane Gianfanga-Miels

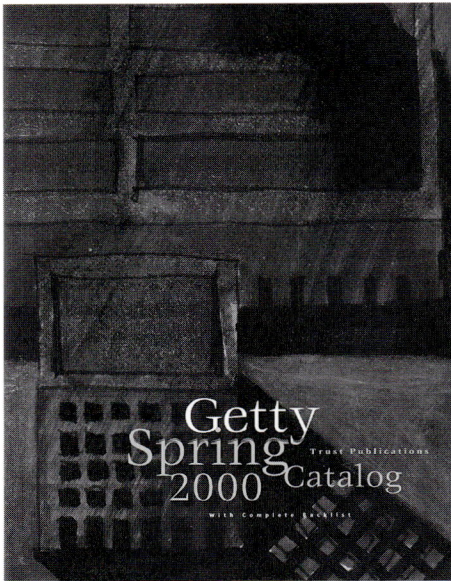

1

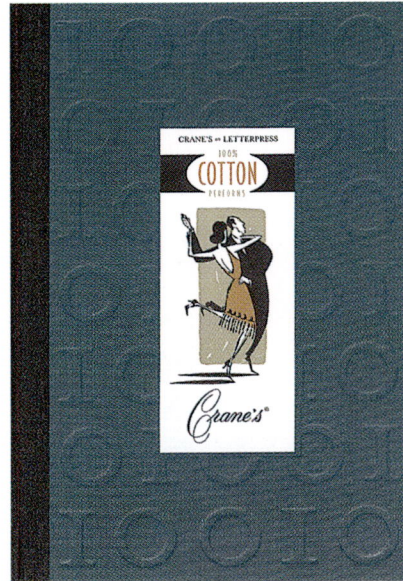

2

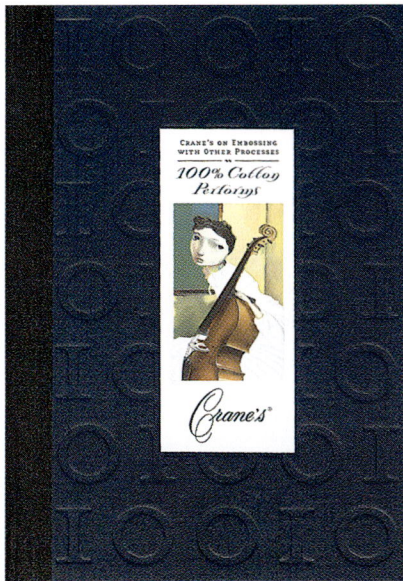

3

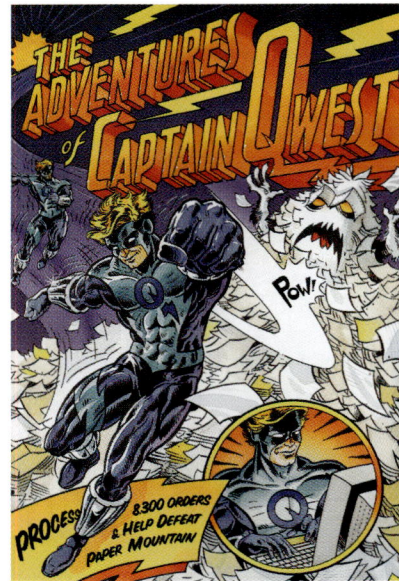

4

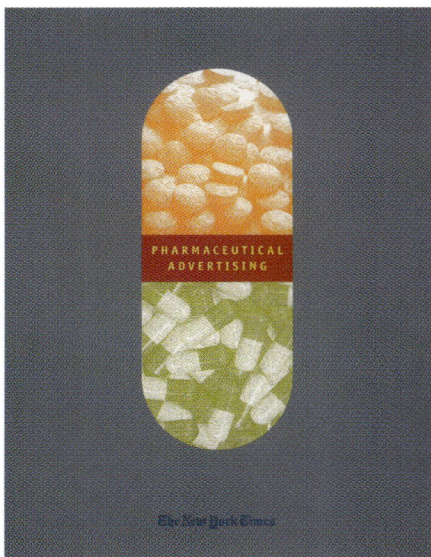

5

1 **Design Firm:** J. Paul Getty Trust-Publications Services, Los Angeles, CA **Client:** J. Paul Getty Trust **Project:** Catalog: Spring 2000 **Designer:** Markus Brilling

2 **Design Firm:** Keiler & Company, Farmington, CT **Client:** Crane & Company **Project:** Crane's on Letterpress **Art Director:** Liz Dzilenski **Designer:** Liz Dzilenski

3 **Design Firm:** Keiler & Company, Farmington, CT **Client:** Crane & Company **Project:** Crane's on Embossing **Art Director:** Aaron Dietz **Designer:** Aaron Dietz

4 **Design Firm:** Kelley Communications Group, Dublin, OH **Client:** Qwest Communications, Inc. **Project:** Captain Qwest Campaign **Art Director:** Kevin Ronnebaum **Illustrator:** Mario Noche

5 **Design Firm:** Leibowitz Communications, New York, NY **Client:** The New York Times **Project:** Pharmaceutical Advertising Kit **Art Director:** Paul Leibowitz **Designer:** Rick Bargmann

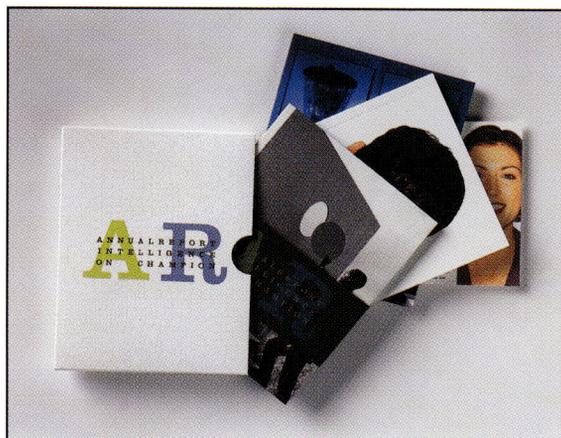

1

2

3

4

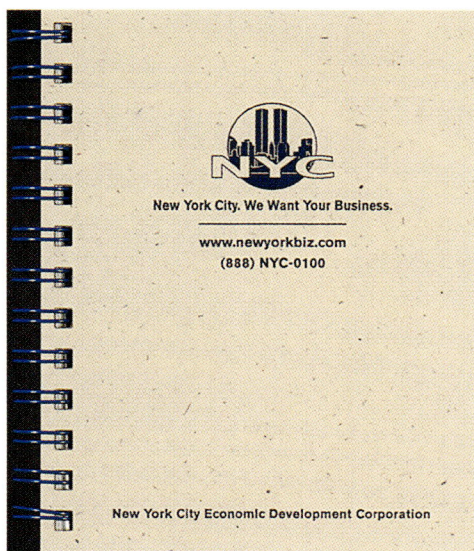

5

1 **Design Firm:** Leimer Cross Design, Seattle, WA **Client:** Champion **Project:** Annual Report: Intelligence on Champion **Art Director:** Kerry Leimer **Designer:** Kerry Leimer **Photographer:** Tyler Boley, Jeff Corwin

2 **Design Firm:** Miller Sports Group, New York, NY **Client:** Tennis Magazine **Project:** Media Kit **Art Director:** Cari Colclough **Designer:** Cari Colclough

3 **Design Firm:** NAK Group, New York, NY **Client:** I/B/E/S International, Inc. **Project:** Promotional Jazz CD and Calendar **Art Director:** Randi Hazan, Michelle Eliseo **Designer:** Randi Hazan **Illustrator:** Elena Coronado

4 **Design Firm:** NDW Communications, Horsham, PA **Client:** Zanders USA **Project:** Mega, Ikono & Chromolux Swatchbooks (Series) **Art Director:** Bill Healey **Designer:** Bill Healey, Tom Brill

5 **Design Firm:** New York City Economic Development Corp., New York, NY **Project:** Notebook **Art Director:** Randi Press **Designer:** Randi Press

1

2

3

4

5

6

1 **Design Firm:** Oliver Kuhlmann, St. Louis, MO **Client:** Mead Coated Papers **Project:** Signature Club: Sign Up New Member **Art Director:** Deanna Kuhlmann-Leavitt **Designer:** Monica King

2 **Design Firm:** Sunspots Creative, Inc., Hoboken, NJ **Client:** Accudart **Project:** Halloween Box Mailer **Art Director:** Deena Hartley **Designer:** Rick Bonelli **Illustrator:** Rick Bonelli

3 **Design Firm:** The Humane Society of the United States, Gaithersburg, MD **Project:** Bookmark Series **Art Director:** Paula Jaworski **Designer:** Paula Jaworski **Illustrator:** Scott Brooks

4 **Design Firm:** The Indigo Group, Shelton, CT **Client:** Camp Laurel South **Project:** Camp Sales Campaign **Art Director:** Dawn Tufano **Designer:** Dawn Tufano **Illustrator:** Dawn Tufano

5 **Design Firm:** Thompson Studio, Doylestown, PA **Client:** Swatch Watch **Project:** Gardening **Art Director:** Emily Thompson **Designer:** Emily Thompson **Illustrator:** Emily Thompson

6 **Design Firm:** UP Design, Montclair, NJ **Client:** Ricoh **Project:** Aficio Color Sales Kit **Art Director:** Gary Underhill **Designer:** Wendy Peters-Underhill

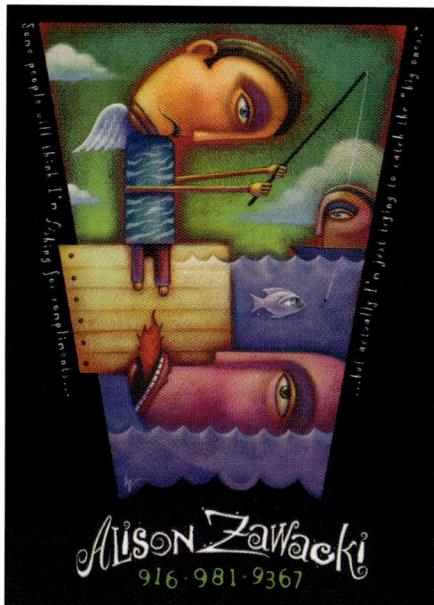

1

2

3

4

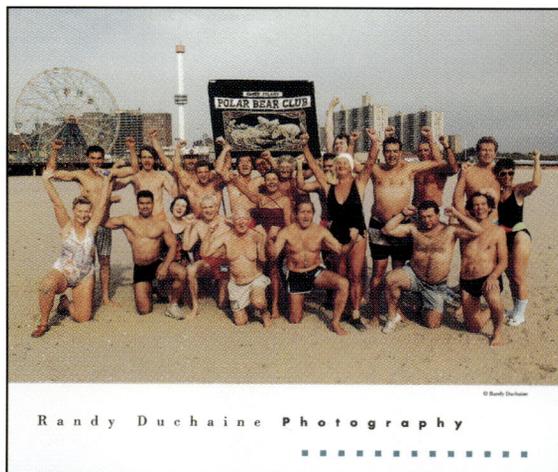

5

Self Promotion

1 **Design Firm:** Alison Zawacki Illustration, Sacramento, CA **Project:** What Will People Think? **Art Director:** Alison Zawacki **Designer:** Alison Zawacki **Illustrator:** Alison Zawacki

2 **Design Firm:** Audra Kirsten Miller, Fairfax, VA **Project:** Self Promotion **Designer:** Audra Kirsten Miller **Photographer:** Audra Kirsten Miller **Illustrator:** Audra Kirsten Miller

3 **Design Firm:** BGDI, Berkeley, CA **Project:** Self Promotion Brochure **Art Director:** Steven Donaldson **Designer:** Randy Rocchi

4 **Design Firm:** Donovan Group, Northborough, MA **Project:** Marketing Package **Art Director:** Pamela Leary **Designer:** Pamela Leary

5 **Design Firm:** Duchaine Communications Inc., Brooklyn, NY **Project:** Self Promotion Mailers **Designer:** Stephanie McClintick **Photographer:** Randy Duchaine

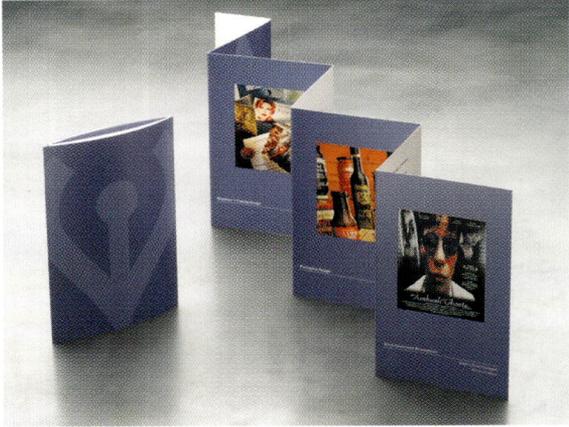

1

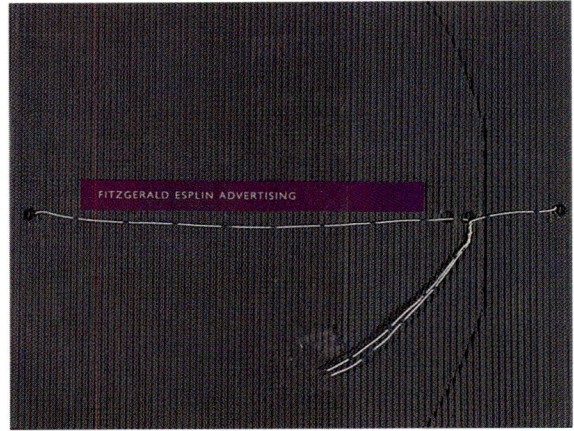

2

3

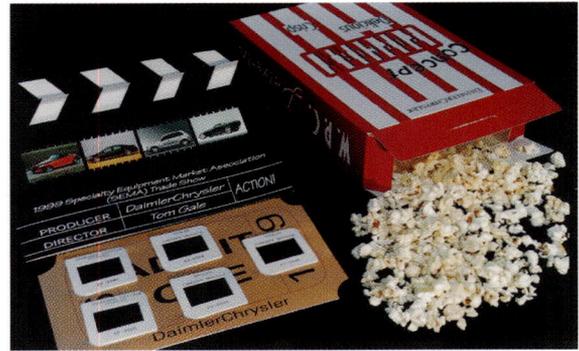

4

5

1 **Design Firm:** Ezzona Design Group, Inc., Burbank, CA **Project:** Self Promotion **Art Director:** Jim Pezzullo **Designer:** Gina Vivona

2 **Design Firm:** Fitzgerald Esplin Advertising, Doylestown, PA **Project:** Self Promotion **Designer:** Ingela Nader

3 **Design Firm:** Full Concept Inc./Turgeon Group, Madison Heights, MI **Client:** DaimlerChrysler **Project:** Concept Cars Press Kit **Art Director:** Kelly Callender **Designer:** Kelly Callender, Karen Hale **Illustrator:** Kelly Callender

4 **Design Firm:** Full Concept Inc./Turgeon Group, Madison Heights, MI **Client:** DaimlerChrysler **Project:** SEMA Show Press Kit **Art Director:** Monique Labadie **Designer:** Monique Labadie **Illustrator:** Monique Labadie

5 **Design Firm:** Full Concept Inc./Turgeon Group, Madison Heights, MI **Client:** KMart Corporation **Project:** Fact Book **Art Director:** Karen Hale **Designer:** Karen Hale **Illustrator:** Karen Hale

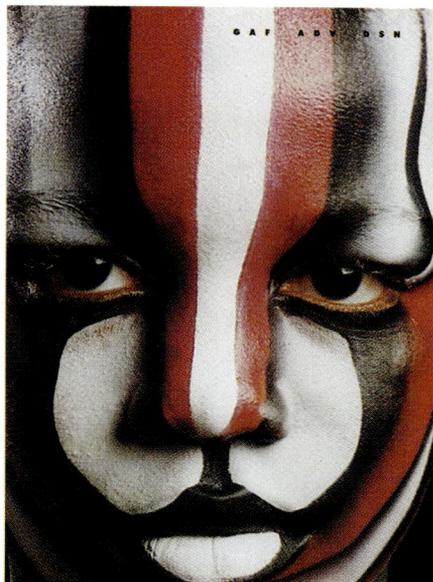

1

2

3

4

5

1 **Design Firm:** GAF Advertising/Design, Dallas, TX **Project:** Get Out of The House Campaign **Art Director:** Gregg A. Floyd **Designer:** Gregg A. Floyd **Photographer:** Gregg A. Floyd **Illustrator:** Gregg A. Floyd

2 **Design Firm:** Glick Design, Kahului, HI **Project:** Portfolio Ten **Art Director:** Robert Glick **Designer:** Robert Glick

3 **Design Firm:** Grayton Integrated Publishing, Grosse Pointe, MI **Project:** Creative Log **Art Director:** Sheila Young Tomkowiak **Photographer:** Howard Ash

4 **Design Firm:** Greenfield/Belser, Washington, DC **Project:** Branding Your Law Firm **Art Director:** Burkey Belser **Designer:** Burkey Belser

5 **Design Firm:** Greenfield/Belser, Washington, DC **Project:** 20 Years of Law Firm Marketing **Art Director:** Burkey Belser **Designer:** Jeanette Nuzum, Burkey Belser **Photographer:** John Burwell

1

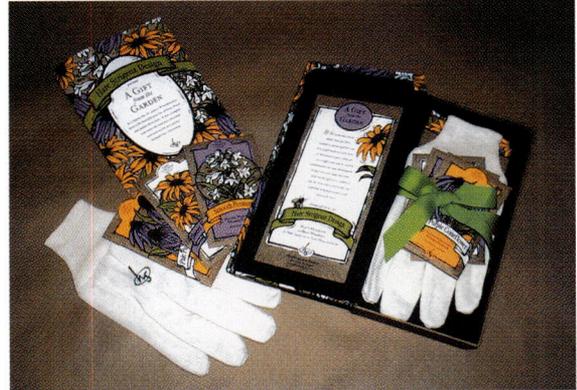

2

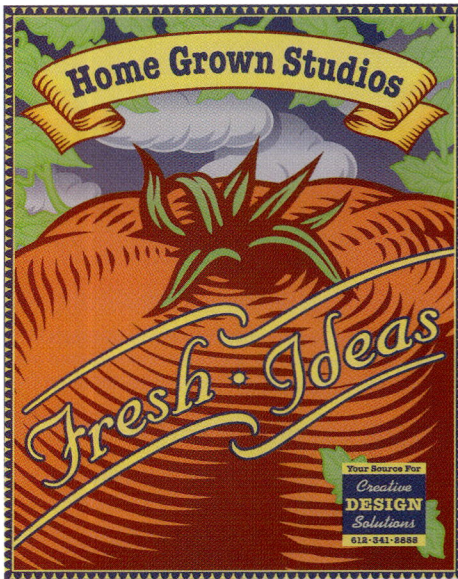

3

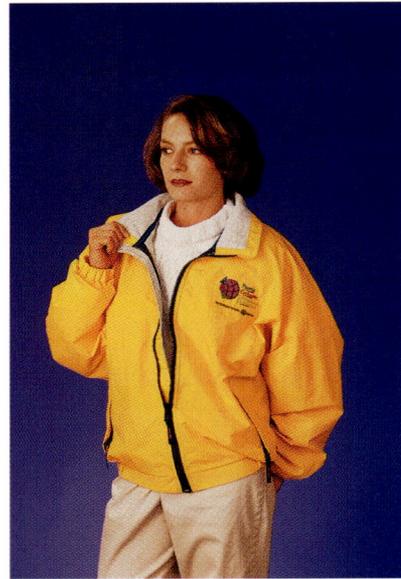

4

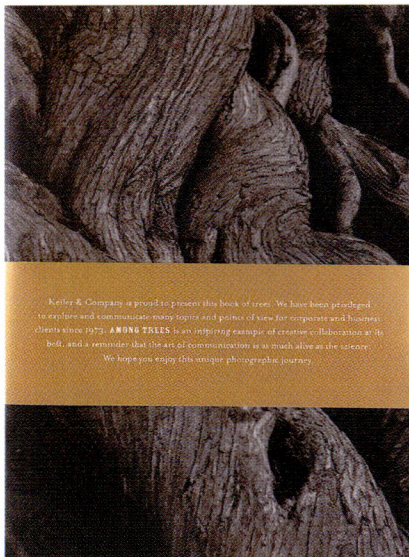

5

1 **Design Firm:** Hansen Design Company, Seattle, WA **Project:** 1999 Holiday Card **Art Director:** Pat Hansen **Designer:** Pat Hansen, Jacqueline Smith

2 **Design Firm:** Hare Strigenz Design, Milwaukee, WI **Project:** A Gift From The Garden **Art Director:** Paula Hare **Illustrator:** Kris Marconnet

3 **Design Firm:** Home Grown Studios, Minneapolis, MN **Project:** Self Promotion **Art Director:** Kent Luebke **Designer:** Joe Monson, Sid Tincher, Johnny Wilson **Illustrator:** Joe Monson, Johnny Wilson

4 **Design Firm:** International Paper, Memphis, TN **Project:** Trade Show Reps Jacket **Art Director:** Roger Rasor **Designer:** Roger Rasor

5 **Design Firm:** Keiler & Company, Farmington, CT **Client:** Sean Kernan Photography **Project:** Among Trees **Art Director:** James Pettus **Designer:** James Pettus **Photographer:** Sean Kernan Photography

1

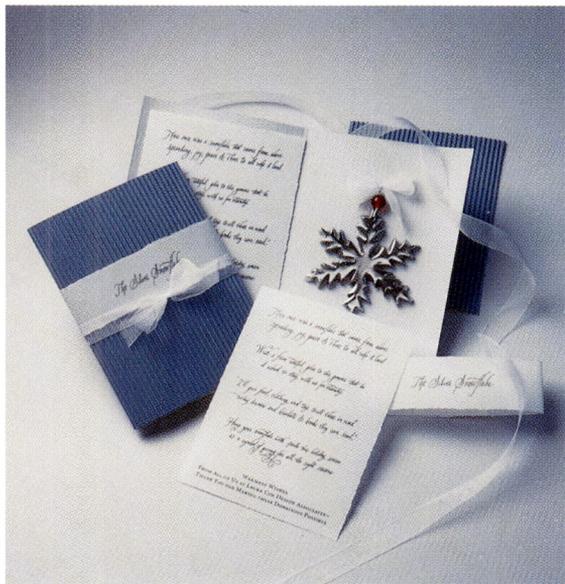

2

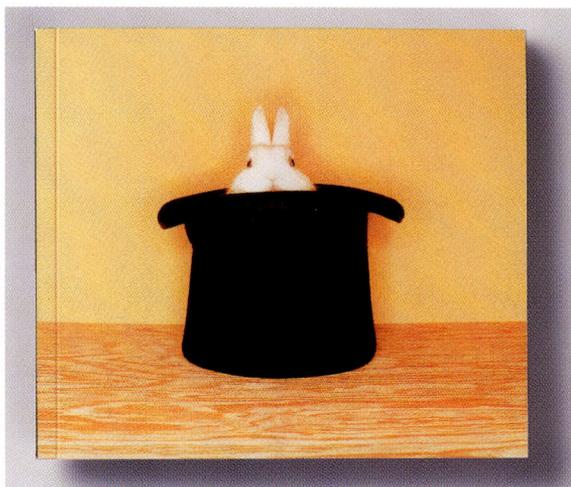

3

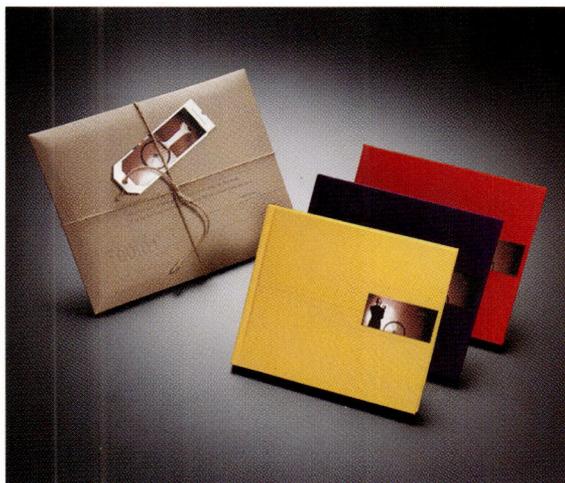

4

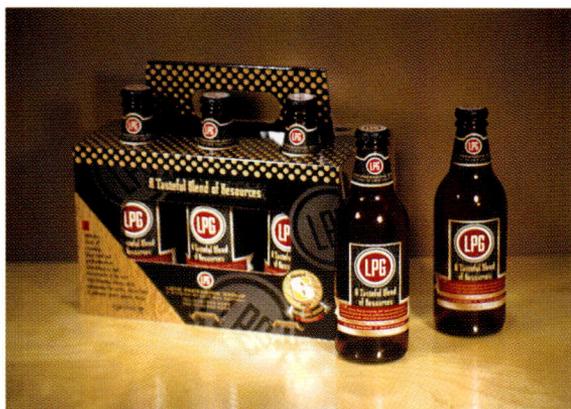

5

1 **Design Firm:** Kirshenbaum Communications, San Francisco, CA **Project:** Holiday Card/Promotion **Art Director:** Susan Kirshenbaum **Designer:** Antoaneta Metchanova **Copywriter:** Nancy Friedman

2 **Design Firm:** Laura Coe Design Associates, San Diego, CA **Project:** Holiday Card **Art Director:** Leanne Leveillee **Designer:** Tom Richman **Creative Director:** Laura Coe Wright

3 **Design Firm:** Leimer Cross Design, Seattle, WA **Project:** Self Promotion **Art Director:** Kerry Leimer **Designer:** Kerry Leimer

4 **Design Firm:** Louey/Rubino Design Group Inc., Santa Monica, CA **Project:** Two Year Calendar **Art Director:** Robert Louey **Designer:** Robert Louey **Photographer:** Sharp & Associates

5 **Design Firm:** Love Packaging Group, Wichita, KS **Project:** A Tasteful Blend of Resources Promotional 6-Pack **Art Director:** Rick Gimlin **Designer:** Rick Gimlin

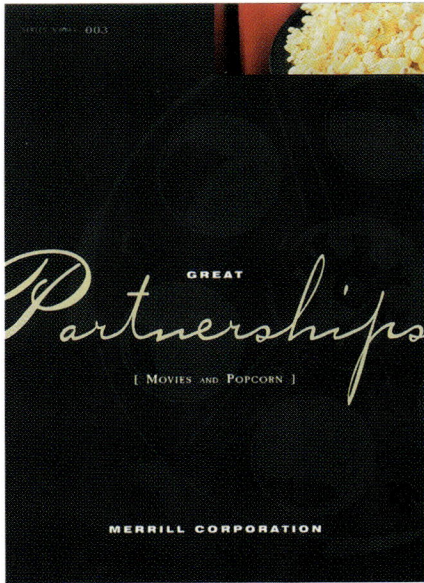

1

2

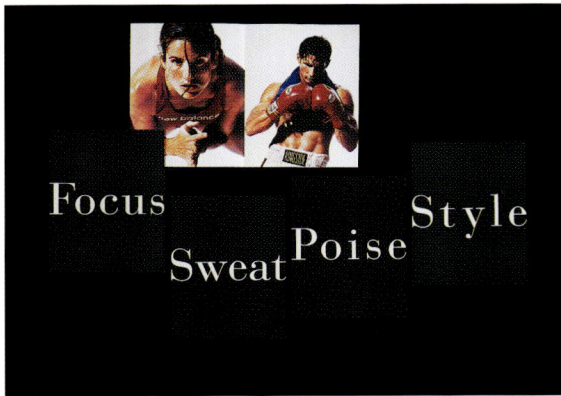

3

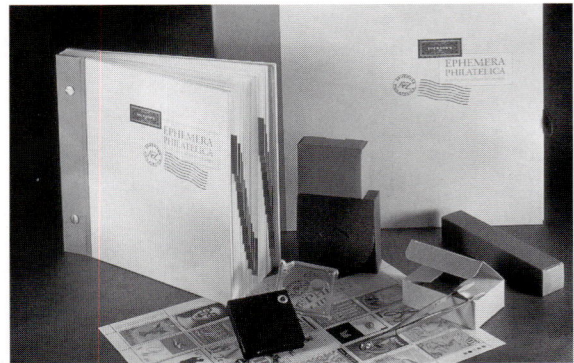

4

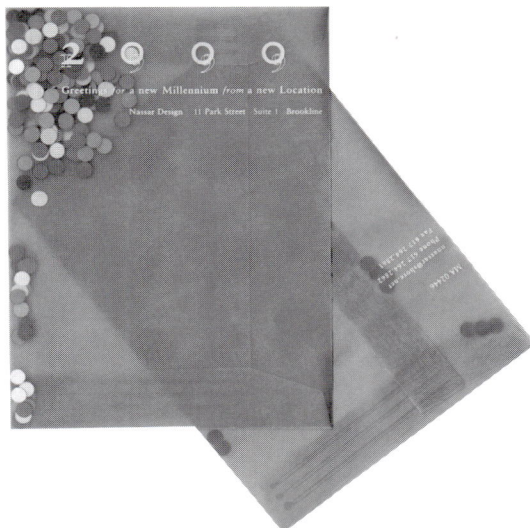

5

1 **Design Firm:** Merrill Corporation, St. Cloud, MN **Client:** MCP/Merrill Corporation **Project:** Partnerships Campaign **Art Director:** Leah Wolters-Nistler **Copywriter:** Shelley Luzaich

2 **Design Firm:** Michael P. Arndt, New York, NY **Project:** Ogilvy & Mather MA Self Promo **Art Director:** Michael P. Arndt **Designer:** Michael P. Arndt

3 **Design Firm:** Michael Indresano Photography, Boston, MA **Project:** Series-Focus, Sweat, Poise, Style **Designer:** Tom Laidlaw **Photographer:** Michael Indresano

4 **Design Firm:** Michael Osborne Design, San Francisco, CA **Client:** Dickson's **Project:** Ephemera Philatelica **Art Director:** Michael Osborne **Designer:** Paul Kagiwada

5 **Design Firm:** Nassar Design, Brookline, MA **Project:** Millennium Card **Art Director:** Nelida Nassar **Designer:** Nelida Nassar

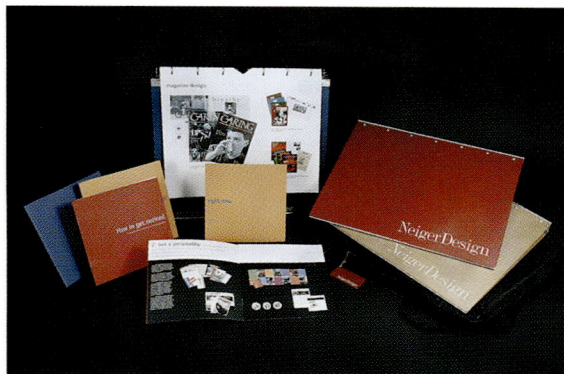

1

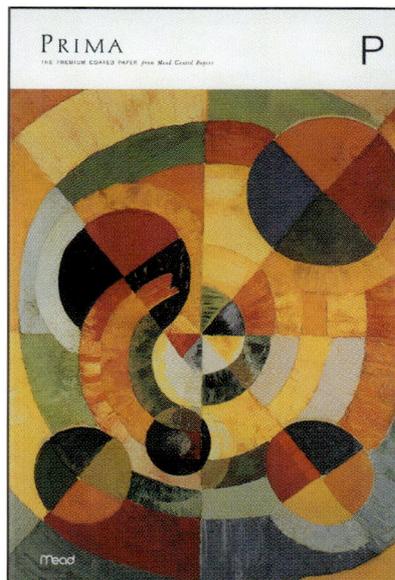

2

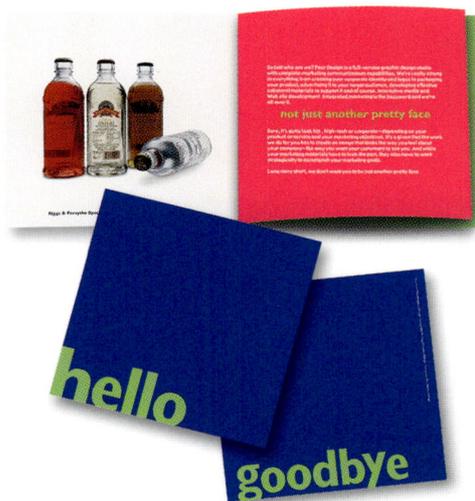

3

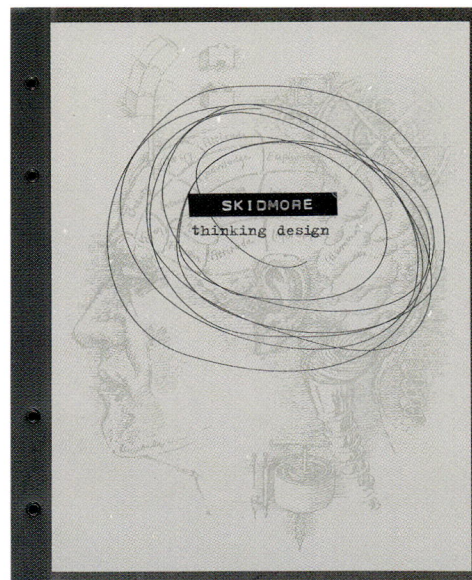

4

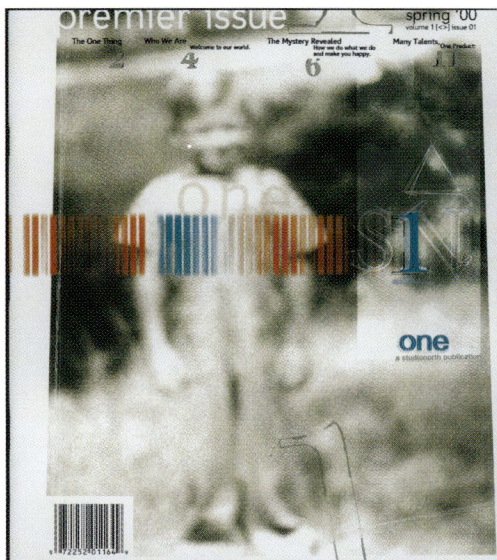

5

1 **Design Firm:** NeigerDesignInc., Evanston, IL **Project:** Marketing Materials **Art Director:** Carol Neiger **Designer:** Carol Neiger, Jason Harvey **Photographer:** Paul Lane **Illustrator:** Metalwork: Eliot Irwin

2 **Design Firm:** Oliver Kuhlmann, St. Louis, MO **Client:** Mead Coated Papers **Project:** Swatchbooks **Art Director:** Deanna Kuhlmann-Leavitt **Designer:** Michael Thede

3 **Design Firm:** Pear Design Incorporated, Chicago, Il **Project:** Sales Brochure **Art Director:** Linda Jackson **Designer:** Linda Jackson, Norbert Marszalek **Photographer:** Tom Street

4 **Design Firm:** Skidmore, Inc., Southfield, MI **Project:** Skidmore Thinking Design **Art Director:** Julie Pincus, Sue Levytsky, Mae Skidmore **Designer:** John Latin, Julie Pincus, Bob Nixon, Laura Hilpert **Photographer:** Jeff Margis, Rocki Pedersen **Illustrator:** Gary Cooley, Steve Magsig, Bob Nixon, Ann Bauer, Scott Olds, Dave O'Connell, Rob Burman, Toni Button, Jeff Rauf, Larry Dodge, Chuck Gillies, Rudy Laslo, Bob Andrews, John Ball, Wayne Appleton, George Burgos

5 **Design Firm:** Studio North, North Chicago, IL **Project:** One **Designer:** Studio North Design Team

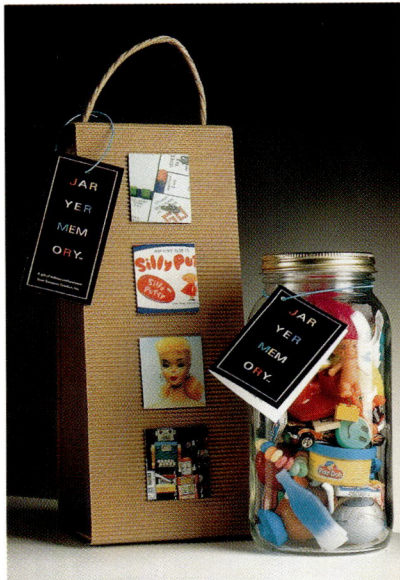

1

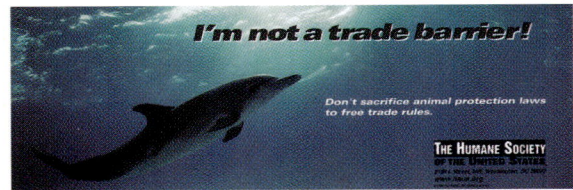

2

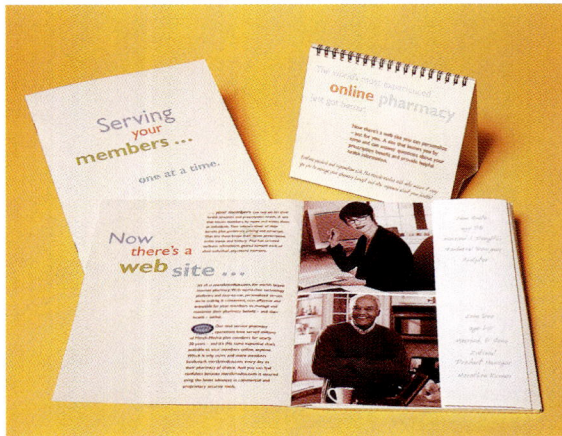

3

4

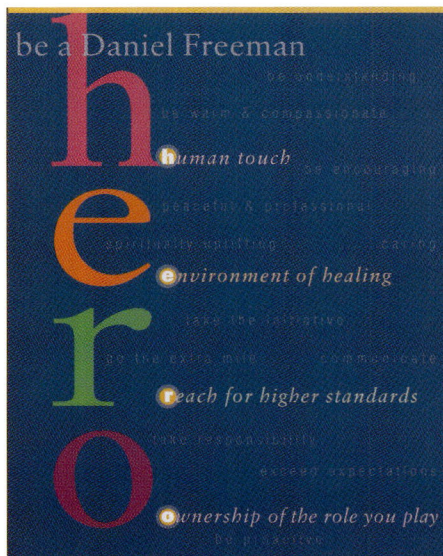

5

1 **Design Firm:** Sunspots Creative, Inc., Hoboken, NJ **Project:** Jar Yer Memory Gift **Art Director:** Rick Bonelli **Designer:** Rick Bonelli, Deena Hartley **Photographer:** Manny Akis

2 **Design Firm:** The Humane Society of the United States, Gaithersburg, MD **Project:** I'm Not a Trade Barrier Series **Art Director:** Paula Jaworski **Designer:** Paula Jaworski

3 **Design Firm:** UP Design, Montclair, NJ **Client:** Merck Medco **Project:** Serving Your Members... **Art Director:** Gary Underhill **Designer:** Carin Manetti **Photographer:** Michael Krinke

4 **Design Firm:** Z Design, Olney, MD **Project:** Cover for Z Design, Self Promotion Piece **Art Director:** Irene Zevgolis **Designer:** Irene Zevgolis **Printer:** Westland Printers

5 **Design Firm:** Zamboo, Marina Del Rey, CA **Client:** Daniel Freeman Hospitals **Project:** H.E.R.O. Campaign **Designer:** Becca Bootes

AGDA Judges

American Graphic Design Awards

We would like to thank this year's extraordinary panel of judges for their participation in the creation of this 2000 Annual Awards Issue. This national panel of creative professionals hails from prominent graphic design firms, advertising agencies, and corporate design departments. The competition, sponsored by Graphic Design:usa, the news monthly for creative professionals since 1963, seeks to recognize excellence in design and marketing, representing the freshest work for a broad range of creative applications.

Harri Boller, Principal, Boller
Coates & Neu, Chicago IL

Born and educated in Switzerland, Harri Boller has been designing annual reports, graphic communications, corporate identity and signage programs for over 35 years. He is a founder and co-owner of the very hot Boller Coates & Neu in Chicago and is the recipient of numerous design awards.

Gwen Granzow, Vice
President/Creative Director, Principal,
Design North, Racine WI

After completing a BFA in graphic design at Northern Illinois University, Gwen Granzow spent several years with Goldsmith, Yamasaki, Specht in Chicago where she gained experience in packaging, structural design and product graphics. She joined Design North in 1986, and in 1993 she was promoted to Vice President/Creative Director. She was also made a partner in the firm. At present she leads a team of eight. She has extensive experience in branding and packaging, and has led major projects for The Quaker Oats Company, Agrilink Foods, Jim Beam Brands, Heinz Frozen Foods, Jones Dairy Farm, Gardetto's Family Bakery, Kaytee Products, Inc., Master Lock, and Snap-on, Inc. Personal creative outlets include steel sculpture and designing one-of-a-kind clothing.

Ron Lars Hansen, Senior
Designer, Belyea, Seattle WA

Creating a strong voice supported by persuasive visuals is the goal of Ron Lars Hansen. Hansen is the senior designer at Seattle-based marketing, communications and design firm Belyea, founded by Patricia Belyea. He works closely with clients and the firm's marketing strategists to develop comprehensive marketing campaigns based on a core message. His creative skills are rooted in his experiences at Rhode Island School of Design where he earned a BFA in graphic design. Among major clients for whom he has developed branding and collateral solutions are Weyerhaeuser, Holland America and Hogue Cellars.

AGDA Judges

Peter Klueger, Associate
Creative Director, Ogilvy & Mather,
New York NY

With 14 years under his belt as an art director, designer, visual artist and multimedia visionary, Peter Klueger has explored the numerous facets of visual communications, graphic design, branding, multimedia design and photography. He has served a wide range of clients including Canon USA, Maxell Electronics, RCA Music/BMG-Bertelsman, Daimler Benz, UniLever, British Petroleum, Kellogg Company and many others. Klueger says his approach to the creative process is to: "Look at the whole picture of communication, not just the visual elements. To be an innovator, a true designer needs to convey the message — the big idea — throughout the entire campaign. You can explore everything, but if form doesn't follow function, you'll end up with a design that merely looks good, but fails to deliver the message."

David Salanitro, Principal, Creative
Director, Oh Boy, A Design Company,
San Francisco CA

Over the past 17 years, David Salanitro has gathered experience in fine art exhibition, architecture, and theatrical and graphic design spanning such industries as technology, publishing, hospitality, medical, business, education, fine arts, and performing arts. Among notable projects are the renovation of the landmark Sheraton Palace Hotel in San Francisco for Skidmore, Owings and Merrill Architects and the redesign of Publish Magazine. Clients of the ten-person shop include Andersen Consulting, Cadence Design Systems and Charles Schwab & Company. Salanitro founded his firm on the concept of collaborative creative efforts between designers and production specialists, and by committing to people who believe in the far-reaching impact of good design to effect change in the way clients, customers, peers and the community perceive and respond. Salanitro's creative talents extend to the stage where he has made appearances as Pish Tush in Gilbert and Sullivan's The Mikado, Richie in Bleacher Burns, and Tevye in Fiddler on the Roof.

Don Sibley, Principal, Creative
Director, Sibley Peteet Design,
Dallas TX

In 1982, Don Sibley teamed with Rex Peteet to form Sibley Peteet Design. Over the years the company has grown to specialize in all forms of print and electronic communication and to attract clients such as Image Bank, Mirage Resorts, Nortel, Chase Bank, and Weyerhaeuser. Sibley is the managing partner and creative director for the firm's Dallas office. His creative efforts have been recognized with the presentation of several national advertising, graphic design and illustration awards. His works are also in the permanent collection of the Library of Congress and the Museum of Modern Art in Hiroshima. Sibley is a frequent lecturer to professional organizations, universities, and conferences across the country. He is an active member of the Dallas Society of Visual Communications, and a founding member and past director of the AIGA, Texas Chapter. His interests extend to raising Bull Terriers ("Spuds") for show and enjoying the Baja Peninsula's culture in Cabo San Lucas.

Bob Talarczyk, Design
Manager, Merck & Co.,
Whitehouse Station NJ

Bob Talarczyk is the design manager at Merck & Co., Worldwide Headquarters. The company's Design Group works on marketing and medical communications projects for 200 countries. Before joining Merck & Co. he was a design director/producer for the inhouse design/agency at Ciba-Geigy. His background also includes a stint with the Healthcare Division of J. Walter Thompson as a senior art director. Along with many accolades for graphic design and art direction, he has the noted distinction of designing and producing the first pharmaceutical commercials created for television. He is also the founder of Mission Control, a healthcare design firm. He attended the New York School of Visual Arts and The School of Fine Arts as well as holding a BA from William Paterson College and Masters of Science from Pratt Institute. In his time off from creative pursuits, Talarczyk is a licensed pilot and flies antique aircraft and also notes sailing, rowing, amateur astronomy, tennis and fishing among his interests.

Firms Represented

2 Sisters Design
Redwood Shores, CA42

2K Design
Clifton Park, NY................................111

3D Effects
Los Angeles, CA94

ADC Creative Services Group
Minnetonka, MN................................25, 81

Addis Group, Inc.
Berkeley, CA................................42, 87, 100, 114

Addison
San Francisco, CA14, 114

AGCD
Montclair, NJ................................42

Akagi Remington
San Francisco, CA9, 42

Alaska Stock
Anchorage, AK71

Alison Zawacki Illustration
Sacramento, CA................................155

Andersen Worldwide
West Chicago, IL................................139

Anderson Mraz Design
Spokane, WA................................43

Ann Hill Communications
San Rafael, CA150

Arrowstreet Graphic Design
Somerville, MA................................68, 139

Art Center College of Design
Pasadena, CA87

Art dot sos
Philadelphia, PA................................14

Artemis Creative, Inc.
Palo Alto, CA25, 26

Arts & Letters, Ltd.
Falls Church, VA................................94

Audra Kirstin Miller
Fairfax, VA................................150

Automotive Recyclers Association
Fairfax, VA................................9

Axion Design Inc.
San Anselmo, CA................................94, 114

b&j Designs
Richmond, VA................................101

Babcox Publications
Akron, OH................................9

Bach-Lees Design, Inc
Boston, MA................................43, 88

Baker Designed Communications
Santa Monica, CA................................43

Bankers Life and Casualty Company
Chicago, IL................................151

Barnett Design, Inc.
Ramsey, NJ................................43

BBK Studio, Inc.
Grand Rapids, MI................................88, 134

Bell & Howell Information and Learning
Ann Arbor, MI................................142

Bellini Design
Oak Brook, IL................................26

Belyea
Seattle, WA................................81, 95, 101

be·design
San Rafael, CA................................75, 76, 95, 101, 135

BGDI
Berkeley, CA................................38, 76, 155

BI Performance Services
Minneapolis, MN................................14, 43, 81

BKD Design
Fountain Valley, CA................................95

Bloomberg
Princeton, NJ................................15, 44, 71, 72

Blue Cross Blue Shield of Rhode Island
Providence, RI................................26

BoldFace Design
Los Angeles, CA................................26, 44

Boller Coates & Neu
Chicago, IL................................27, 28

Bonato Design
Berwyn, PA................................95

Boston University
Boston, MA................................15

Brandesign Incorporated
Monroe, NJ................................101, 115

Brodeur Worldwide
Boston, MA................................15, 151

Broom & Broom, Inc.
San Francisco, CA................................28

Brown Design & Company
Portland, ME................................68, 95, 115

Business Travel News
New York, NY................................142

BWITT.Com
Danbury, CT................................88

C&C Graphics
Malverne, NY................................142

CAG Design
Hackettstown, NJ................................115

Callison
Seattle, WA................................130

Cambridge Design Group
Andover, MA................................44

Carla Hall Design Group
New York, NY................................44, 88

Casady & Greene
Salinas, CA................................9

Caserta Design Company
Stratford, CT................................96

Catalyst Direct, Inc.
Rochester, NY................................81, 112

Ceradini Design
New York, NY................................115, 116, 117

CF/NAPA
Napa, CA................................117

Champagne/Lafayette Communications Inc.
Natick, MA................................45, 81

Chris Carline Design
San Francisco, CA................................16, 101

Firms Represented

Chute Gerdeman, Inc.
Columbus, Ohio ..130, 131

Cinergy Design Services
Plainfield, IN...45

CIO Magazine
Framingham, MA...............................9, 10, 143

Clarion Marketing & Communications Atlanta
Atlanta, GA10, 45, 118, 131

Clarke & Associates LLC
Somerville, NJ.......................................88, 89

Clicquot, Inc.
New York, NY..72

CMg Design Inc.
Pasadena, CA........................29, 45, 76

Coffee Cup Design Studio
New York, NY..68

Concord Litho Group
Concord, NH..68

Cornerstone Design Associates
New York, NY..118

Cornett Advertising
Lexington, KY..29

Courtney & Company
New York, NY..143, 151

Crawford/Mikus Design, Inc.
Atlanta, GA........................16, 46, 82, 96

Creative Alliance Marketing & Communications
Southport, CT..46, 151

Creative Fusion Design Company
Stony Creek, CT..77

CRSR Designs
Kingston, NY..89

Dakota Group, Inc.
Wilton, CT..29, 46

Dart Design
Fairfield, CT..46, 82

David Carter Graphic Design Associates
Dallas, TX........................16, 47, 102

Davis Harrison Dion
Chicago, IL10, 47, 102

DCI Marketing
Milwaukee, WI........................131, 132

Dennis Johnson Design
Oakland, CA..29, 139

Dermal Group
Torrance, CA........................10, 47, 83

Design Guys
Minneapolis, MN................10, 83, 96, 118, 119

Design Matters, Inc!
New York, NY........................16, 47, 83

Design North, Inc.
Racine , WI..102, 119

Design Source East
Cranford, NJ.................17, 47, 69, 96, 112

designTHIS!
Napa, CA..89

Development Design Group Inc.
Baltimore, MD..17

Dever Designs
Laurel, MD................................48, 143, 144

Di Vincenzo Design
Dobbs Ferry, NY..48

Dickson Design
Redwood City, CA97, 112

Digidesign
Palo Alto, CA17, 48

Directions Incorporated
Neenah, WI................48, 102, 119

Diversity: Architecture & Design
New York, NY........................17, 18, 48, 49

Donaldson Makoski Inc.
Avon, CT..777, 119

Donovan Group
Northborough, MA..155

Duchaine Communications Inc.
Brooklyn, NY..155

Dugan Valva Contess
Morristown, NJ..49

EAB
Uniondale, NY..95, 102

Eagleye Creative
Littleton, CO..90, 132

Edge Communications, Inc.
Hermosa Beach, CA..95

Egad Dzyn
Burbank, CA..38

Emerson, Wajdowicz Studios
New York, NY........................97, 49, 50, 135

Evenson Design Group
Culver City, CA..50

Ezzona Design Group, Inc.
Burbank, CA........................18, 72, 120, 156

Faust Associates
Chicago, IL..72

Fitzgerald Esplin Advertising
Doylestown, PA..50, 156

Flaherty Sabol Carroll Marketing Communications
Pittsburgh, PA..140

Flourish
Cleveland, OH..50, 83

Ford & Earl Associates, Inc.
Troy, MI........................18, 97, 132

Freeman Design Ltd.
Evanston , IL..69

Fresh Fish Design
San Diego, CA..151

Full Concept Inc./Turgeon Group
Madison Heights, MI........................31, 156

Fusion Media, Inc.
Fishkill, NY..77

GAF Advertising/Design
Dallas , TX..50, 157

Gammon Ragonesi Associates
New York, NY..11, 51

Gardner Group
Montgomery Village, MD................135

Gateway Arts
Thousand Oaks, CA72, 90

Firms Represented

Gatta Design & Co., Inc.
New York, Ny..18

Gazette Newspapers
Gathersburg, MD...144

Genghis Design
Lakewood , CO..73

Genysis Creative Services
Scottsdale, AZ..120

Gibson Design
Middletown, CT..51

Glick Design
Kahului, HI..157

Glory Studios
Dade City, FL..103

GMO/Hill Holliday
San Francisco, CA11, 18, 51, 77, 132

Gold & Associates, Inc.
Ponte Vedra Beach, FL....................................135

Graphic Design Concepts
Cleveland , OH..19

Graphic Edge Studio Inc.
Reno , NY...19

Grayton Integrated Publishing
Grosse Pointe, MI......................................144, 157

Greenfield/Belser
Washington, DC...........11, 19, 90, 103, 120, 157

Greenhouse Design
Highland Park, NJ......................................133, 144

Group Chicago
Chicago, IL..52

Hadassah Magazine
New York, NY...144

Hansen Design Company
Seattle , WA...............................52, 140, 158

Hanson Associates
Philadelphia , PA..103

Hare Strigenz Design
Milwaukee, WI...19, 158

Harman Consumer Group
Woodbury, NY..52

Harper & Harper
New Haven, CT..52

HC Creative Communications
Bethesda, MD...31, 103

Hedstrom/Blessing, Inc.
Minneapolis, MN...121

Hill and Knowlton
Los Angeles, CA................................19, 20, 53, 112

Home Grown Studios
minneapolis, MN...158

Household International Employee Communications
Prospect Heights, IL...133

Howry Design Associates
San Francisco, CA...31

Hull Creative Group
Boston, MA...83, 90

Hunt Weber Clark Associates, Inc.
San Francisco, CA...............20, 69, 77, 979,
..103, 104

Idea Integration
Houston, TX...90, 91

IDEC Corporation
Sunnyvale, CA..11

Ilium Associates, Inc.
Bellevue, WA...53, 133

Inkdigital
New York, NY..78

International Paper
Memphis, TN..................121, 122, 135, 136, 158

Intertec Publishing
Overland Park, KS...145

J. Paul Getty
Trust-Publications Services
Los Angeles, CA ...39, 152

JA Design Solutions
Coppell, TX...84, 104

Jacqueline Barrett Design Inc.
Oceanport , NJ..53, 112, 145

Jager Di Paola Kemp Design
Burlington, VT..123

Janet Hughes and Associates
Wilmington, DE ..140

JDC Design, Inc.
New York, NY...20, 53

John Kallio Graphic Design
New Haven, CT...20, 146

John Kneapler Design
New York , NY...20, 113

Joseph Marcou Design Inc. and
Marcou/Scheafer
Monroe Township, NJ104

Jostens ProMedia
Burnsville, MN..54

Julie Chun Design
Mill Valley, CA..32

Jupiter Design Group, Inc.
Midland Pk, NJ..32

JWT Specialized Communications
St. Louis, MO..21, 54

Karl Kromer Design
San Jose, CA..104, 105

Keiler & Company
Farmington, CT...............................11, 32, 84, 140,
..152, 158

Kelley Communications Group
Dublin , OH...84, 152

Kircher
Washington, DC..84

Kirshenbaum Communications
san Francisco, CA...78, 159

Kittner Design
Suite 150, Takoma Park....................................136

Kor Group
Boston, MA...54, 55, 146

Firms Represented

Kramer & Larkin
Philadelphia, PA.....................73

Landor Associates
San Francisco, CA.....................105, 123

Laughing Horse Graphics
Quakertown, PA.....................55

Laughing Stock
S. Newfane, VT.....................73

Laura Coe Design Associates
San Diego, CA.....................133, 159

Laura Medeiros
Sunnyvale, CA.....................111

Laura Tolar Design
Ocean Springs, MS.....................21

Leibowitz Communications
New York, NY.....................21, 152

Leimer Cross Design
Seattle, WA.....................32, 33, 153, 159

Les Cheneaux Design
Ypsilanti, MI.....................21, 78

Level 3 Communications
Broomfield, CO.....................136

Leverage Marketing Group
Newtown, CT.....................21

Libby Perszyk Kathman
Cincinnati, OH.....................141

Life Time Fitness
Eden Prairie, MN.....................105

Lipson Alport Glass
Northbrook, IL.....................124

Litton Data Systems
Agoura Hills, CA.....................146

Liturgy Training Publications
Chicago, IL.....................125

Louey/Rubino Design Group Inc.
Santa Monica, CA.....................159

Love Packaging Group
Wichita, KS.....................22, 55, 105, 106, 125,
.....................133, 159

Magic Pencil Studios
Orlando, FL.....................106

Malcolm Grear Designers
Providence, RI.....................78, 106, 141

Malish & Pagonis
Philadelphia, PA.....................55, 69, 85

March of Dimes
White Plains, NY.....................55, 56

MarchFIRST
New York, NY.....................91

Mark Oliver, Inc.
Santa Barbara, CA.....................125

Marketing Communications
New York, NY.....................97, 136

Marketpartners, Inc. Results by Design
Denver, CO.....................106

Marriott International
Washington, DC.....................91

Matthew Schmidt Design
Exton, PA.....................56

McElfish & Company
Troy, MI.....................56, 78, 97

McGowan Advertising, Inc.
Lakewood, WA.....................57

McMillan Associates
West Dundee, IL.....................34

McMillian Design
Woodside, NY.....................107

Mebane Packaging of Westvaco
Mebane, NC.....................12

Merck & Co, Inc.
Whitehouse Station , NJ.....................70

Merck Worldwide
Whitehouse Station , NJ.....................57

Merrill Corporation
St. Cloud, MN.....................160

Messiah College
Grantham, PA.....................147

Meyers Design, Inc.
Chicago, Il.....................22

Michael Fanizza Designs
Haslett, MI.....................73

Michael Indresano Photography
Boston, MA.....................160

Michael Osborne Design
San Francisco, CA.....................79, 98, 160

Michael P. Arndt
New York, NY.....................22, 160

Microware Systems Corp.
Des Moines, IA.....................92

Mikaelian Design
Philadelphia, PA.....................22, 73

Miller Sports Group
New York, NY.....................153

Mission House Creative
Raleigh, NC.....................57

Mitten Design
San Francisco, CA.....................107

Monaco/Viola Incorporated
Chicago, IL.....................57

Morgan Stanley Dean Witter: IBD Creative Services
New York, NY.....................12, 136

NAK Group
New York, NY.....................153

Naked Eye Studios
Orlando, FL.....................107

Nassar Design
Brookline, MA.....................23, 39, 98, 160

NDW Communications
Horsham, PA.....................57, 586, 113, 153

NeigerDesignInc.
Evanston, IL.....................161

Nesnadny & Schwartz
Cleveland , OH.....................34, 58, 70, 92

Network World
Southborough, MA.....................58, 79

New Riders Publishing
Indianapolis, IN.....................40

Firms Represented

New York City Economic Development Corp.
New York, NY..............................58, 153

Nicholson Design
Carlsbad, CA..............................74

NRTC
Herndon, VA..............................34, 58

O&J Design Inc.
New York, NY..............34, 59, 70, 79, 98

Odgis & Co.
New York, NY..............................59

Oliver Kuhlmann
St. Louis, MO..............59, 137, 154, 161

Olver Dunlop Associates
Chicago, IL..............................35, 70

Optum Communications
McLean, VA..............................79

p11creative
Santa Ana Heights, CA..............59, 107, 147

Page Design, Inc.
Sacramento, CA..............35, 60, 70, 107,
..............................126, 137

Paul Kaza Associates, Inc.
So. Burlington, VT..............................12

Pear Design Incorporated
Chicago, Il..............................161

Peggy Lauritsen Design Group
Minneapolis, MN..............................108

Pepsi-Cola Company
Purchase, NY..............60, 71, 98, 126

Petertil Design Partners
Oak Park, IL..............................85, 141

Petrick Design
Chicago, IL..............................35, 74, 85

Pierre Rademaker Design
San Luis Obispo, CA..............................60, 108

Pinnacle Communications
Baltimore, MD..............................23, 60

Pinnacle Graphics
Addison, TX..............................60, 126

PiperStudiosInc
Chicago, IL..............................61, 92

Pisarkiewicz, Mazur & Co., Inc.
New York, NY..............................61, 108

Popular Mechanics
New York, NY..............137, 147, 148

Posner Advertising
New York, NY..............................35, 61

PPG Industries
Pittsburgh, PA..............................36, 92

Premier Design Studio, Inc.
Royal Oak, MI..............................127

Prentice Hall
Upper Saddle River, NJ..............................61, 74

Primedia Enthusiast Group
Leesburg, VA..............................148, 149

Proma Technologies Co.
Franklin, MA..............................113

Propeller Works
Stamford, CT..............................127

Quad Creative, L.L.C.
Milwaukee, WI..............................74

R&J Integrated Marketing Communications
Parsippany, NJ..............................13

Raincastle Communications
Newtown, MA..............................36, 75, 108

Rappy & Company, Inc.
New York, NY..............................80, 1091

Rare Medium, Inc.
New York, NY..............................92, 93

Raytheon Technical Services Co.
Burlington, MA..............................61, 109

Rector Communications, Inc.
Philadelphia, PA..............................62

RiechesBaird
Irvine, CA..............................109

Risk Management Solutions
Menlo Park, CA..............................23

Robideaux! Advertising & Marketing
Spokane, WA..............................127

Ron Lieberman Studio
New York , NY..............................40

Rossignol
Williston, VT..............................75

Rutgers, The State University of New Jersey
New Brunswick, NJ..............................36, 149

Sabre Design & Publishing
Henderson , NV..............................109

Salomon Smith Barney
New York, NY..............................36, 62, 134

Saraceno Design Inc.
Bethlehem, PA..............................141

Sayles Graphic Design
Des Moines, IA..............................40, 62, 127

Scott Design Communications
Philadelphia, PA..............................23, 63

Sharon Elwell Graphic Design
North Reading , MA..............................85

Sherman Advertising Associates
New York, NY..............................13, 63, 64

SiD studios
Concord, OH..............................80, 98

SJI Associates Inc.
New York, NY..............................23, 24, 99, 109

Skidmore, Inc.
Southfield , MI..............................99, 161

South-Western College Publishing
Cincinnati, OH..............................40

Spark Design
Tempe, AZ..............................64, 71

Spielman Design, LLC
Collinsville, CT..............................24

St. Jacques Communications Design
Morristown, NJ..............................13

Stan Gellman Graphic Design
St. Louis, MO..............................24

Stephen Loges Graphic Design
New York, NY..............................110

Firms Represented

Sterling Group
New York, NY..24, 127, 128

Studio G
Reno, NV..71

Studio North
North Chicago, IL...161

Sullivan Creative
Newton, MA ...24, 80, 93

Sunspots Creative, Inc.
Hoboken, NJ...............................13, 25, 154, 162

Suze Wilson Design Studio
Mill Valley, CA..137

t.a. design
Hamilton, NJ..110

Tamada Brown & Associates
Chicago, IL..110

Target Packaging
Minneapolis, MW...128

Teltone Corp.
Bothell, WA...64

TFW Design, Inc.
Alexandria, VA..36

That's Nice, LLC
New York, NY...93, 94

The Allied Group
Glastonbury, CT...80

The Boston Globe
Boston, MA..64, 65

The Humane Society of the United States
Gaithersburg, MD65, 99, 137, 138, 141,
...154, 162

The Indigo Group
Shelton, CT...99, 138, 154

The Longaberger Company
Newark, OH..99

The Mr. Gasket Performance Group
Cleveland, OH...14

The New York Times Company Magazine Group
Trumbull, CT...149

The Siebels Bruce Group, Inc.
Columbia, SC..138

The Taunton Press
Newtown, CT...41

The Valvoline Company
Lexington, KY..128, 129

The Vanguard Group
Malvern, PA..65, 66, 113

Thermo Electron Corporation
Waltham, MA...37

Thibiant International, Inc.
Chatsworth, CA..80

Thompson Design Group
San Francisco, CA..129

Thompson Studio
Doylestown, PA...25, 154

Three & Associates, Inc.
Cincinnati, OH..37

Three-Five Systems, Inc.
Tempe, AZ..37

Tieken Design & Creative Services
Phoenix, AZ..14, 86, 150

Tim Kenney Design Partners
Bethesda, MD...94, 138

Tom Graboski Associates Inc. Design
Coral Gables, FL...134

Towson University
Towson, MD...75, 86, 113

Trained Eye Graphics
El Sobrante, CA...138

Tribune Media Services
Chicago, IL..86

U.S. General Accounting Office
Washington , DC...110, 139

über, inc.
New York, NY...25

UC Berkeley Summer Sessions
Berkeley, CA..38, 134

Uncommon Design
Laurel, MD...100

UP Design
Montclair, NJ..155, 162

VIA
New York, NY...66

VICAM
Watertown, MA..66

Vinje Design, Inc.
San Francisco, CA..38

Visual Marketing Associates, Inc.
Dayton, OH...66

Wallace Church Associates Inc.
New York, NY...100, 129, 130

Warkulwiz Design Associates
Philadelphia, PA...66, 150

Warner Books
New York, NY...41

Wendell Minor Design
Washington, CT...41, 42, 75

Westwood Studios
Las Vegas, NV...111, 130

whiteSTARdesign
Bethlehem, PA...100, 111

William M. Gould Design
Scottsdale, AZ..130

Williams & Stevens, Inc.
Seven Hills, OH..67

Xerox Corporation
WilsonVille, OR...67

Z Design
Olney, MD..42, 162

Zamboo
Marina Del Rey, CA.....................67, 86, 114, 162

ZGraphics, Ltd.
East Dundee, IL.............................67, 68, 86, 111

Zinc
New York, NY...87